Morocco

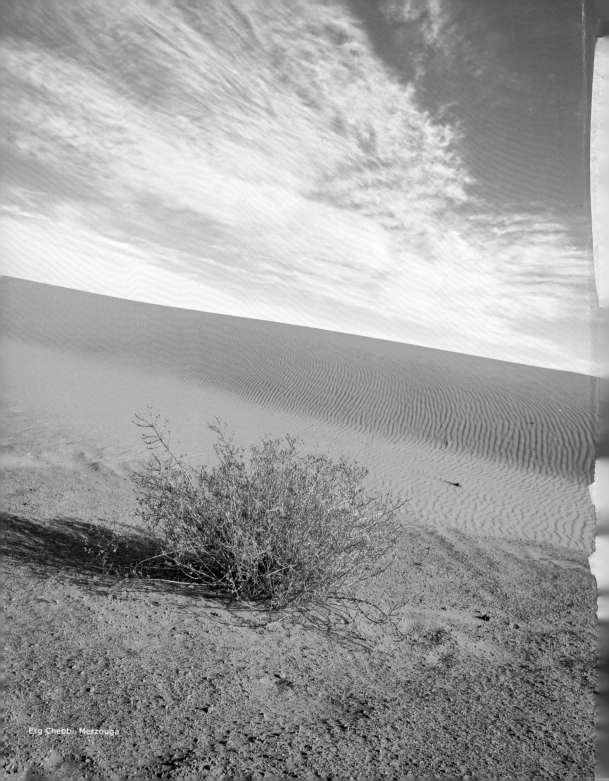

Erg Chebbi, Merzouga

Morocco

Christine Metzger

ÉDITIONS
PLACE DES
VICTOIRES

KÖNEMANN

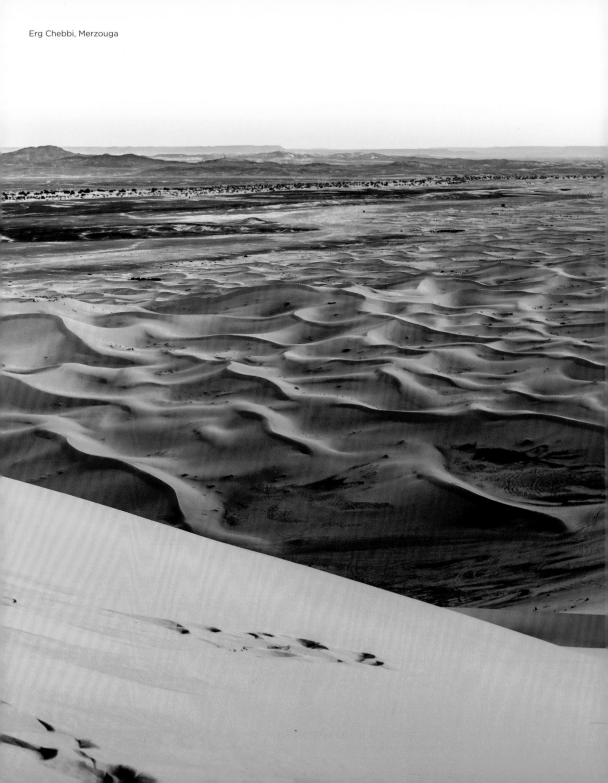

Erg Chebbi, Merzouga

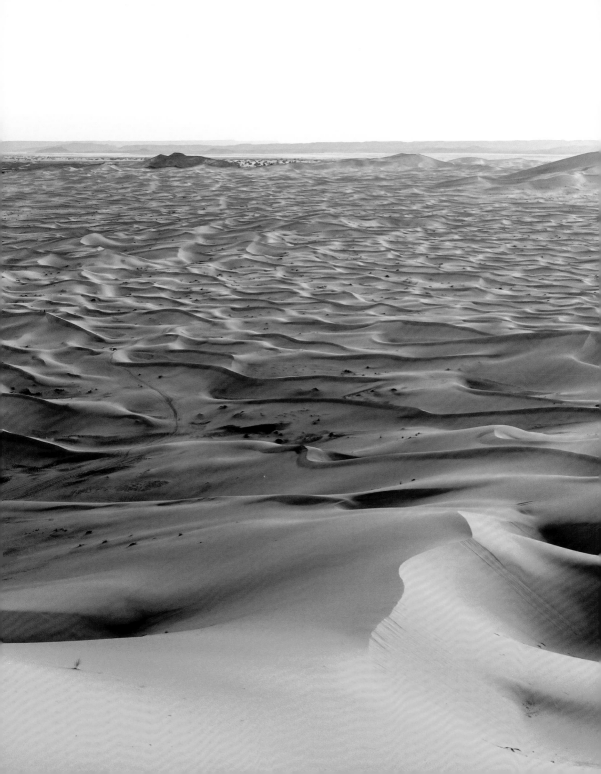

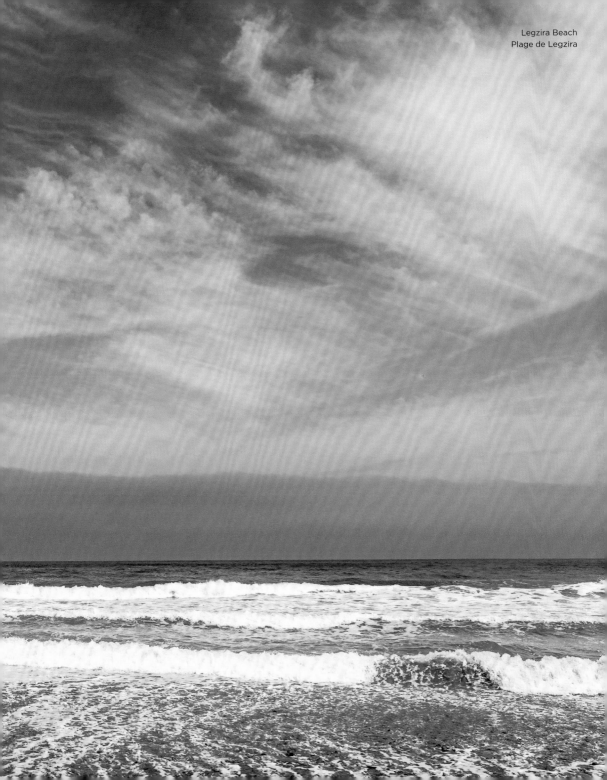

Legzira Beach
Plage de Legzira

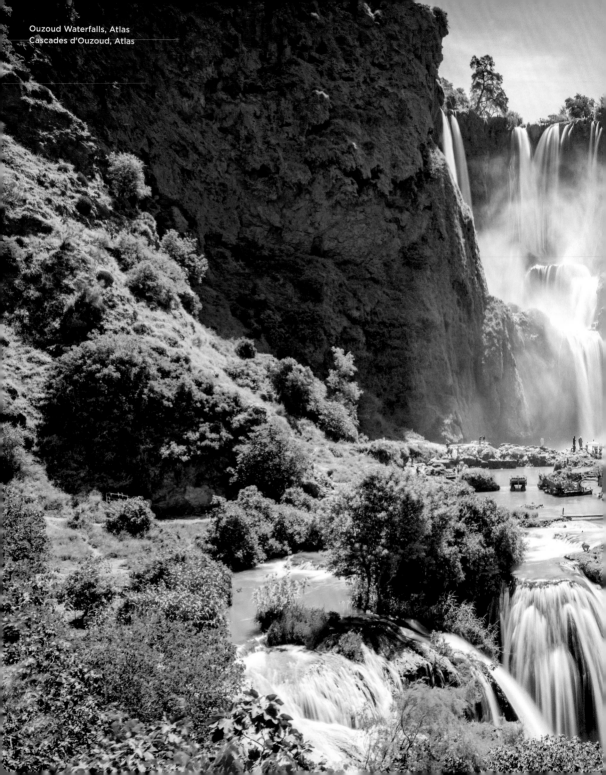

Ouzoud Waterfalls, Atlas
Cascades d'Ouzoud, Atlas

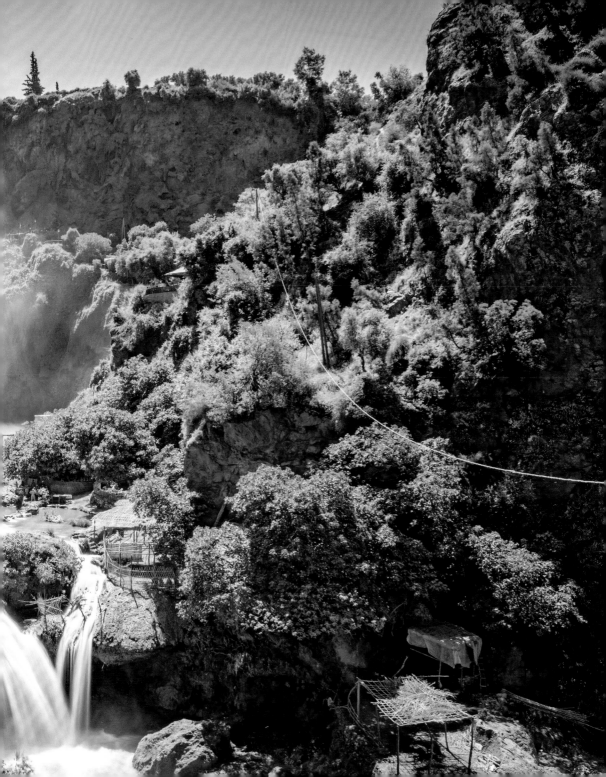

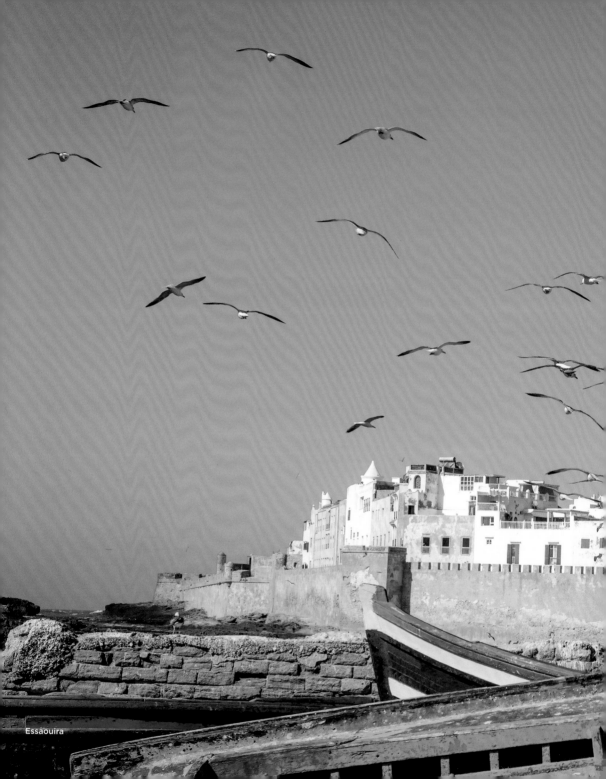
Essaouira

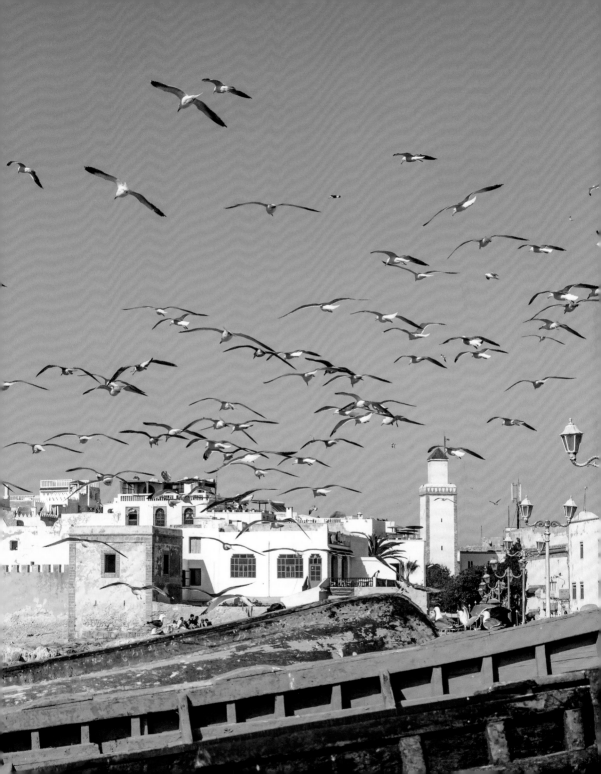

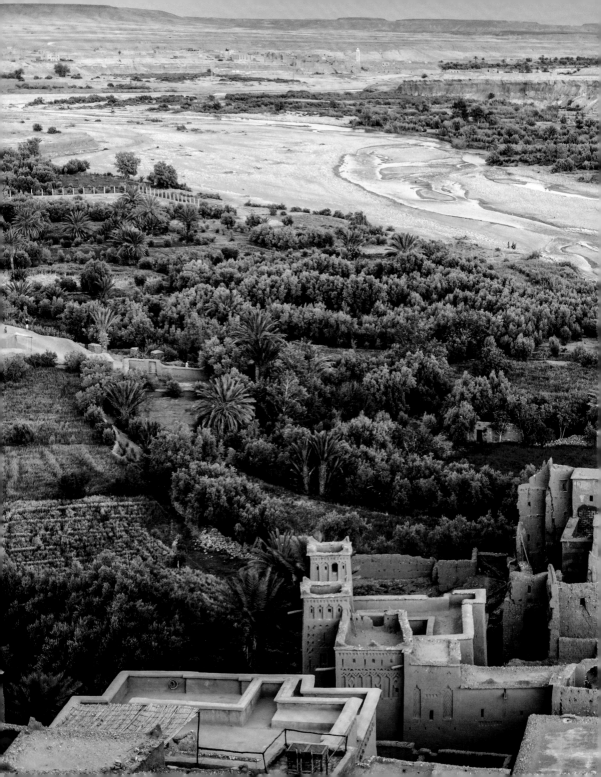

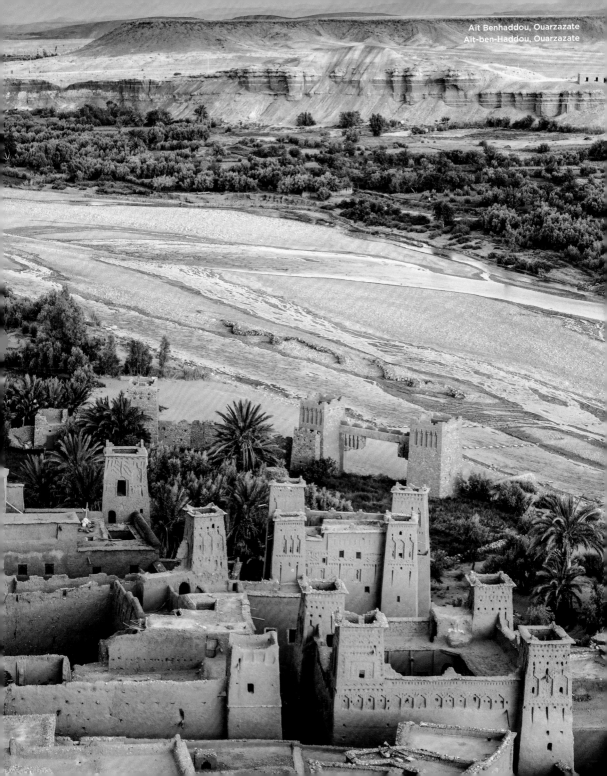

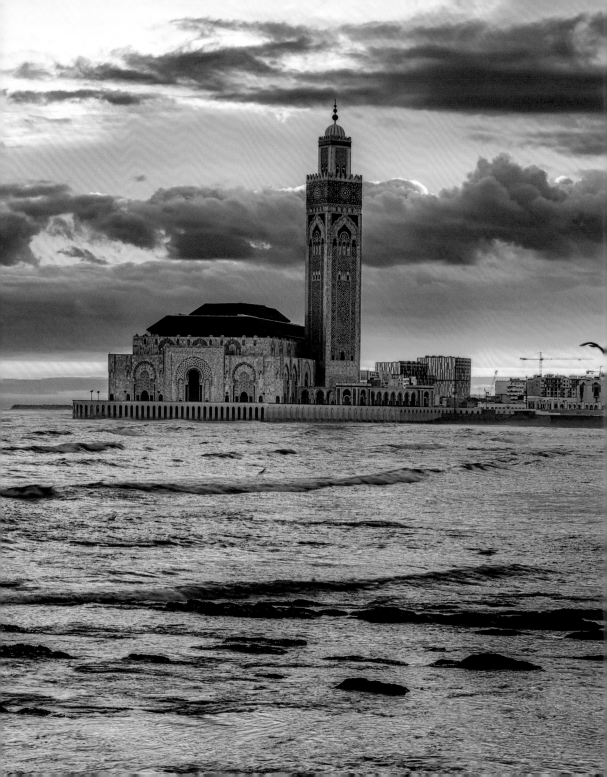

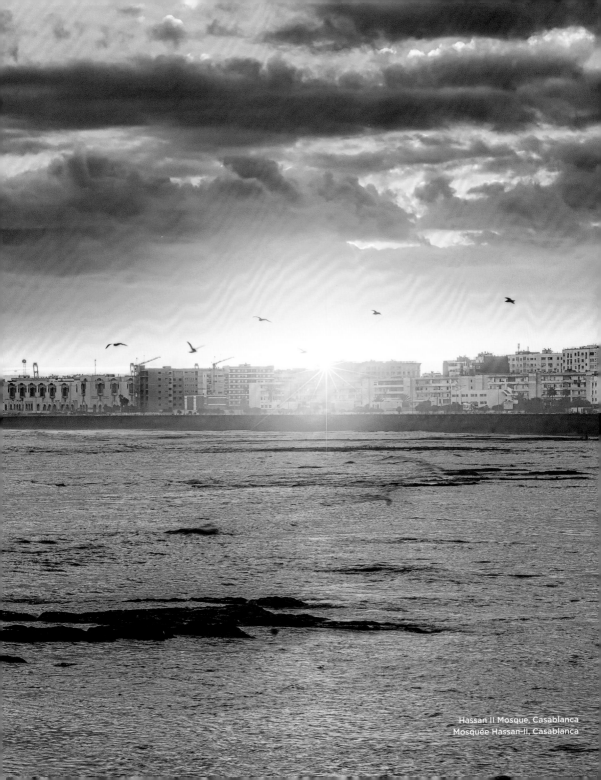

Hassan II Mosque, Casablanca
Mosquée Hassan-II, Casablanca

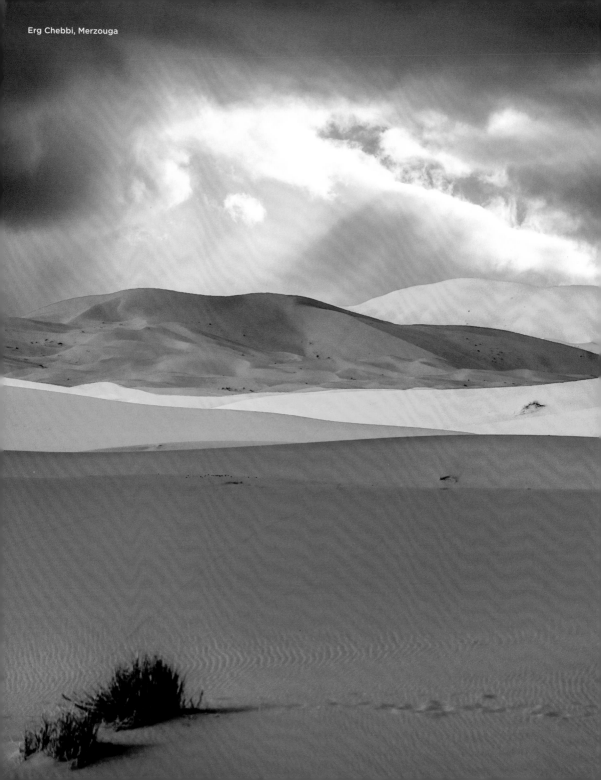

Erg Chebbi, Merzouga

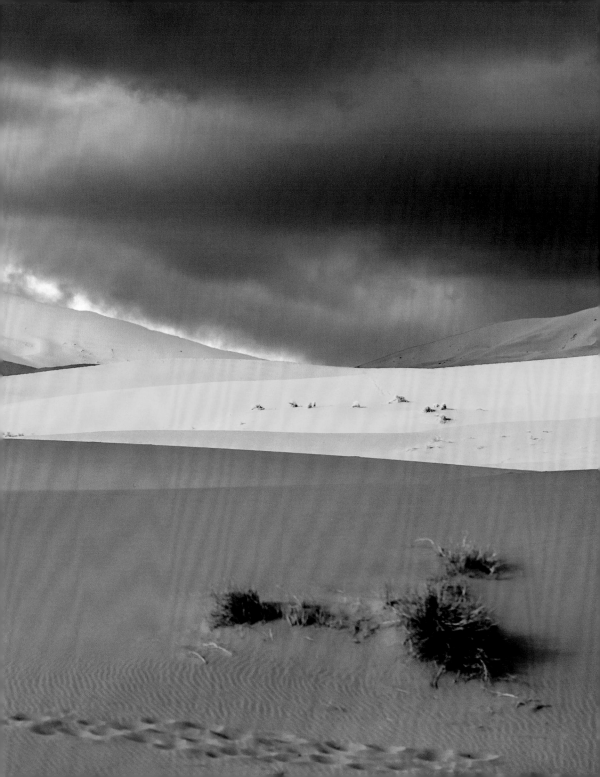

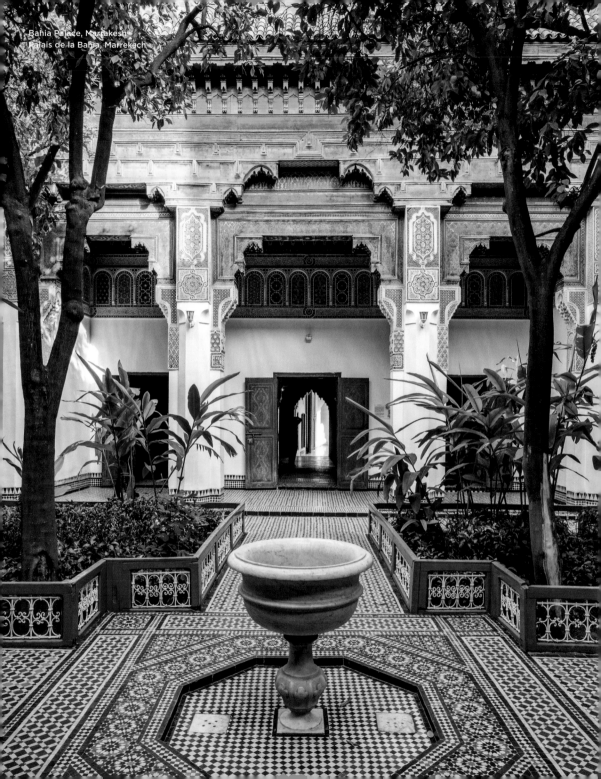

Bahia Palace, Marrakesh
Palais de la Bahia, Marrekech

Contents · Sommaire · Inhalt · Índice · Indice · Inhoud

Morocco

If one wanted to characterize Morocco in one word, that word might be 'diversity'. Carthaginians, Romans, Berbers, Arabs, Jews, various colonial powers—among them Spanish and Portuguese—have all left their mark on the country, shaped the townscapes, created cultural monuments and enriched the cuisine.

On the coasts of the Mediterranean and the Atlantic there are steep cliffs, wide bays, sandy beaches and harbours of international importance. In the interior, the mountains rise in some places to over 4 000 m. Each mountain range—Rif, High Atlas, Anti-Atlas and Middle Atlas—has its own character, from peacefully Mediterranean to rugged and snow-covered. Valleys and gorges have dug into the mountain ranges where the Berbers built their forts and settlements. Their traces can also be found in the many oasis towns, through which the desert-traversing caravans used to pass.

Besides the impressive landscapes, the country also has a lot to offer culturally. Tangier and Casablanca were once the places of inspiration for artists, writers and filmmakers. The four royal cities of Fes, Marrakesh, Mèknes and Rabat were magnificently developed by their rulers. The medinas, with their winding alleys, are dominated by the souks where craftsmen produce and sell their goods and exotic scents abound, all accompanied by the sound of the muezzin's call to prayer.

Maroc

Si l'on devait définir le Maroc en un seul mot : diversité. Carthaginois, Romains, Berbères, Arabes, Juifs, diverses puissances coloniales – dont l'Espagne et le Portugal – ont marqué le pays, façonné les paysages urbains, créé des monuments culturels et enrichi la cuisine.

Sur les littoraux de la Méditerranée et de l'Atlantique, on trouve des côtes escarpées, de larges baies, des plages de sable et des ports d'importance internationale. À l'intérieur des terres, des montagnes s'élèvent à plus de 4 000 m d'altitude. Chaque chaîne montagneuse – Rif, Haut Atlas, Anti-Atlas, Moyen Atlas – dispose d'un caractère qui lui est propre, du climat méditerranéen paisible aux environnements sauvages et même enneigés. Des vallées et des gorges se sont creusées dans les chaînes de montagnes où les Berbères ont construit leurs châteaux et leurs villages. Leurs traces se retrouvent également dans les nombreuses villes et les oasis, à travers lesquelles les caravanes se rendaient jusqu'aux déserts de dunes de sable.

Outre ses paysages impressionnants, le pays a aussi beaucoup à offrir culturellement. Tanger et Casablanca inspiraient autrefois la nostalgie aux artistes, aux écrivains et aux cinéastes. Les quatre villes royales de Fès, Marrakech, Meknès et Rabat ont été magnifiquement développées par leurs souverains. Les médinas, avec leurs ruelles sinueuses, sont dominées par les souks où les artisans produisent et vendent leurs denrées, au milieu des parfums exotiques et de l'appel du muezzin.

Marokko

Will man Marokko mit einem Wort charakterisieren, so lautet das: Vielfalt. Karthager, Römer, Berber, Araber, Juden, diverse Kolonialmächte – unter ihnen Spanier und Portugiesen –, hinterließen ihre Spuren im Land, prägten die Stadtbilder, schufen Kulturdenkmäler und bereicherten auch die Küche.

An den Küsten von Mittelmeer und Atlantik finden sich steile Küsten, weite Buchten, sandige Strände und Häfen von internationaler Bedeutung. Im Landesinneren erheben sich die Berge zum Teil über 4 000 m hoch. Jeder Gebirgszug – Rif, Hoher Atlas, Anti-Atlas, Mittlerer Atlas – hat seinen eigenen Charakter von mediterran lieblich bis schroff und schneebedeckt. Täler und Schluchten haben sich in die Gebirgsketten gegraben, in denen die Berber ihre Burgen und Siedlungen errichteten. Ihre Spuren findet man auch in den vielen Oasenstädten, durch die früher Karawanen in die Sanddünenwüsten zogen.

Neben den beeindruckenden Landschaften hat das Land auch kulturell eine Menge zu bieten. Tanger und Casablanca waren einst Sehnsuchtsorte von Künstlern, Schriftstellern und Cineasten. Die vier Königsstädte Fès, Marrakesch, Mèknes und Rabat wurden von ihren Herrschern prunkvoll ausgebaut. Die Medinas mit ihren verwinkelten Gassen, werden beherrscht von den Souks, in denen Handwerker ihre Waren herstellen und zum Verkauf anbieten, exotischen Düften und dem Ruf des Muezzins.

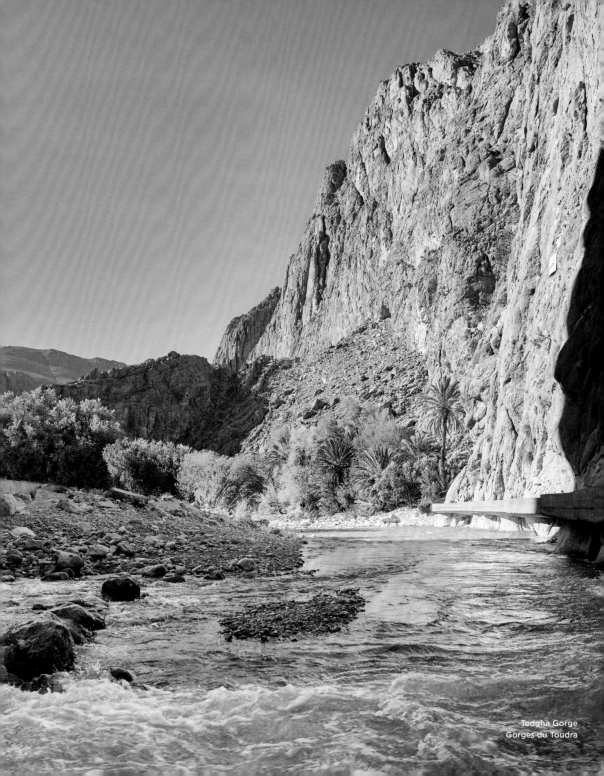

Todgha Gorge
Gorges du Toudra

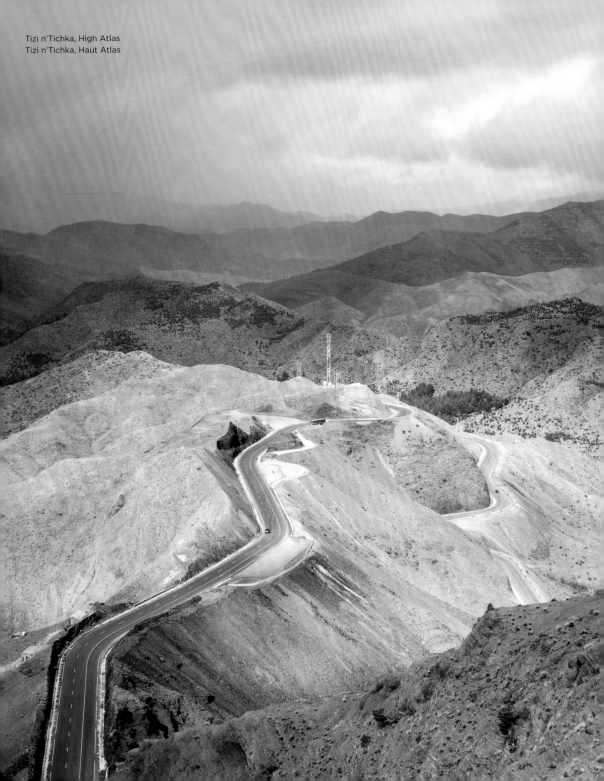

Tizi n'Tichka, High Atlas
Tizi n'Tichka, Haut Atlas

Marruecos

Si hubiese que describir Marruecos con una palabra, esta sería "diversidad". Cartagineses, romanos, bereberes, árabes, judíos, varias potencias coloniales (entre ellas españolas y portuguesas) dejaron su huella en el país, dieron forma a los paisajes urbanos, crearon monumentos culturales y enriquecieron la gastronomía.

En las costas del Mediterráneo y del Atlántico hay costas escarpadas, amplias bahías, playas de arena y puertos de importancia internacional. En el interior algunas montañas superan los 4 000 m de altura. Cada cordillera (Rif, Alto Atlas, Anti-Atlas, Medio Atlas) tiene un carácter propio: desde el dulce mediterráneo hasta el escarpado y nevado. Valles y gargantas han excavado en las cordilleras donde los bereberes construyeron sus castillos y asentamientos. Sus huellas también se pueden encontrar en los numerosos pueblos oasis, a través de los cuales las caravanas viajaban a los desiertos de las dunas de arena.

Además de los impresionantes paisajes, el país también tiene mucho que ofrecer culturalmente. Tánger y Casablanca fueron una vez los lugares de anhelo de artistas, escritores y cineastas. Las cuatro ciudades reales de Fez, Marrakech, Mequinez y Rabat fueron magníficamente desarrolladas por sus gobernantes. Las medinas, con sus callejuelas sinuosas, están dominadas por los zocos, donde los artesanos producen y venden sus productos; los aromas exóticos y la reputación del muecín.

Maroco

Sulla carta geografica è una striscia lunga e A voler definire il Marocco con una parola, diversità è quella che fa perfettamente al caso. Cartaginesi, romani, berberi, arabi, ebrei, nonché varie potenze coloniali – tra cui spagnoli e portoghesi – hanno lasciato il segno nel paese, plasmandone i paesaggi urbani, edificando monumenti e arricchendone la cucina.

Sulle coste del Mediterraneo e dell'Atlantico si trovano scogliere scoscese, ampie baie, spiagge sabbiose e porti di importanza internazionale. All'interno, le montagne si ergono in parte oltre i 4 000 m di altezza. Ogni catena montuosa – Rif, Alto e Medio Atlante e Anti Atlante – ha il suo carattere, da quello più dolce, mediterraneo, a quello più scosceso e innevato. Tra i monti si aprono valli e gole dove i berberi hanno edificato castelli e insediamenti. Le loro tracce si trovano anche nelle numerose città delle oasi, attraversate un tempo dalle vie carovaniere che si recavano nei deserti delle dune di sabbia.

Oltre a paesaggi impressionanti, il paese ha anche molto da offrire da un punto di vista culturale. Tangeri e Casablanca erano un tempo mete di artisti, scrittori e cineasti. Le quattro città imperiali di Fès, Marrakech, Mèknes e Rabat sono state arricchite di magnifici edifici dalle varie dinastie regnanti. Le medine, con i loro vicoli tortuosi, sono caratterizzate dai suk – i mercati dove gli artigiani producono e vendono i loro prodotti –, dai profumi esotici e dai muezzin che chiamano alla preghiera.

Marokko

Als je Marokko in één woord wilt karakteriseren, is het wel diversiteit. Carthagers, Romeinen, Berbers, Arabieren, Joden, diverse koloniale mogendheden – onder wie Spanjaarden en Portugezen – lieten hun sporen na op het land, vormden de stadsgezichten, creëerden culturele monumenten en verrijkten de keuken.

Aan de kusten van de Middellandse Zee en de Atlantische Oceaan liggen steile klippen, brede baaien, zandstranden en havens van internationale betekenis. In het binnenland rijzen de bergen ten dele meer dan 4 000 m hoog op. Elke bergketen – Rif, Hoge-Atlas, Anti-Atlas, Midden-Atlas – heeft zijn eigen karakter, van mediterraan lieflijk tot ontoegankelijk en besneeuwd. Valleien en ravijnen hebben zich een weg door de bergen gegraven, waar Berbers hun burchten en nederzettingen bouwden. Hun sporen zijn ook te vinden in de vele oasestadjes, waar vroeger karavanen door de zandduinwoestijnen naartoe reisden.

Naast indrukwekkende landschappen heeft het land cultureel ook veel te bieden. Tanger en Casablanca waren ooit de droomoorden van kunstenaars, schrijvers en cineasten. De vier koninklijke steden Fez, Marrakesh, Mèknes en Rabat werden schitterend uitgebreid door hun heersers. De medina's met hun doolhofachtige steegjes worden gedomineerd door de soeks, waar handwerkslieden hun spullen maken en verkopen, exotische geuren en de oproep van de muezzin.

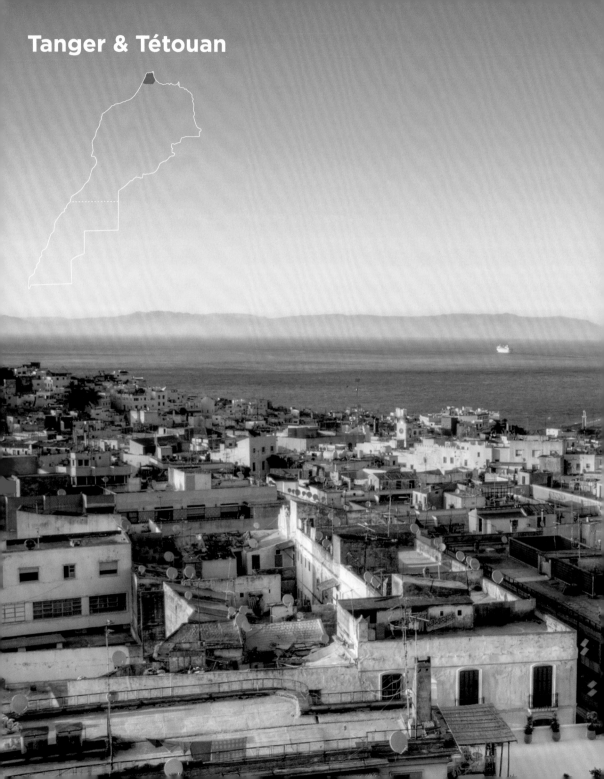

Tanger & Tétouan

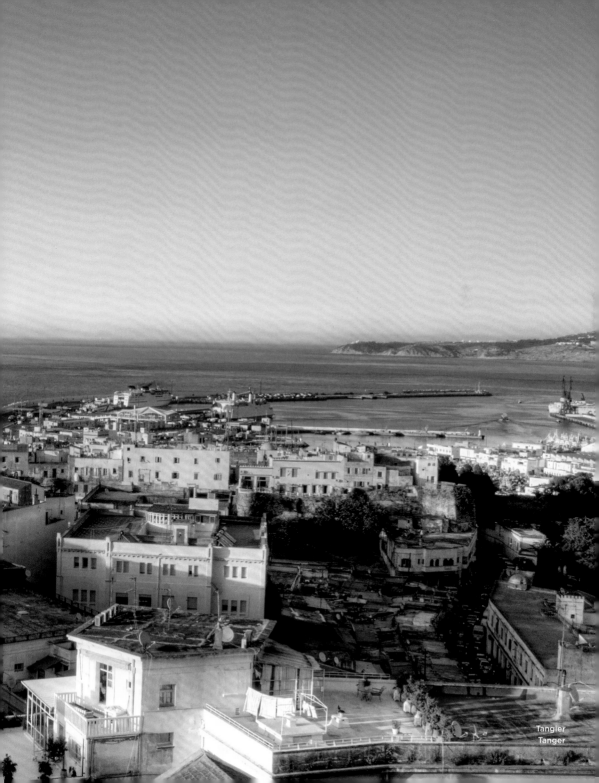

Tangier
Tanger

Tangier
Tanger

Tangier & Tétouan

During the years of the mid-20th century, Tangier was considered "Europe's most permissive city", inspiring artists from both Europe and America. Painters, writers and societal dropouts lived in the city, contributing to its international flair. Tétouan, however, is very different. UNESCO declared the city a World Heritage Site in 1997, praising its medina as one of the smallest in Morocco, but as the "most perfect".

Tanger & Tétouan

Au milieu du xxᵉ siècle, Tanger était considérée comme « la ville la plus permissive d'Europe » et a inspiré de nombreux artistes d'Europe et d'Amérique. Beaucoup de peintres, d'écrivains et de marginaux y ont vécu et ont contribué à son aura internationale. Tétouan est très différent. L'UNESCO a inscrit la ville au patrimoine de l'humanité en 1997 et fait l'éloge de sa médina, l'une des plus petites du Maroc, mais qui serait aussi la « plus parfaite ».

Tanger & Tétouan

Tanger galt Mitte des 20. Jahrhunderts als „freizügigste Stadt Europas" und hat Künstler aus Europa und Amerika inspiriert. Maler, Literaten und Aussteiger lebten hier und trugen zum internationalen Flair bei. Ganz anders Tétouan. Die UNESCO erklärte die Stadt 1997 zum Weltkulturerbe und rühmt deren Medina als zwar eine der kleinsten Marokkos, aber als die „vollkommenste".

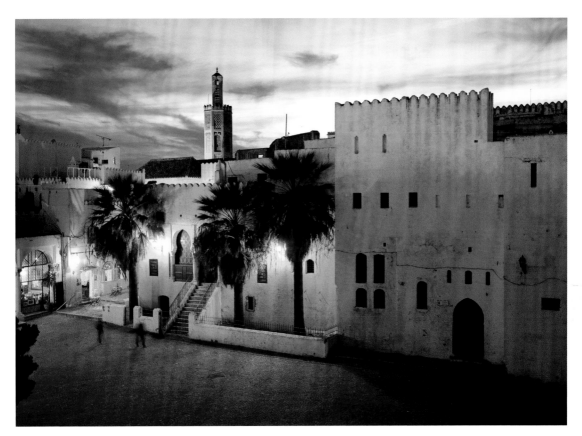

Tangier
Tanger

Tánger & Tetuán

A mediados del siglo XX, Tánger fue considerada "la ciudad más liberal de Europa" e inspiró a artistas de Europa y América. Pintores, escritores y desertores vivieron aquí y contribuyeron al ambiente internacional. Tetuán es muy diferente. La UNESCO la declaró Patrimonio de la Humanidad en 1997 y alaba su medina como una de las más pequeñas de Marruecos, pero como la "más perfecta".

Tánger & Tetuán

A metà del XX secolo, Tangeri era considerata "la città più permissiva d'Europa" e ispirò artisti provenienti anche dall'America. Hanno vissuto qui pittori, scrittori ed è stata spesso scelta chi aveva deciso di cambiare completamente vita, contribuendo al suo fascino internazionale. Tetouan è invece molto diversa. L'UNESCO ha dichiarato la città Patrimonio dell'Umanità nel 1997 e loda la sua medina, nonostante sia tra le più piccole, come la "più perfetta" del Marocco.

Tanger & Tetouan

Halverwege de 20e eeuw werd Tanger gezien als de 'tolerantste stad van Europa' en inspireerde het kunstenaars uit Europa en Amerika. Schilders, schrijvers en alternatievelingen woonden hier en droegen bij aan de internationale allure. Tétouan is heel anders. Unesco riep de stad in 1997 uit tot werelderfgoed en roemt zijn medina als weliswaar een van de kleinste van Marokko, maar wel de 'meest volmaakte'.

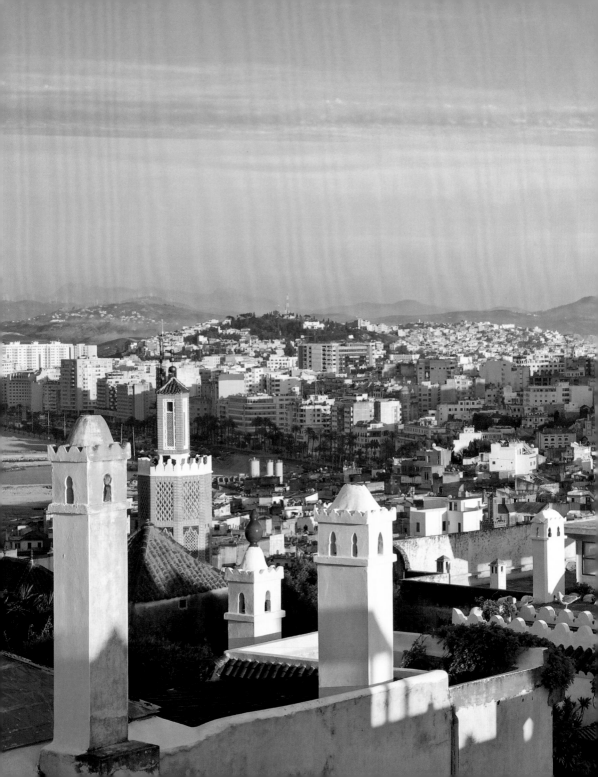

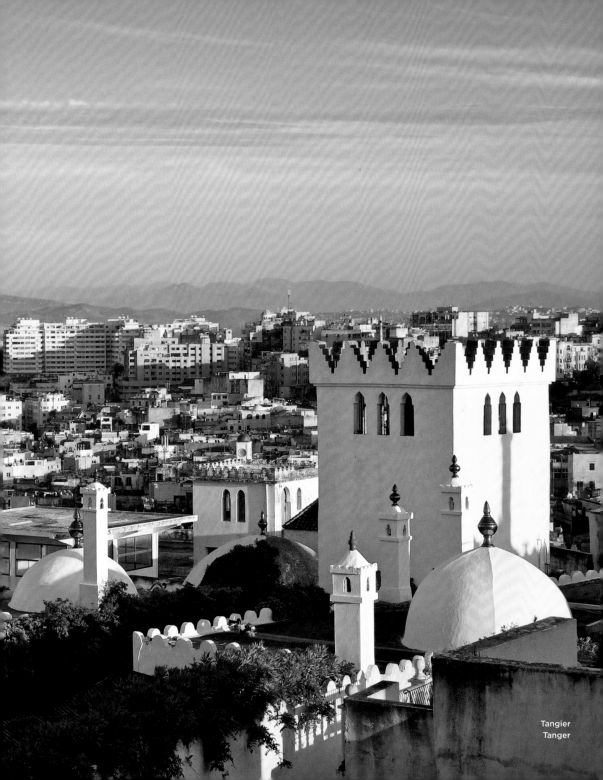

Tangier
Tanger

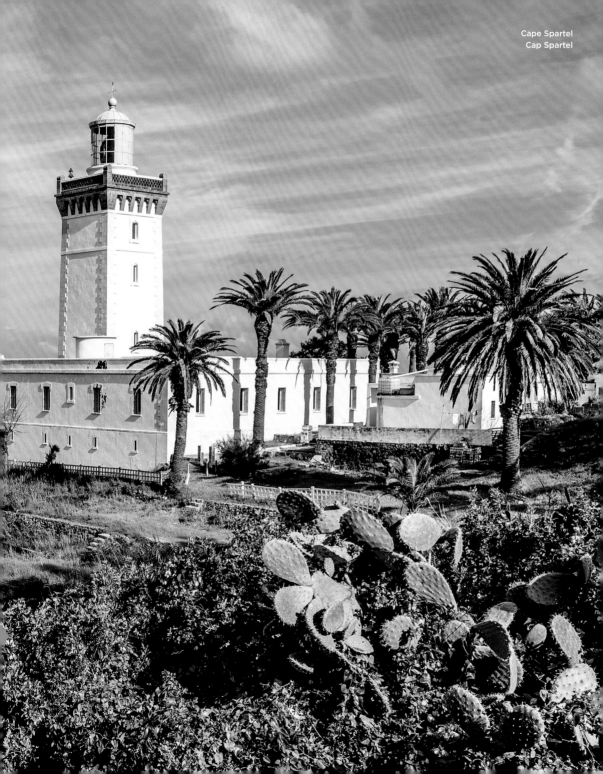

Cape Spartel
Cap Spartel

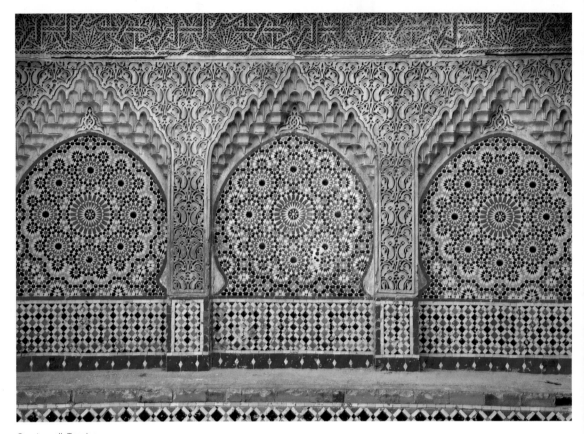

Ornate wall, Tangier
Mur orné, Tanger

Ornamentation

For religious reasons, no living creatures
may be depicted on Moroccan tiles, so
artists have to work with ornamentation
which they create using luminous colours.
A basic pattern, which may often be
seen, is the "spider web of God", a
system of lines forming stars with eight
to 16 points. Another common motif is
the arabesque, which is an ornamentation
with intertwining tendrils. The Moors took
the craft to the Iberian peninsula, where it
developed its own pictorial language.

Ornementation

Pour des raisons religieuses, aucune
créature vivante ne peut être représentée
sur les tuiles marocaines. Les artistes
créent donc eux-mêmes des ornements de
couleurs vives. L'un des modèles les plus
communs est la « toile d'araignée de Dieu
», un système de lignes formant des étoiles
de huit à seize points. On trouve aussi
souvent des arabesques, des ornements
en forme de vrille. Avec les diverses
conquêtes des Maures, cet artisanat a
atteint la péninsule ibérique, où son propre
langage pictural s'est développé.

Ornamentik

Aus religiösen Gründen dürfen auf
marokkanischen Fliesen keine lebenden
Wesen gezeigt werden. Die Künstler
müssten mit Ornamenten arbeiten, die
sie mit leuchtenden Farben gestalten. Ein
Grundmuster, das man häufig sieht, ist das
„Spinnengewebe Gottes", ein Liniensystem,
das Sterne mit acht bis 16 Zacken
bildet. Ein weiteres häufiges Motiv ist
die Arabeske, ein Rankenornament. Mit
den Mauren kam das Handwerk auf die
iberische Halbinsel, wo sich eine eigene
Bildsprache entwickelte.

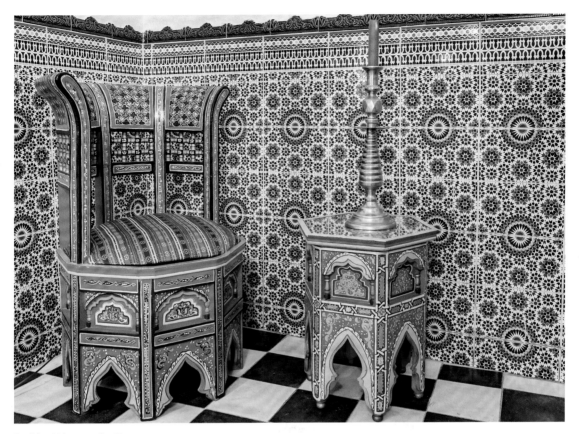

Traditional Moroccan furniture
Meubles traditionnels marocains

Ornamentación

Por razones religiosas, ningún ser vivo puede aparecer en los azulejos marroquíes. Los artistas tendrían que trabajar con adornos que crean con colores brillantes. Un patrón básico que se ve a menudo es la "telaraña de Dios", un sistema de líneas que forma estrellas de ocho a 16 puntos. Otro motivo común es el arabesco, un adorno de zarcillos. Con los moriscos la artesanía llegó a la Península Ibérica, donde se desarrolló un lenguaje pictórico propio.

Decori e ornamenti

Per motivi religiosi, nessun essere vivente può essere dipinto sulle tipiche mattonelle marocchine. Gli artisti elaborano motivi usando colori brillanti. Tra i più diffusi c'è quello detto "ragnatela di Dio", un sistema di linee che forma stelle che hanno da 8 a 16 punte. Molto comune è anche l'arabesco, un motivo a intreccio. Con i mori la manifattura delle mattonelle è giunta nella penisola iberica, dove si sono sviluppati motivi e decorazioni propri.

Ornamentiek

Om religieuze redenen mogen er geen levende wezens op Marokkaanse tegels worden afgebeeld. De kunstenaars moeten werken met ornamenten, die ze met felle kleuren maken. Een basispatroon dat je vaak ziet, is het 'spinnenweb van God', een netwerk van lijnen die sterren met acht tot zestien punten vormen. Een ander veelvoorkomend motief is de arabesk, een rankornament. Met de Moren kwam dit handwerk naar het Iberisch schiereiland, waar het een eigen beeldtaal ontwikkelde.

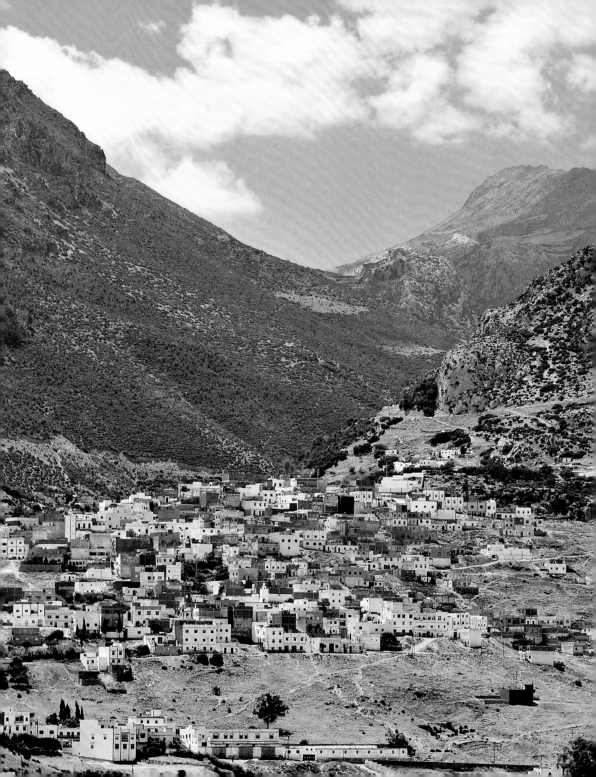

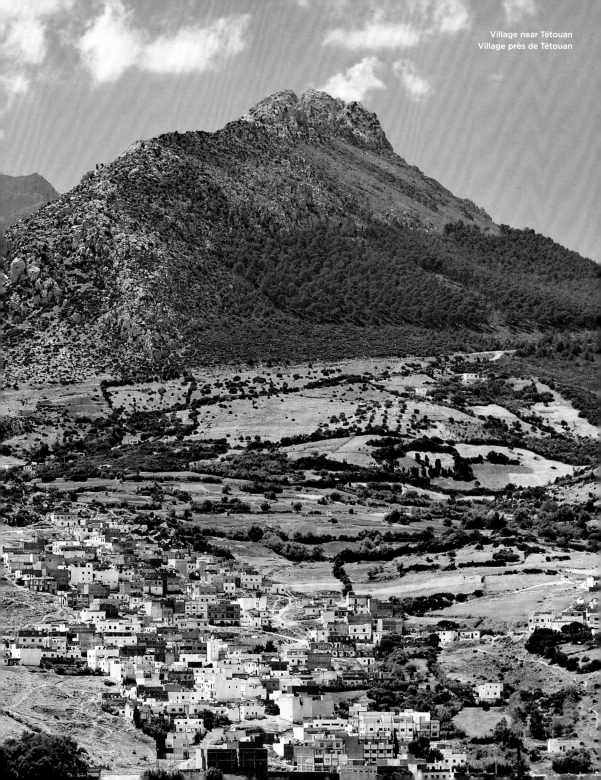

Village near Tétouan
Village près de Tétouan

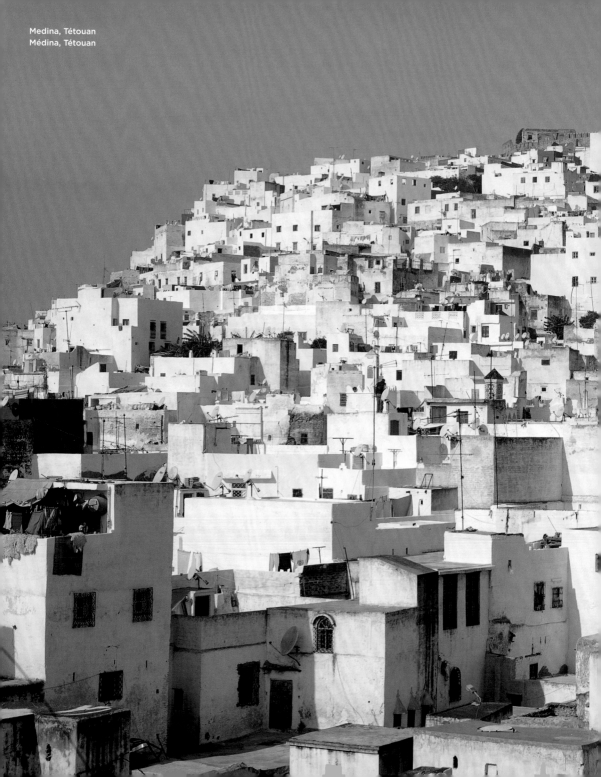

Medina, Tétouan
Médina, Tétouan

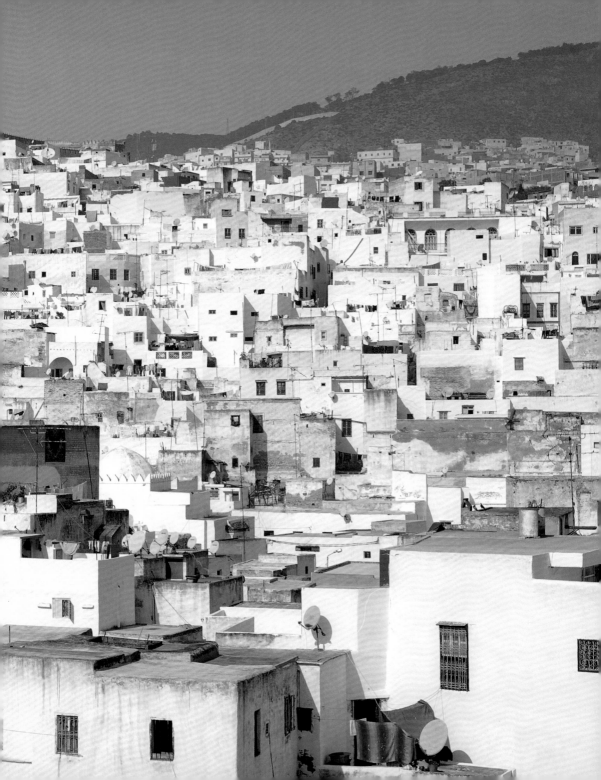

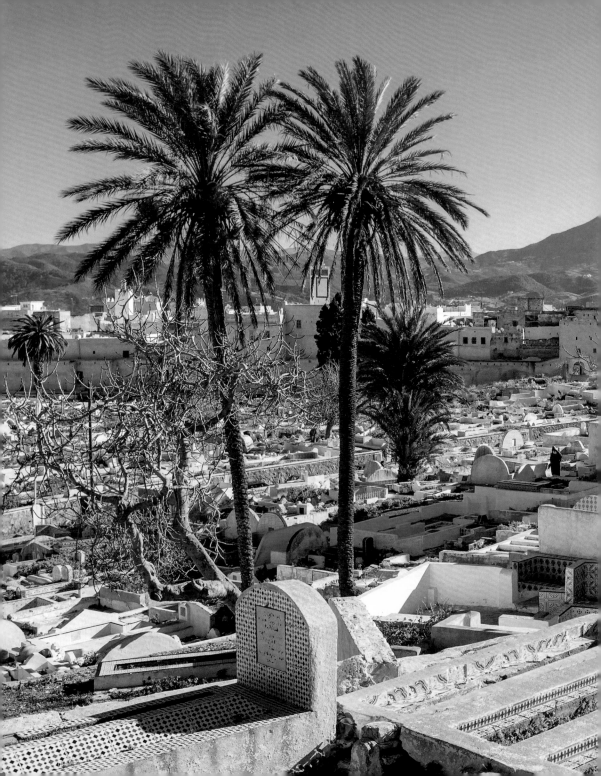

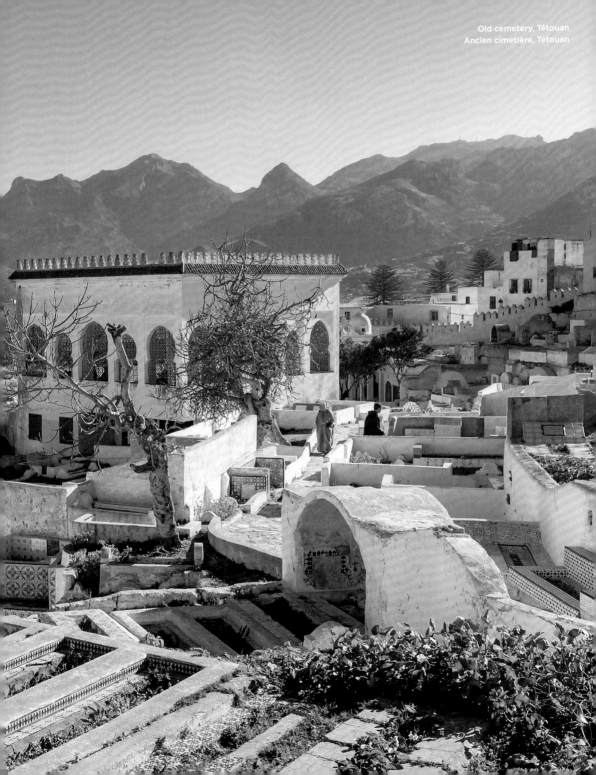

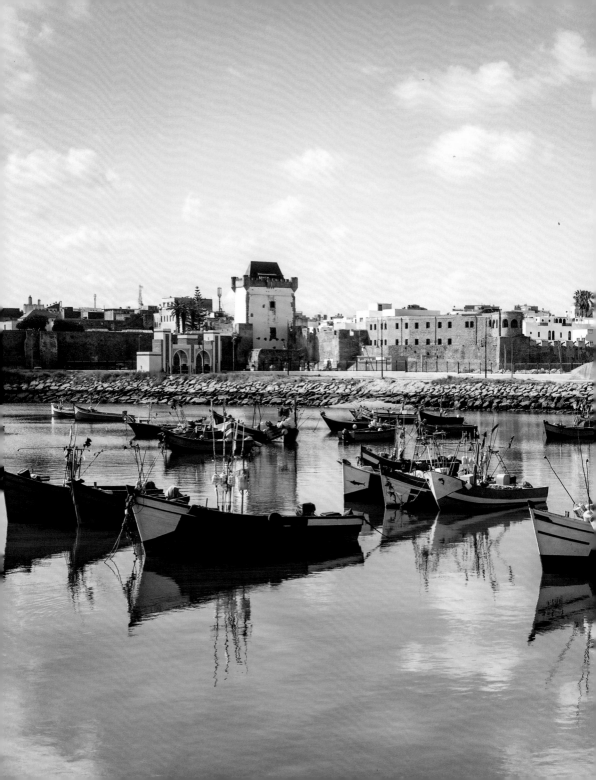

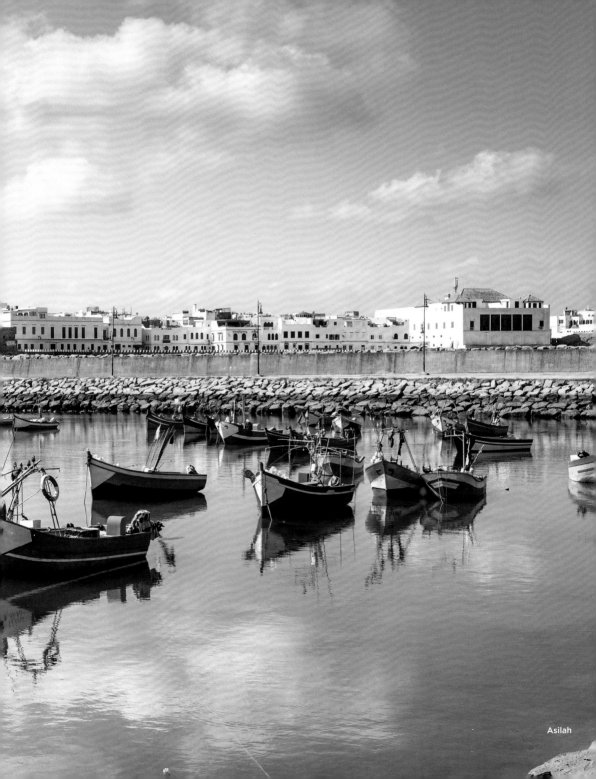

Asilah

Asilah

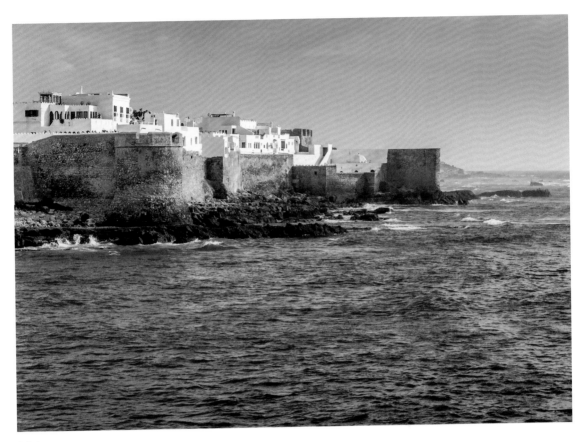

Asilah

Asilah

The medina of Asilah was an ugly grey duckling in the 1960s, but today it presents itself as a radiant white swan. Two men took the initiative, in calling for the cleaning of the streets, which marked the beginning of the renovation of the old houses. They also organized an international cultural festival, which still takes place today.

Asilah

La médina d'Asilah faisait office de vilain petit canard dans les années 1960, mais elle se présente aujourd'hui comme un cygne blanc rayonnant. Ce changement est dû à l'initiative de deux hommes, artistes et intellectuels de la région, qui appelèrent au nettoyage des rues et marquèrent ainsi le début de la rénovation des vieilles maisons. Ils sont également à l'origine du festival culturel international qui s'y déroule encore aujourd'hui.

Asilah

Die Medina von Asilah war in den 1960er-Jahren ein hässliches graues Entlein, heute präsentiert sie sich als strahlend weißer Schwan. Zwei Männer ergriffen damals die Initiative und riefen zur Reinigung der Straßen auf, die den Auftakt zur Renovierung der alten Häuser bildete. Sie organisierten auch ein internationales Kulturfestival, das bis heute stattfindet.

Asilah

La medina de Asilah, que en los años 60 era un patito feo gris, hoy se presenta como un radiante cisne blanco. Dos hombres tomaron la iniciativa en aquella época y pidieron que se limpiaran las calles, lo que marcó el comienzo de la renovación de las viejas casas. También organizaron un festival cultural internacional, que todavía se celebra hoy en día.

Assila

Negli anni '60 del Novecento, la medina di Assila era un brutto anatroccolo grigio. Oggi si presenta come un radioso cigno bianco. Due privati presero l'iniziativa, esortando a pulire le strade e segnando così l'inizio della ristrutturazione delle vecchie case. Fa capo a loro anche il festival culturale internazionale che si svolge ancora oggi.

Asilah

De medina van Asilah was in de jaren zestig een lelijk eendje, maar tegenwoordig presenteert ze zich als een prachtige witte zwaan. Twee mannen namen destijds het initiatief en riepen op om de straten schoon te maken. Dit zou de opmaat vormen tot de renovatie van de oude huizen. Ook organiseerden zij een internationaal cultuurfestival, dat tot op heden plaatsvindt.

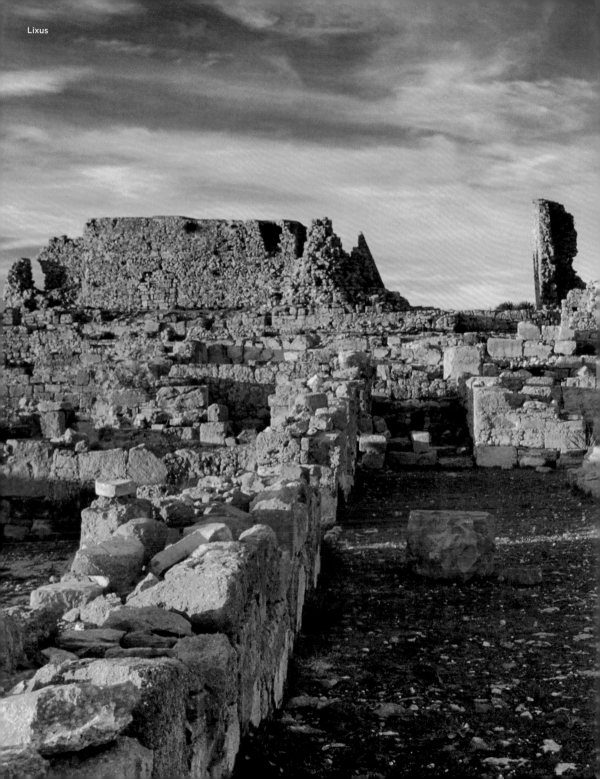

Lixus

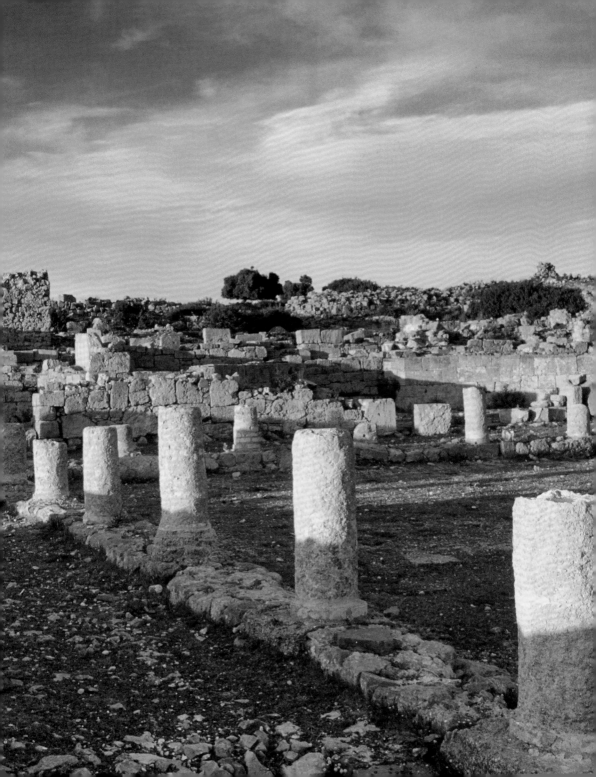

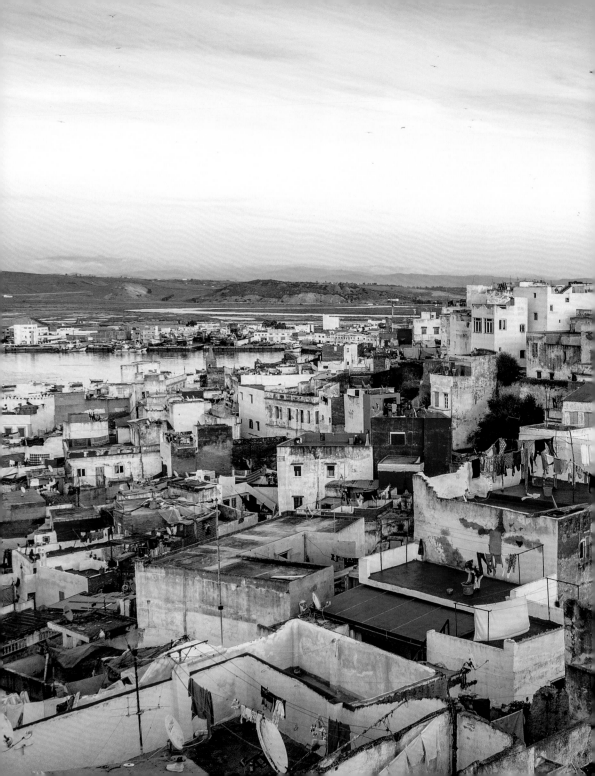

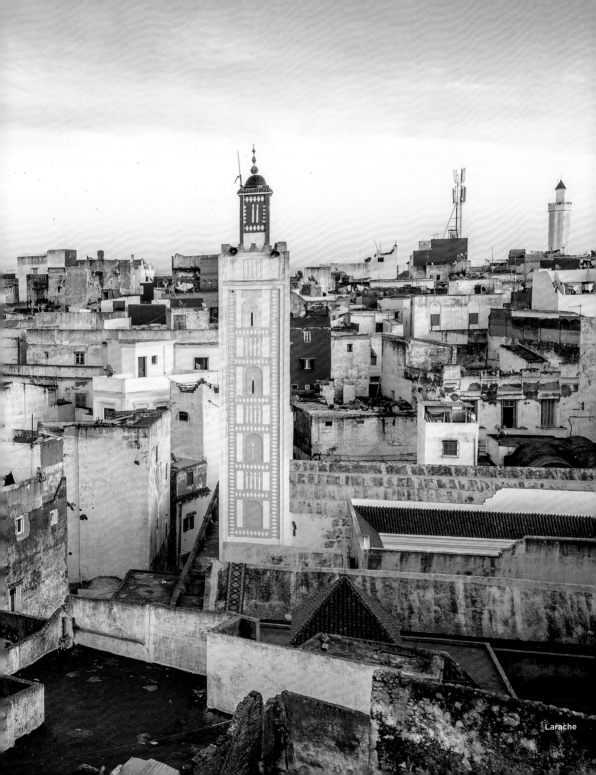

Larache

Larache

Larache

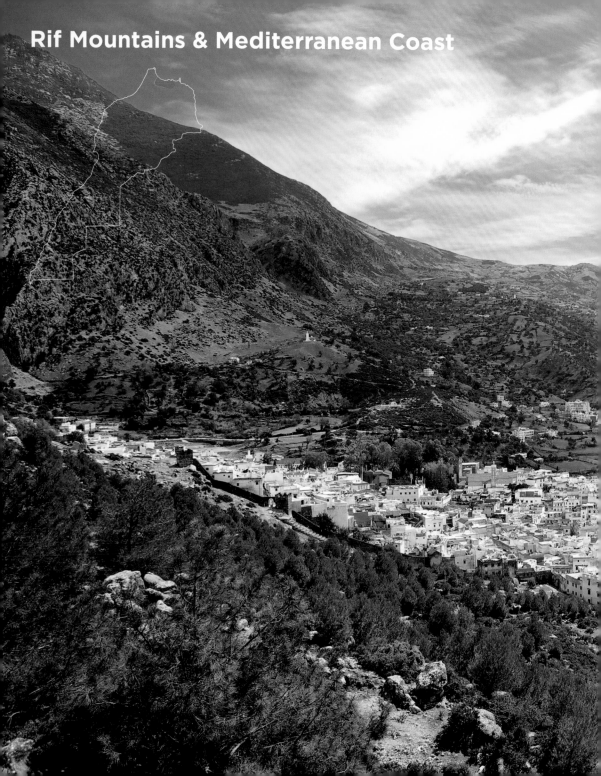

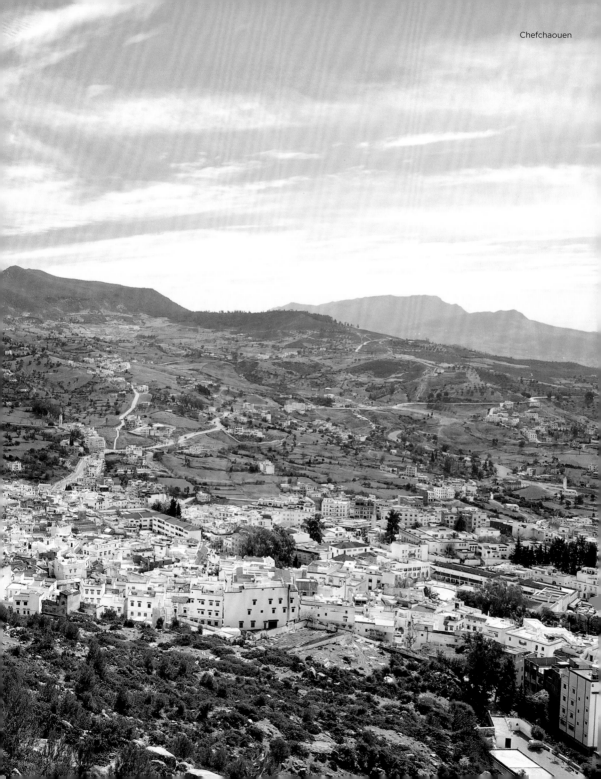

Chefchaouen

Between Targuist and Al Hoceima
Entre Targuist et Al Hoceima

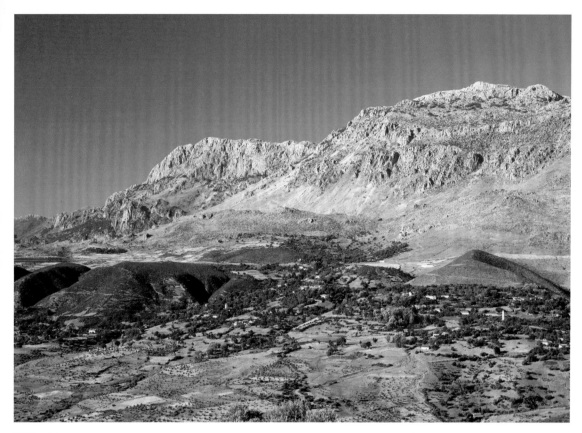

Rif Mountains
Le Rif

Rif Mountains & Mediterranean Coast
The Rif Mountains run as a coastal range from the Strait of Gibraltar to the mouth of the Moulouya River. The rugged mountain range is sparsely populated and is known as a cultivation area for hemp plants. Morocco is the world's largest exporter of hashish. However, caution should be exercised, as whoever gets caught with the drug may face a prison sentence.

Montañas del Rif & costa mediterránea
Las montañas del Rif corren como montañas costeras desde el Estrecho de Gibraltar hasta la desembocadura del río Moulouya. La escarpada cordillera está poco poblada y es conocida como zona de cultivo de plantas de cáñamo. Marruecos es el mayor exportador mundial de hachís. Pero no nos acerquemos a las drogas o nos enfrentaremos a penas de prisión.

Montagnes du Rif & côte méditerranéenne
Les montagnes accidentées du Rif bordent la côte méditerranéenne du détroit de Gibraltar à l'embouchure de la rivière Moulouya. La région, peu peuplée, est connue pour être une zone de culture du chanvre. Le Maroc est d'ailleurs le premier exportateur mondial de haschisch. Cependant, ne touchez pas à la drogue, quiconque se fera prendre sera passible d'une peine de prison.

Rif montuoso & costa mediterranea
Le montagne del Rif si estendono lungo la costa dallo stretto di Gibilterra alla foce del fiume Muluia. La frastagliata catena montuosa è scarsamente popolata ed è nota per le coltivazioni di canapa. Il Marocco è il più grande esportatore mondiale di hashish, ma chi viene colto in possesso di droga viene condannato a pene detentive.

Rifgebirge & Mittelmeerküste
Das Rifgebirge verläuft als Küstengebirge von der Straße von Gibraltar bis zur Mündung des Flusses Moulouya. Die zerklüftete Bergkette ist dünn besiedelt und bekannt als Anbaugebiet für Hanfpflanzen. Marokko ist weltweit der größte Exporteur von Haschisch. Allerdings: Finger weg von der Droge, wer erwischt wird, muss mit Gefängnisstrafen rechnen.

Rifgebergte & Middellandse Zeekust
Het Rifgebergte loopt als kustgebergte van de Straat van Gibraltar tot de monding van de Moulouya-rivier. Het gebergte met zijn diepe kloven is dunbevolkt en staat bekend als landbouwareaal voor hennepplanten. Marokko is 's werelds grootste exporteur van hasj. Maar handen af van deze drug – wie wordt betrapt, kan rekenen op een gevangenisstraf.

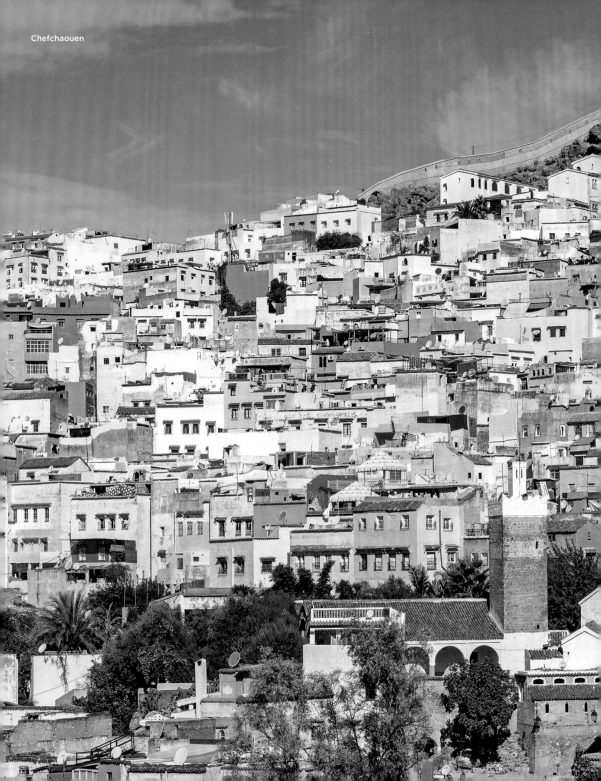
Chefchaouen

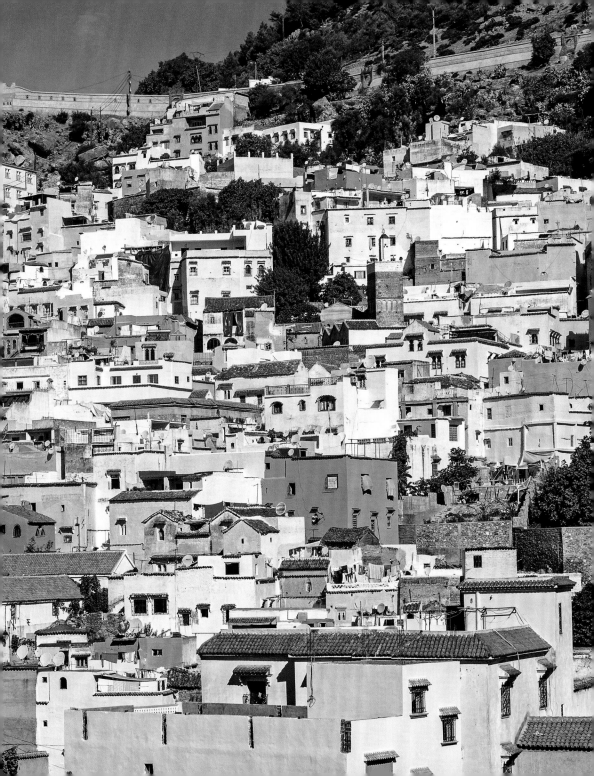

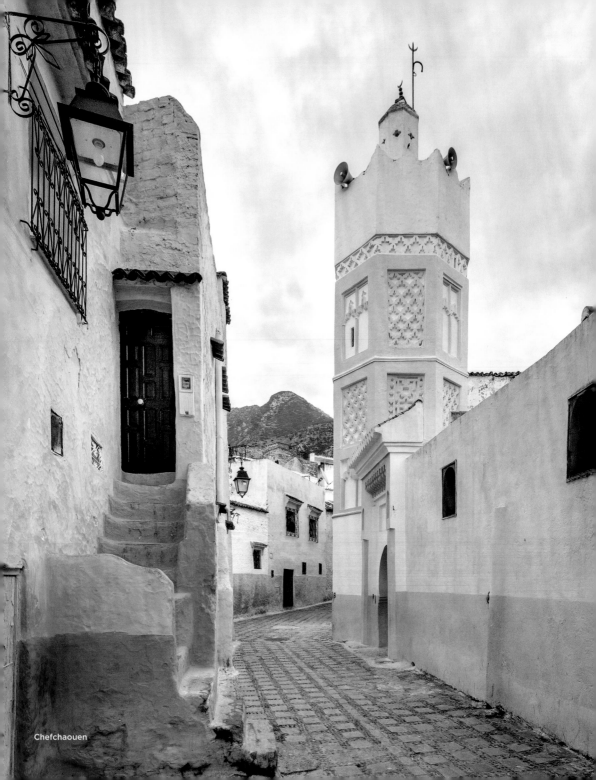

Chefchaouen

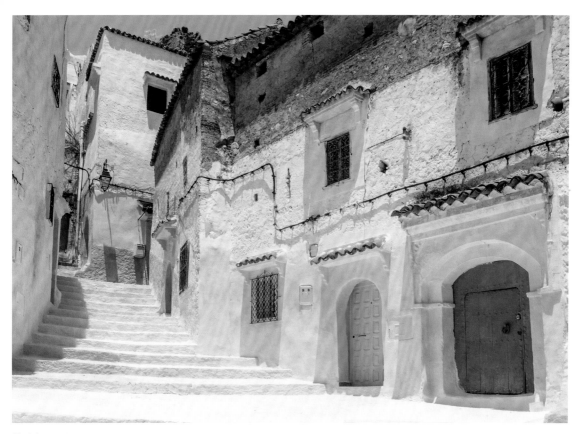

Chefchaouen

Chefchaouen

In this enchanting town in the Rif mountains, not only the lightness of being but also the excellent Moroccan cuisine can be enjoyed against a white-blue backdrop. Chefchaouen is one of the regions in the Mediterranean whose traditional cuisine was declared an intangible cultural heritage of mankind by UNESCO in 2013.

Chefchaouen

En esta encantadora ciudad de las montañas del Rif no solo se puede disfrutar de la ligereza del ser, sino también de la excelente cocina marroquí. Chefchaouen es una de las regiones del Mediterráneo cuya cocina tradicional fue declarada patrimonio cultural inmaterial de la humanidad por la UNESCO en 2013.

Chefchaouen

Dans cette enchanteresse ville bleue et blanche des montagnes du Rif, on peut apprécier non seulement la douceur de vivre mais également l'excellente cuisine marocaine. Chefchaouen est l'une des régions de la Méditerranée dont la cuisine traditionnelle a été déclarée patrimoine culturel immatériel de l'humanité par l'UNESCO en 2013.

Chefchaouen

In questa incantevole città sui monti del Rif, sullo sfondo bianco e azzurro delle sue case, è possibile godere non solo della leggerezza dell'essere ma anche dell'eccellente cucina marocchina. Dal 2013 Chefchaouen è tra le regioni del Mediterraneo la cui cucina tradizionale è stata dichiarata dall'UNESCO Patrimonio Culturale Immateriale dell'Umanità.

Chefchaouen

In der bezaubernden Stadt im Rifgebirge lässt sich vor weiß-blauer Kulisse nicht nur die Leichtigkeit des Seins, sondern auch die ausgezeichnete marokkanische Küche genießen. Chefchaouen gehört zu den Mittelmeerregionen, deren traditionsreiche Küche 2013 von der UNESCO zum Immateriellen Kulturerbe der Menschheit erklärt wurde.

Chefchaouen

In dit betoverende plaatsje in het Rifgebergte kan men tegen de wit-blauwe achtergrond niet alleen van de lichtheid van het bestaan, maar ook van de uitstekende Marokkaanse keuken genieten. Chefchaouen is een van de regio's in het Middellandse Zeegebied waarvan de traditionele keuken in 2013 door Unesco werd uitgeroepen tot immaterieel cultureel erfgoed van de mensheid.

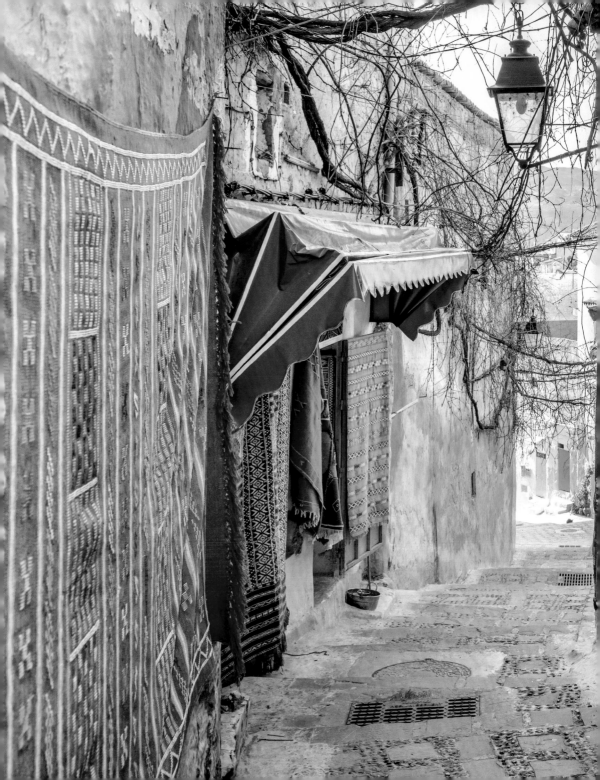

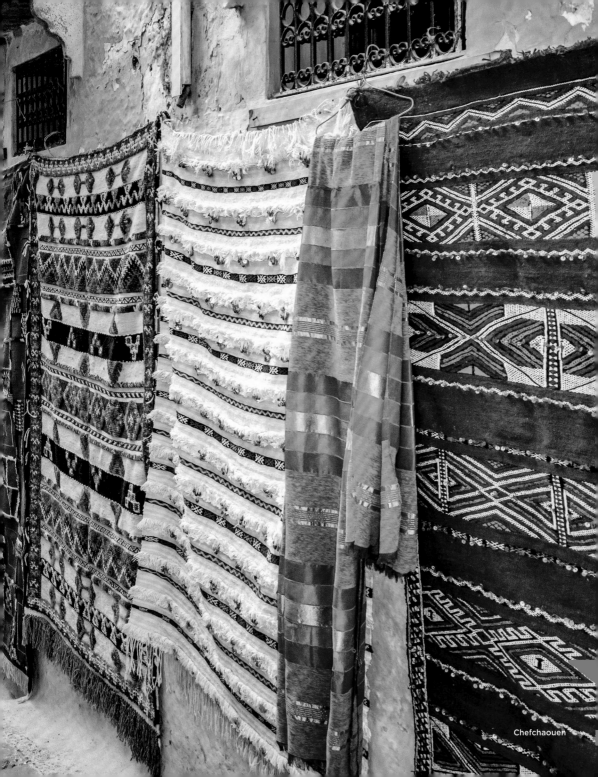
Chefchaouen

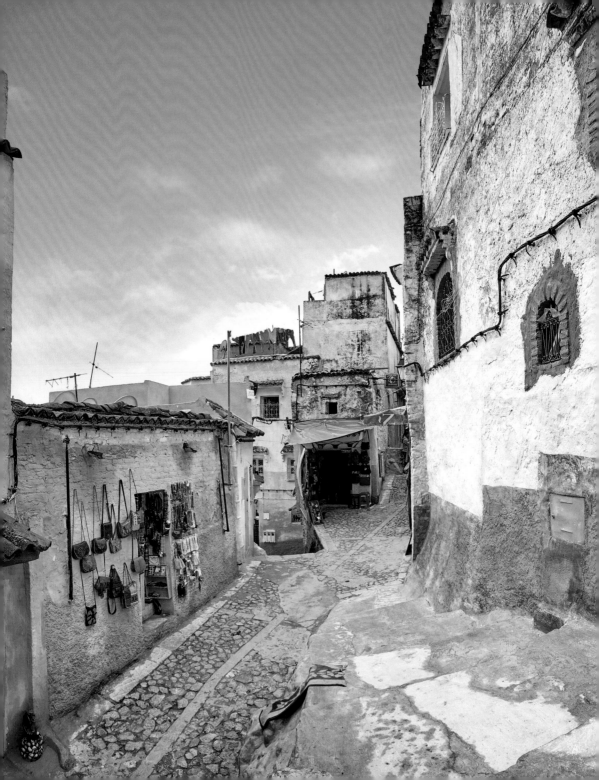

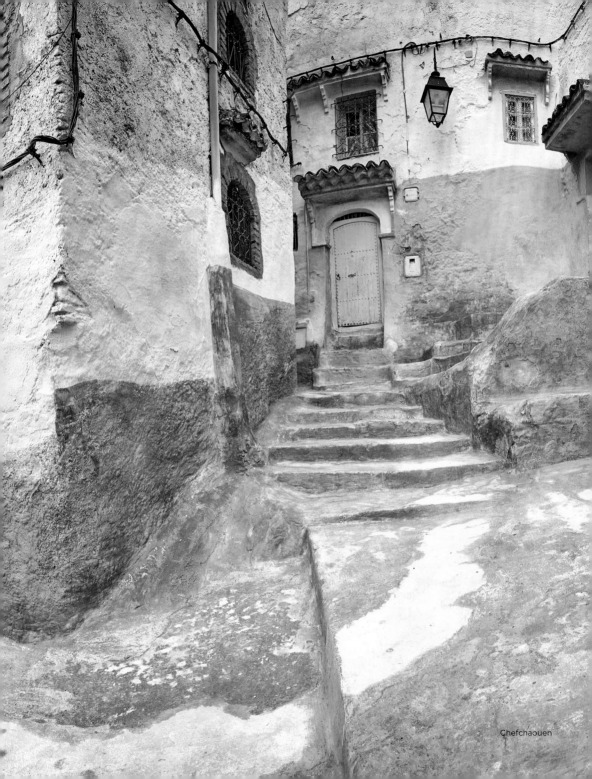

Chefchaouen

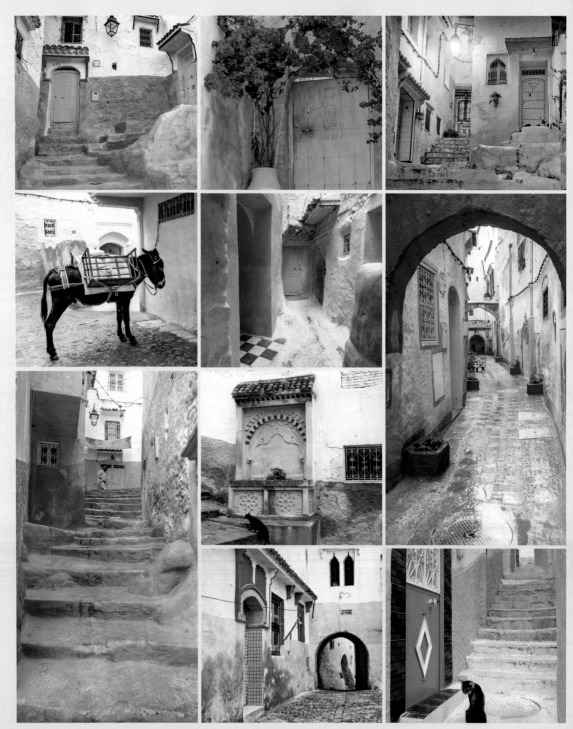

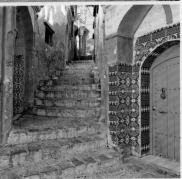

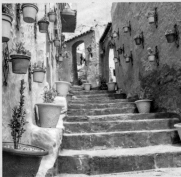

Chefchaouen

Chefchaouen was founded in 1471 for Muslims who fled Tangier and Ceuta and also served as a refuge for displaced Jews in 1609. Until 1920 Christians were forbidden to enter. There are mystical and profane explanations for the dominance of blue, as supposedly the colour protects against the 'evil eye' and repels the mosquitoes.

Chefchaouen

Chefchaouen a été fondée en 1471 pour les musulmans qui ont fui Tanger et Ceuta et a également servi de refuge pour les Juifs déplacés en 1609. Jusqu'en 1920, les chrétiens n'avaient pas le droit d'entrer. La prédominance du bleu s'explique pour des raisons mystiques et profanes : le bleu protégerait du mauvais œil et repousserait les moustiques.

Chefchaouen

Chefchaouen wurde 1471 für aus Tanger und Ceuta geflüchtete Moslems gegründet und diente 1609 auch vertriebenen Juden als Zufluchtsstätte. Bis 1920 war Christen der Zutritt verboten. Für die Dominanz der Farbe Blau gibt es eine mystische und eine profane Erklärungen: Blau schützt vor dem bösen Blick und es weist die Mücken ab.

Chefchaouen

Chefchaouen fue fundada en 1471 para los musulmanes que huyeron de Tánger y Ceuta y también sirvió como refugio para los judíos desplazados en 1609. Hasta 1920 se prohibió la entrada a los cristianos. Hay explicaciones místicas y profanas para el dominio del azul: el azul protege contra el mal de ojo y repele a los mosquitos.

Chefchaouen

In questa incantevole città sui monti del Rif, sullo sfondo bianco e azzurro delle sue case, è possibile godere non solo della leggerezza dell'essere ma anche dell'eccellente cucina marocchina. Dal 2013 Chefchaouen è tra le regioni del Mediterraneo la cui cucina tradizionale è stata dichiarata dall'UNESCO Patrimonio Culturale Immateriale dell'Umanità.

Chefchaouen

Chefchaouen werd in 1471 gesticht voor moslims die Tanger en Ceuta waren ontvlucht en diende in 1609 ook als toevluchtsoord voor verdreven Joden. Tot 1920 was de toegang voor christenen verboden. Er zijn mystieke en profane verklaringen voor de overheersing van de kleur blauw: blauw beschermt tegen het kwade oog en stoot muggen af.

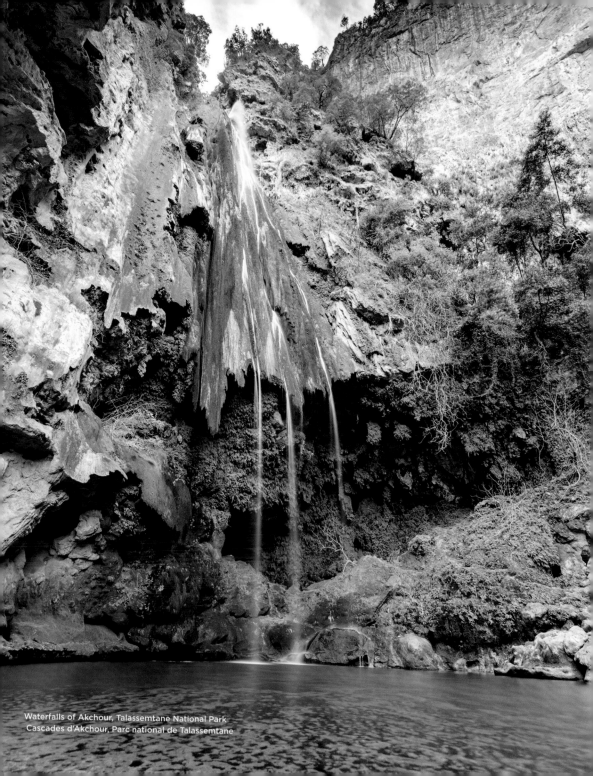

Waterfalls of Akchour, Talassemtane National Park
Cascades d'Akchour, Parc national de Talassemtane

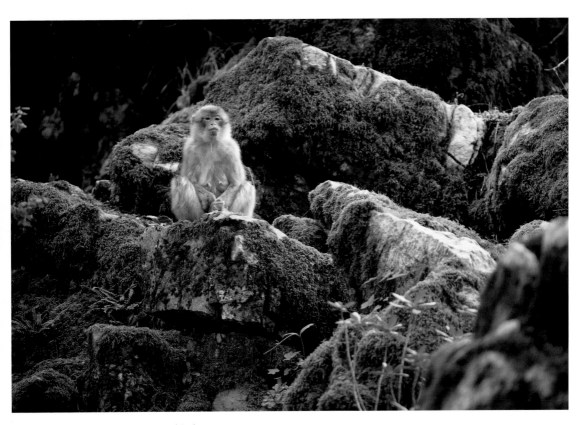

Barbary macaque, Talassemtane National Park
Macaque de Barbarie, Parc national de Talassemtane

Talassemtane National Park

The Rif Mountains are verdant, being covered with lush vegetation at the lower altitudes. The Talassemtane National Park has been established to ensure that this remains so, and that logging is prohibited, with the fir tree being considered a particularly endangered species. It is a wonderful hiking area featuring valleys, streams and panoramic views, where one may take tours lasting several days.

Parque Nacional Talassemtane

Las montañas del Rif son verdes y están cubiertas de exuberante vegetación en las altitudes más bajas. El Parque Nacional Talassemtane se creó para asegurar que esto permanezca así y que no se tale nada (el abeto es considerado una especie en peligro de extinción). Una maravillosa zona de senderismo con valles, arroyos y vistas panorámicas, donde también se pueden realizar excursiones de varios días.

Parc national de Talassemtane

Dans les basses altitudes, les montagnes du Rif sont verdoyantes et couvertes d'une végétation luxuriante. Le parc national de Talassemtane a été créé pour veiller à ce que cela reste ainsi et qu'aucun arbre n'y soit coupé – en particulier le sapin, considéré comme une espèce en voie de disparition. Une merveilleuse région de randonnée constellée de vallées, ruisseaux et vues panoramiques, où il est possible de faire des excursions de plusieurs jours.

Parco nazionale di Talassemtane

Le montagne del Rif sono verdi e ricoperte a bassa quota da una vegetazione lussureggiante. Il Parco nazionale di Talassemtane è stato istituito per garantire che nulla venga cambiato e per frenare il disboscamento – in particolare l'abete è ritenuto in pericolo. Qui si trova una meravigliosa area ricca di valli, ruscelli e punti da cui è possibile ammirare il panorama. È possibile effettuare escursioni di più giorni.

Talassemtane Nationalpark

Das Rifgebirge ist grün und in den tieferen Lagen von üppiger Vegetation bedeckt. Damit das auch so bleibt und nichts abgeholzt wird – vor allem die Tanne gilt als bedrohte Spezies – wurde der Talassemtane Nationalpark eingerichtet. Ein wunderbares Wandergebiet mit Tälern, Bächen und Panoramablicken, in dem man auch mehrtägige Touren machen kann.

Nationaal park Talassemtane

Het Rifgebergte is groen en op de lagere hoogten bedekt met weelderige vegetatie. Het nationale park Talassemtane is opgericht om ervoor te zorgen dat dit zo blijft en dat er niets wordt gekapt – vooral de spar wordt beschouwd als een bedreigde species. Een prachtig wandelgebied met dalen, beekjes en panoramische uitzichten, waar u ook meerdaagse tochten kunt maken.

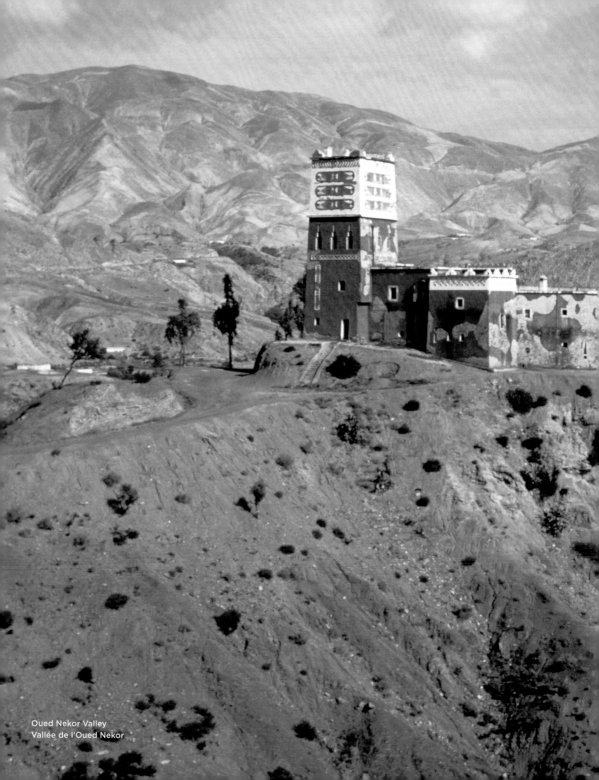

Oued Nekor Valley
Vallée de l'Oued Nekor

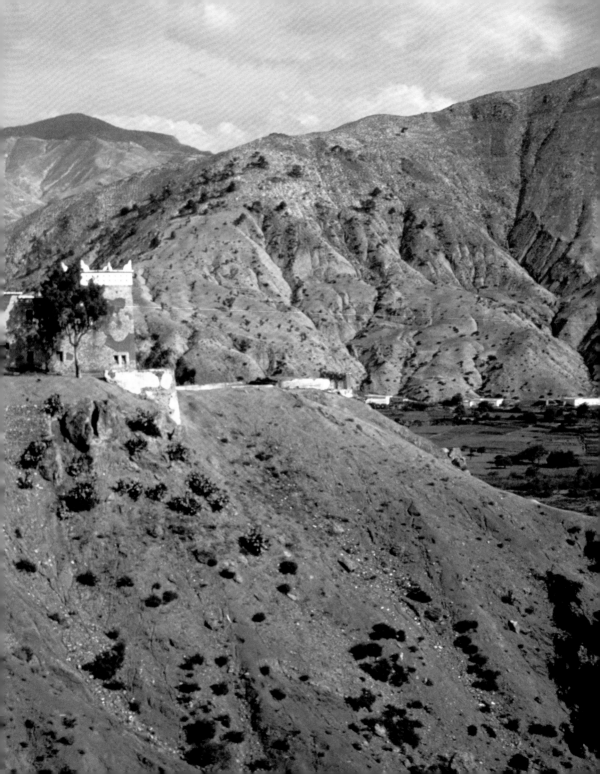

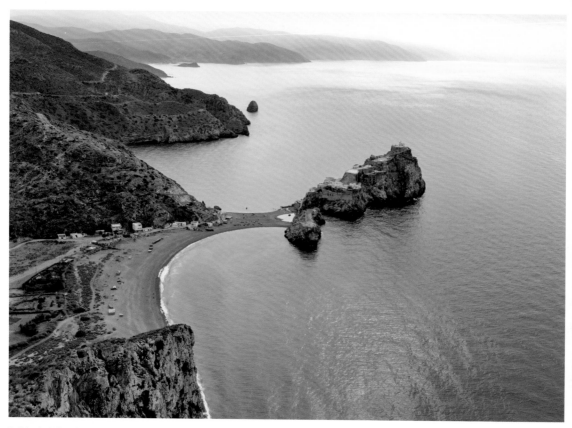

Peñón de Vélez de la Gomera

Peñón de Vélez de la Gomera

The 77 m high rock was once an island which was used by privateers as a base for their piracy and raiding expeditions. After the island was taken from them by the Spanish, becoming a Spanish possession, it was used as a prison. Its existence as an island ended in 1934 when huge storms deposited sand, changing Peñón de Vélez de la Gomera from an island to a tombolo. The land still belongs to Spain, with about 60 soldiers living there. Civilians are not permitted to enter this "territory", neither by boat nor by swimming.

Peñón de Vélez de la Gomera

Ce rocher de 77 m de haut était autrefois une île et servait de base aux pirates. Après sa conquête par les Espagnols, elle a été utilisée comme prison. Puis l'existence même de l'île a pris fin en 1934, lorsque les orages ont accumulé du sable et fait de Peñón de Vélez de la Gomera une péninsule. Cette parcelle de terre appartient encore à l'Espagne, et environ 60 soldats vivent aujourd'hui sur l'enclave. Les civils n'ont pas le droit d'entrer sur le « territoire », en bateau comme en plongée.

Peñón de Vélez de la Gomera

Der 77 m hohe Felsblock war einmal eine Insel und diente als solche Seeräubern als Ausgangspunkt für ihre Beutezüge. Danach kam das Eiland in spanischen Besitz und wurde als Gefängnis genutzt. 1934 endete das Inseldasein: Unwetter häuften Sand an und seitdem ist Peñón de Vélez de la Gomera eine Halbinsel. Zu Spanien gehört das Fleckchen Land noch immer, auf der Exklave leben rund 60 Soldaten. Für Zivilisten ist der Zugang verboten, man darf sich dem „Hoheitsgebiet" weder per Boot noch tauchend nähern.

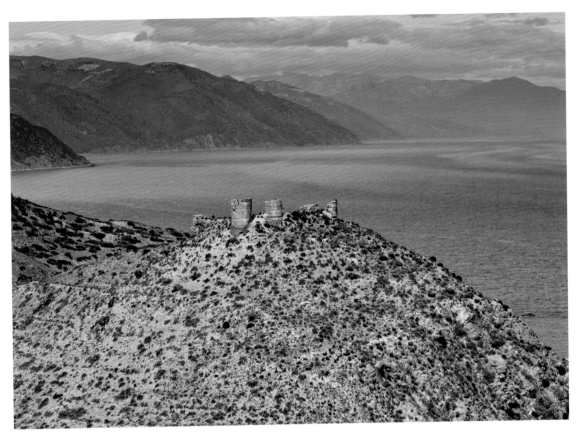

Torres de Alcala, Al Hoceima National Park
Torres de Alcala, Parc national d'Al Hoceïma

Peñón de Vélez de la Gomera

La roca de 77 m de altura fue una vez una isla y sirvió en la piratería como punto de partida para las presas. Después de eso, la isla entró en posesión de los españoles y fue utilizada como prisión. La existencia de la isla terminó en 1934: las tormentas acumularon arena y desde entonces el Peñón de Vélez de la Gomera ha sido una península. La parcela de tierra todavía pertenece a España; en el exclave viven unos 60 soldados. No se permite a los civiles entrar en el "territorio", ni en barco ni buceando.

Peñón de Vélez de la Gomera

Lo scoglio alto 77 m era un tempo un'isola e serviva come punto di partenza ai predoni del mare per le loro scorribande. In seguito, l'isola fu presa dagli spagnoli, diventando la sede di una prigione. L'esistenza da isola terminò nel 1934, a causa di temporali che accumularono sabbia: da allora Peñón de Vélez de la Gomera è una penisola. Il lembo di terra appartiene ancora oggi alla Spagna, circa 60 soldati vivono su questo "territorio" fuori confine. Ai civili non è consentito entrarvi né in barca né a nuoto.

Peñón de Vélez de la Gomera

De 77 meter hoge rots was ooit een eiland en diende piraten als uitgangspunt voor hun rooftochten. Daarna kwam het eiland in Spaans bezit en werd het gebruikt als gevangenis. Het bestaan van het eiland eindigde in 1934: onweersbuien hoopten zand op en sindsdien is Peñón de Vélez de la Gomera een schiereiland. Het stukje land hoort nog steeds bij Spanje; op de exclave wonen zo'n 60 soldaten. Burgers mogen het territorium niet betreden, noch per boot, noch als duiker.

Rif Mountains
Le Rif

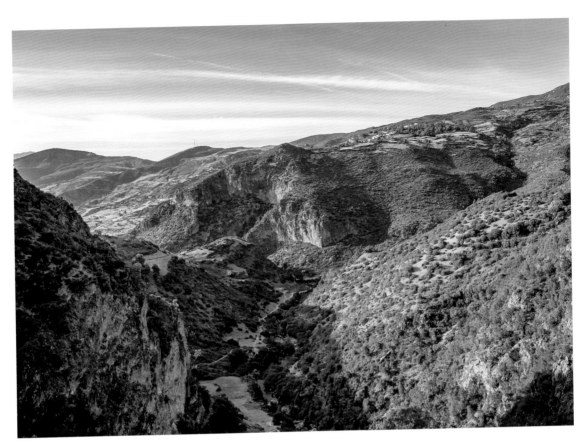

Rif Mountains
Le Rif

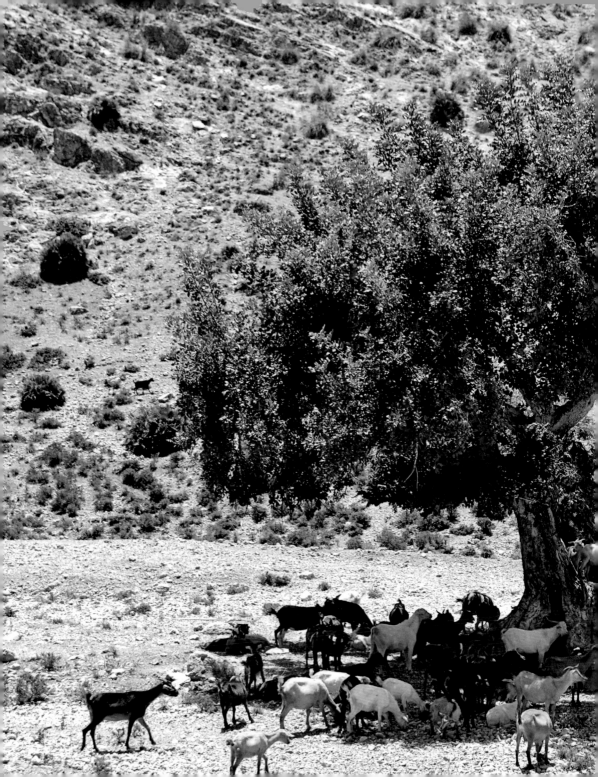

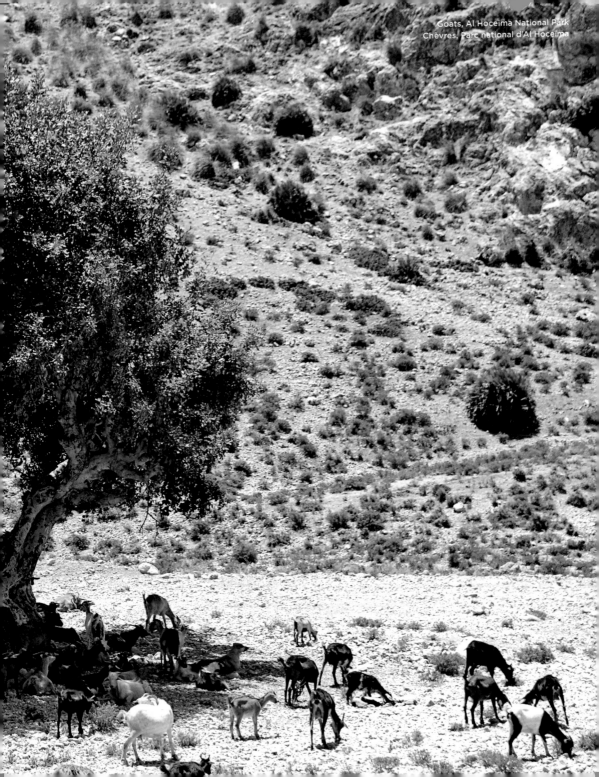

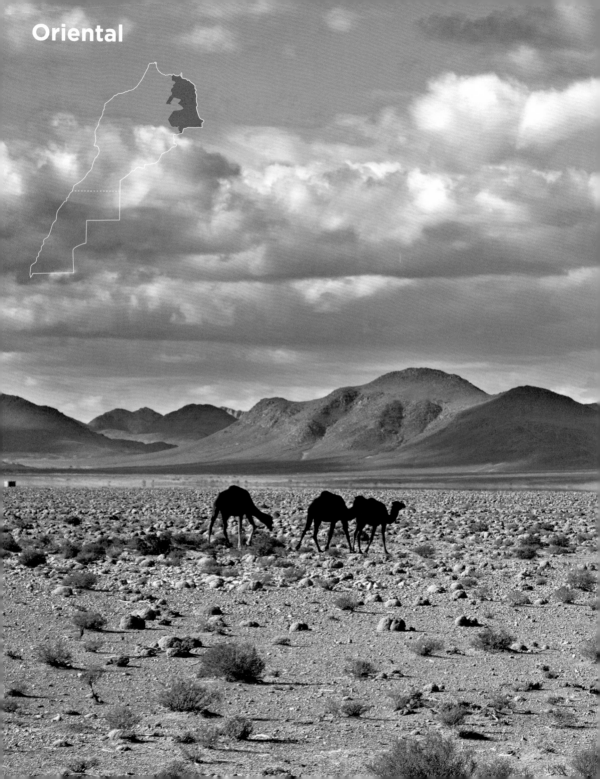

Oriental

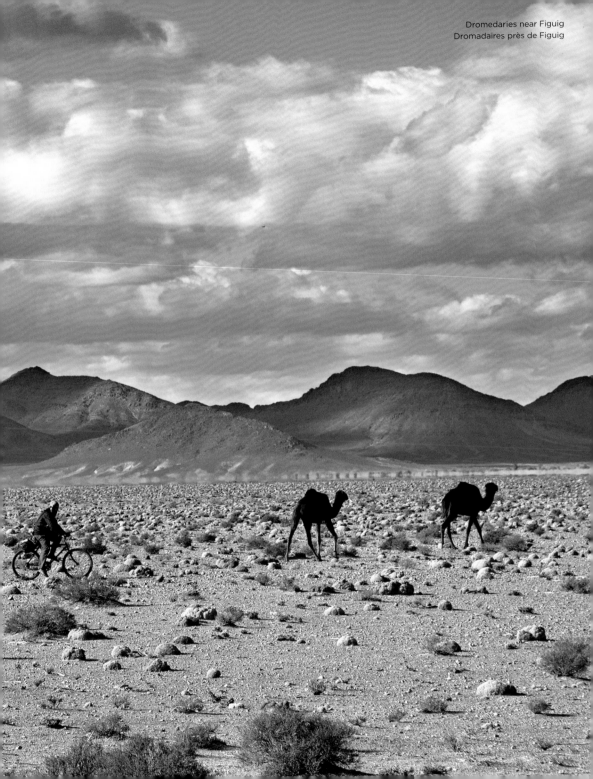

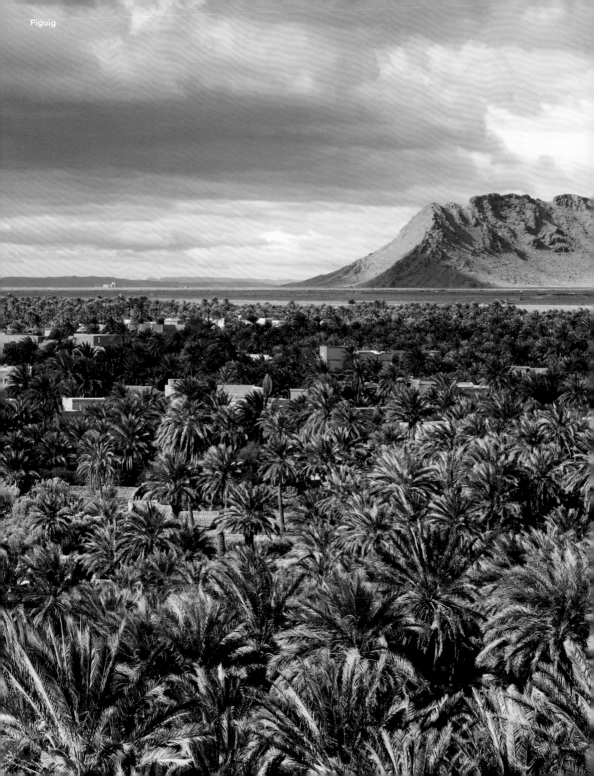

Oujda

Oriental

Apart from Saïdia, a popular seaside resort on the Mediterranean coast, the region is relatively undeveloped for tourism. The Al Hoceima National Park encompasses both the coastal land area and also a part of the sea. Here one may combine bathing and hiking. In the interior of the country there are wide arid areas dotted with green oases.

Oriental

Aparte de Saïdia, un popular balneario en la costa mediterránea, la región está relativamente poco desarrollada para el turismo. El Parque Nacional de Alhucemas protege tanto la zona costera como partes del mar. Aquí se pueden combinar agradables baños con el senderismo. En el interior del país hay amplias zonas áridas donde los oasis colorean manchas verdes.

Oriental

En dehors de Saïdia, station balnéaire populaire de la côte méditerranéenne, la région est relativement peu développée pour le tourisme. Le parc national d'Al Hoceïma protège à la fois la zone côtière et certaines parties de la mer, et permet de conjuguer baignades et randonnées. L'intérieur des terres est principalement composé de larges zones arides, parfois ravivé du vert d'une oasis.

Regione Orientale

Oltre a Saidia, una popolare località balneare sulla costa mediterranea, la regione è relativamente poco conosciuta ai turisti. Il Parco nazionale di al-Hoseyma si estende sia lungo la zona costiera che sul mare. In queste zone è possibile combinare i tuffi in mare con le escursioni a piedi. All'interno ci sono ampie regioni aride interrotte dalle aree verdi delle oasi.

Oriental

Bis auf Saidia, einem beliebten Badeort an der Mittelmeerküste, ist die Region touristisch relativ wenig erschlossen. Der Al Hoceima Nationalpark schützt sowohl das Küstengebiet als auch Teile des Meeres. Hier kann man Badefreunden mit Wanderungen verbinden. Im Landesinneren erstrecken sich weite aride Flächen, in denen Oasen grüne Tupfer setzen.

Oosters

Afgezien van Saidia, een populaire badplaats aan de Middellandse Zeekust, is de regio relatief weinig ontwikkeld voor het toerisme. Het nationale park Al Hoceima beschermt zowel het kustgebied als delen van de zee. Hier kunt u een strandvakantie combineren met wandelen. In het binnenland zijn uitgestrekte droge gebieden, waar oases groene vlekken vormen.

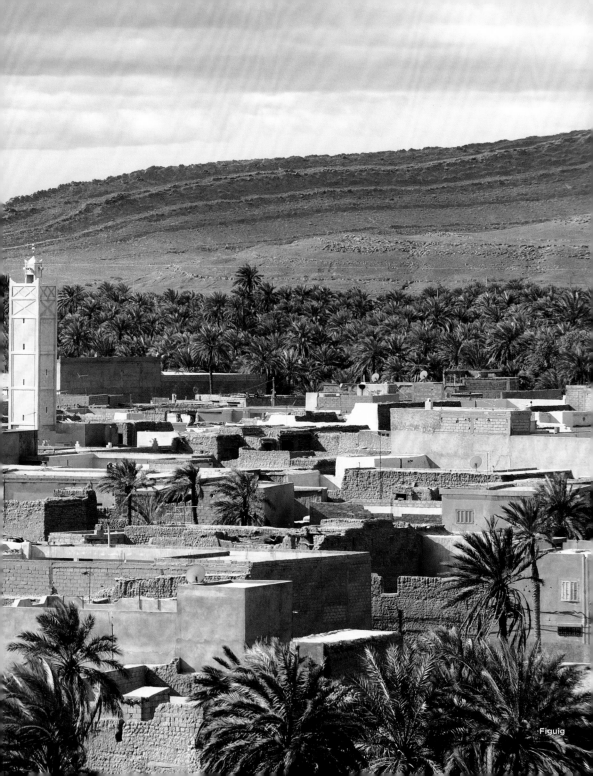

Figuig

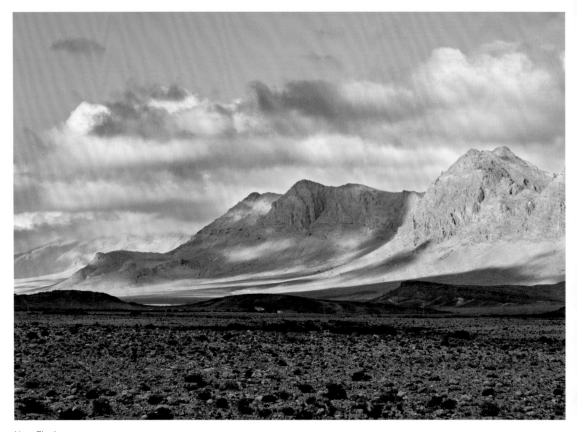

Near Figuig
Près de Figuig

Figuig

The oasis of Figuig consists of a main village and several smaller villages, featuring fortified clay-built houses. The population of around 11 000 people cultivate about 190 000 date palms. The management of an oasis follows a strictly hierarchical principle, at the top of which is the date palm. This provides shade for smaller shrubs and fruit trees, which then in turn protect plants close to the ground, such as onions, tomatoes or fodder plants, from the scorching sun. Irrigation is carried out via a canal system. Water laws allocate a share to each oasis farmer.

Figuig

L'oasis Figuig est composée d'un village principal et de plusieurs villages fortifiés en argile. Près de 11 000 personnes y cultivent environ 190 000 palmiers dattiers. La gestion d'une oasis se fait selon un principe strictement hiérarchique : au sommet se trouve le palmier dattier, qui fournit de l'ombre aux arbustes et aux arbres fruitiers plus petits. Ceux-ci protègent à leur tour du soleil brûlant les plantes proches du sol, comme les oignons, les tomates ou les plantes fourragères. L'irrigation s'effectue par un système de canaux ; la loi sur l'eau attribue une part à chaque agriculteur d'oasis.

Figuig

Die Oase Figuig besteht aus einem Hauptort und mehreren befestigten Lehmdörfern. Etwa 11 000 Menschen kultivieren rund 190 000 Dattelpalmen. Die Bewirtschaftung einer Oase folgt einem streng hierarchischen Prinzip: Ganz oben steht die Dattelpalme, die kleineren Sträuchern und Obstbäumen Schatten spendet. Diese wiederum schützen bodennahe Pflanzen, wie Zwiebeln, Tomaten oder Futterpflanzen, vor der sengenden Sonne. Bewässert wird über ein Kanalsystem. Das Wasserrecht teilt jedem Oasenbauern seinen Anteil zu.

Figuig

Figuig

El oasis de Figuig está formado por un pueblo principal y varios pueblos fortificados de arcilla. Alrededor de 11000 personas cultivan unas 190000 palmeras datileras. El cultivo de un oasis sigue un principio estrictamente jerárquico: en la parte superior se encuentra la palmera datilera, que da sombra a los arbustos más pequeños y a los árboles frutales. Estos, a su vez, protegen del sol abrasador las plantas cercanas al suelo, como cebollas, tomates o plantas forrajeras. El riego se realiza a través de un sistema de canales. La ley de aguas asigna una proporción a cada oasis agrícola.

Figuig

L'oasi di Figuig è costituita da una parte principale e da diversi villaggi costruiti in argilla. Gli 11000 abitanti coltivano circa 190000 palme da dattero. La coltivazione di un'oasi avviene secondo una stretta gerarchia: la palma da dattero si erge sopra a tutto e fornisce ombra agli arbusti e agli alberi da frutto più piccoli. Questi, a loro volta, proteggono dal sole cocente le piante più basse, come cipolle, pomodori e piante da foraggio. L'irrigazione avviene tramite un sistema di canali. La legge sull'acqua assegna una quota a ciascun agricoltore dell'oasi.

Figuig

De oase Figuig bestaat uit een hoofddorp en meerdere versterkte dorpen met lemen huizen. Zo'n 11000 mensen kweken daar circa 190000 dadelpalmen. De bewerking van een oase volgt een strikt hiërarchisch principe: bovenaan staan de dadelpalmen, die schaduw bieden aan kleinere struiken en fruitbomen. Deze beschermen op hun beurt laag groeiende gewassen, zoals uien, tomaten en voedergewassen, tegen de verzengende zon. Het bewateren gebeurt via een kanalensysteem. Het waterrecht wijst iedere oaseboer een aandeel toe.

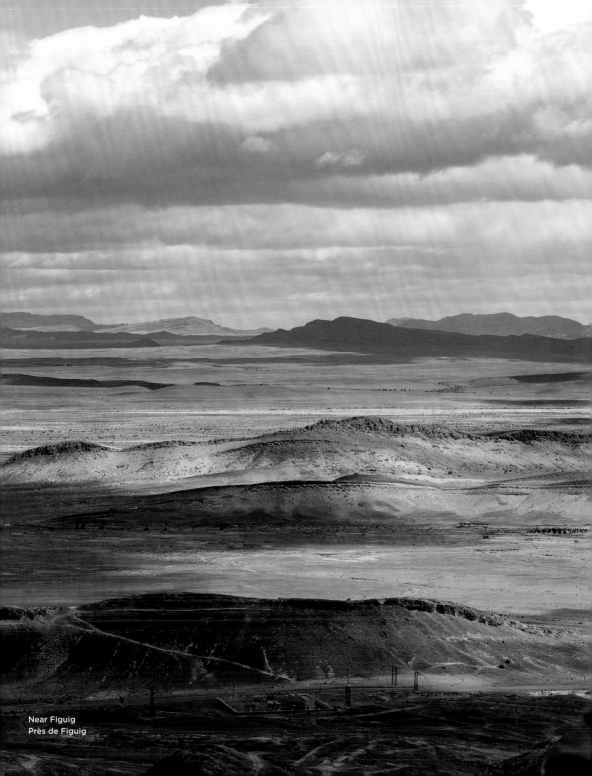

Near Figuig
Près de Figuig

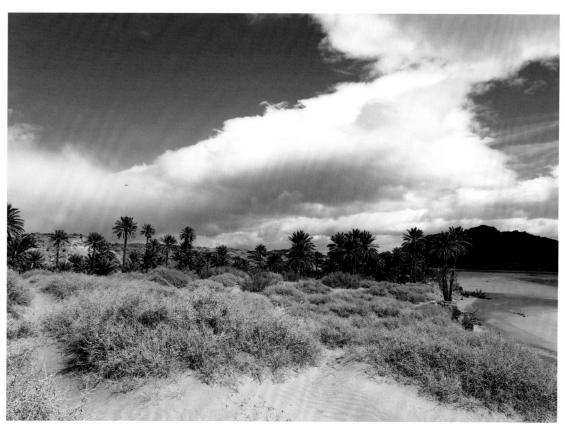

Near Figuig
Près de Figuig

Fes, Meknes & Middle Atlas

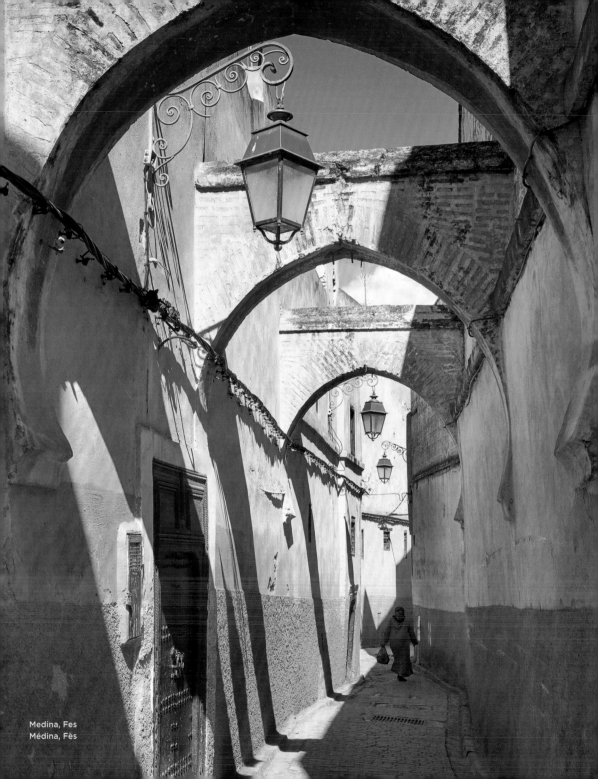

Medina, Fes
Médina, Fès

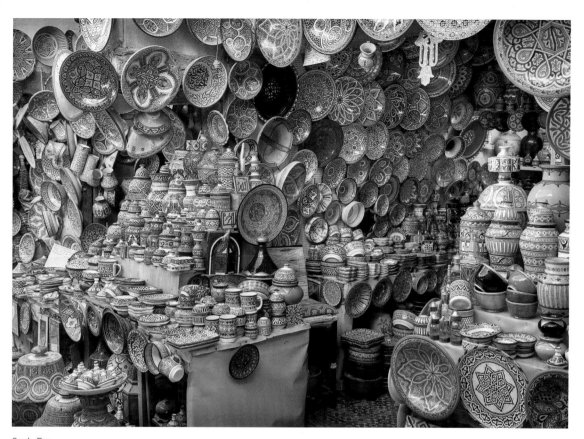

Souk, Fes
Souk, Fès

Fes, Meknès & Middle Atlas

The Middle Atlas shows different facets of the mountain world, with high rugged peaks reaching over 3 000 m to the east and south, whilst south of Fès and Meknès there are many lakes, streams and vegetation. Cultural highlights are Fes, the oldest university town in the world, and Meknès, another of the impressive 'Imperial Cities'. Both royal cities are designated UNESCO World Heritage Sites.

Fez, Mequinez & Atlas Medio

Más de 3 000 m de altura, montañas escarpadas al este y al sur, lagos, arroyos y mucho verdor al sur de Fez y Mequinez: el Atlas Medio muestra diferentes facetas del mundo montañoso. Fez, la ciudad universitaria más antigua del mundo, y Mequinez, una impresionante Ciudad Imperial, son lugares de interés cultural. Ambas ciudades reales son Patrimonio de la Humanidad de la UNESCO.

Fès, Meknès & Moyen Atlas

Plus de 3 000 m d'altitude, des montagnes accidentées à l'est et au sud, des lacs, des ruisseaux et beaucoup de verdure au sud de Fès et Meknès : le Moyen Atlas présente différentes facettes du paysage montagnard. Les deux cités royales, Fès, plus ancienne ville universitaire du monde, et Meknès, avec son impressionnante ville impériale, sont classées au patrimoine mondial de l'UNESCO.

Fès, Meknès & Medio Atlante

A est e a sud montagne dal profilo frastagliato, alte oltre 3 000 m, a sud di Fès e Meknès laghi, ruscelli e molto verde: il Medio Atlante mostra le varie sfaccettature del mondo montano. Fès, la più antica città universitaria del mondo, e Meknès offrono numerose attrazioni culturali. Entrambe le città imperiali sono Patrimonio dell'Umanità dell'UNESCO.

Fès, Meknès & Mittlerer Atlas

Über 3 000 m hohe, zerklüftete Berge im Osten und Süden, Seen, Bäche und viel Grün südlich von Fès und Meknès: Der Mittlere Atlas zeigt verschiedene Facetten der Bergwelt. Kulturelle Höhepunkte bieten Fès, älteste Universitätsstadt der Welt, und Meknès mit der beeindruckenden Ville Imperial. Beide Königsstädte gehören zum UNESCO Weltkulturerbe.

Fez, Meknès & Midden-Atlas

Meer dan 3 000 m hoge, gekloofde bergen ten oosten en zuiden, meren, beken en veel groen ten zuiden van Fez en Meknès: de Midden-Atlas toont verschillende facetten van de bergwereld. Culturele hoogtepunten zijn Fez, de oudste universiteitsstad ter wereld, en Meknès, met het indrukwekkende Ville Imperial. Beide koninklijke steden staan op Unesco's werelderfgoedlijst.

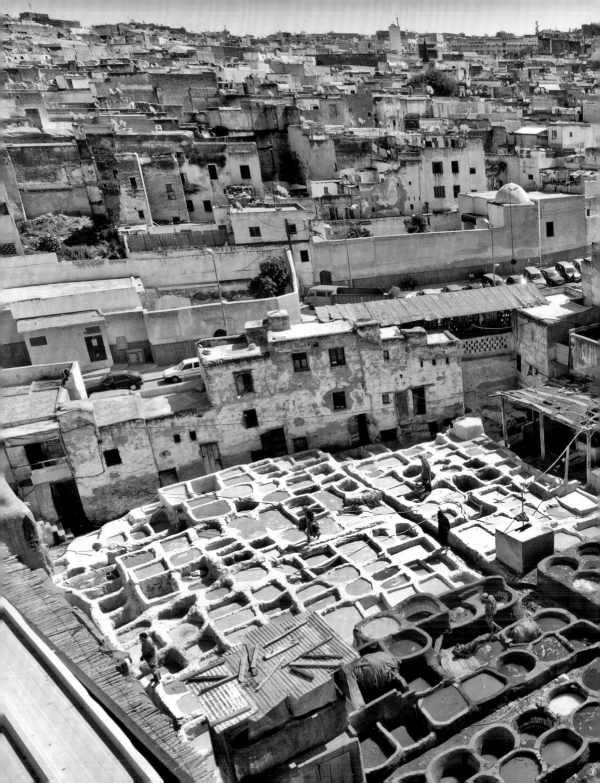

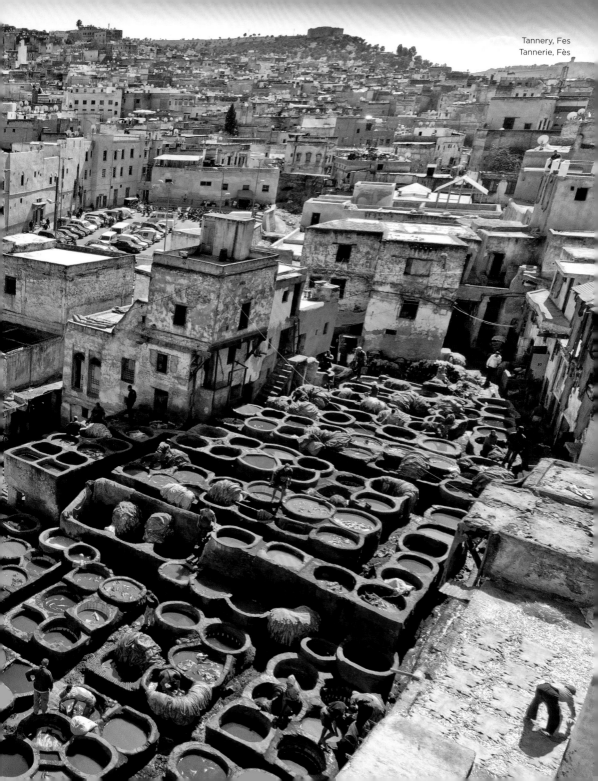

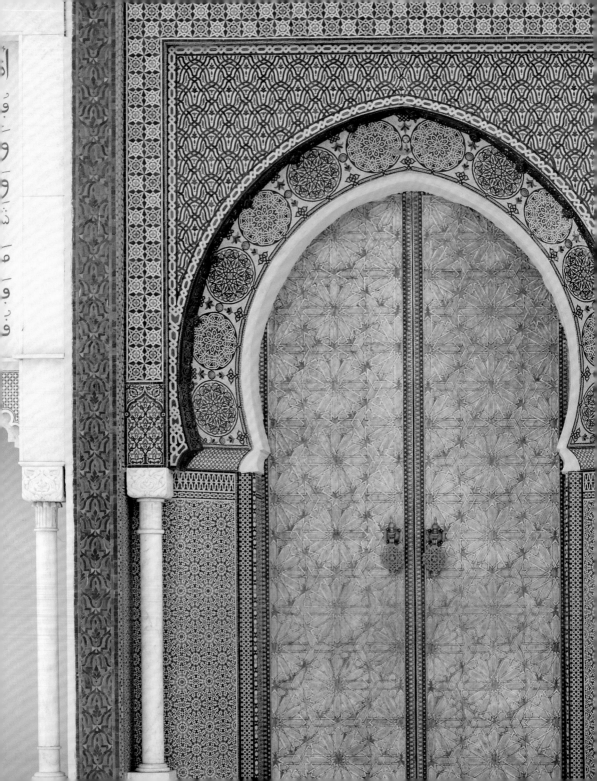

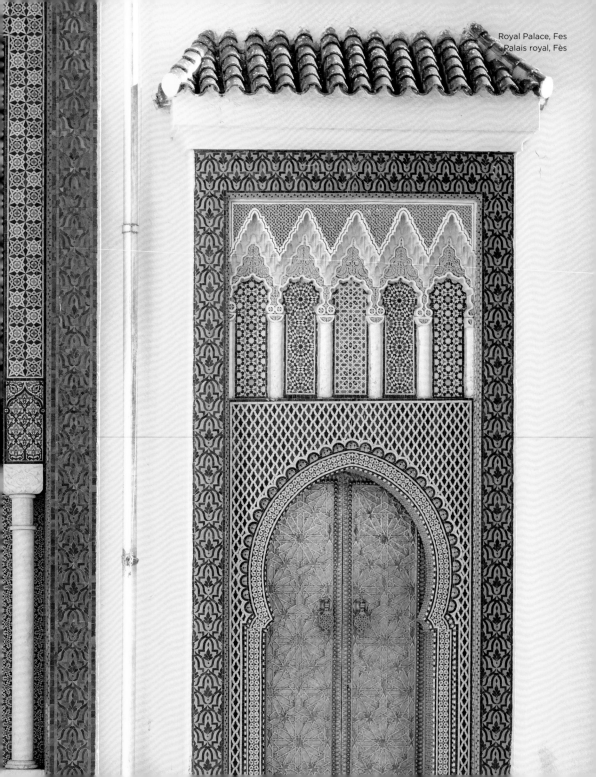

Royal Palace, Fes
Palais royal, Fès

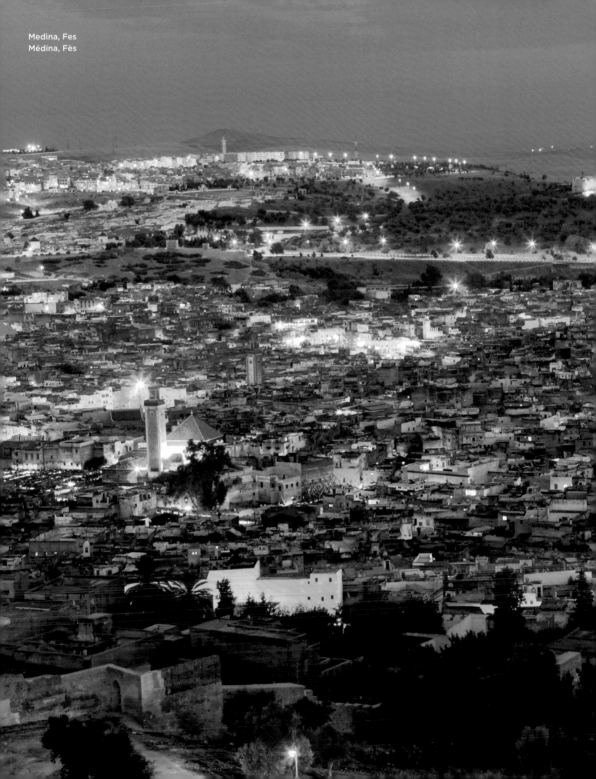

Medina, Fes
Médina, Fès

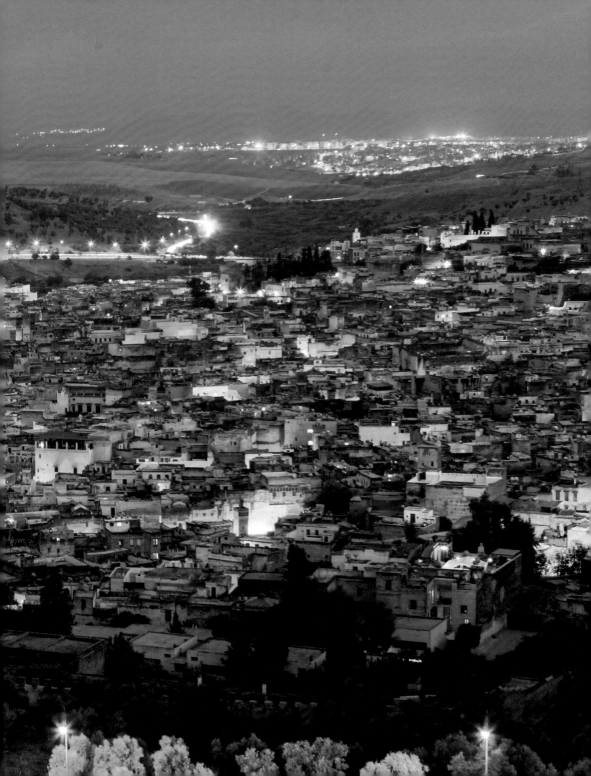

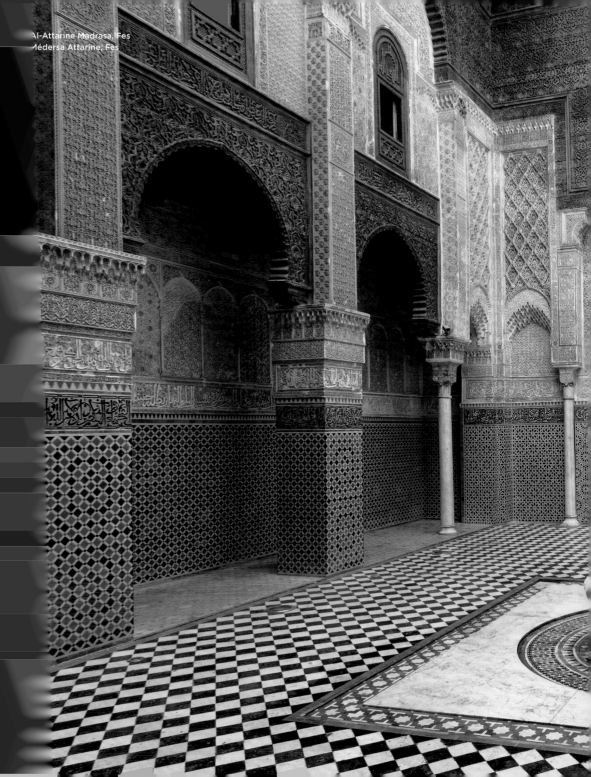

Al-Attarine Madrasa, Fes
Médersa Attarine, Fes

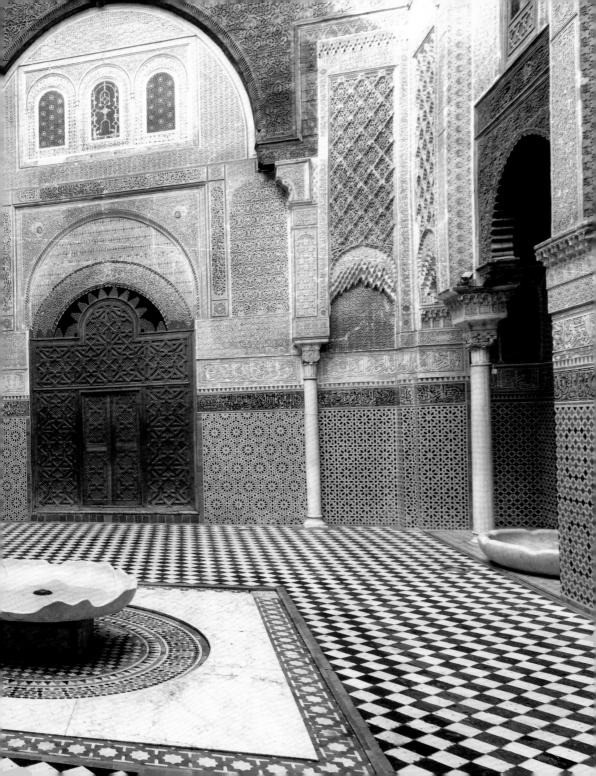

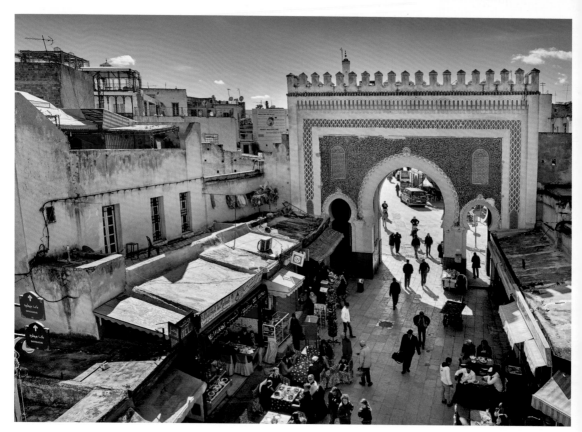

Fes
Fès

University of Al-Karaouine

The *Guinness Book of World Records* lists the University in Fes as the oldest continuously functioning educational institution in the world. It only became a university in 1957, but its foundation as a madrasa, where Islamic subjects were taught, dates back to 859, when it was established by a woman, Fatima al-Fihri.

Universidad de Kairaouine

En el *Libro Guinness de los Récords Mundiales,* la Universidad de Fez figura como la institución educativa más antigua que queda en el mundo. No se convirtió en universidad hasta 1957, pero su creación como madrasa (escuela donde se enseñaban las ciencias islámicas) data del año 859. La fundadora, también digna de un récord, era una mujer: Fátima al-Fihri.

Université Al Quaraouiyine

Le *Livre Guinness des records* présente l'Université de Fès comme la plus ancienne institution d'enseignement au monde. Elle n'est devenue une université qu'en 1957, mais sa fondation, en tant que madrasa – école des sciences islamiques –, remonte à 859. Autre record, elle fut fondée par une femme, Fatima al-Fihriya.

Università di al-Karaouine

Il *Guinness dei primati* elenca l'università di Fès come la più antica istituzione educativa esistente al mondo. Divenne università solo nel 1957, ma la sua fondazione come madrasa, ossia scuola coranica, risale all'859. Anche da record il fatto che a fondarla sia stata una donna, Fatima al-Fihriya.

Universität al-Qarawīyīn

Das *Guiness-Buch der Rekorde* führt die Universität von Fès als älteste noch bestehende Bildungseinrichtung der Welt auf. Zur Universität wurde sie erst 1957, aber ihre Gründung als Madrasa – Schule, in der islamische Wissenschaften unterrichtet wurden – reicht ins Jahr 859 zurück. Die Gründerin, auch das ist rekordverdächtig, war eine Frau: Fatima al-Fihri.

Universiteit van Kairaouine

Het *Guinness Book of Records* noemt de universiteit van Fez als de oudste nog bestaande onderwijsinstelling ter wereld. Hij werd pas in 1957 een universiteit, maar de oprichting ervan als madrassa, een hogeschool waar islamitisch-juridische wetenschappen werden onderwezen, dateert van 859. De eveneens records brekende oprichter was een vrouw: Fatima al-Fihri.

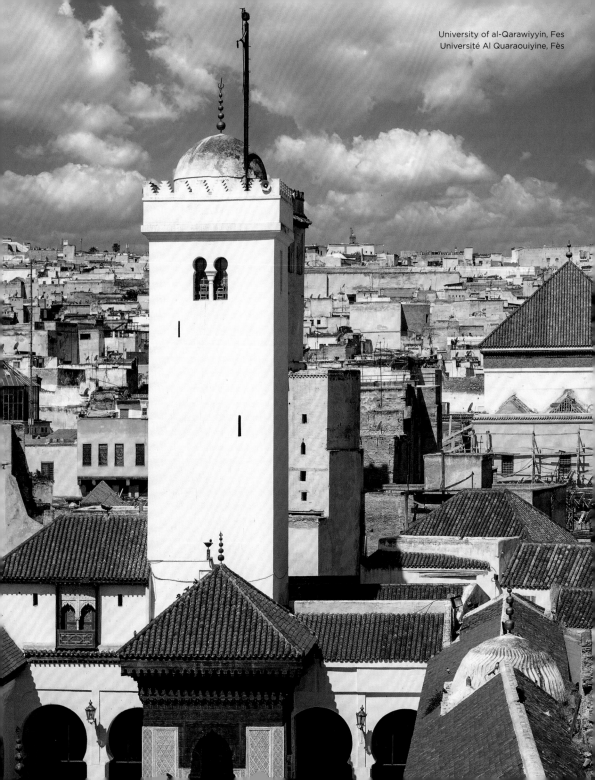

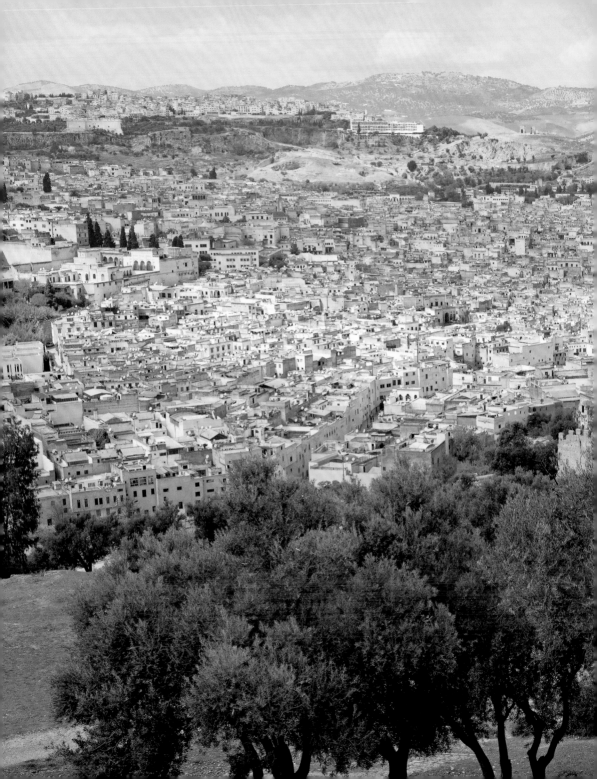

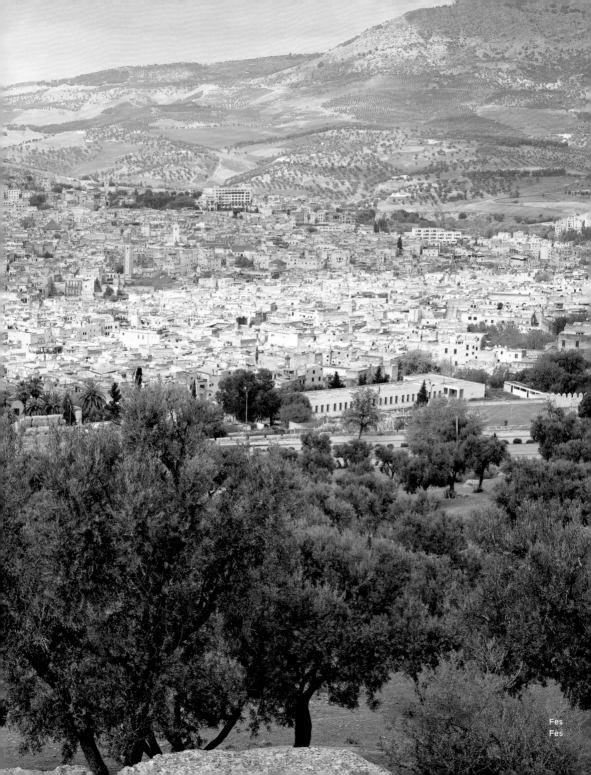

Fes
Fès

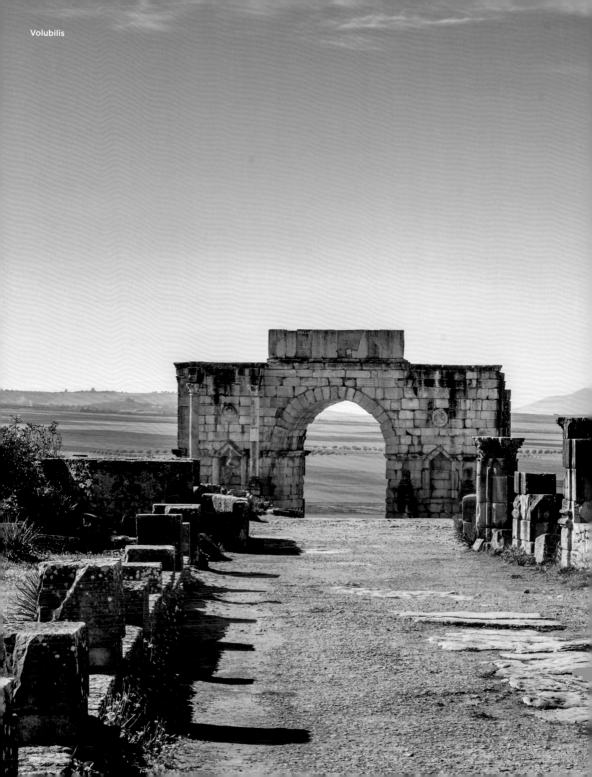
Volubilis

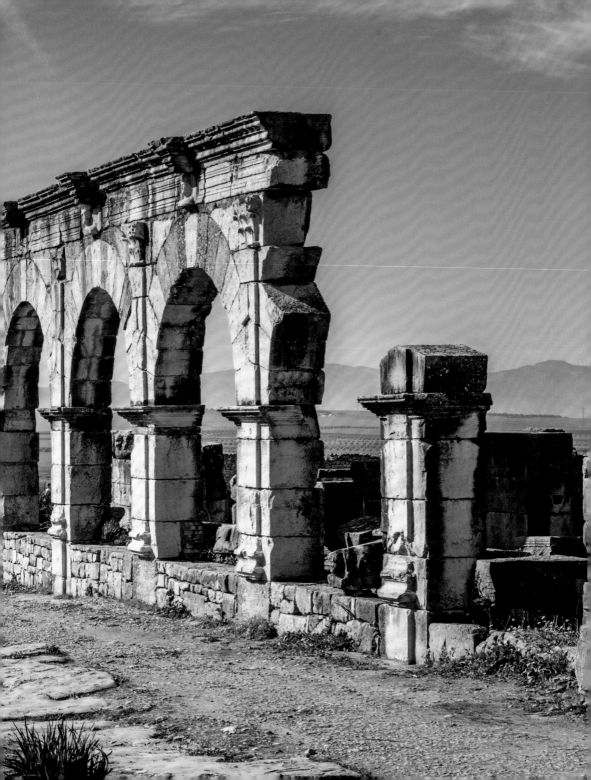

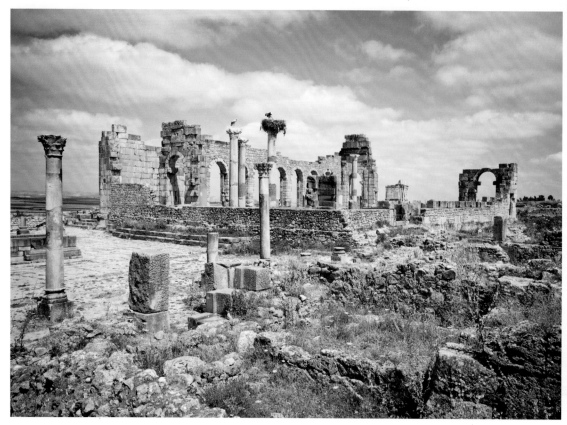
Volubilis

Volubilis

Asterix was wrong—the Romans weren't mad. Anyone who can build such magnificent buildings, including basilica, triumphal arches, temples, thermal baths, and who can lay mosaics of this quality, must have a fine sense of organization. Volubilis testifies to this. The settlement was probably founded in the year 25 and then annexed by the Romans in the year 40. The city experienced its heyday under Emperor Septimius Severus (193–211), during which time the ramparts were renewed, and most of the buildings date from this period. At times, 10 000 people lived here.

Volubilis

Astérix avait tort : les Romains ne sont pas fous. Quiconque peut construire des édifices aussi magnifiques – basiliques, arcs de triomphe, temples, thermes – et y poser des mosaïques de cette qualité, avait forcément une tête bien faite. Volubilis en est la preuve : la colonie, probablement fondée en l'an 25 et annexée par les Romains en 40, a connu son apogée sous l'empereur Septimius Severus (193–211). Les remparts ont été rénovés, mais la plupart des bâtiments datent de cette période. La cité a accueilli jusqu'à 10 000 habitants.

Volubilis

Asterix irrt: Die Römer spinnen nicht. Wer derart großartige Bauwerke errichten kann – Basilika, Triumphbogen, Tempel, Therme –, wer Mosaiken dieser Qualität legen kann, muss seine fünf Sinne beisammen haben. Volubilis zeugt davon. Die Siedlung wurde vermutlich im Jahr 25 gegründet und im Jahr 40 von Römern annektiert. Ihre Blütezeit erlebte die Stadt unter Kaiser Septimius Severus (193–211). Die Wälle wurden erneuert, die meisten Bauten stammen aus dieser Zeit. Zeitweise lebten hier 10 000 Menschen.

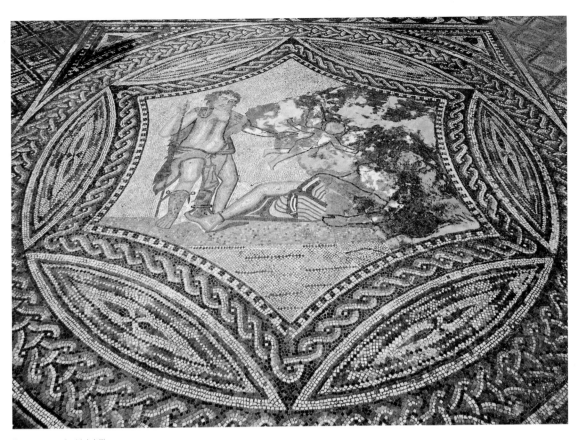

Roman mosaic, Volubilis
Mosaïque romaine, Volubilis

Volubilis

Astérix se equivoca: los romanos no están locos. Cualquiera que pueda construir estos magníficos edificios (basílica, arco de triunfo, templo, baños termales), que pueda colocar mosaicos de esta calidad, debe tener sus cinco sentidos bien puestos. Volubilis lo atestigua; el asentamiento se fundó probablemente en el año 25 y fue anexionado por los romanos en el año 40. La ciudad vivió su apogeo bajo el emperador Septimio Severo (193–211). Las murallas fueron renovadas y la mayoría de los edificios datan de esta época. Hubo épocas en las que llegaron a vivir aquí unas 10 000 personas.

Volubilis

Asterix ha torto: i romani non sono pazzi. Chi sa costruire edifici di tale splendore - basiliche, archi di trionfo, templi e terme –, chi è capace di creare mosaici di questa qualità non può che agire nel pieno possesso delle proprie facoltà. Volubilis ne è testimonianza. L'insediamento fu probabilmente fondato nell'anno 25 e annesso dai romani nel 40. La città visse il suo periodo di massimo splendore sotto l'imperatore Settimio Severo (193–211), periodo in cui i bastioni vennero rinnovati e la maggior parte degli edifici è stata eretta. Qui vivevano in certi periodi anche 10 000 persone.

Volubilis

Asterix heeft ongelijk: de Romeinen zijn niet gek. Wie zulke prachtige gebouwen kan bouwen – basiliek, triomfboog, tempel, thermaalbaden – en mozaïeken van deze kwaliteit kan leggen, moet ze alle vijf op een rijtje hebben. Volubilis getuigt daarvan. De nederzetting is waarschijnlijk in 25 n. Chr. gesticht en in 40 n.Chr. door de Romeinen geannexeerd. De stad beleefde zijn hoogtijdagen onder keizer Septimius Severus (193–211). De wallen zijn vernieuwd, de meeste gebouwen stammen uit deze tijd. Hier woonden soms 10 000 mensen.

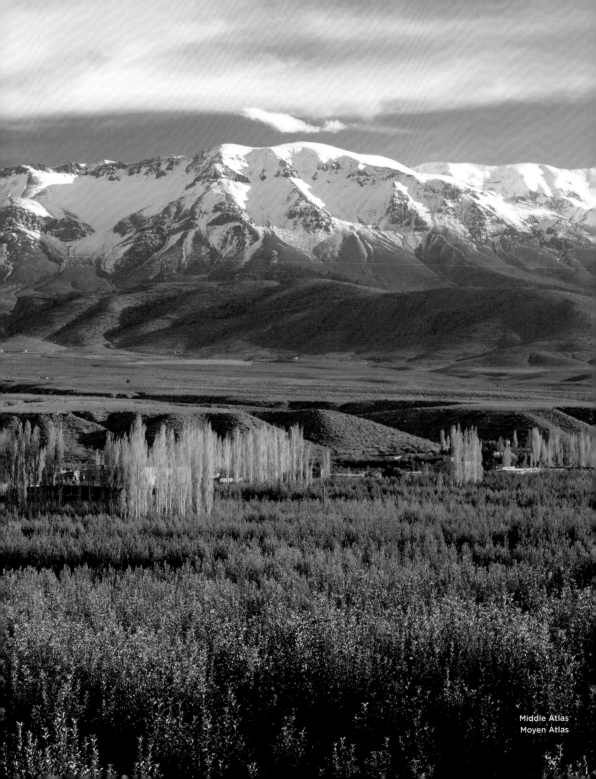

Middle Atlas
Moyen Atlas

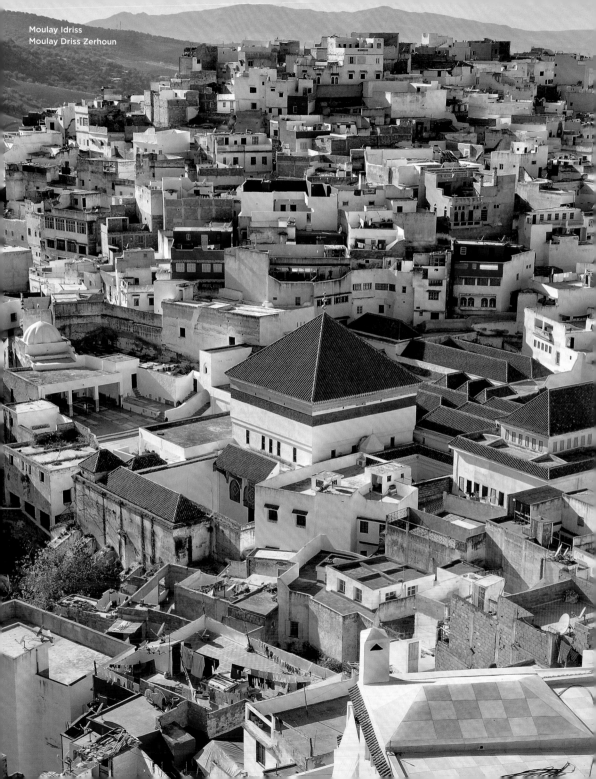

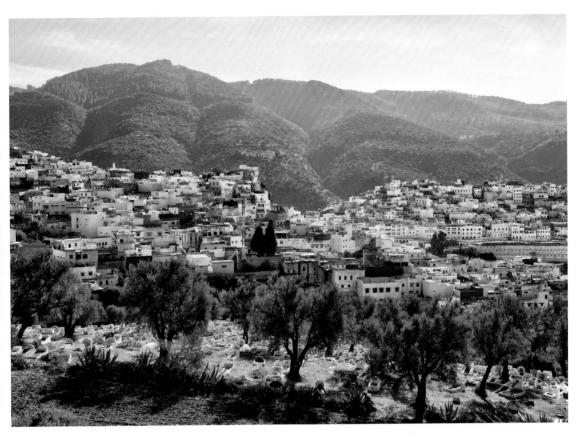

Moulay Idriss
Moulay Driss Zerhoun

Moulay Idriss

Welcome to the oldest city in Morocco, where "unbelievers" were not welcome until the beginning of the 20th century, and forbidden to stay overnight until 2005. Here lies the tomb of Idris I, also known as *Idris ibn Abdillah*, who founded the city in 788. Moulay Idriss is a place of pilgrimage, and many Moroccans who cannot afford to travel to Mecca make a pilgrimage to the tomb of Idris I.

Moulay Idriss

Bienvenidos a la ciudad más antigua de Marruecos, donde los "infieles" no fueron bienvenidos hasta bien entrado el siglo XX: Aquí se encuentra la tumba de Idris I, que fundó la ciudad en 788. Moulay Idriss es un lugar de peregrinación. Los marroquíes que no pueden permitirse viajar a La Meca peregrinan a la tumba de Idris Ben Abdellah.

Moulay Idriss

Bienvenue dans la plus ancienne ville du Maroc, où, jusqu'au XXᵉ siècle, les « non-croyants » n'étaient pas les bienvenus. C'est ici que repose Idris Iᵉʳ, fondateur de la ville en 788. Sa tombe participe d'ailleurs à faire de Moulay Idriss un lieu de pèlerinage : les Marocains qui n'ont pas les moyens de se rendre à La Mecque viennent s'y recueillir.

Moulay Idriss

Benvenuti nella città più antica del Marocco, dove fino a XX secolo inoltrato i "miscredenti" erano tutt'altro che benvenuti: qui si trova infatti la tomba di Idris I, che fondò la città nel 788. Moulay Idriss è un luogo di pellegrinaggio: i marocchini che non possono permettersi di recarsi alla Mecca fanno un pellegrinaggio alla tomba di Idris I.

Moulay Idriss

Willkommen in der ältesten Stadt Marokkos, in der bis weit ins 20. Jahrhundert hinein „Ungläubige" nicht willkommen waren: Hier liegt das Grab von *Idris ibn Abdellah*, der die Stadt 788 gründete. Moulay Idriss ist eine Pilgerstätte. Marokkaner, die sich die Fahrt nach Mekka nicht leisten können, pilgern zum Grab des Idris Ben Abdellah.

Moulay Idriss

Welkom in de oudste stad van Marokko, waar 'ongelovigen' tot ver in de 20e eeuw niet welkom waren. Hier ligt het graf van Idris ibn Abdullah, die de stad in 788 stichtte. Moulay Idriss is een bedevaartsoord. Marokkanen die het zich niet kunnen veroorloven om naar Mekka te reizen, maken een pelgrimstocht naar het graf van Idris ibn Abdullah.

Near Meknes
Près de Meknès

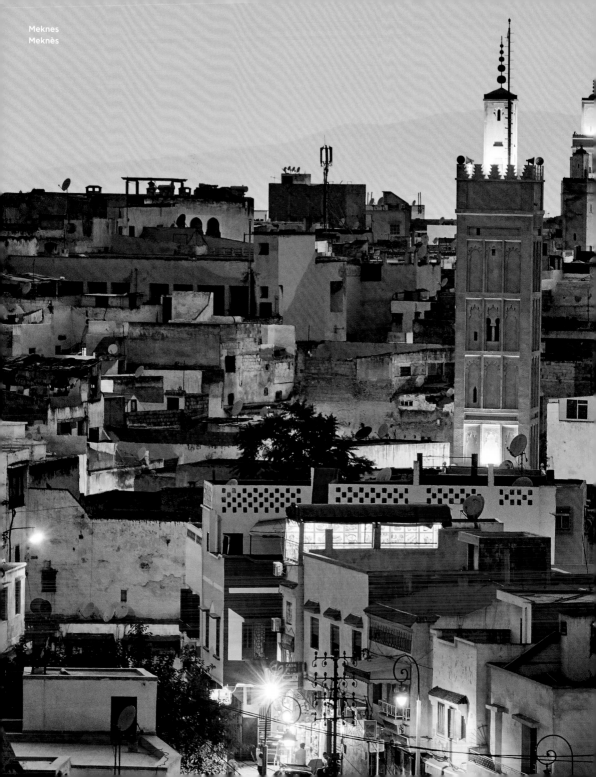

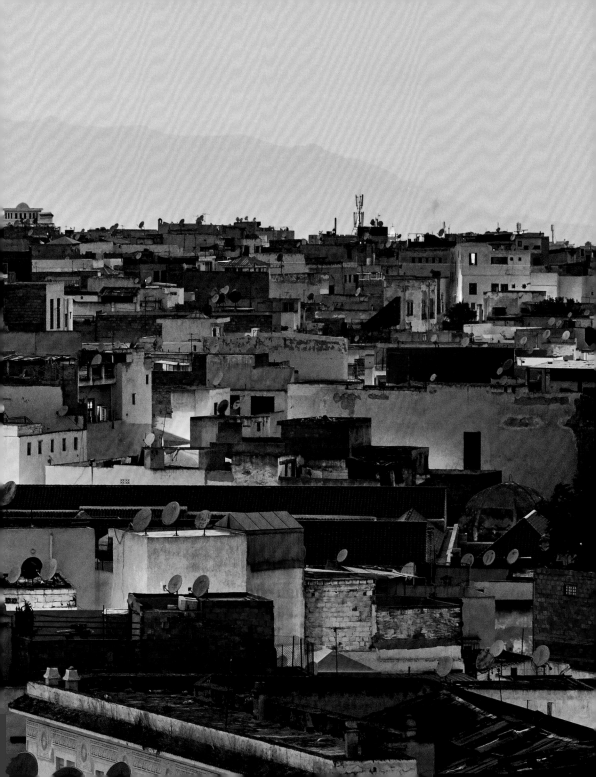

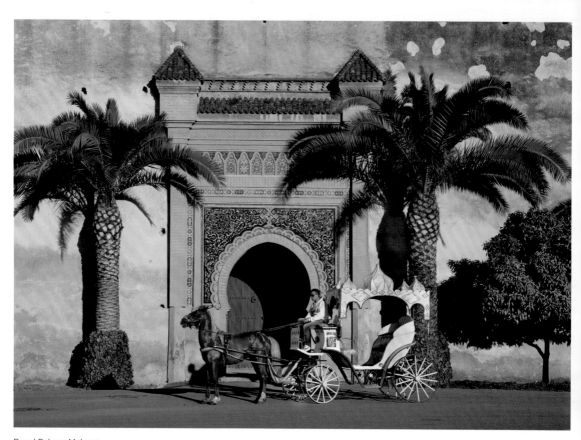

Royal Palace, Meknes
Palais royal, Meknès

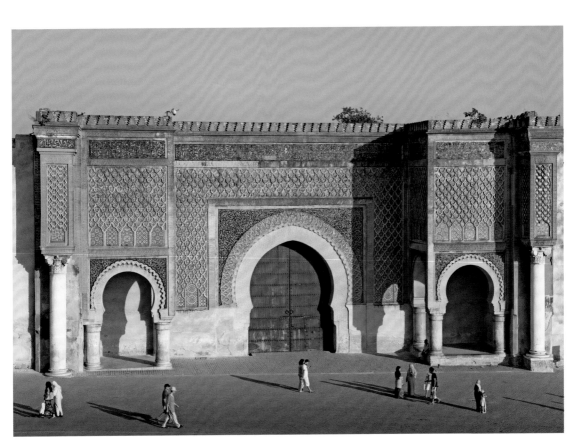

Bab El-Mansour, Meknes
Bab El-Mansour, Meknès

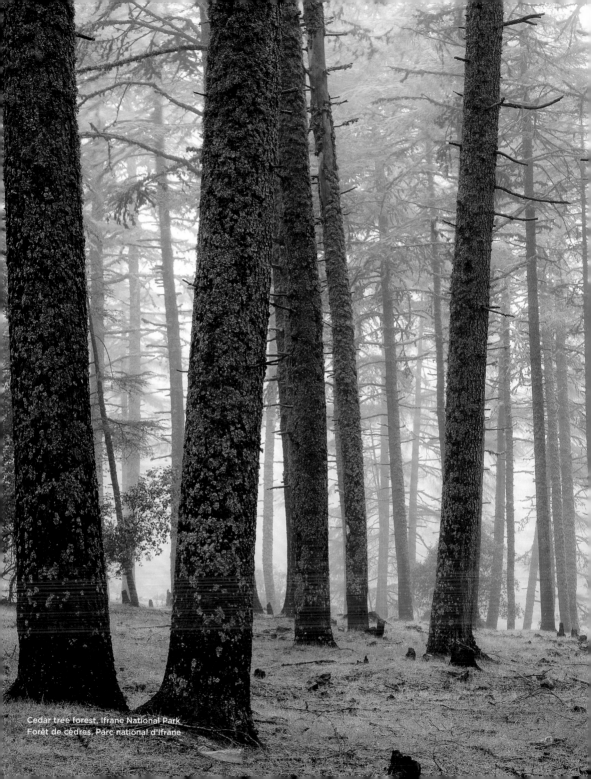

Cedar tree forest, Ifrane National Park
Forêt de cèdres, Parc national d'Ifrane

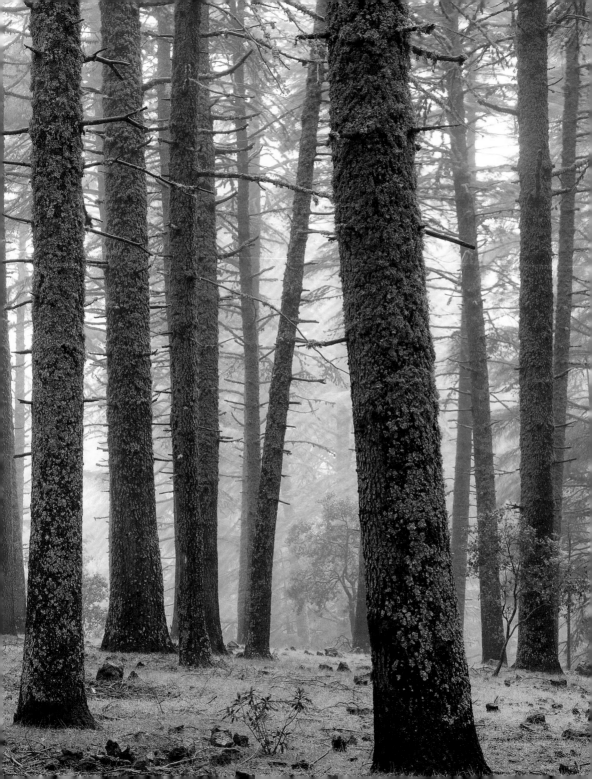

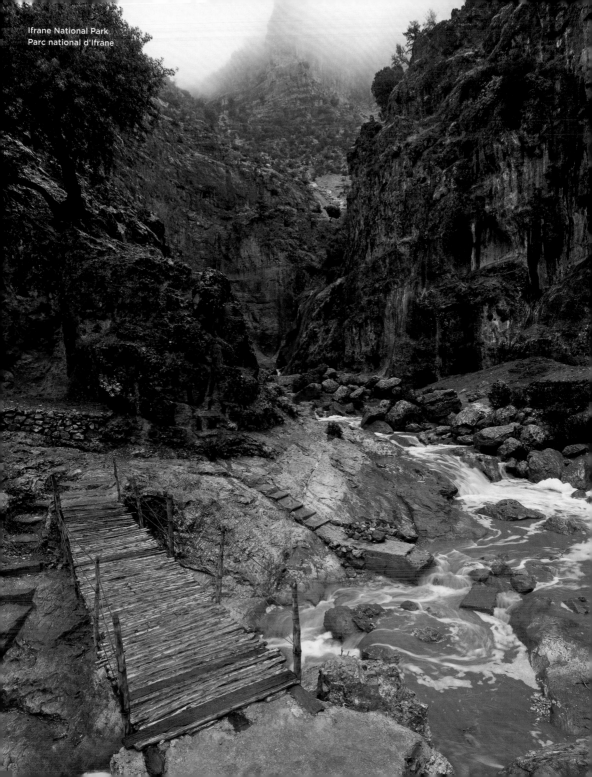

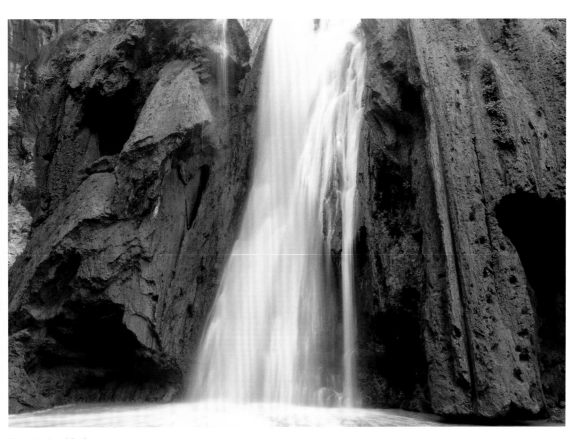

Ifrane National Park
Parc national d'Ifrane

Ifrane National Park

Forests, mountains, lakes, waterfalls—the Ifrane National Park is an ideal hiking area. It is home to Morocco's largest cedar and holm oak forests, and also to some three dozen species of mammals, including Berber deer and Barbary macaques, the latter of which are also to be found on Gibraltar, where they were probably introduced by humans.

Parque Nacional de Ifrane

Bosques, montañas, lagos, cascadas: el Parque Nacional de Ifrane es una zona ideal para practicar senderismo. Aquí se extienden los bosques más grandes de cedros y encinas de Marruecos y es el hogar de unas tres docenas de especies de mamíferos, incluyendo ciervos berberiscos y monos berberiscos. Los monos berberiscos también viven en Gibraltar, donde probablemente fueron introducidos por los humanos.

Parc national d'Ifrane

Forêts, montagnes, lacs, cascades : le parc national d'Ifrane est un lieu de randonnée idéal. Il abrite les plus grandes forêts de cèdres et de chênes verts du Maroc, mais également une trentaine d'espèces de mammifères, dont le cerf berbère et le macaque de Barbarie. On trouve également ces derniers à Gibraltar, où ils ont probablement été introduits par l'homme.

Parco nazionale di Ifrane

Foreste, montagne, laghi, cascate - il Parco nazionale di Ifrane è un'area escursionistica ideale. Ospita i più grandi boschi di cedri e lecci del Marocco e una trentina di specie di mammiferi, tra cui il cervo berbero e la bertuccia. Quest'ultima vive anche a Gibilterra, dove probabilmente venne introdotta dall'uomo.

Ifrane Nationalpark

Wälder, Berge, Seen, Wasserfälle – der Ifrane Nationalpark ist ein ideales Wandergebiet. Hier erstrecken sich Marokkos größte Zedern- und Steineichenwälder, etwa drei Dutzend Säugetierarten, unter ihnen Berberhirsche und Berberaffen, finden hier Schutz. Berberaffen leben auch auf Gibraltar, wo sie allerdings vermutlich vom Menschen eingeführt wurden.

Nationaal park Ifrane

Bossen, bergen, meren, watervallen – het nationale park Ifrane is een ideaal wandelgebied. Het is de thuisbasis van Marokko's grootste ceder- en steeneikenbossen, habitat van zo'n dertig soorten zoogdieren, waaronder de hertachtige *Cervus elaphus barbarus* en de berberapen. Berberapen leven ook op Gibraltar, waar ze waarschijnlijk door mensen zijn geïntroduceerd.

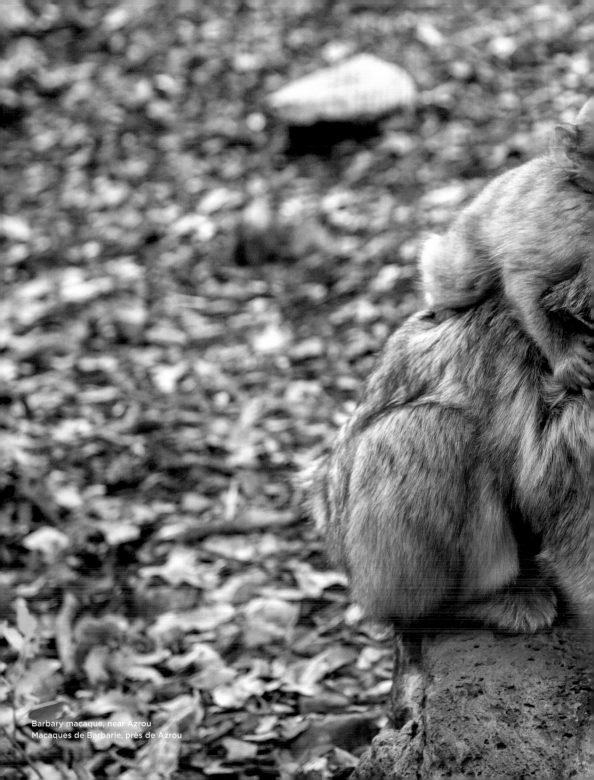

Barbary macaque, near Azrou
Macaques de Barbarie, près de Azrou

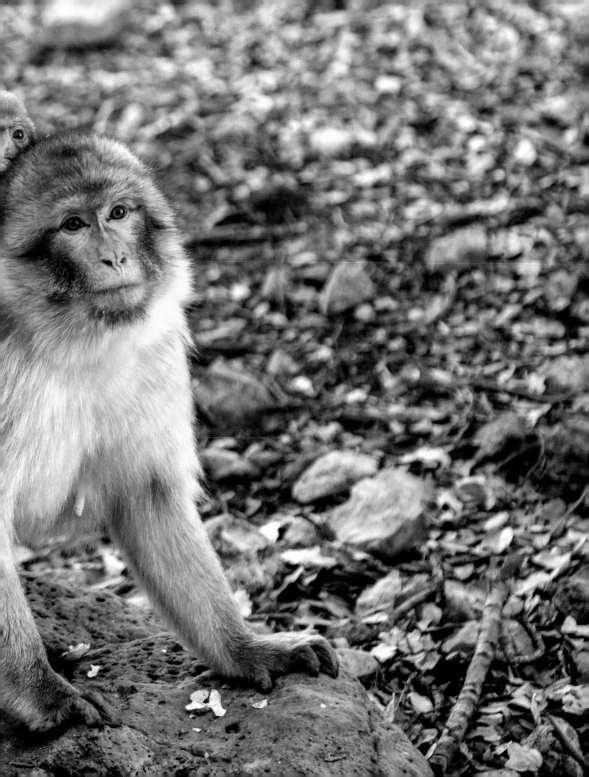

Near Ifrane
Près d'Ifrane

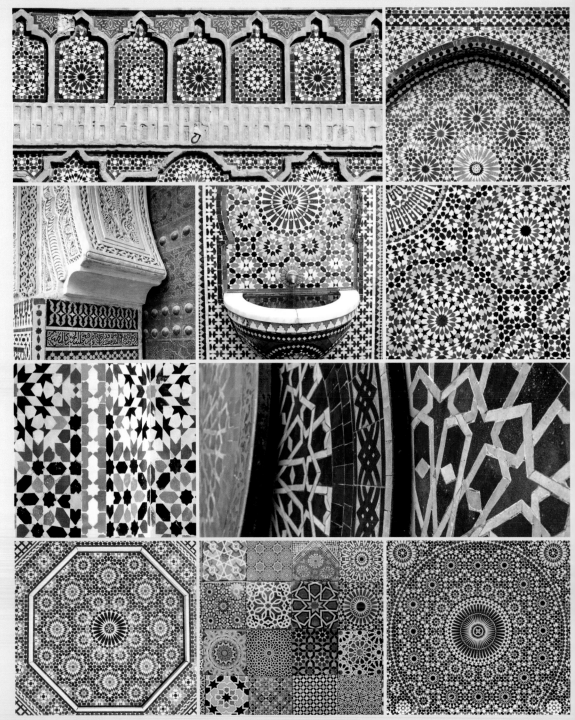

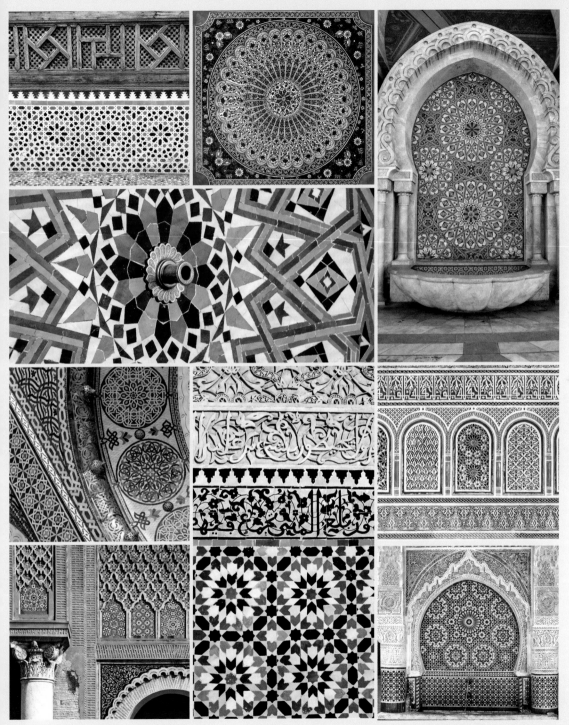

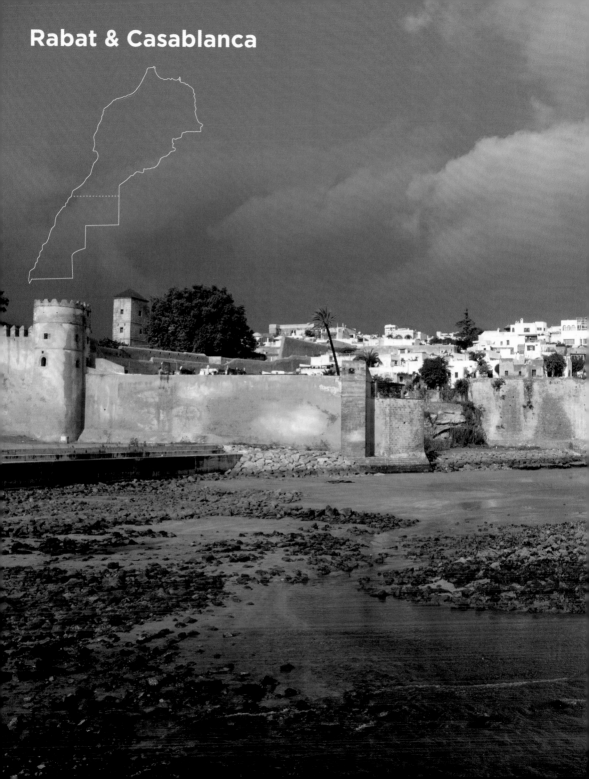

Rabat & Casablanca

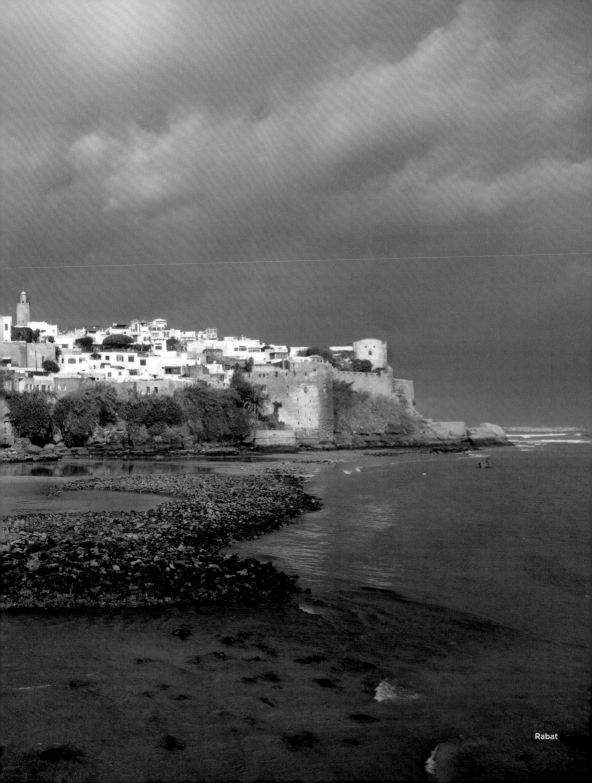

Rabat

White stork, Rabat
Cigogne blanche, Rabat

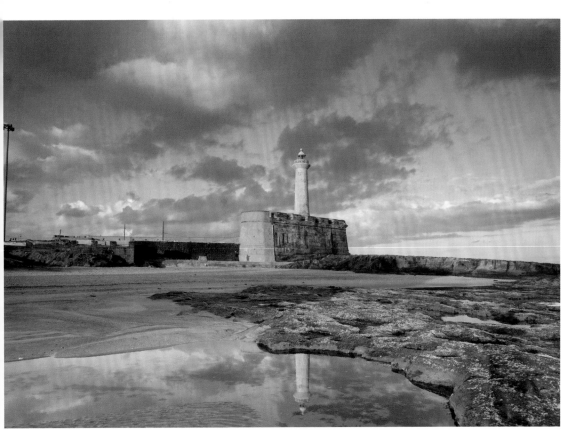

Rabat Lighthouse
Phare de Rabat

Rabat & Casablanca
The capital Rabat is situated at the mouth of the Bou Regreg river and seems almost tranquil in comparison with Casablanca, which is both the country's largest city and its most important commercial and industrial centre. The city of Casablanca is forever anchored in the collective consciousness through the 1942 film of the same name, starring Ingrid Bergman and Humphrey Bogart.

Rabat & Casablanca
La capital Rabat está situada en la desembocadura del río Bou-Regreg y hasta parece tranquila, mientras que Casablanca es la ciudad de los superlativos: la más grande del país y con el centro comercial e industrial más importante. Y, por supuesto, siempre anclada en la conciencia colectiva a través de la película de 1942 *Casablanca* con Ingrid Bergman y Humphrey Bogart.

Rabat & Casablanca
La capitale Rabat, située à l'embouchure de la rivière Bouregreg, semble presque tranquille, tandis que Casablanca se vante de superlatifs : elle est la plus grande ville du pays, mais aussi le plus important centre commercial et industriel. Et elle reste bien entendu ancrée à jamais dans la conscience collective à travers le film *Casablanca* (1942), avec Ingrid Bergman et Humphrey Bogart.

Rabat & Casablanca
La capitale Rabat è situata alla foce del fiume Bou Regreg ed è piuttosto tranquilla, mentre Casablanca è la città dei superlativi: è la più grande del Marocco e il suo centro commerciale e industriale più importante. E ovviamente è stata resa immortale dal film *Casablanca* del 1942, con Ingrid Bergman e Humphrey Bogart.

Rabat & Casablanca
Die Hauptstadt Rabat liegt an der Mündung des Flusses Bou-Regreg und wirkt fast beschaulich, während Casablanca mit Superlativen prahlt: größte Stadt des Landes, wichtigstes Handels- und Industriezentrum. Und natürlich für immer im kollektiven Bewusstsein verankert durch den 1942 gedrehten Film *Casablanca* mit Ingrid Bergman und Humphrey Bogart.

Rabat & Casablanca
De hoofdstad Rabat ligt aan de monding van de Bouregreg-rivier en oogt haast ingetogen, terwijl Casablanca pronkt met superlatieven: de grootste stad van het land, het belangrijkste handels- en industriecentrum. En natuurlijk voor altijd in het collectieve bewustzijn verankerd door de film *Casablanca* uit 1942, met Ingrid Bergman en Humphrey Bogart.

Coast near Rabat
Côte près de Rabat

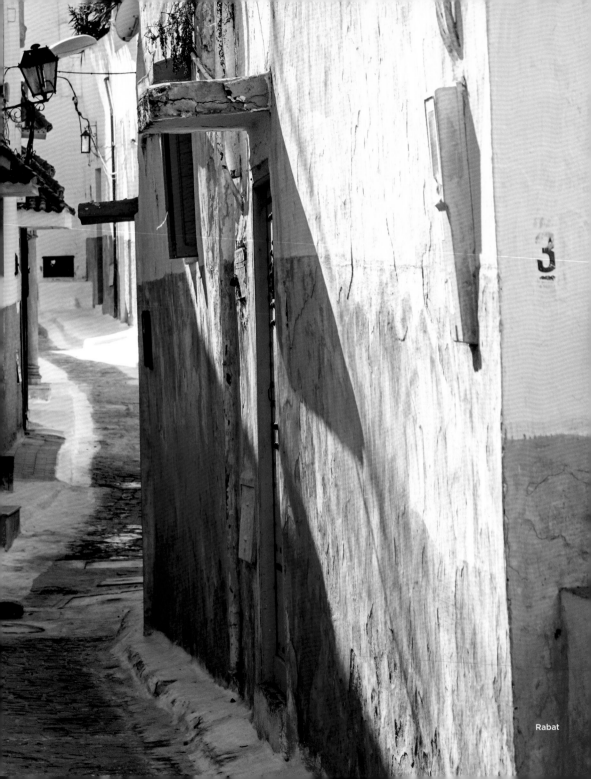

Rabat

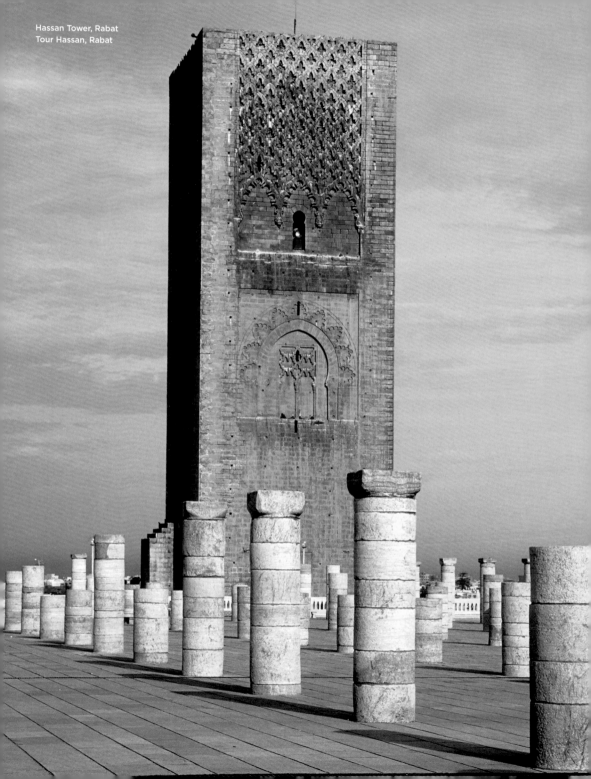

Hassan Tower, Rabat
Tour Hassan, Rabat

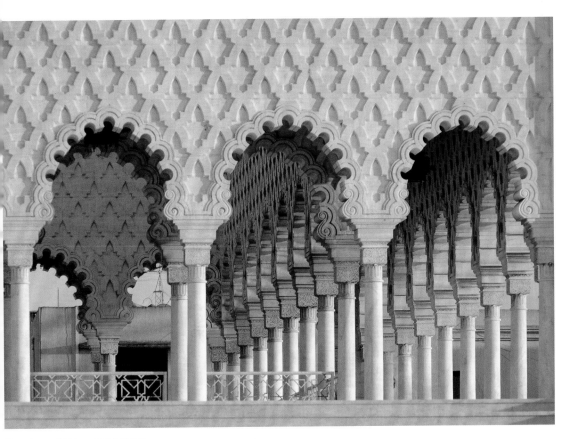

Mausoleum of Mohammed V, Rabat
Mausolée Mohammed V, Rabat

Hassan Tower

The plans were grand. The largest Islamic mosque, with a prayer room for 50 000 people, was to be built in Rabat at the end of the 12th century. From the ground plan it may be calculated that a minaret over 80 m high was planned, however, the client died and the construction work was stopped. The tower had reached a height of just 44 m.

Torre Hassan

Los planes eran geniales: a finales del siglo XII se construiría en Rabat la mezquita islámica más grande con una sala de oración para 50 000 personas. A partir del plano de planta se puede calcular que se planificó un minarete de más de 80 m de altura. Pero entonces el cliente murió y se detuvieron los trabajos de construcción. La torre acababa de alcanzar una altura de 44 m.

Tour Hassan

Le projet était grandiose : à la fin du XIIᵉ siècle, il était prévu de construire à Rabat la plus grande mosquée islamique, avec une salle de prière pouvant accueillir 50 000 personnes. À partir du plan de départ, on peut estimer que le minaret aurait culminé à plus de 80 m de hauteur. Mais le client est décédé, et les travaux de construction ont été arrêtés. La tour venait d'atteindre les 44 mètres.

Torre Hassan

Il progetto era ambizioso: costruire a Rabat alla fine del XII secolo la più grande moschea islamica, con una sala di preghiera per 50 000 persone. Da uno schizzo rimasto si è calcolato che il progetto prevedesse un minareto di oltre 80 m di altezza. Ma poi il committente decedette e i lavori vennero interrotti. La torre era arrivata a un'altezza di appena 44 m.

Hassan-Turm

Die Pläne waren hochtrabend: In Rabat sollte Ende des 12. Jahrhunderts die größte islamische Moschee mit einem Gebetsraum für 50 000 Leute entstehen. Aus dem Grundriss lässt sich errechnen, dass ein über 80 m hohes Minarett geplant war. Doch dann verstarb der Auftraggeber, die Bauarbeiten wurden eingestellt. Der Turm war gerade bis zu einer Höhe von 44 m gediehen.

Hassantoren

De plannen waren hoogdravend: in Rabat zou eind 12e eeuw de grootste islamitische moskee met een gebedsruimte voor 50 000 mensen worden gebouwd. Uit de plattegrond kan worden afgeleid dat er een minaret van ruim 80 m hoog was gepland. Maar toen de opdrachtgever overleed, werd de bouw stilgelegd. De toren had een hoogte van 44 m bereikt.

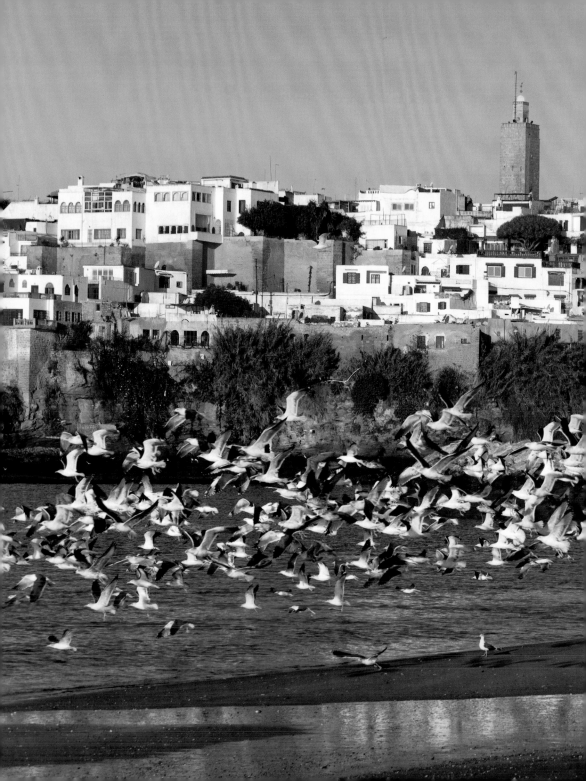

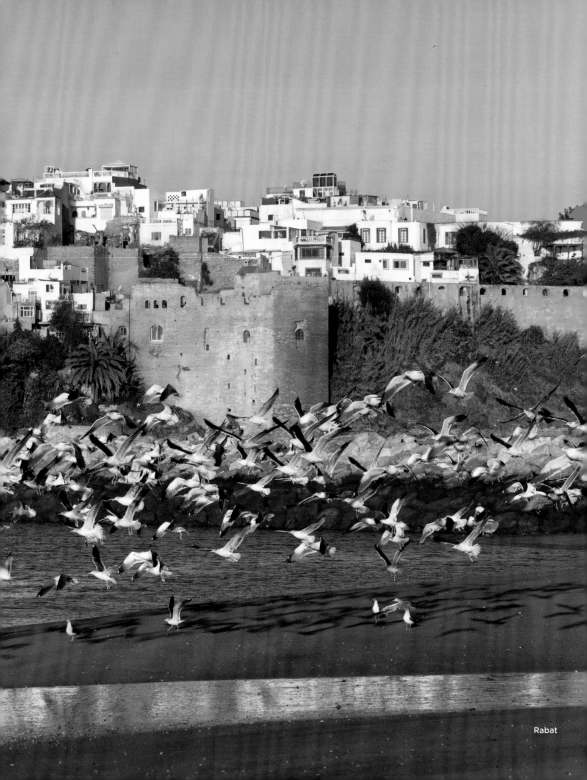

Rabat

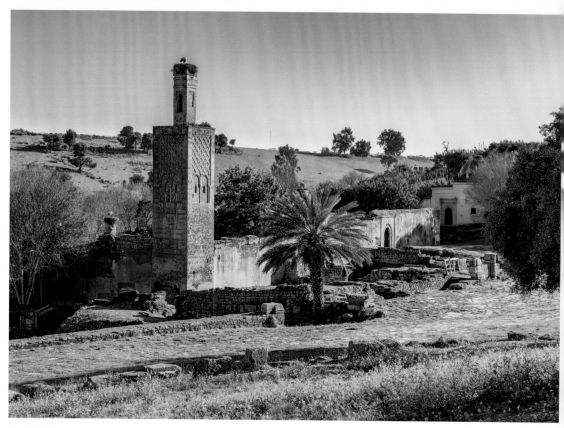

Chellah, Rabat

Chellah

Here one can rest—behind protective walls, guarded by towers. Peace may be found in the sprawling greenery, in the shade of the palm trees, under trees where storks nest. Chellah is the name of the magical place, a necropolis on a hill, removed from the hustle and bustle of Rabat. This cemetery was completed in 1339, and in the past only Muslims were allowed to enter. In 1755 an earthquake destroyed part of the site and since then no more burials have taken place. Today anyone may visit the cemetery and enjoy the silence.

Chellah

Ici, vous pouvez vous reposer – derrière des murs de protection, gardés par des tours. Retrouvez la paix dans la verdure luxuriante, à l'ombre des palmiers, sous les arbres où les cigognes nichent. Chellah est le nom de ce lieu magique, une nécropole postée sur une colline loin de l'agitation de Rabat. Ce cimetière existe depuis 1339. Dans le passé, seuls les musulmans pratiquants étaient autorisés à y entrer. En 1755, un tremblement de terre a détruit une partie du site ; depuis lors, il n'y a plus eu d'enterrements. Aujourd'hui, tout le monde peut visiter le cimetière et profiter de son silence.

Chellah

Hier möchte man ruhen – hinter schützenden Mauern, bewacht von Türmen. Frieden finden im wuchernden Grün, im Schatten der Palmen, unter Bäumen, in denen Störche nisten. Chellah heißt der magische Ort, eine Nekropole auf einem Hügel fernab des Trubels von Rabat. Seit 1339 gibt es diesen Friedhof. Früher durften ihn nur gläubige Muslime betreten. 1755 zerstörte ein Erdbeben einen Teil der Anlage, seitdem finden keine Beisetzungen mehr statt. Heute kann jeder den Friedhof besuchen und die Stille genießen.

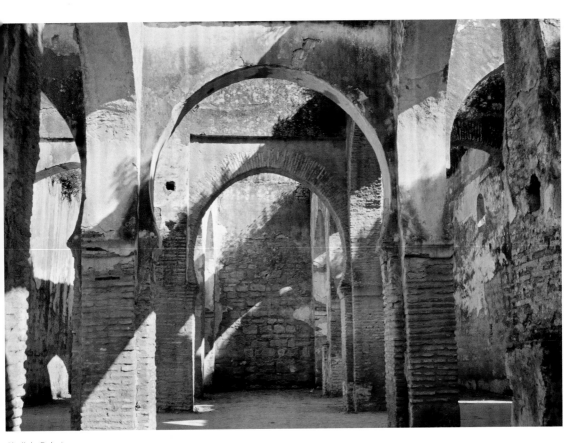

Chellah, Rabat

Chellah

Aquí se viene a descansar detrás de los muros de protección, que están custodiados por torres. Es fácil encontrar la paz entre toda la vegetación, a la sombra de las palmeras, bajo los árboles donde anidan las cigüeñas. Chellah es el nombre del lugar mágico, una necrópolis en una colina alejada del ajetreo de Rabat. Este cementerio existe desde 1339. En el pasado, solo se permitía la entrada a los musulmanes creyentes. En 1755 un terremoto destruyó parte del lugar y desde entonces no ha habido más entierros. Hoy todo el mundo puede visitar el cementerio y disfrutar aquí del silencio.

Chella

È qui che si vorrebbe riposare – dietro mura che proteggono e sotto la sorveglianza delle torri. Trovare la pace nel verde lussureggiante, all'ombra delle palme, sotto gli alberi dove nidificano le cicogne. Chella è il nome di questo luogo magico, una necropoli su una collina lontana dal trambusto di Rabat. Il cimitero esiste dal 1339. In passato, solo ai musulmani credenti era permesso di entrarvi. Nel 1755 un terremoto distrusse parte del sito e da allora non vi sono più state sepolture. Oggi tutti possono visitare il cimitero e godersi il silenzio che qui regna.

Chellah

Hier wilt u uitrusten – achter beschermende muren, bewaakt door torens. Vind rust in het woekerende groen, in de schaduw van de palmbomen, onder bomen waar ooievaars nestelen. Chellah is de naam van de magische plek, een necropool op een heuvel ver weg van de drukte van Rabat. Deze begraafplaats bestaat sinds 1339. Vroeger mochten alleen gelovige moslims hem betreden. In 1755 verwoestte een aardbeving een deel van het terrein en sindsdien is er niemand meer begraven. Tegenwoordig mag iedereen de begraafplaats bezoeken en genieten van de stilte.

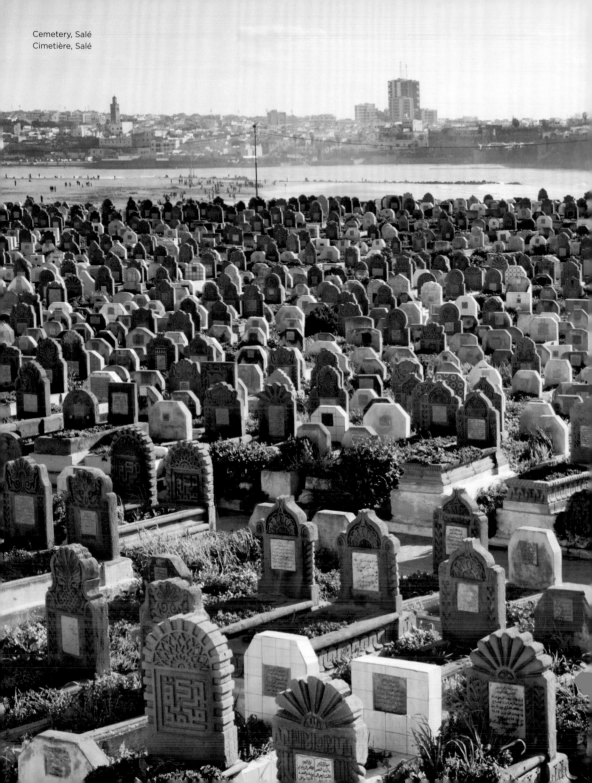

Cemetery, Salé
Cimetière, Salé

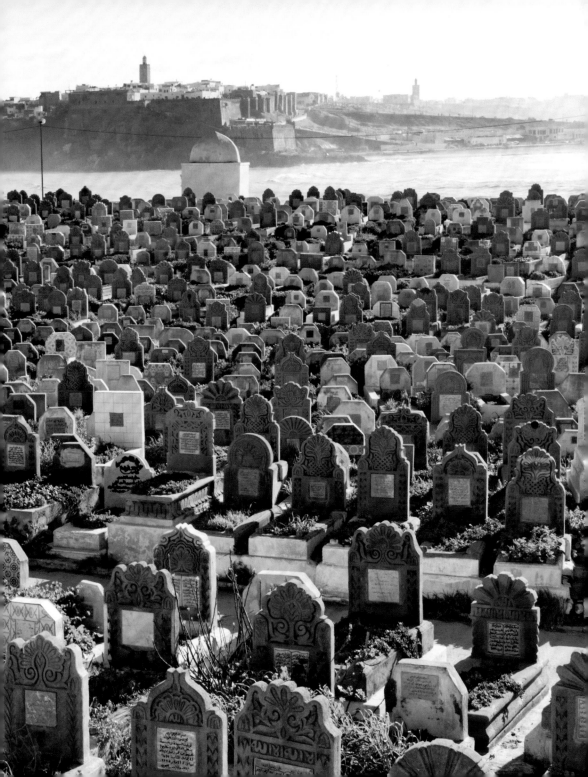

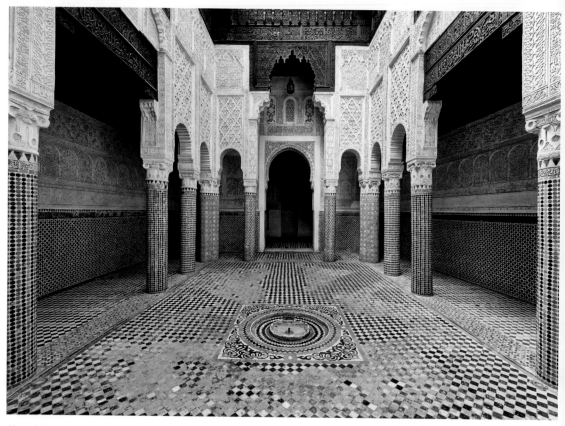

Abou al-Hassan Madrasa, Salé
Médersa Abu al-Hassan, Salé

Abou al-Hassan Madrasa, Salé
Médersa Abu al-Hassan, Salé

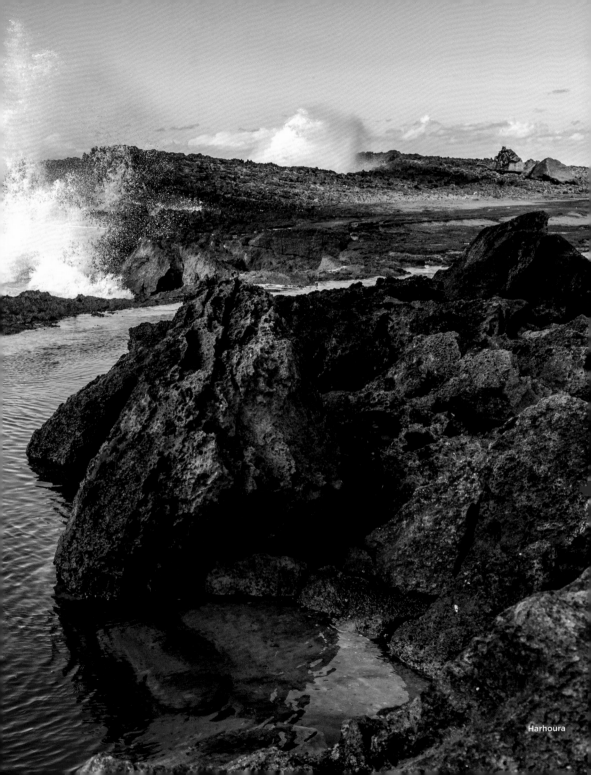

Harhoura

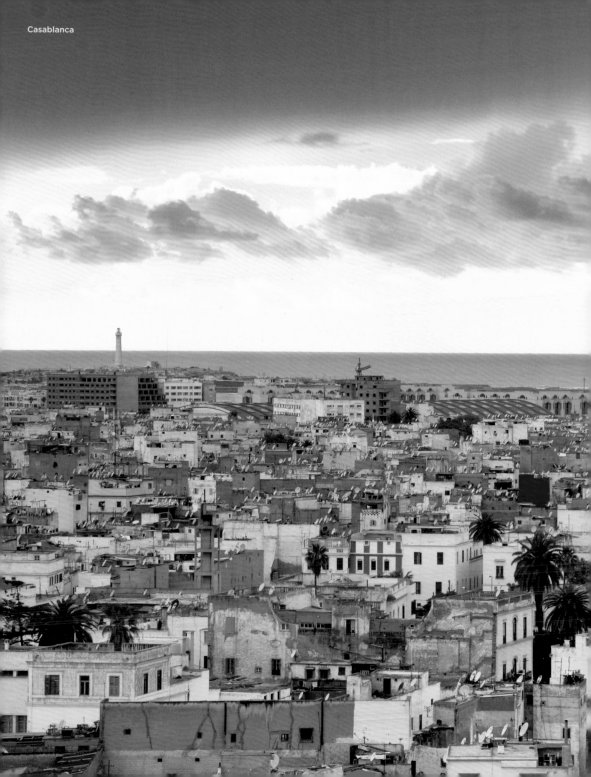

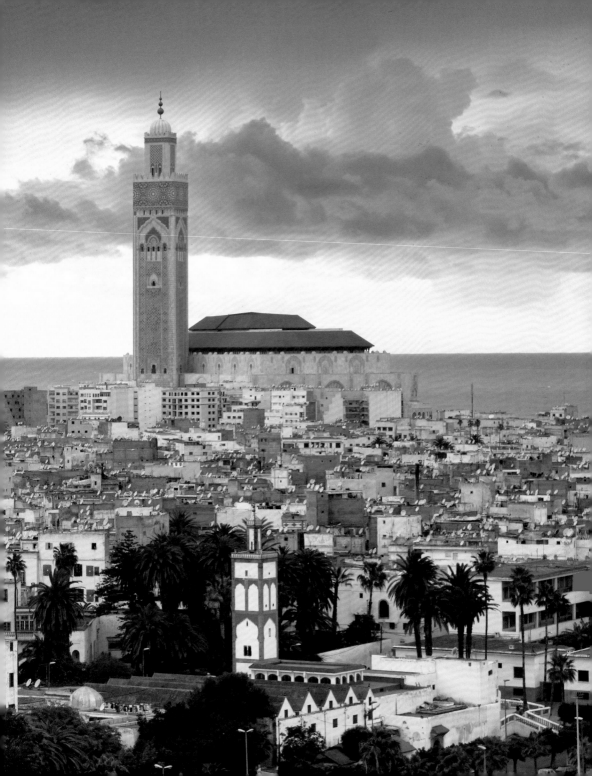

Hassan II Mosque, Casablanca
Mosquée Hassan-II, Casablanca

Hassan II Mosque

A building of superlatives: one of the world's largest mosques, with room for 25 000 praying people, and the highest minaret (210 m). The prayer hall has underfloor heating and the roof can be opened at the push of a button. It was built to last for centuries, but fewer than 15 years after its opening in 1993, massive repairs had to be carried out. Parts of the mosque reach out into the Atlantic Ocean and the seawater took its toll, with chloride ions penetrating the concrete and attacking the steel reinforcement.

Mosquée Hassan-II

Un bâtiment de superlatifs : l'une des plus grandes mosquées du monde, avec 25 000 places pour les priants et le minaret le plus haut (210 m). La salle de prière est équipée d'un chauffage au sol, le toit peut être ouvert par la simple pression d'un bouton. Il s'agissait d'un bâtiment centenaire, mais 15 ans après son ouverture en 1993, des réparations massives ont dû être effectuées. La mosquée s'étend jusqu'à l'océan Atlantique et le climat rigoureux a fait des ravages : les ions chlorure ont pénétré le béton et attaqué l'armature métallique.

Hassan II Moschee

Ein Bau der Superlative: eine der größten Moscheen der Welt, in der 25 000 Betende Platz finden, und höchstes Minarett (210 m). Die Gebetshalle verfügt über Fußbodenheizung, das Dach lässt sich per Knopfdruck öffnen. Es sollte ein Jahrhundertbau werden, aber 15 Jahre nach der Eröffnung 1993 mussten massive Reparaturen durchgeführt werden. Die Moschee reicht bis in den Atlantik hinein und dessen raues Klima forderte sein Tribut: Chloridionen drangen in den Beton ein und griffen die Stahlbewehrung an.

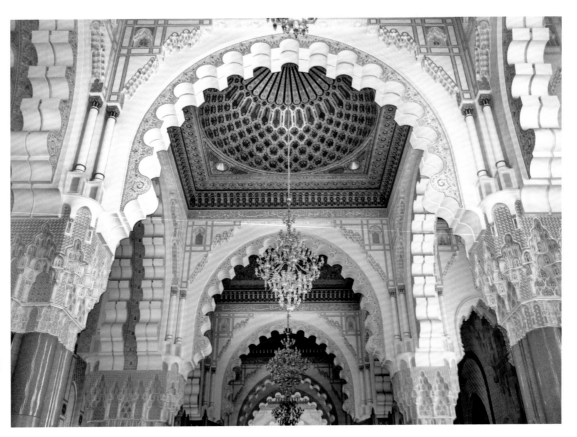

Hassan II Mosque, Casablanca
Mosquée Hassan-II, Casablanca

Mezquita de Hassan II

Una construcción de superlativos: una de las mezquitas más grandes del mundo, con capacidad para 25 000 personas que rezan, y el minarete más alto (210 m). La sala de oración tiene calefacción por suelo radiante, el techo puede abrirse pulsando un botón. Iba a ser un edificio de un siglo de antigüedad, pero 15 años después de su apertura en 1993, hubo que llevar a cabo reparaciones masivas. La mezquita se adentra en el Océano Atlántico y su clima tan duro se cobra su precio: los iones de cloruro penetran en el hormigón y atacan la armadura de acero.

Moschea di Hassan II

Un edificio impressionante: una delle moschee più grandi del mondo, con spazio per la preghiera che può accogliere fino a 25 000 persone e il minareto più alto (210 m). La sala di preghiera è dotata di riscaldamento a pavimento, il tetto può essere aperto automaticamente. Doveva diventare l'edificio del secolo, ma quindici anni dopo la sua apertura, nel 1993, si dovettero effettuare massicci lavori di riparazione. La moschea sorge in prossimità dell'oceano Atlantico e paga le conseguenze del clima qui rigido: il cloruro è penetrato nel cemento e ha attaccato l'acciaio di rinforzo.

Hassan II-moskee

Een gebouw van superlatieven: een van de grootste moskeeën ter wereld, met ruimte voor 25 000 biddende mensen en de hoogste minaret (210 m). De gebedsruimte heeft vloerverwarming en het dak kan met een druk op de knop worden geopend. Het gebouw zou een eeuw meegaan, maar vijftien jaar na de opening, in 1993, moesten er al enorme reparaties worden uitgevoerd. De moskee reikt tot in de Atlantische Oceaan en het ruige klimaat eist zijn tol: chloride-ionen dringen het beton binnen en tasten het wapeningsstaal aan.

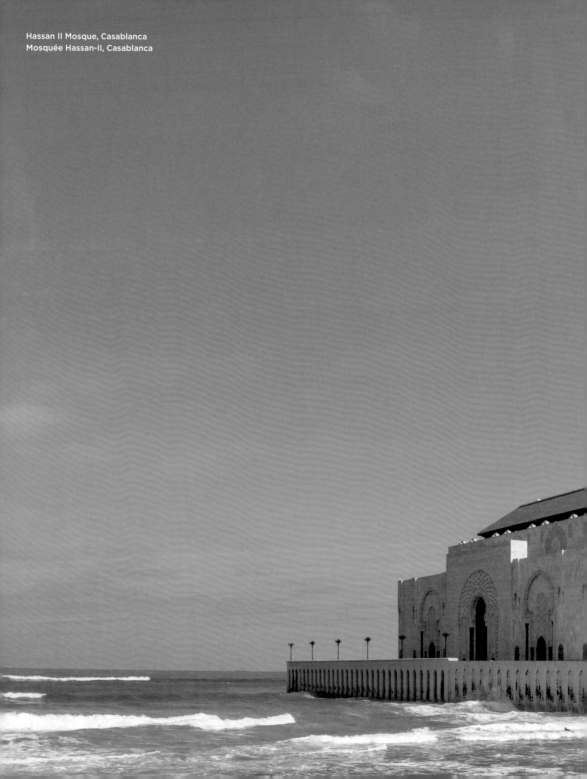

Hassan II Mosque, Casablanca
Mosquée Hassan-II, Casablanca

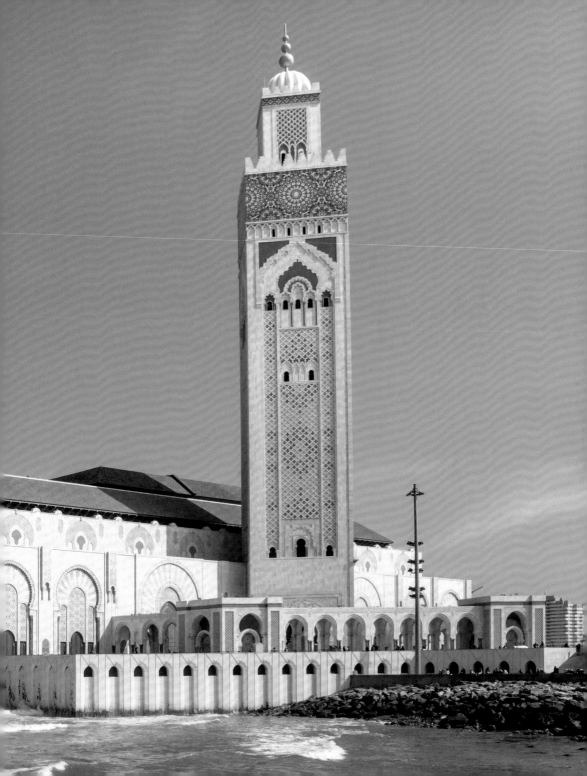

El Jadida & Essaouira

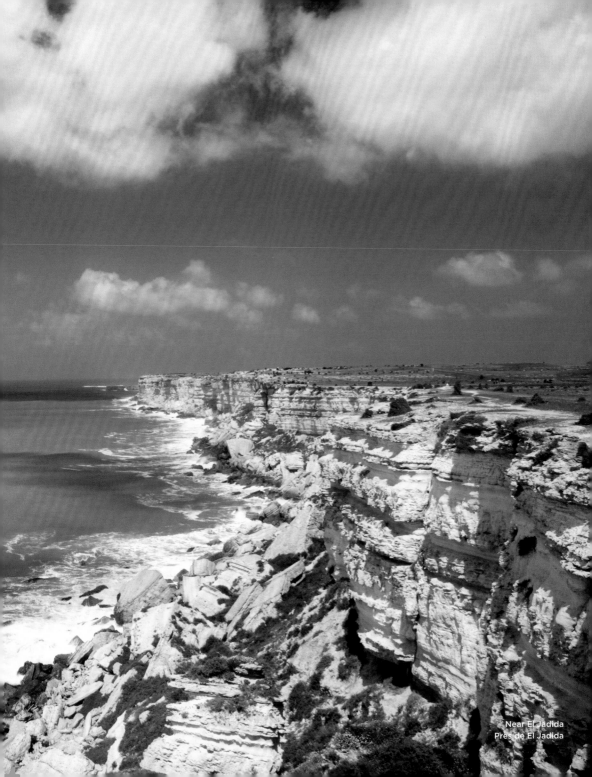

Near El Jadida
Près de El Jadida

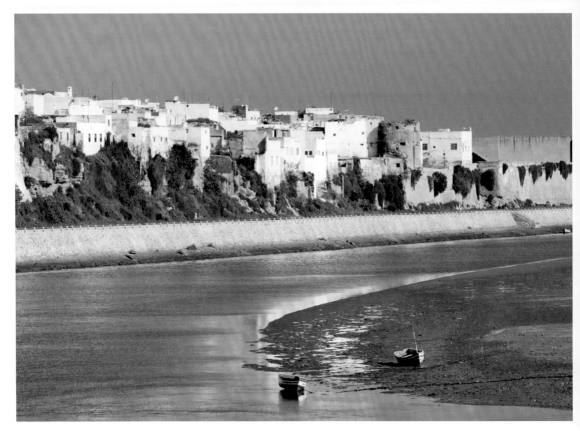

Azemmour

El Jadida & Essaouira

The Portuguese and Spaniards both threw desiring glances at the Moroccan Atlantic coast. Portugal was the more successful, and at the beginning of the 16th century it controlled all the major Atlantic ports in Morocco. Their conquests, stations on the sea voyage to India, were fortified, and both El Jadida and Essaouira bear witness to this era of colonial history. Four bastions guard the 'Cité Portugaise of El Jadida' which, like Essaouira, is on the UNESCO World Heritage List.

El Jadida & Essaouira

Les Portugais et les Espagnols ont jeté des regards envieux sur la côte atlantique marocaine. C'est le Portugal qui a eu le plus de succès : au début du XVIᵉ siècle, il contrôlait tous les grands ports atlantiques du Maroc. Les bases conquises, stations de la route maritime vers l'Inde, étaient fortifiées. El Jadida et Essaouira témoignent de cette époque de l'histoire coloniale. Quatre bastions gardent la cité portugaise d'El Jadida, comme Essaouira, la ville est inscrite sur la liste du patrimoine mondial de l'UNESCO.

El Jadida & Essaouira

Portugiesen und Spanier warfen begehrliche Blicke auf die marokkanische Atlantikküste. Portugal war erfolgreicher: Anfang des 16. Jahrhunderts kontrollierte es alle wichtigen Atlantikhäfen Marokkos. Die eroberten Stützpunkte, Stationen auf der Seereise nach Indien, wurden wehrhaft befestigt. El Jadida und Essaouira zeugen von dieser Epoche der Kolonialgeschichte. Vier Bastionen bewachen die Cité Portugaise von El Jadida, wie Essaouira steht die Stadt auf der Liste des UNESCO Weltkulturerbes.

Oualidia

El Jadida & Essaouira

Los portugueses y los españoles miraron con deseo la costa atlántica marroquí. Portugal tuvo más éxito: a principios del siglo XVI controlaba todos los principales puertos atlánticos de Marruecos. Las bases conquistadas, estaciones en el viaje por mar a la India, fueron fortificadas. El Jadida y Essaouira son testigos de esta época de la historia colonial. Cuatro baluartes custodian la Cité Portugaise de El Jadida, al igual que Essaouira, la ciudad está inscrita en la Lista del Patrimonio Mundial de la UNESCO.

El Jadida & Essaouira

In passato, portoghesi e spagnoli hanno sempre guardato con interesse alla costa atlantica marocchina. Il Portogallo ha avuto più successo: all'inizio del XVI secolo controllava tutti i principali porti atlantici del Marocco. I punti di appoggio conquistati, che fungevano da stazione lungo il tragitto in mare per l'India, furono fortificati. El Jadida e Essaouira sono testimonianze di quest'epoca di storia coloniale. Quattro bastioni custodiscono la "cité portugaise" di El Jadida. Come nel caso di Essaouira, la città è sulla lista del Patrimonio dell'Umanità dell'UNESCO.

El Jadida & Essaouira

De Portugezen en Spanjaarden wierpen begerige blikken op de Marokkaanse Atlantische kust. Portugal was succesvoller: begin 16e eeuw had het alle grote Atlantische havens in Marokko in handen. De veroverde steunpunten, haltes op de zeereis naar India, werden versterkt. El Jadida en Essaouira getuigen van deze periode in de koloniale geschiedenis. Vier bastions bewaken de Cité Portugaise van El Jadida. Net als Essaouira staat de stad op de werelderfgoedlijst van de Unesco.

Near El Jadida
Près de El Jadida

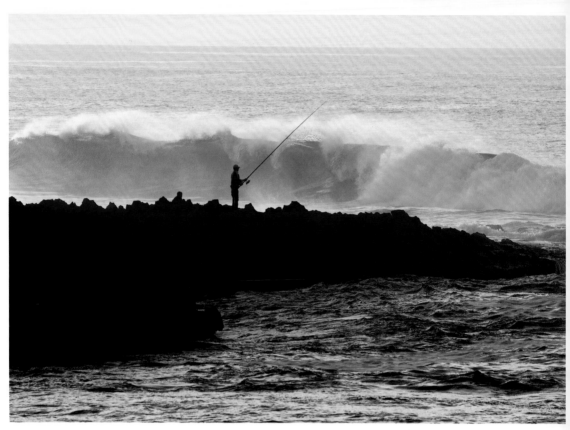

Oualidia

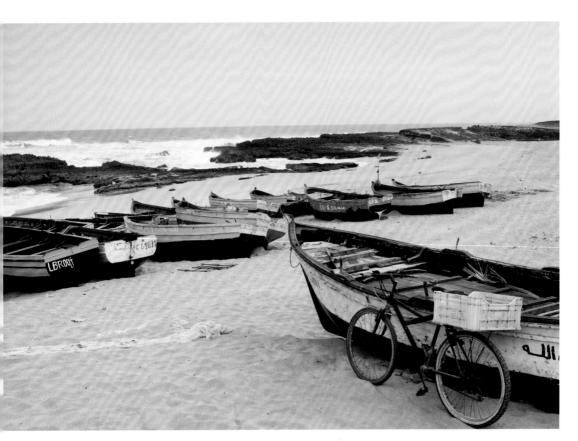

Oualidia

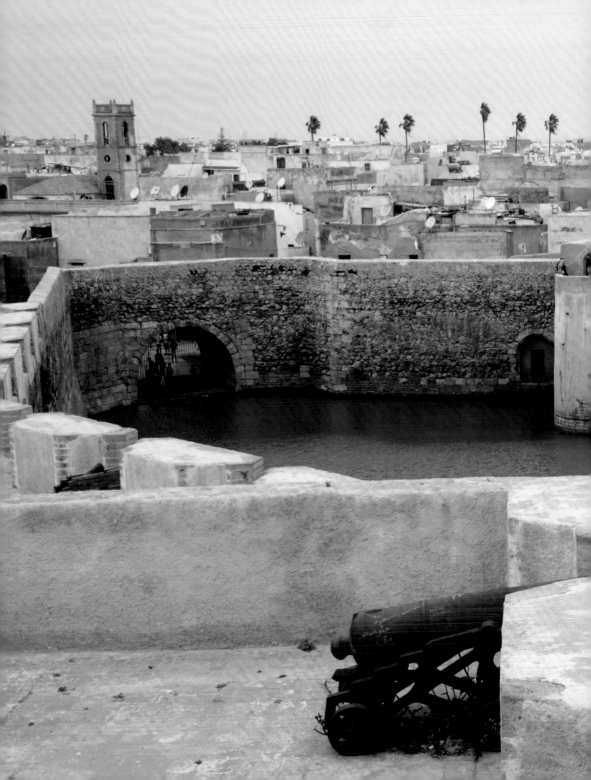

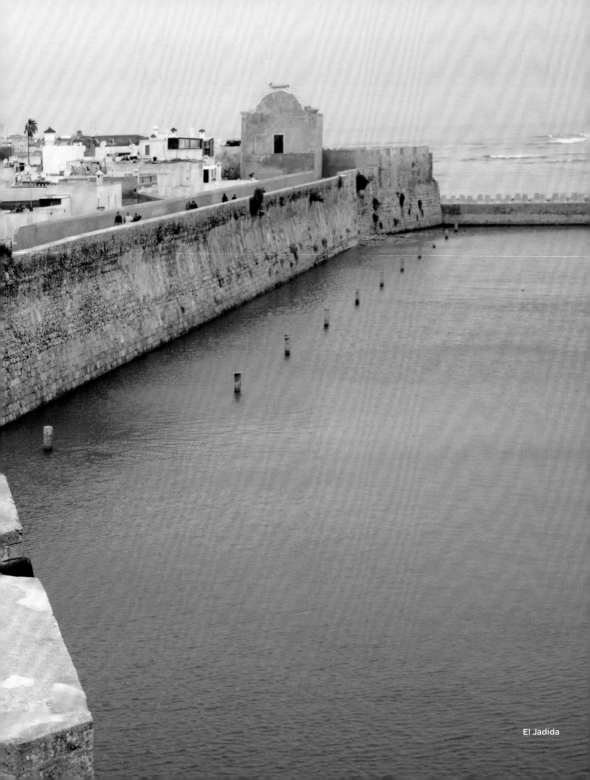
El Jadida

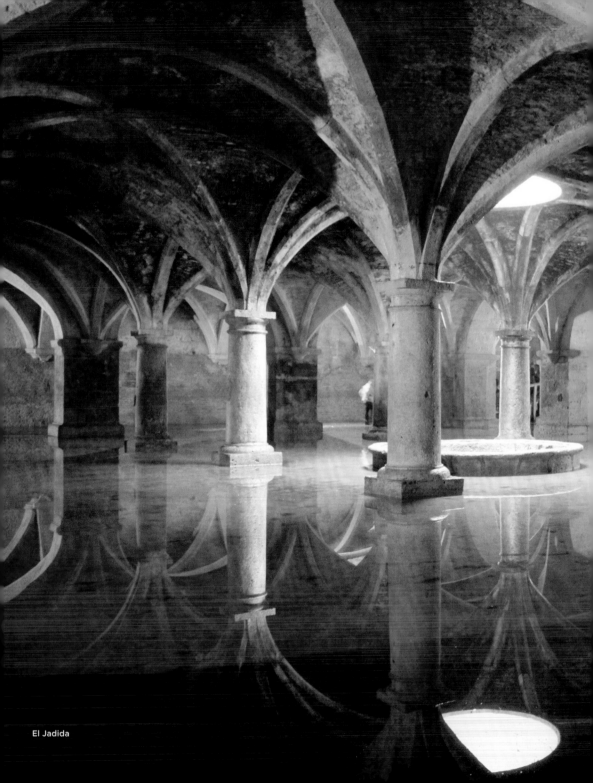

El Jadida

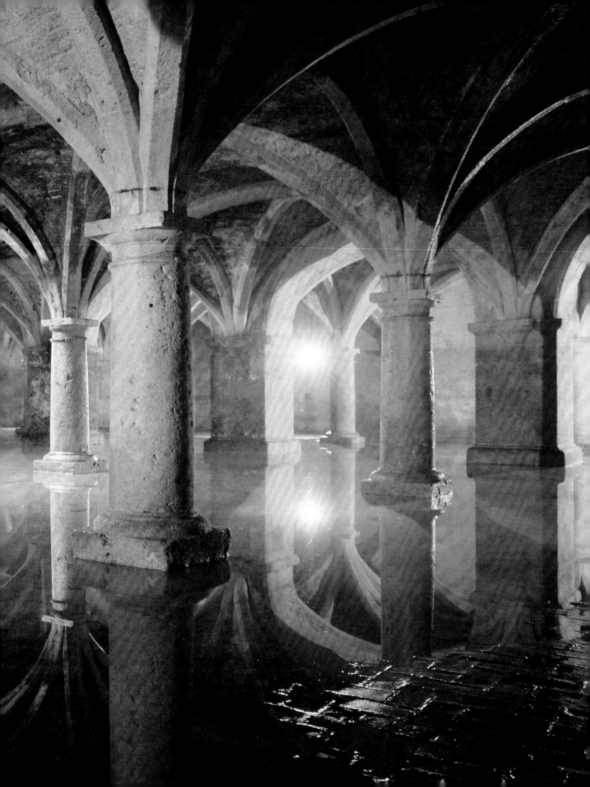

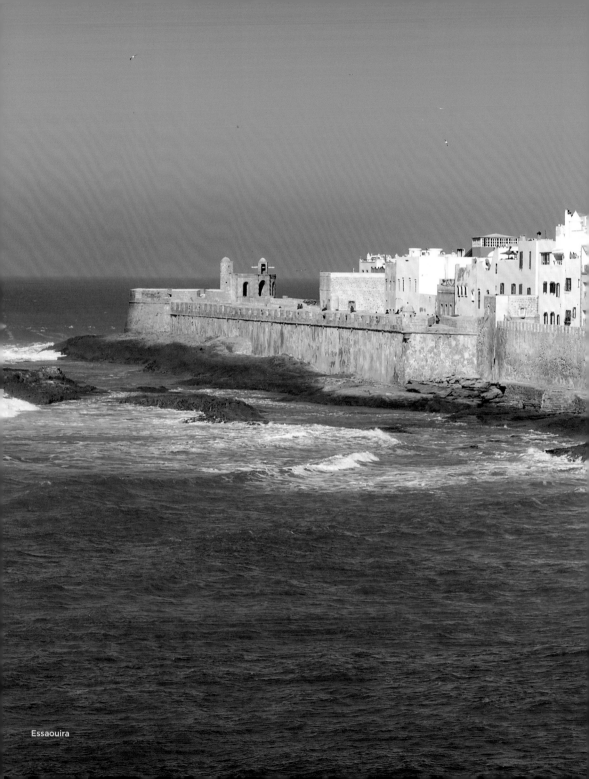
Essaouira

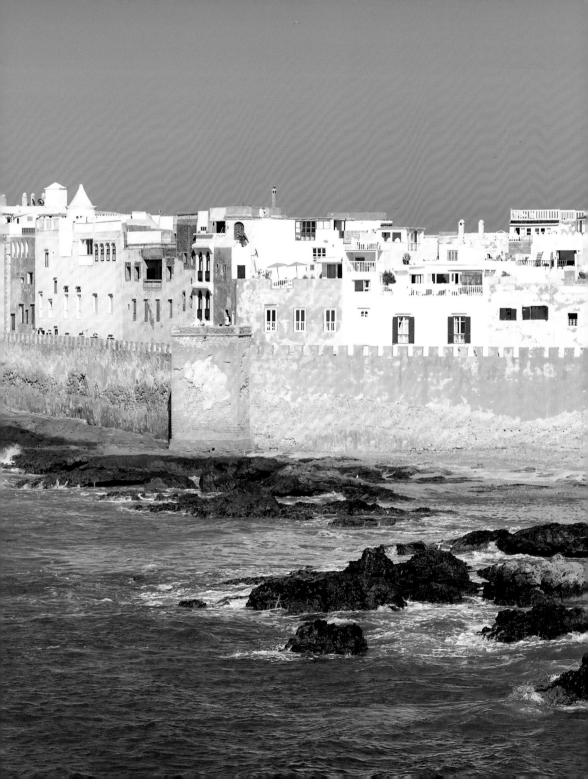

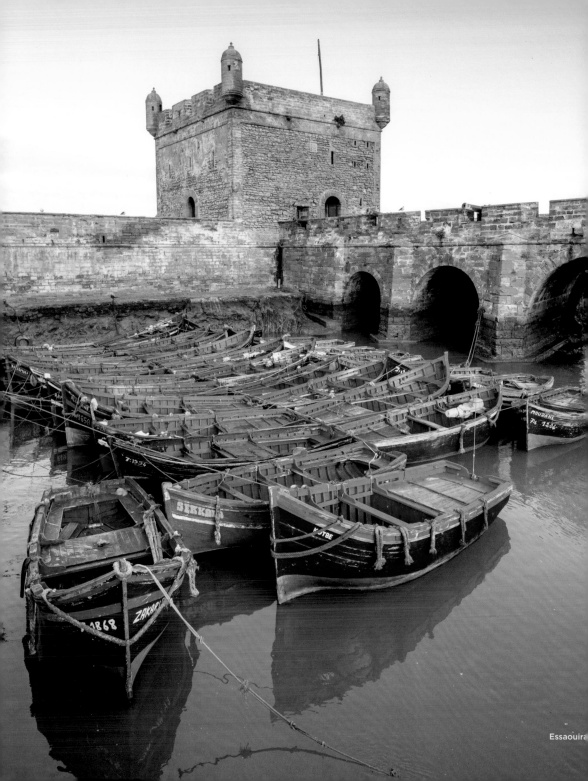

Essaouira

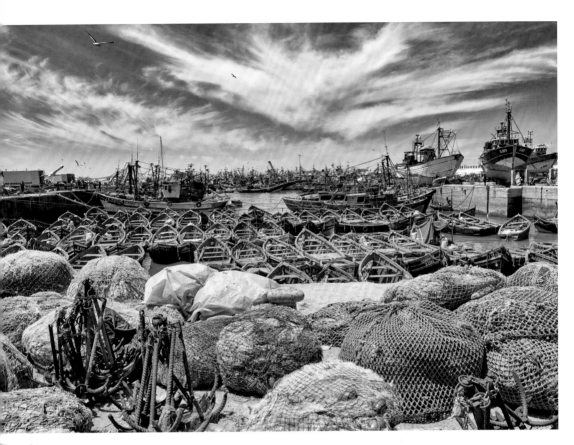

Essaouira

Port of Essaouira

In this harbour, protected by mighty walls, you feel as if you have fallen out of time. The blue coloured fishing boats are still made by hand, with their nets spread out and waiting to be repaired. If you want to watch the women gut fish with their nimble fingers, you'll only have to follow the screaming of the seagulls. They're always found on the spot where the boats land.

Puerto de Essaouira

En este puerto, protegido por poderosas murallas, uno se siente como si el tiempo se hubiera parado hace muchos años. Los botes azules siguen siendo hechos a mano, las redes están extendidas y esperando a ser remendadas. Para ver a las mujeres pescando con dedos ágiles, solo hay que seguir los gritos de las gaviotas, que siempre están en el lugar cuando atracan los barcos.

Port d'Essaouira

Dans ce port, protégé par de puissants murs, on a la sensation d'être hors du temps. Les bateaux bleus sont encore fabriqués à la main, les filets sont étalés et attendent d'être rapiécés. Si vous voulez voir des femmes vider les poissons avec leurs doigts agiles, vous devez suivre les cris des mouettes. Ils sont toujours sur place quand les bateaux rentrent au port.

Porto di Essaouira

In questo porto protetto da possenti mura si ha l'impressione di essere fuori dal tempo. Le barche blu sono ancora fatte a mano, le reti giacciono sparse in attesa di essere ricucite. Chi volesse osservare l'abilità delle donne nel pulire il pesce deve solo seguire le urla dei gabbiani che accorrono veloci quando le barche tornano in porto.

Hafen von Essaouira

In diesem von mächtigen Mauern geschützten Hafen fühlt man sich wie aus der Zeit gefallen. Die blauen Boote werden noch von Hand gefertigt, Netze liegen ausgebreitet und warten darauf, geflickt zu werden. Wer den Frauen zusehen will, wie sie mit flinken Fingern Fische ausnehmen, muss dem Geschrei der Möwen folgen. Die sind immer zur Stelle, wenn die Boote anlanden.

Haven van Essaouira

In deze door machtige muren beschermde haven heb je het gevoel dat je in heel een andere tijd bent beland. De blauwe boten worden nog steeds met de hand gemaakt, de netten liggen uitgespreid en wachten op herstel. Wie de vrouwen wil zien die met vaardige vingers de vissen eruit halen, moet het gekrijs van de meeuwen volgen. Ze zijn er altijd als de kippen bij als de boten aan land komen.

Near Essaouira
Près d'Essaouira

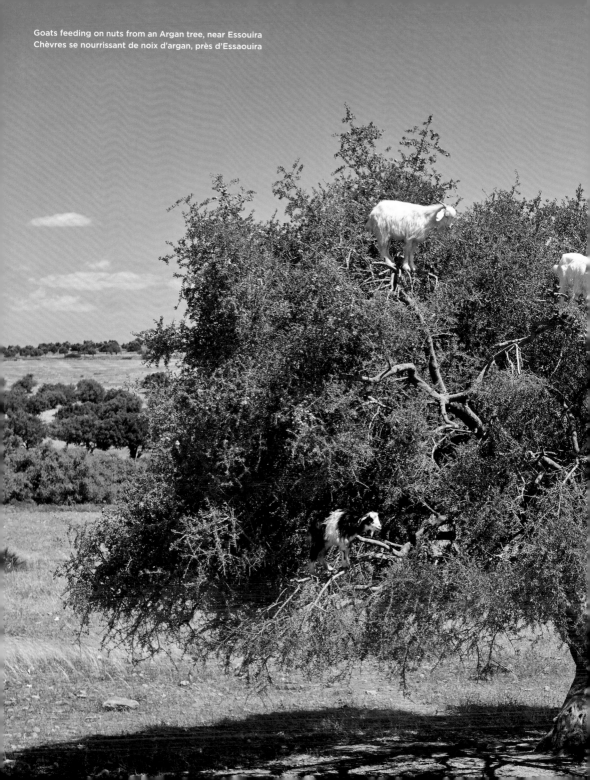

Goats feeding on nuts from an Argan tree, near Essouira
Chèvres se nourrissant de noix d'argan, près d'Essaouira

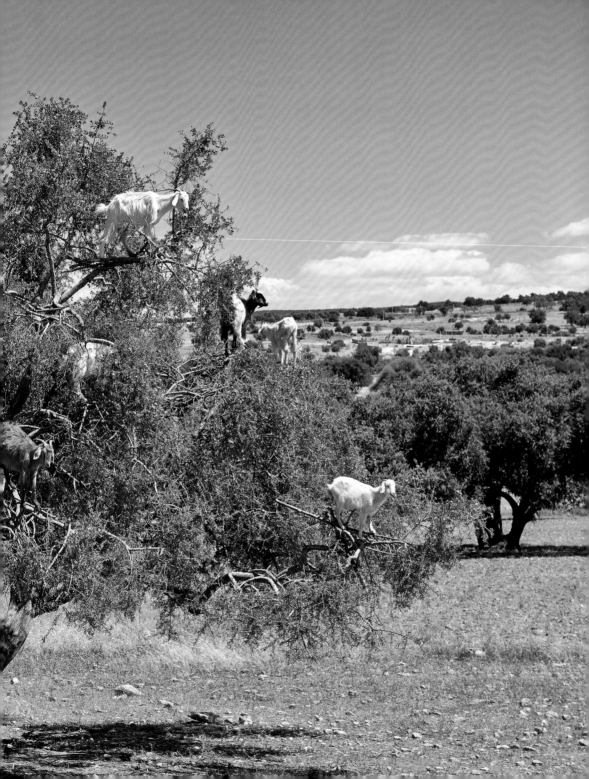

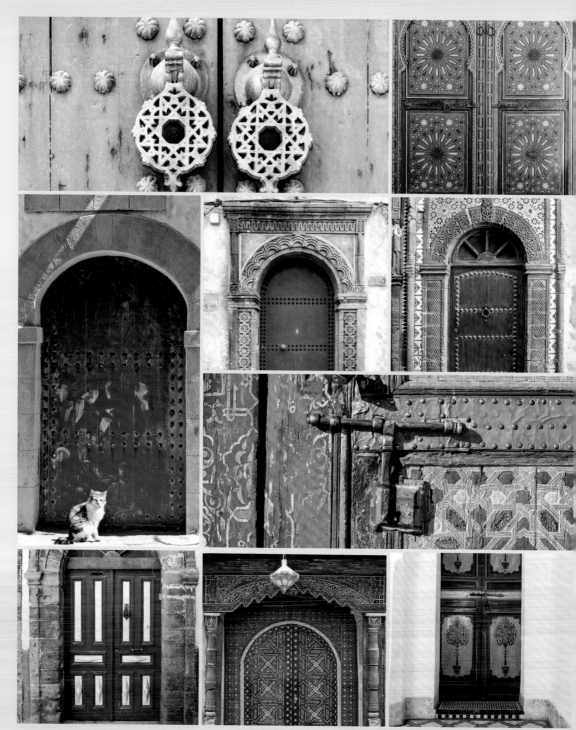

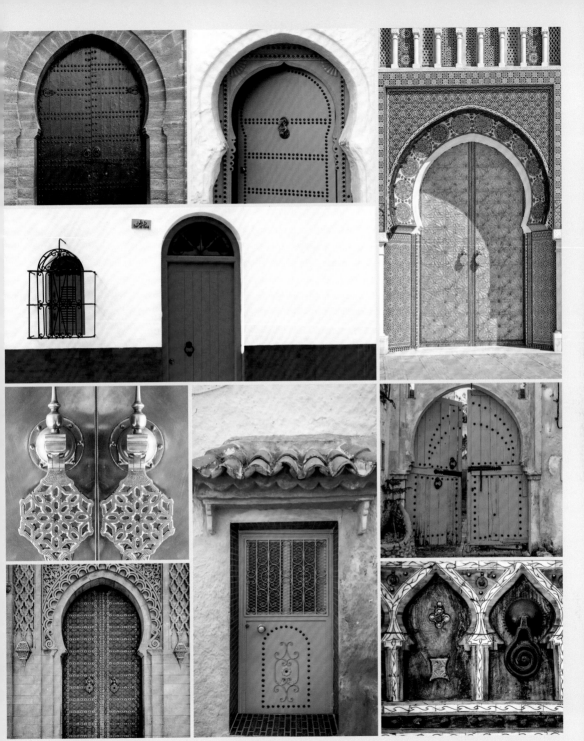

Marrakesh

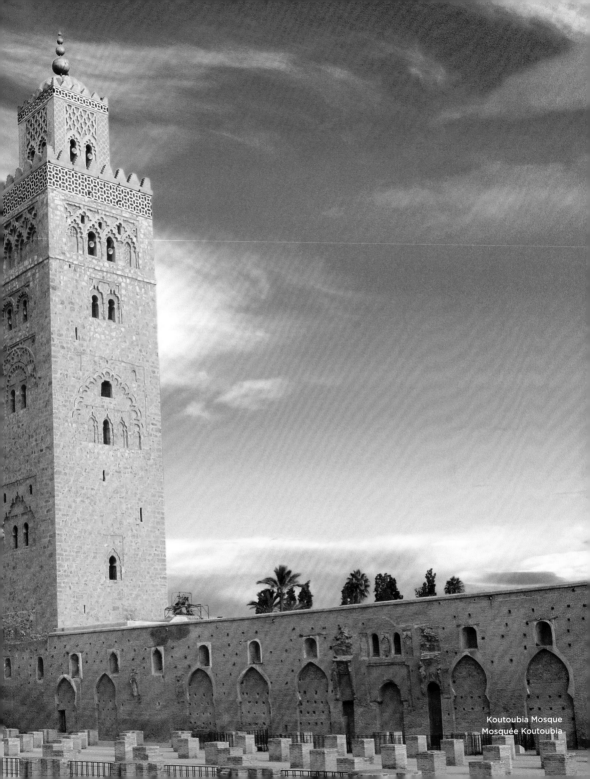

Koutoubia Mosque
Mosquée Koutoubia

Donkey
Âne

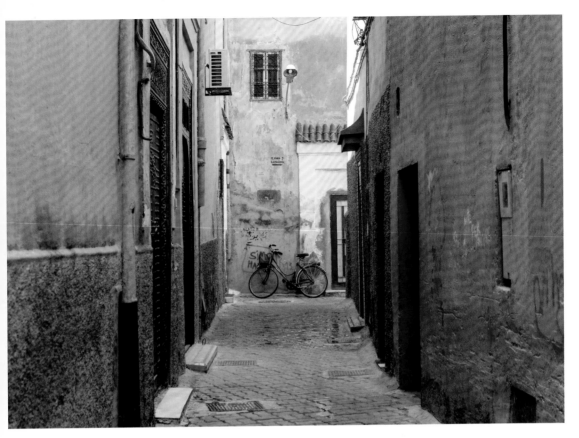

Medina
Médina

Marrakesh

Marrakesh is rich in sights, with its gardens, the Saadian tombs, the Ben Youssef Madrasa, the souks, and so on. But the most famous attraction is Jemaa el-Fnaa. Jugglers, musicians, dancers and snake charmers all enliven the bustling square, with many culinary delights also on offer.

Marrakech

En Marrakech hay muchas cosas que ver: jardines, tumbas de Saadier, Medersa Ben Youssef, los zocos... Pero la atracción más famosa es Yamaa el Fna. Malabaristas, músicos, bailarines y encantadores de serpientes animan la "plaza de la aniquilación ", y también se ofrecen delicias culinarias.

Marrakech

Marrakech est riche en curiosités : les jardins, les tombeaux Saadiens, la médersa Ben Youssef, les souks... Mais l'attraction la plus célèbre est la Jemaa el-Fna. Jongleurs, musiciens, danseurs, charmeurs de serpents animent la « place des trépassés » et des délices culinaires sont également proposés.

Marrakech

Marrakech è ricca di attrazioni turistiche: giardini, il complesso funerario delle tombe Sadiane, la scuola coranica di architettura Medersa Ben Youssef, i suk... Ma l'attrazione più famosa è Jamaa el Fna: giocolieri, musicisti, danzatori e incantatori di serpenti animano la "piazza dei defunti", che offre anche svariate delizie culinarie.

Marrakesch

Marrakesch ist reich an Sehenswürdigkeiten: Gärten, die Saadier-Gräber, Medersa Ben Youssef, die Souks ... Die bekannteste Attraktion aber ist Djemaa el Fna. Gaukler, Musiker, Tänzer, Schlangenbeschwörer beleben den „Platz der Geköpften", und auch kulinarisch wird einiges geboten.

Marrakesh

Marrakesh is rijk aan bezienswaardigheden: tuinen, Saaditombes, de Ben Joesoefmadrassa, de soeks... Maar de bekendste attractie is het plein Djemaa el Fna. Jongleurs, muzikanten, dansers en slangenbezweerders verlevendigen het 'plein van de onthoofden' en ook op culinair gebied heeft het veel te bieden.

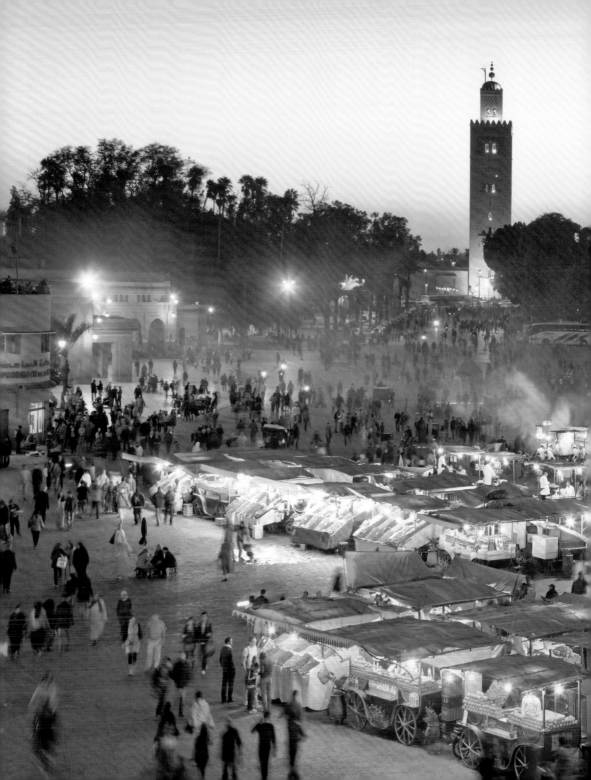

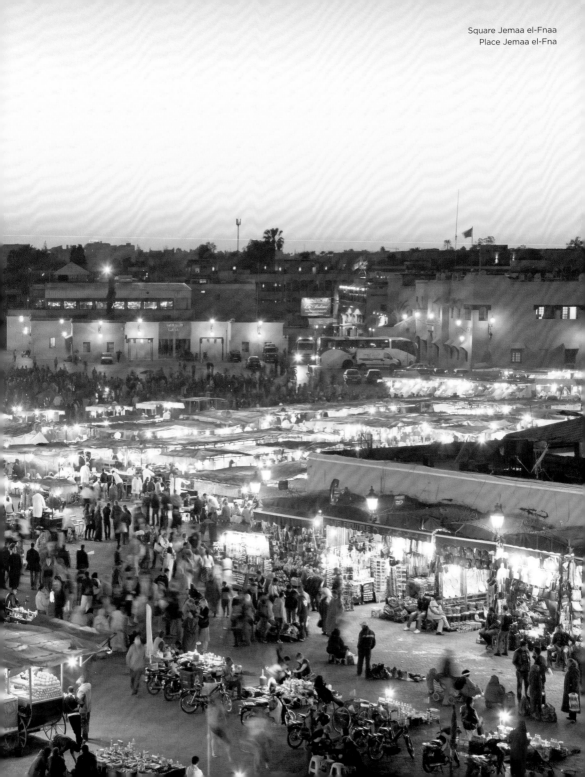

Square Jemaa el-Fnaa
Place Jemaa el-Fna

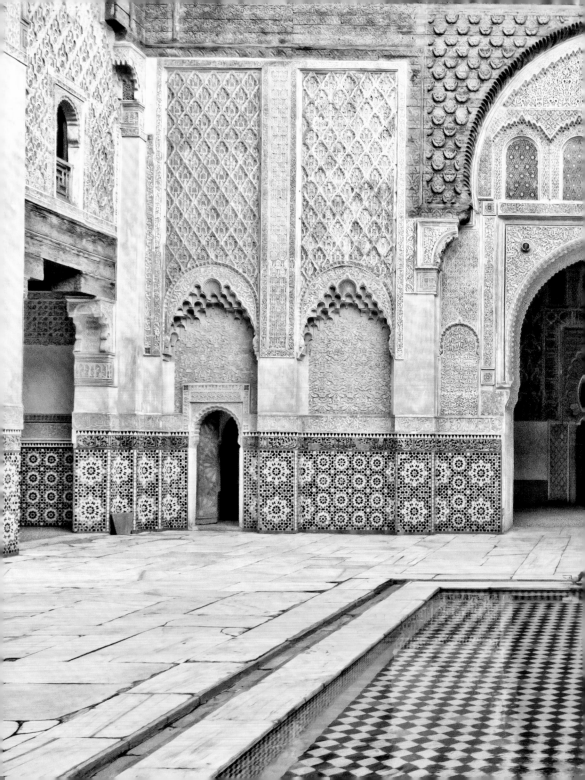

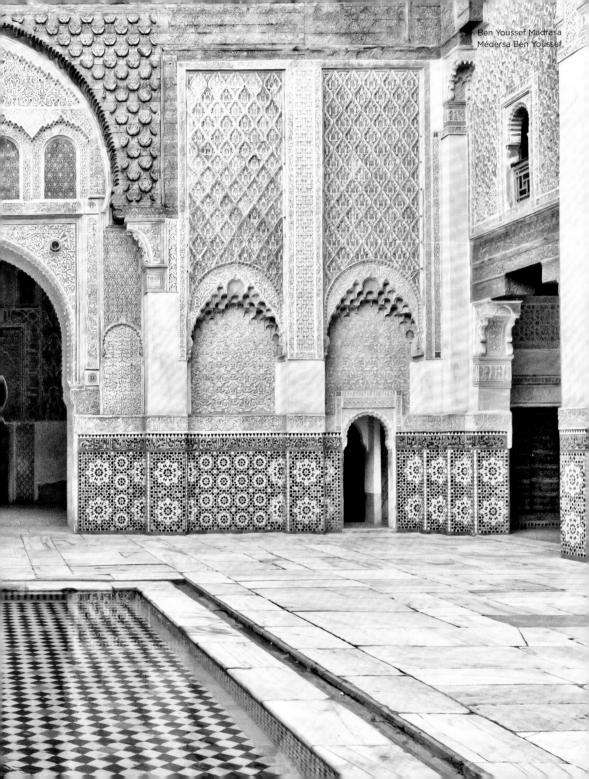

Ben Youssef Madrasa
Médersa Ben Youssef

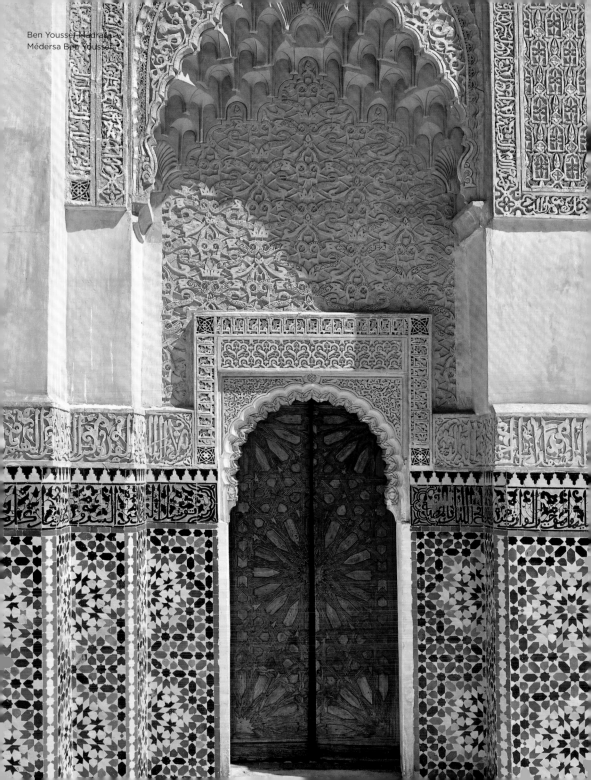

Ben Youssef Madrasa
Médersa Ben Youssef

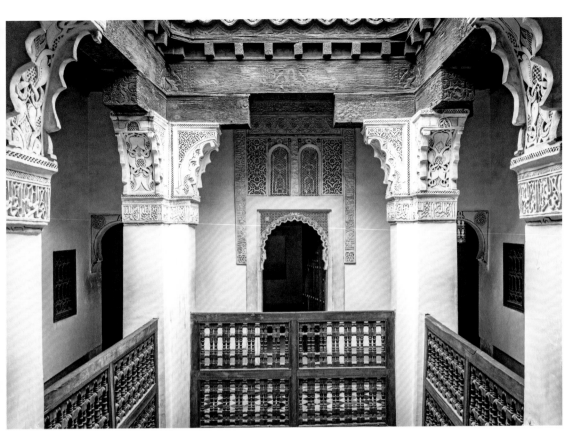

Ben Youssef Madrasa
Médersa Ben Youssef

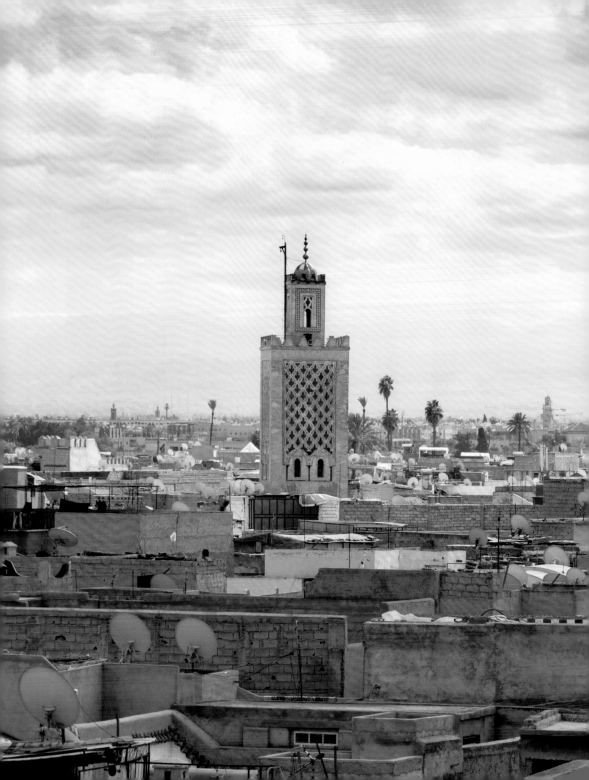

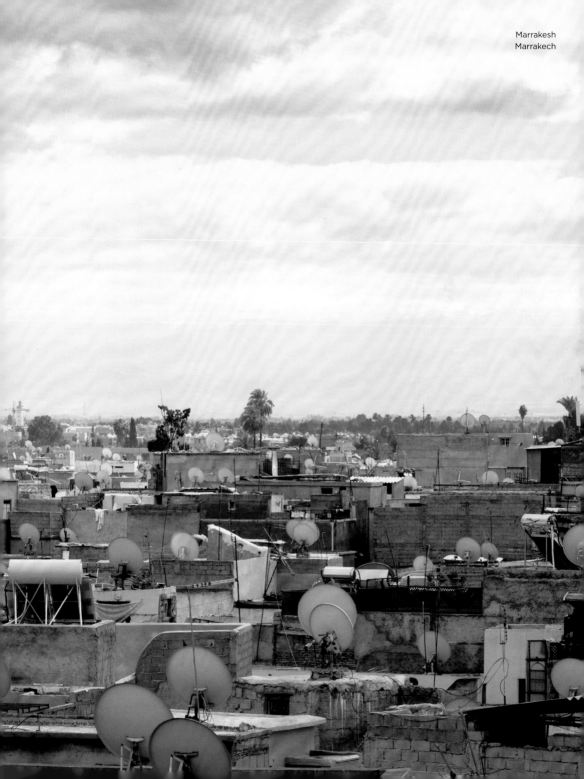

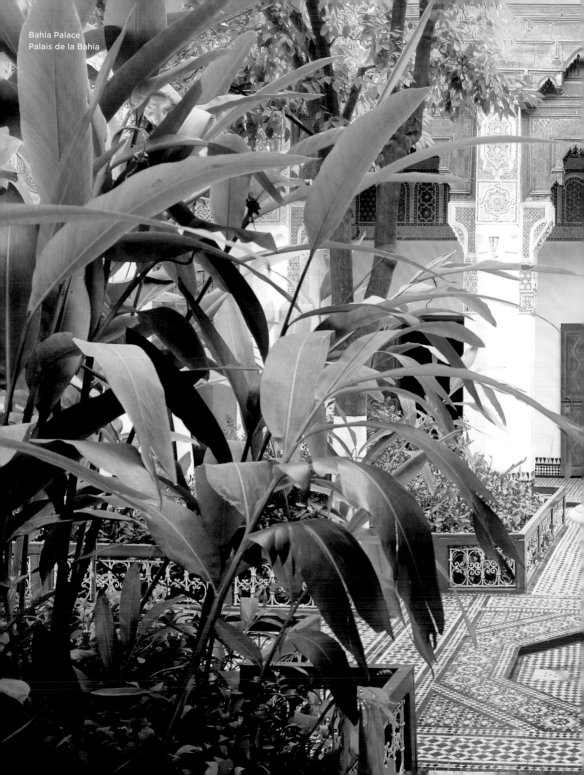

Bahia Palace
Palais de la Bahia

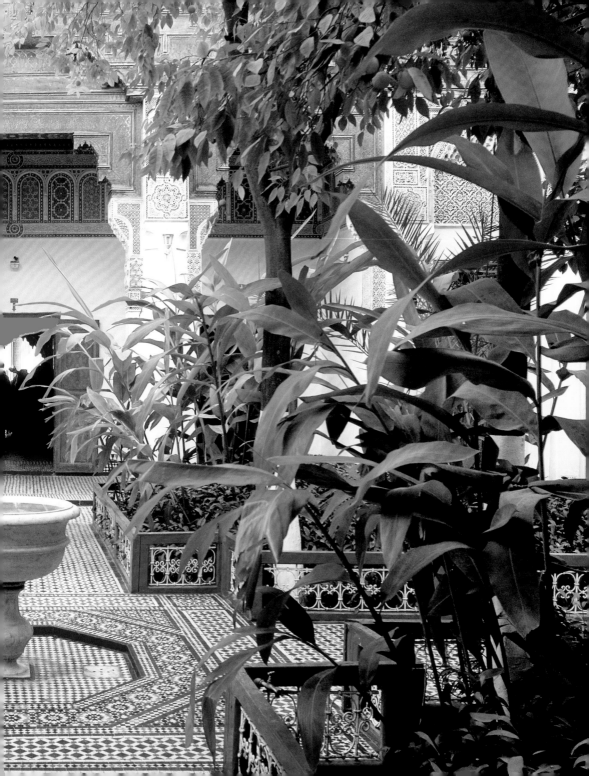

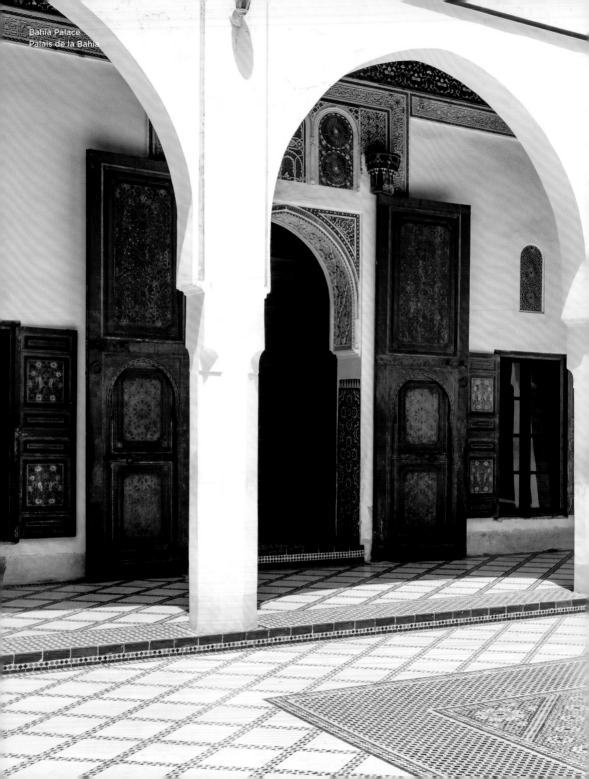

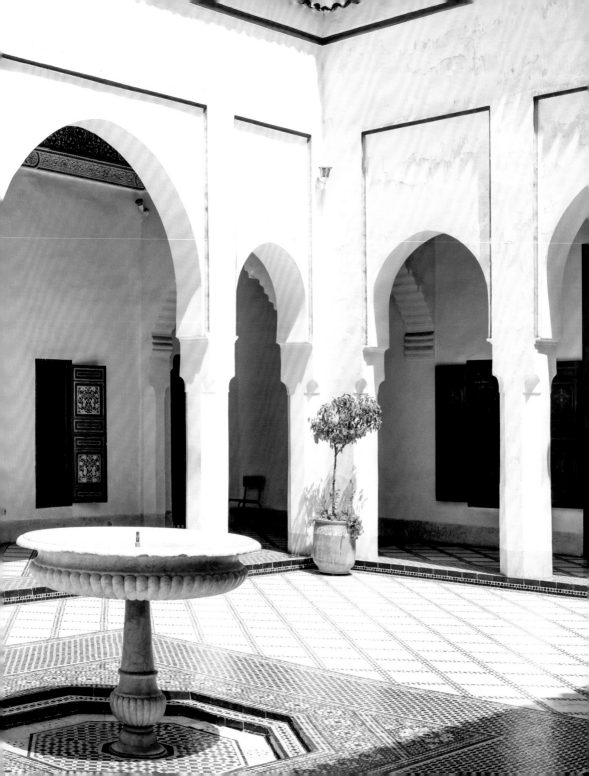

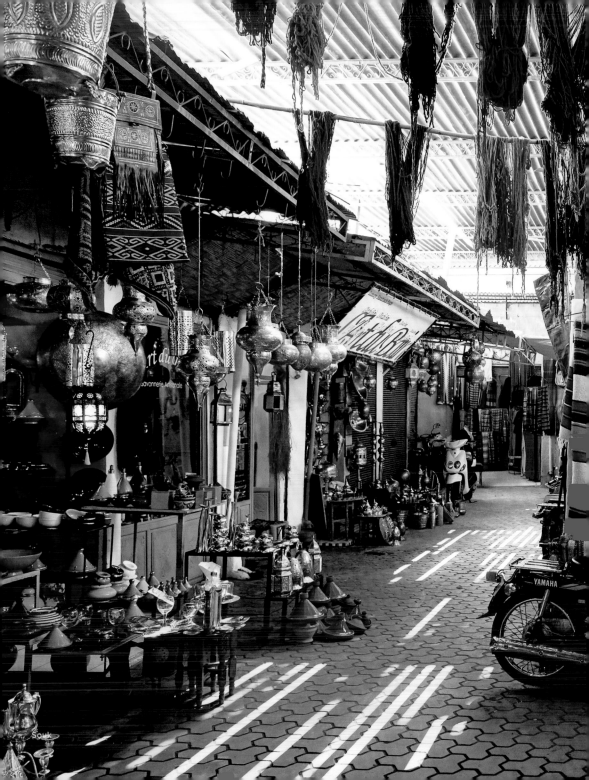

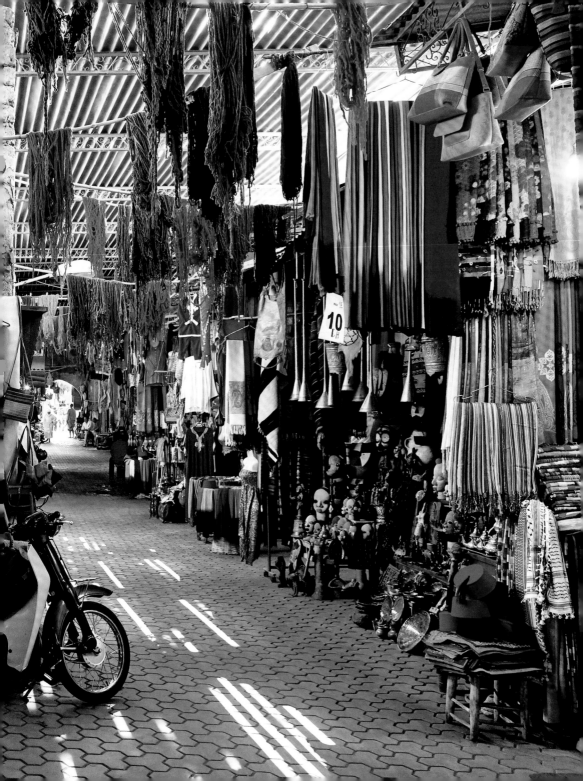

Medina
Médina

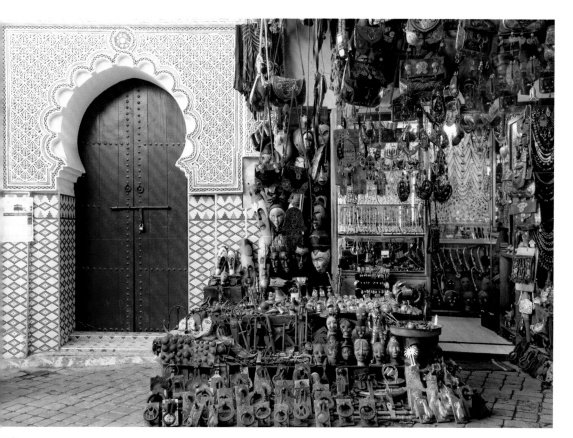

ouk

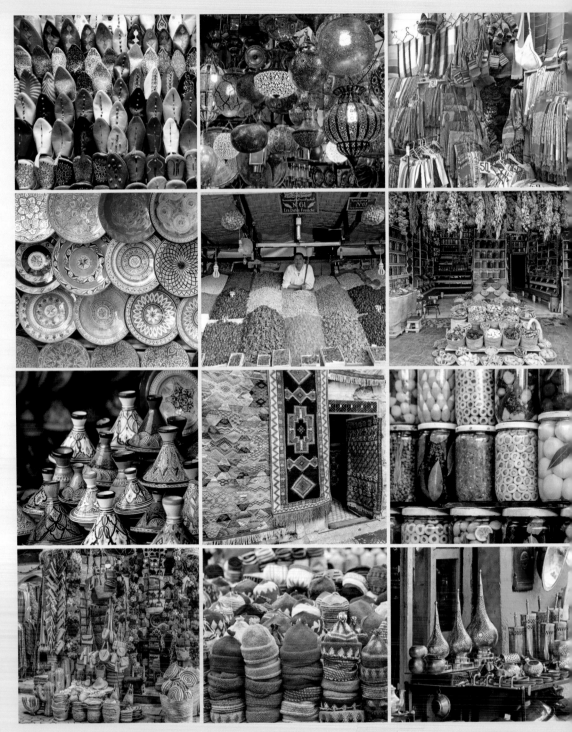

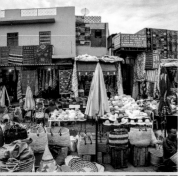
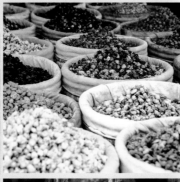
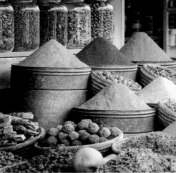

Souks

Walking through the alleys of the *souks* is one of the experiences that give rise to '1001-nights' feelings. Silk, leather, silver, carpets and other colourful fabrics are all on display, with the *souks* being organized in such a way that each alley is associated with a different craft. Not only are the products sold here, but the dealers are also craftsmen and one may watch how the products are manufactured.

Souks

Se promener dans les allées des *souks* est l'une des expériences qui suscitent mille et une atmosphères différentes. Soie, cuir, argent, tapis, tissus colorés – les *souks* sont organisés de telle façon que chaque ruelle est associée à un métier. Non seulement les produits sont vendus ici, mais les commerçants sont aussi des artisans et vous pouvez ainsi assister directement à l'élaboration des diverses denrées.

Souks

Durch die Gassen der *Souks* zu wandern, gehört zu den Erlebnissen, die 1001-Nacht-Gefühle aufkommen lassen. Seide, Leder, Silber, Teppiche, bunte Stoffe – die *Souks* sind so organisiert, dass jede Gasse einem Handwerk zugeordnet ist. Hier wird nicht nur verkauft, die Händler sind auch Handwerker und man kann zusehen, wie die Produkte gefertigt werden.

Zocos

Caminar por los callejones de los *zocos* es una de las experiencias que dan lugar a sensaciones de 1001 noches. Seda, cuero, plata, alfombras, tejidos de colores. Los *zocos* están organizados de tal manera que cada callejón está asociado con una artesanía. No solo se venden los productos aquí, los distribuidores también son artesanos y se puede ver cómo se fabrican los productos.

Suk

Camminare per i vicoli dei *suk* è una delle esperienze da 1001 notte. Seta, cuoio, argento, tappeti, tessuti colorati – i *suk* sono organizzati in modo tale che ogni vicolo sia legato ad un artigianato. Qui i prodotti non vengono solo venduti: a commerciarli sono gli stessi artigiani che li lavorano davanti agli occhi dei passanti.

Soeks

Wandelen door de steegjes van de *soeks* is een ervaringen die 1001-nachtachtige gevoelens oproept. Zijde, leer, zilver, tapijten, kleurige stoffen – de *soeks* zijn zo georganiseerd dat elke steeg is verbonden met een ambacht. Hier worden niet alleen de producten verkocht, de handelaars zijn ook ambachtslieden en u kunt zien hoe de producten worden vervaardigd.

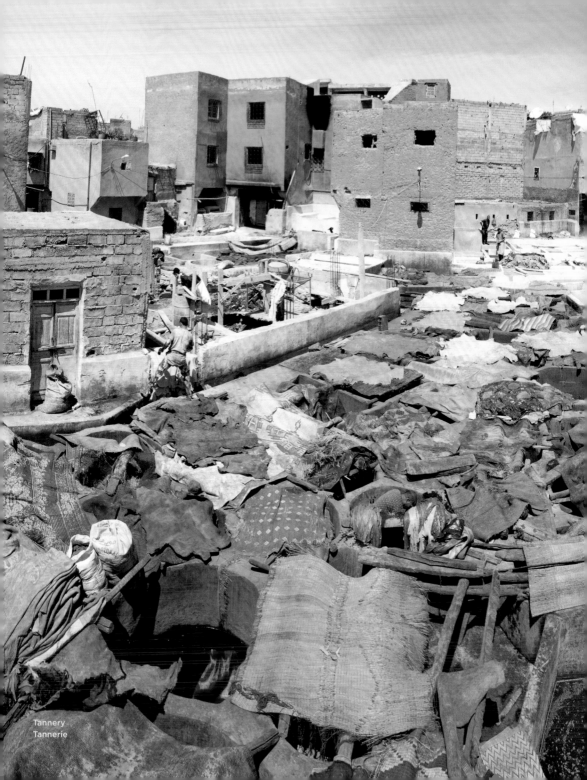

Tannery
Tannerie

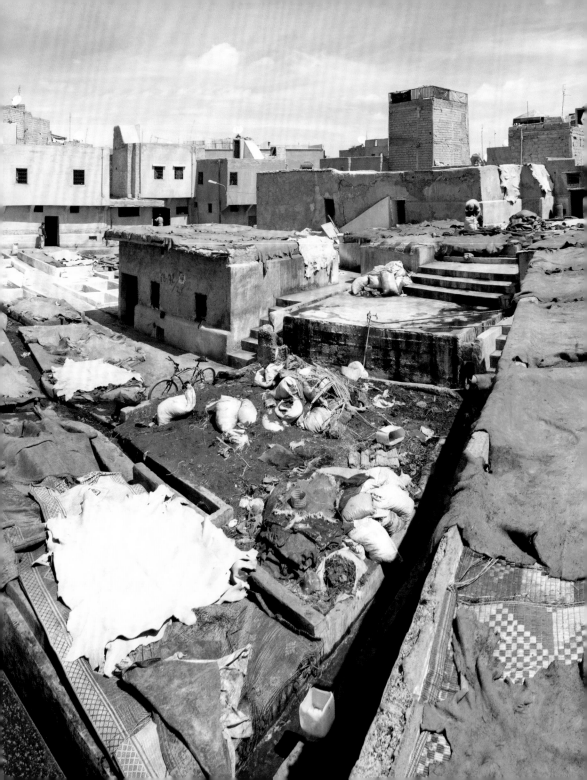

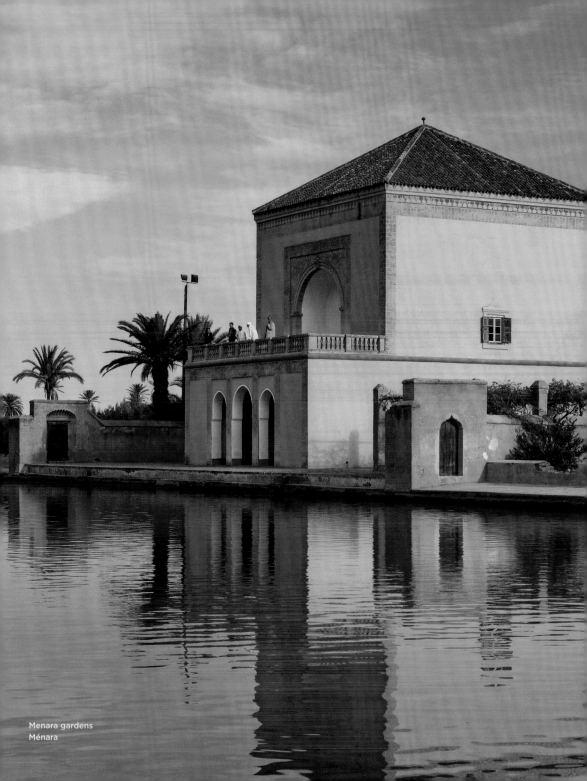

Menara gardens
Ménara

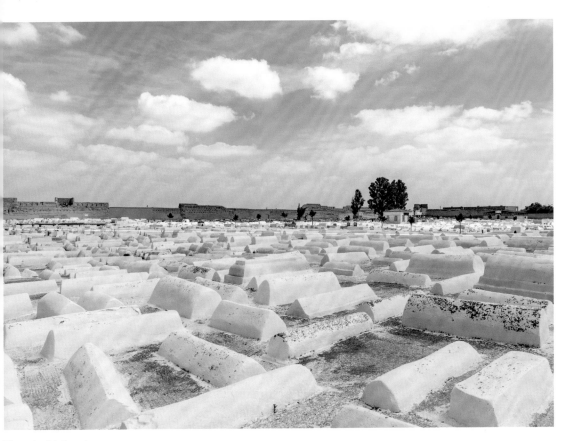

Miaara Jewish Cemetery
Cimetière juif Miaara

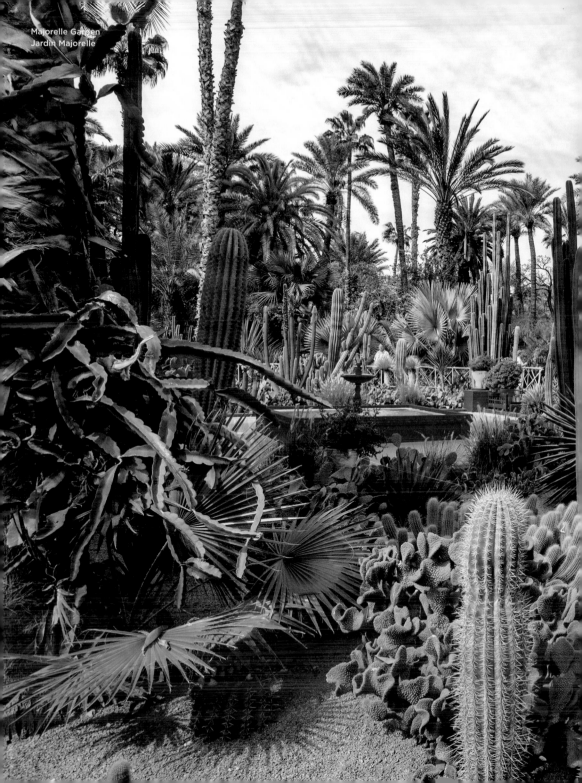

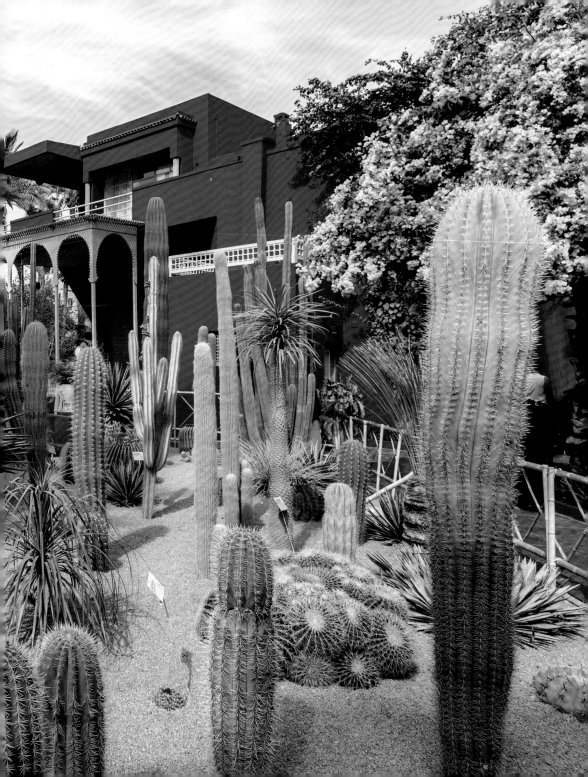

Majorelle Garden
Jardin Majorelle

Majorelle Garden
Jardin Majorelle

Majorelle Garden

In 1980, Yves Saint Laurent and his partner bought the dilapidated garden, which had been created over 40 years by the artist Jacque Majorelle, and restored it to its original state in which blue and green form the colourful leitmotif. Nearby to the Jardin Majorelle is the *Musée Yves Saint Laurent, Marrakech* where one may see works by the French designer..

Jardin Majorelle

En 1980, Yves Saint Laurent y su pareja compraron un jardín en ruinas que había sido creado por el artista Jacque Majorelle y cuya construcción le llevó más de 40 años, y lo restauraron a su estado original, en el que el azul y el verde formaban el colorido leitmotiv. Cerca del Jardín Majorelle se encuentra el *Museo Yves Saint Laurent*, donde se pueden ver obras del diseñador francés.

Jardin Majorelle

En 1980, Yves Saint Laurent et son partenaire achètent un jardin délabré et le transforment en un paradis où le bleu et le vert forment un véritable leitmotiv coloré. Dans le musée à côté du jardin Majorelle, vous pourrez trouver des œuvres du fameux couturier français.

Jardin Majorelle

Nel 1980, Yves Saint Laurent e il suo compagno acquistarono il giardino, allora fatiscente, creato dall'artista Jacques Majorelle oltre 40 anni prima e lo riportarono allo stato originale in cui il blu e il verde erano i colori prevalenti. Nei pressi del Jardin Majorelle si trova il *Museo Yves Saint Laurent*, dove è possibile ammirare opere dello stilista francese.

Jardin Majorelle

1980 erwarben Yves Saint Laurent und sein Partner einen verfallenen Garten, der vom Künstler Jacque Majorelle über 40 Jahre lang angelegt worden war, und versetzten ihn in seinen ursprünglichen Zustand zurück, in dem Blau und Grün das farbliche Leitmotiv bildeten. In der Nähe des Jardin Majorelle befindet sich das *Musée Yves Saint Laurent*, wo man Werke des französischen Designers sehen kann.

Jardin Majorelle

In 1980 kochten Yves Saint Laurent en zijn partner de vervallen tuin, die meer dan 40 jaar door de kunstenaar Jacque Majorelle was aangelegd, en herstelde deze in de oorspronkelijke staat waarin blauw en groen het kleurrijke leidmotief vormen. Vlakbij de Jardin Majorelle ligt het *Musée Yves Saint Laurent, Marrakech* waar men werken van de Franse ontwerper kan zien.

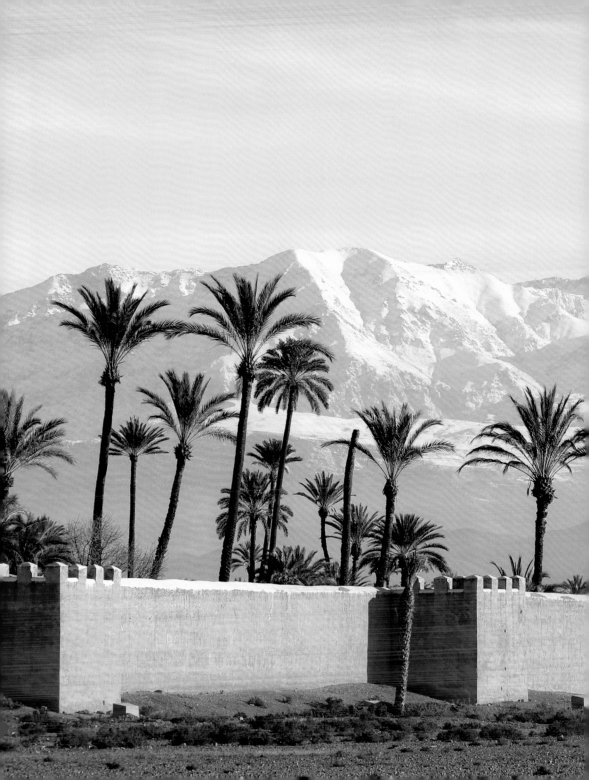

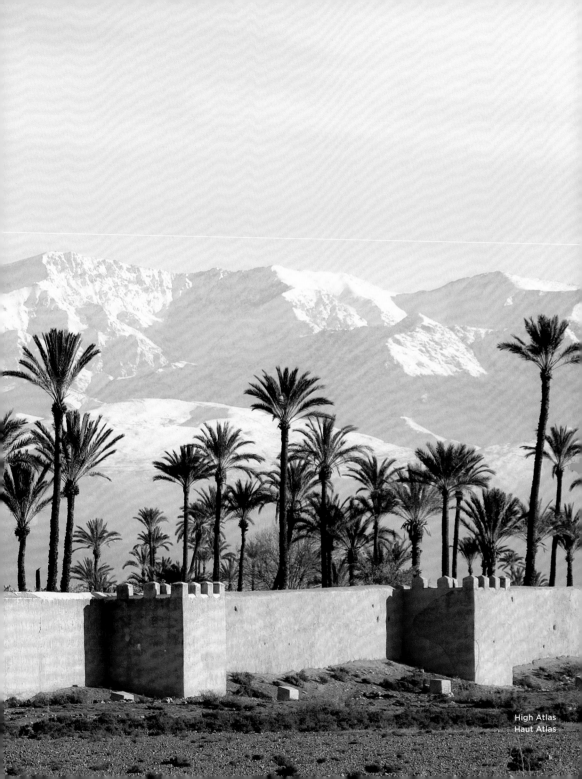

High Atlas
Haut Atlas

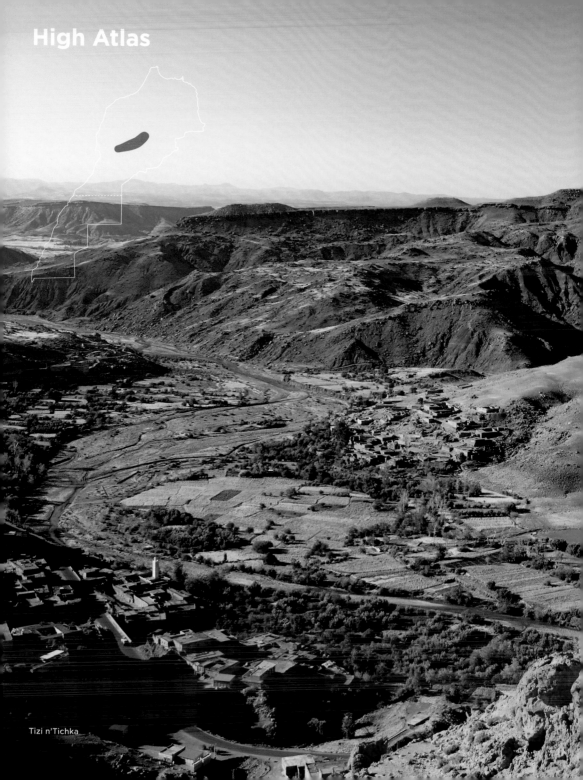

High Atlas

Tizi n'Tichka

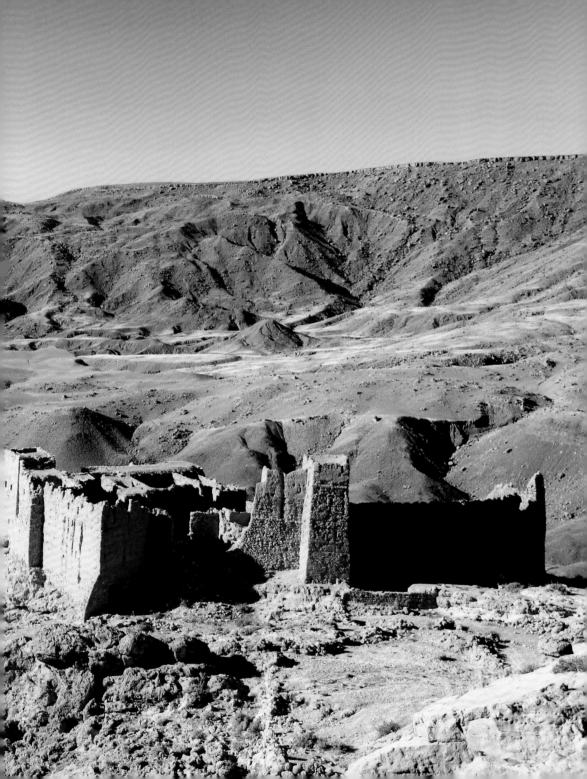

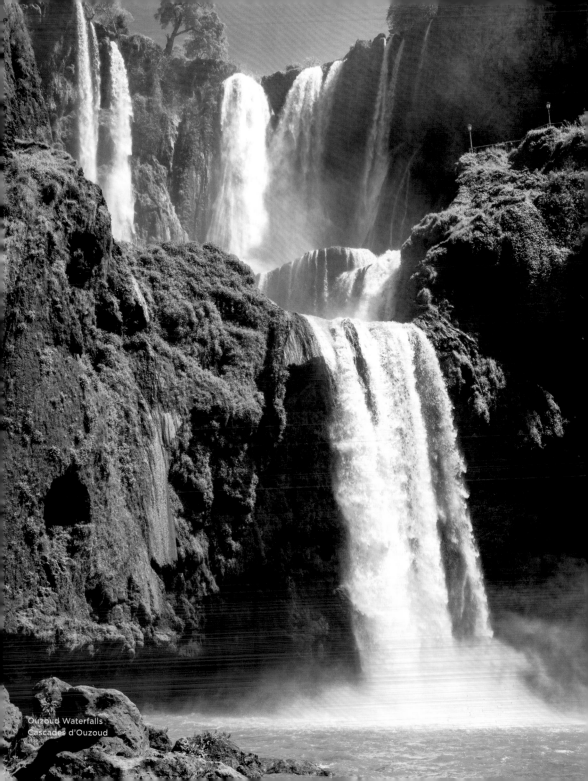
Ouzoud Waterfalls
Cascades d'Ouzoud

Timmit

High Atlas

It's in the name. The High Atlas is the highest mountain range in the country, boasting several four thousand metre peaks, which are also an attraction for tourists. Not only hikers, but also winter sports enthusiasts will find their paradise here. Adventurous and breathtaking: the journey from Marrakech to Ouarzazate over the 2268 m high Tizi n'Tichka Pass.

Alto Atlas

El nombre lo dice todo: el Alto Atlas es la cadena montañosa más alta del país y cuenta con varias cumbres de unos cuatro mil metros que enriquecen la oferta turística de Marruecos. No solo los amantes de la playa, sino también los amantes de los deportes de invierno encontrarán aquí su paraíso. Aventurero e impresionante: el viaje de Marrakech a Ouarzazate a través de los 2268 m de altura Tizi-n-Tichka-Pass.

Haut Atlas

Le nom dit déjà tout : le Haut Atlas est la plus haute chaîne de montagnes du pays et compte plusieurs sommets à quatre mille mètres d'altitude qui enrichissent l'offre touristique du Maroc. Non seulement les amoureux de la plage, mais aussi les amateurs de sports d'hiver y trouveront leur bonheur. Aventureux et époustouflant : telles sont les promesses du voyage de Marrakech à Ouarzazate par le col tizi n'Tichka à 2268 m d'altitude.

Alto Atlante

Il nome è programma: l'Alto Atlante è la catena montuosa più alta del paese e vanta diverse vette di quattromila metri che vanno ad arricchire l'offerta turistica del Marocco. Non solo gli amanti della spiaggia, ma anche gli appassionati di sport invernali trovano qui il loro paradiso. Avventuroso e mozzafiato è il viaggio da Marrakech a Ouarzazate che attraversa il passo Tizi n'Tichka, alto 2268 m.

Hoher Atlas

Der Name verrät's: Der Hohe Atlas ist die höchste Gebirgskette des Landes und prunkt mit einigen Viertausendern, die Marokkos touristisches Angebot bereichern: Nicht nur Strandliebhaber auch Wintersportler finden hier ihr Paradies. Abenteuerlich und atemberaubend: die Fahrt von Marrakesch nach Ouarzazate über den 2268 m hohen Tizi-n-Tichka-Pass.

Hoge Atlas

De naam zegt het al: de Hoge Atlas is het hoogste gebergte van het land en kan bogen op enkele bergtoppen van 4000 m hoog, die het toeristische aanbod van Marokko verrijken. Het is niet alleen voor strandliefhebbers, maar ook voor wintersporters een paradijs. Avontuurlijk en adembenemend: de tocht van Marrakesh naar Ouarzazate over de 2268 m hoge Tizi-n-Tichka-bergpas.

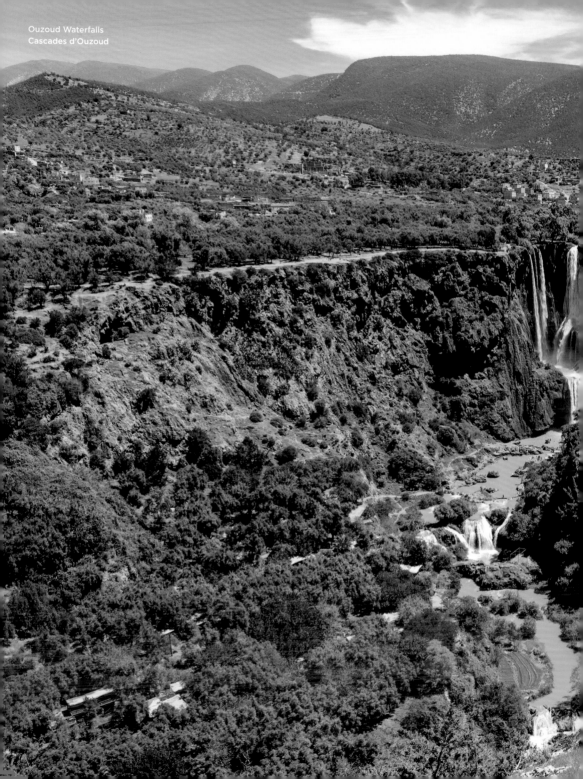

Ouzoud Waterfalls
Cascades d'Ouzoud

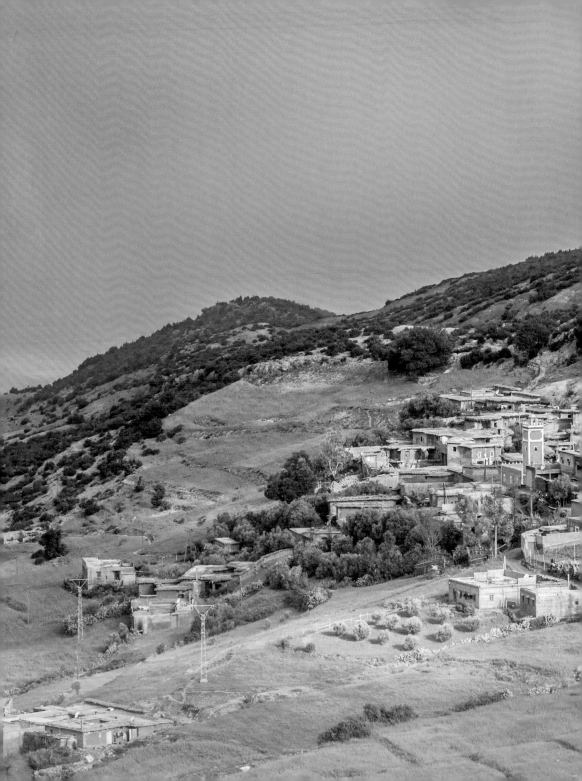

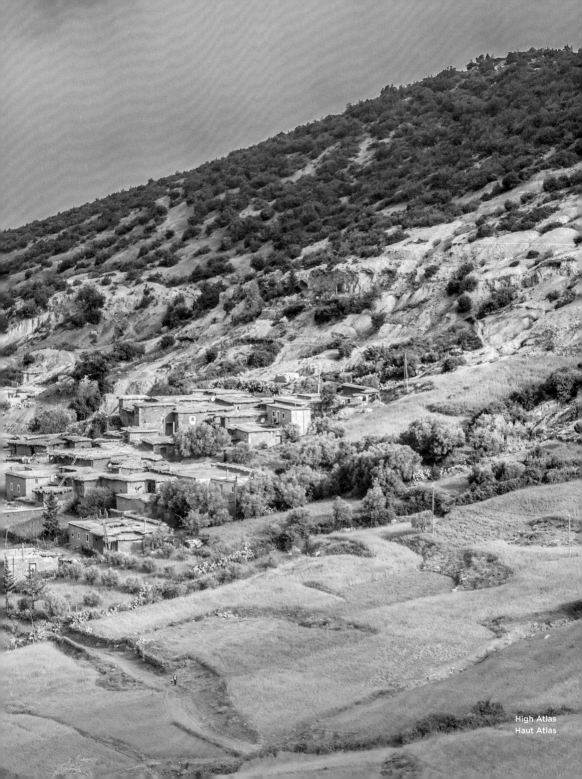

High Atlas
Haut Atlas

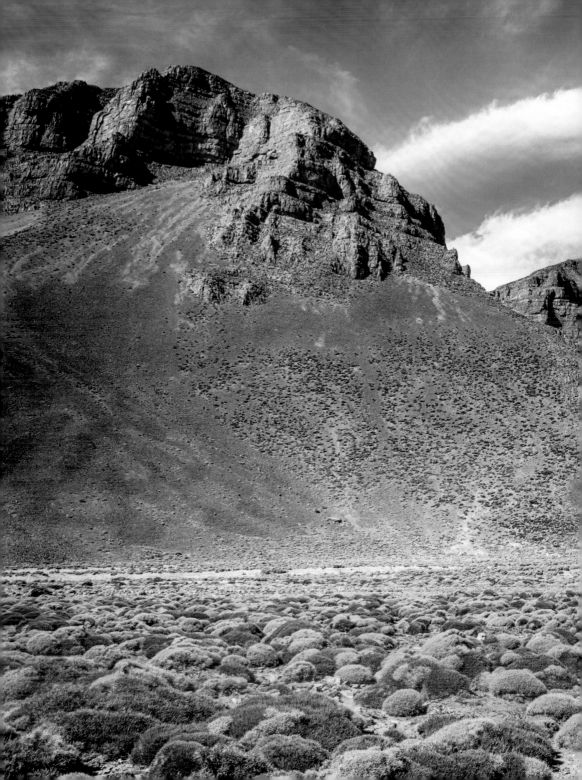

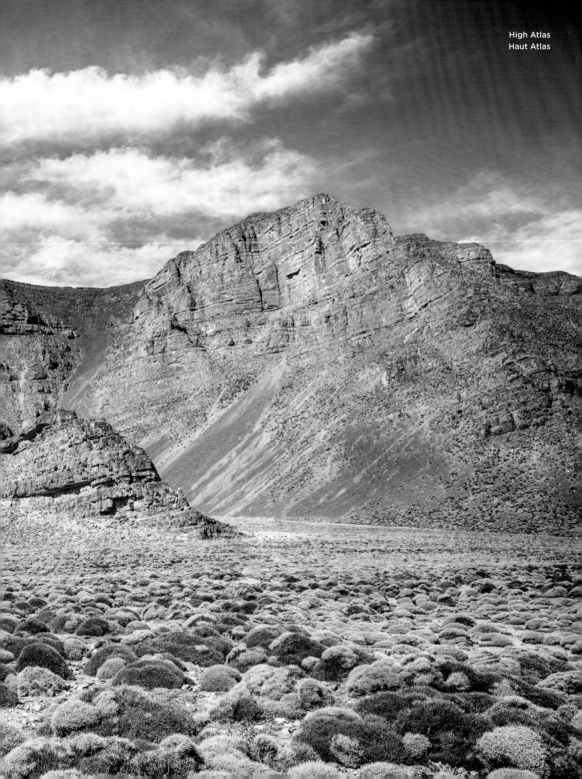

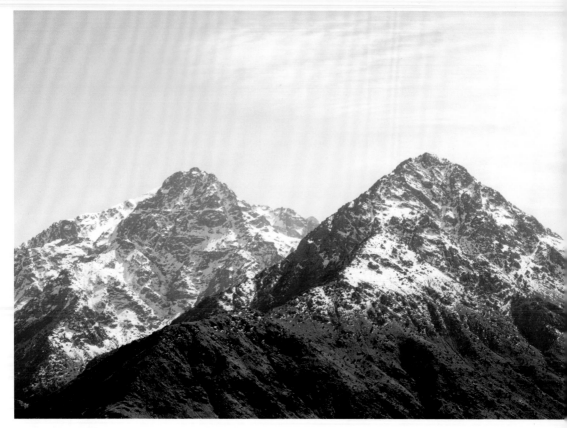

Toubkal (4167 m 13671 ft)
Djebel Toubkal (4167 m)

Winter sports in the High Atlas

When one thinks of Morocco, beach
holidays, medinas and desert tours
immediately come to mind. However,
winter sports also have a tradition here,
with skiers coming to Oukaïmeden
since the 1930s. The village is located
in the Toubkal National Park, where
Morocco's highest mountain (4167 m),
the Toubkal, rises. The winter sports
area of Oukaïmeden lies at an altitude of
2610–3268 m.

Les sports d'hiver dans le Haut Atlas

Quand vous pensez au Maroc, vous
pensez aux plaisirs de la baignade et aux
excursions dans le désert. Mais les sports
d'hiver au Maroc disposent aussi d'une
longue tradition : les skieurs viennent à
Oukaïmden depuis les années 1930. Le
village est situé dans le parc national de
Toubkal, où s'élève la plus haute montagne
du Maroc (4167 m) : le Toubkal. La station
de sports d'hiver d'Oukaïmden se trouve
à une altitude comprise entre 2610 et
3268 m.

Wintersport im Hohen Atlas

Bei Marokko denkt man an Badefreuden
und Wüstentouren. Aber auch Wintersport
hat Tradition: Seit den 1930er-Jahren
kommen Skifahrer nach Oukaïmeden.
Der Ort liegt im Toubkal Nationalpark,
in dem sich der mit 4167 m höchste
Berg Marokkos erhebt, der Toubkal. Das
Wintersportgebiet Oukaïmeden liegt auf
einer Höhe von 2610–3268 m.

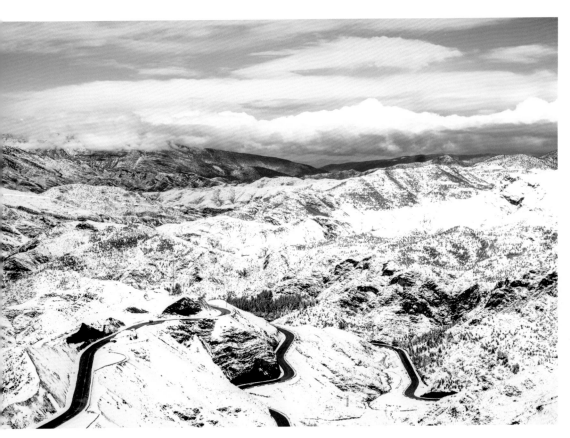

Tizi n'Tichka

Deportes de invierno en el Alto Atlas
Cuando la gente piensa en Marruecos, suele pensar en el placer del baño y las excursiones por el desierto. Pero los deportes de invierno también tienen una tradición: los esquiadores han estado viniendo a Oukaïmeden desde la década de 1930. El pueblo está situado en el Parque Nacional del Toubkal, donde se alza la montaña más alta de Marruecos (4167 m), el Toubkal. La zona de deportes de invierno de Oukaïmeden se encuentra a una altitud de 2610–3268 m.

Sport invernali sull'Alto Atlante
Quando si pensa al Marocco, vengono in mente i bagni in mare e le escursioni nel deserto. Ma anche gli sport invernali hanno qui tradizione: dagli anni '30 del Novecento Oukaïmeden è meta di sciatori. Il villaggio si trova nel Parco nazionale del Toubkal, dove sorge la montagna più alta del Marocco (4167 m), il Toubkal. L'area di Oukaïmeden dove vengono praticati gli sport invernali si estende tra i 2610 e i 3268 m di altitudine.

Wintersport in de Hoge Atlas
Als je aan Marokko denkt, denk je aan zwemplezier en woestijntochten. Maar er is ook een wintersporttraditie: skiërs komen al sinds de jaren dertig naar Oukaïmeden. Het dorp ligt in het nationale park Toubkal, waar de hoogste berg van Marokko (4167 m), de Toubkal, verrijst. Het wintersportgebied Oukaïmeden ligt op een hoogte van 2610-3268 m.

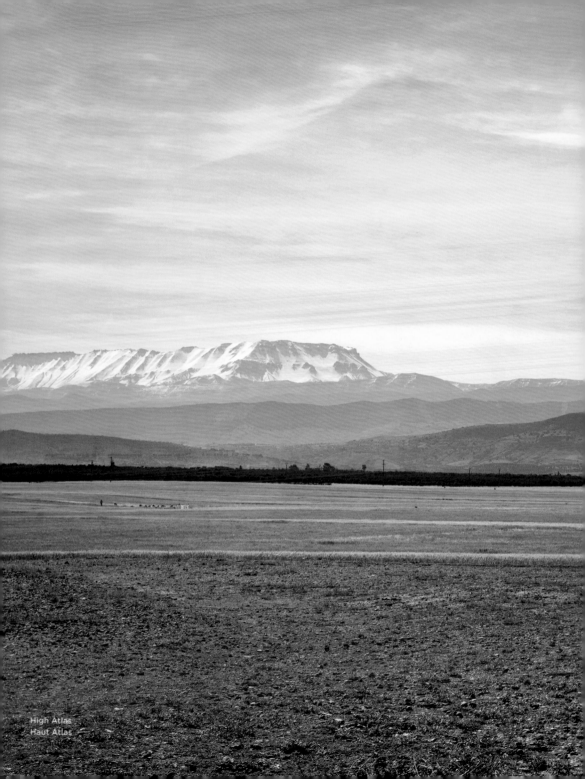

High Atlas
Haut Atlas

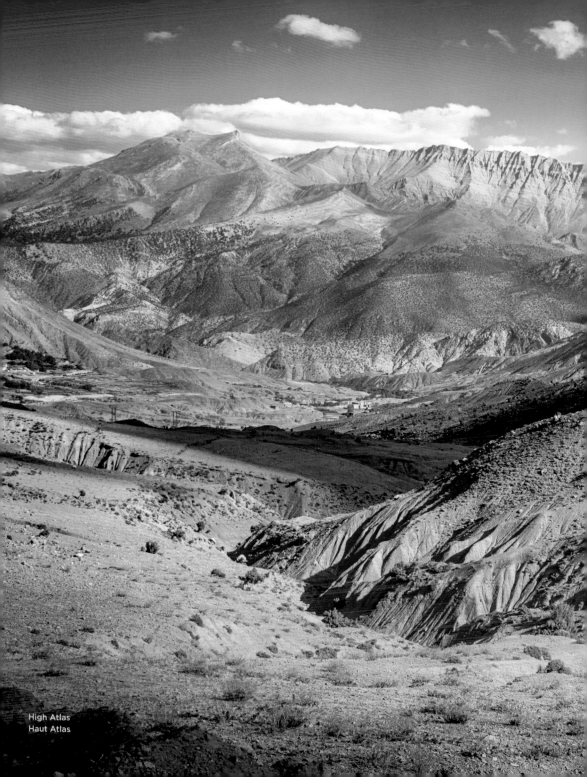

High Atlas
Haut Atlas

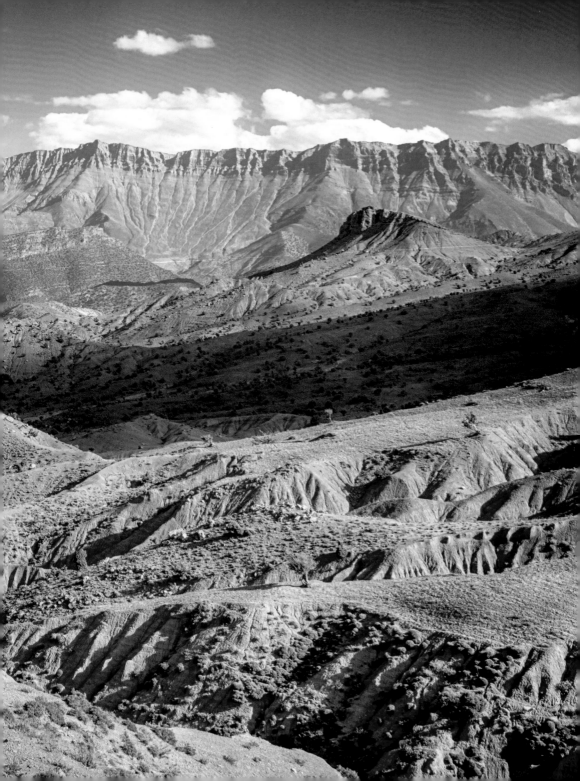

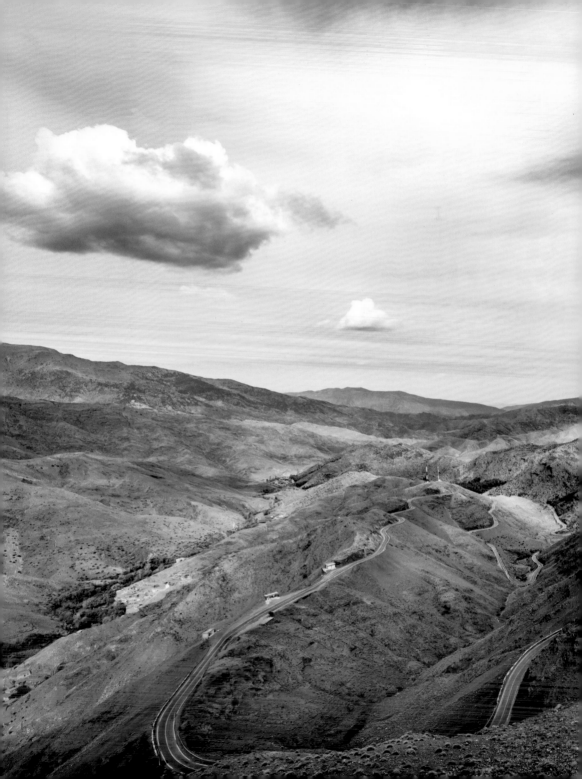

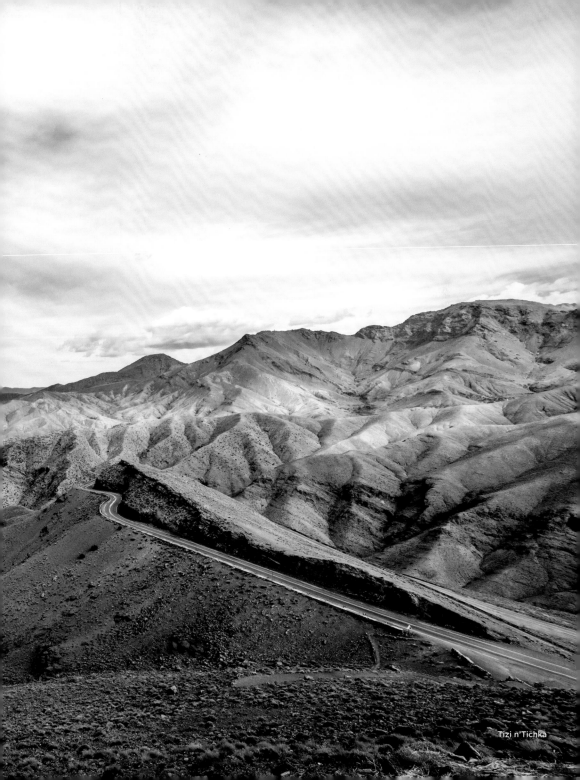

Tizi n'Tichka

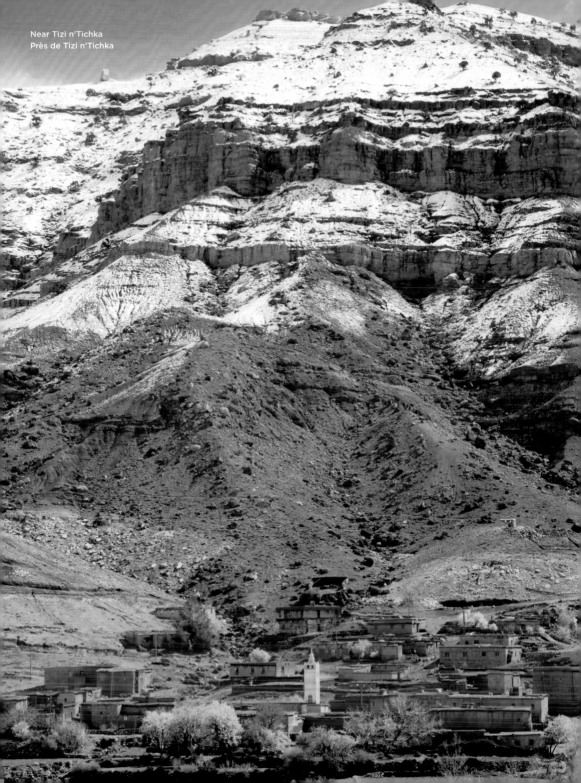

Near Tizi n'Tichka
Près de Tizi n'Tichka

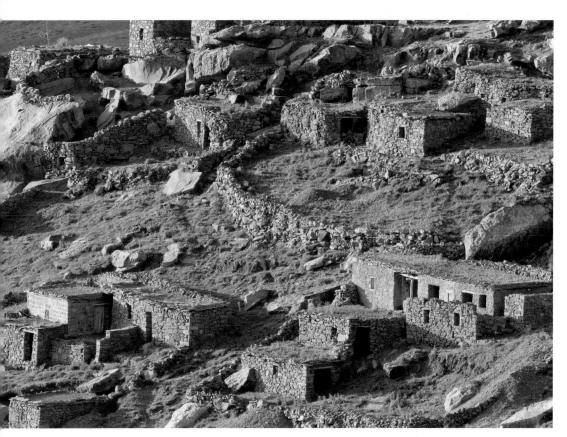

ukaïmden

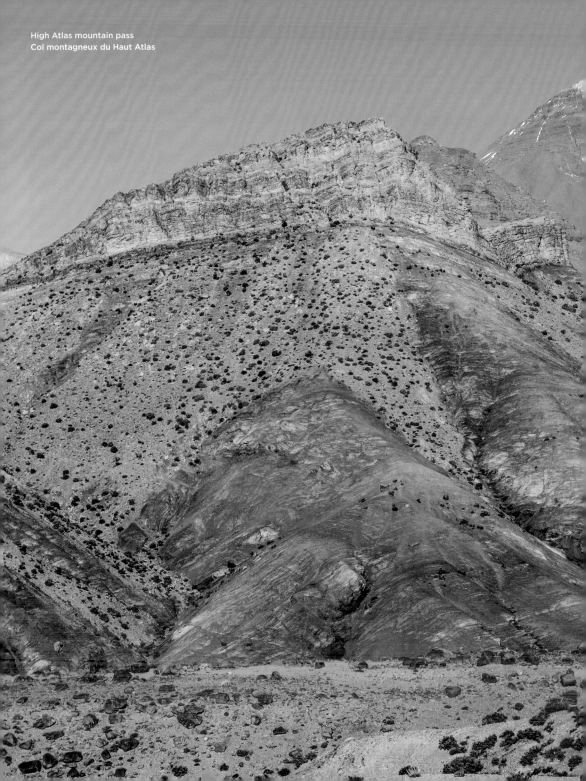

High Atlas mountain pass
Col montagneux du Haut Atlas

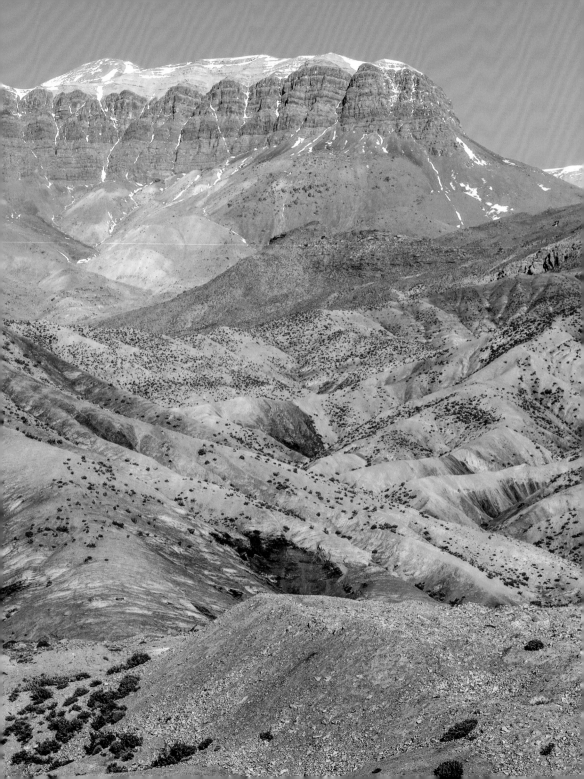

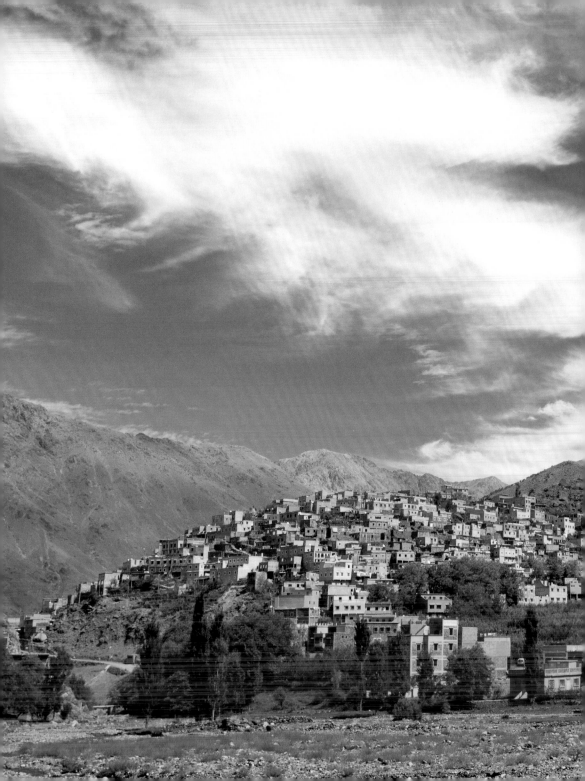

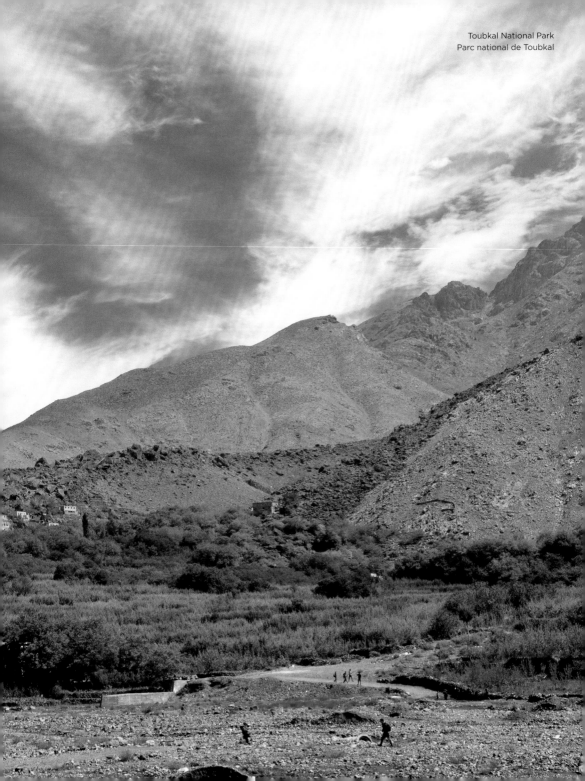

Ourika Valley, Toubkal National Park
Vallée de l'Ourika, Parc national de Toubkal

Mountain goat, Toubkal National Park
Chèvre de montagne, Parc national de Toubkal

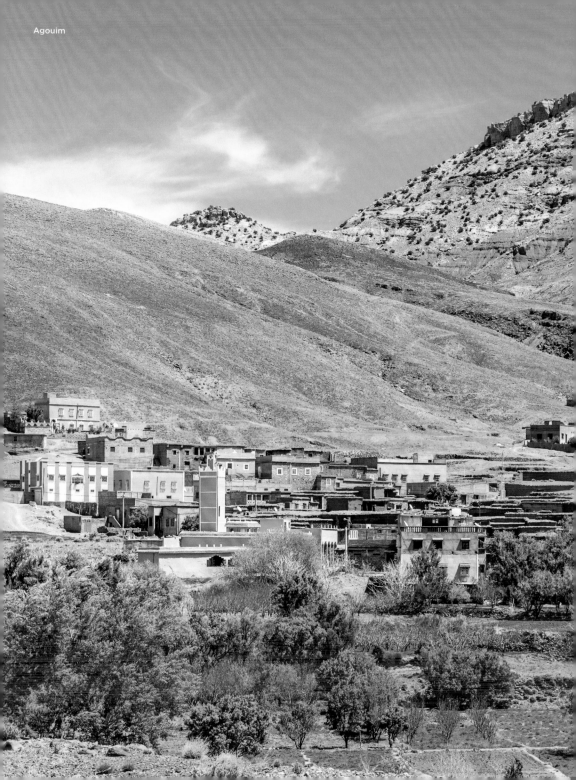
Agouim

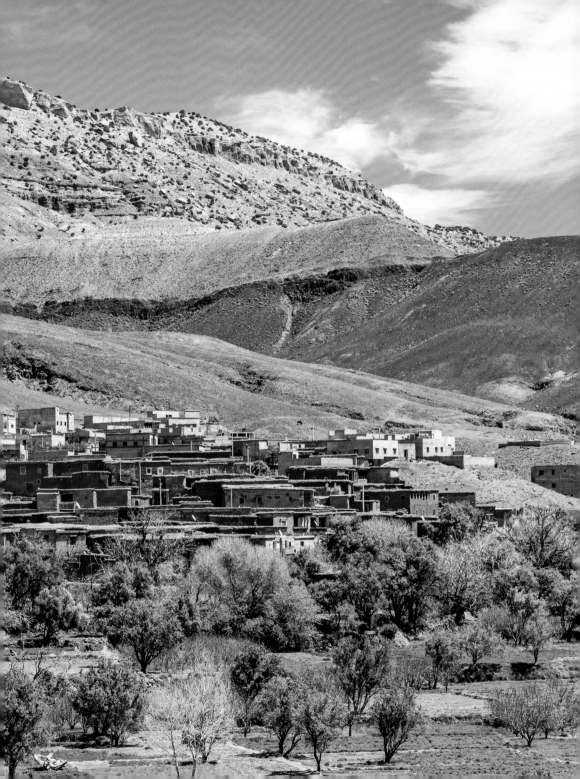

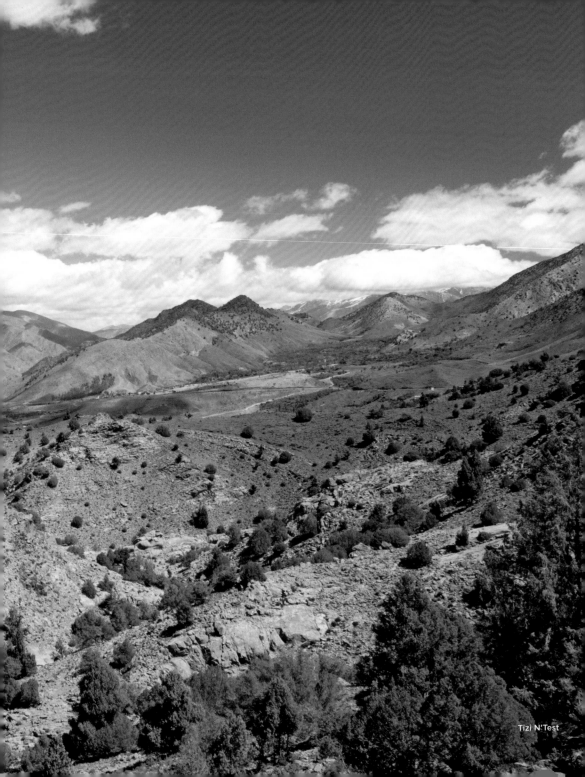

Tizi N'Test

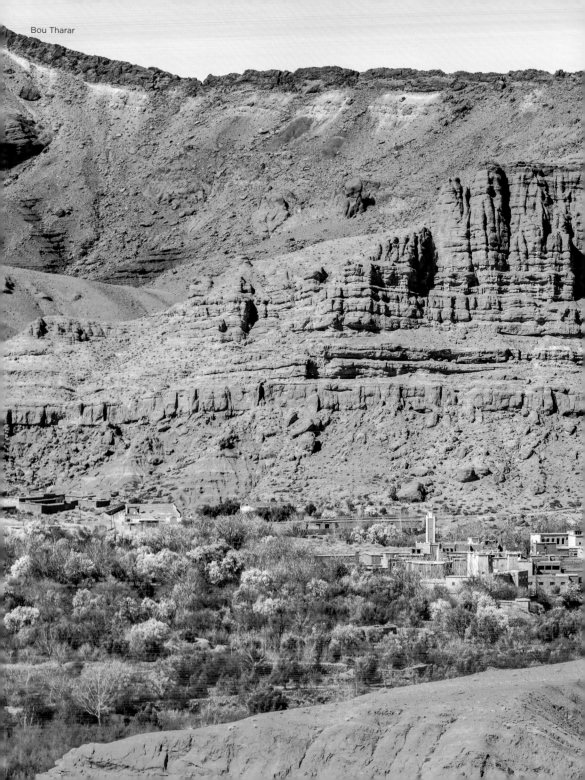

Bou Tharar

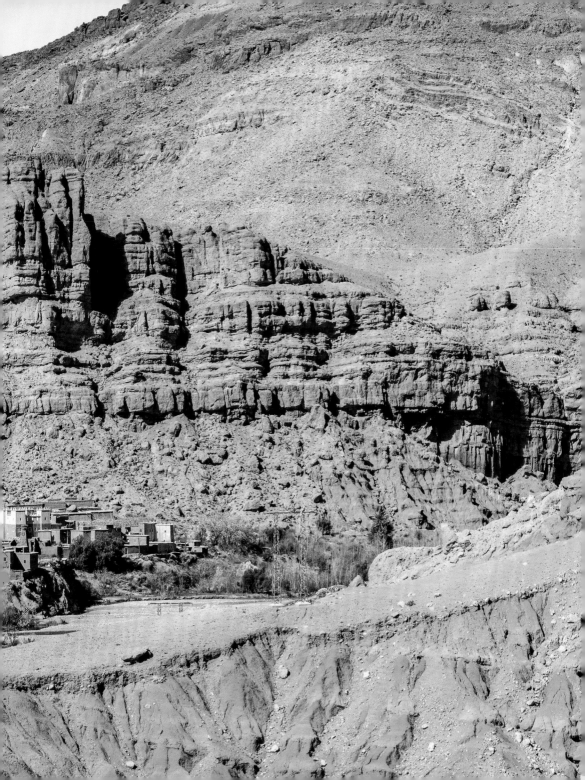

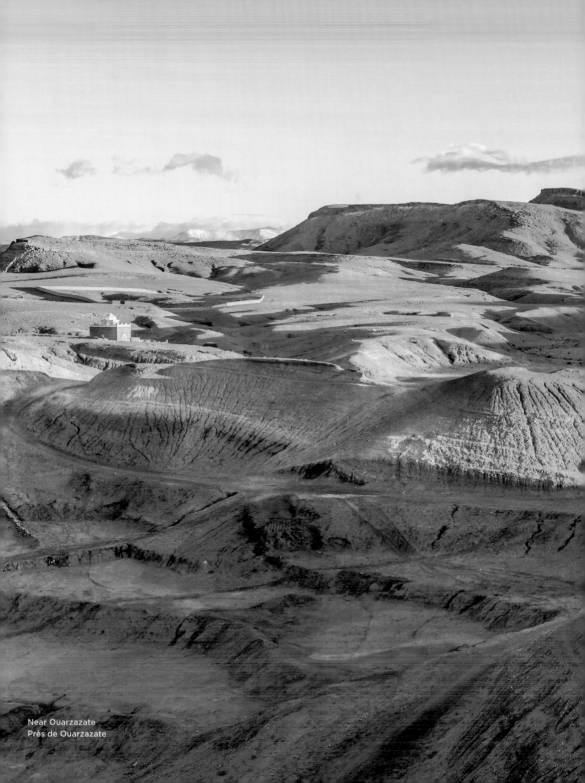

Near Ouarzazate
Près de Ouarzazate

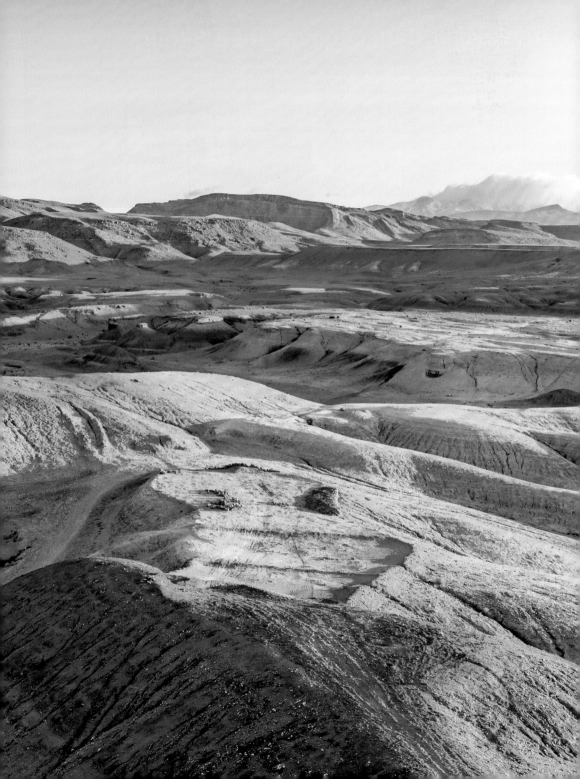

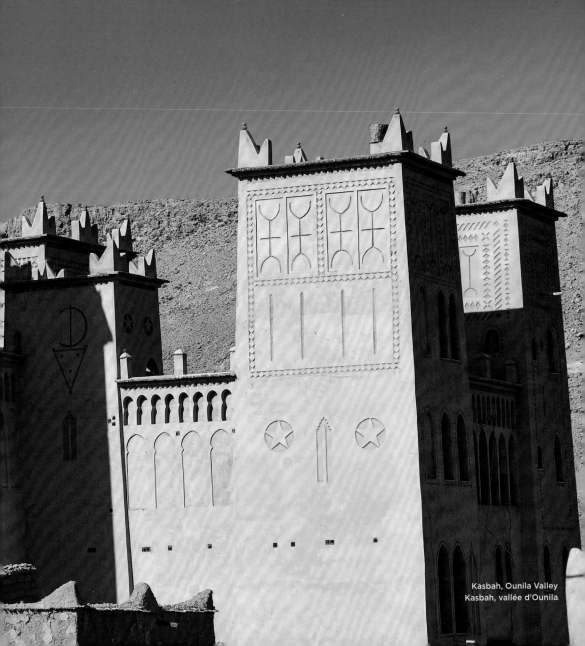

Kasbah, Ounila Valley
Kasbah, vallée d'Ounila

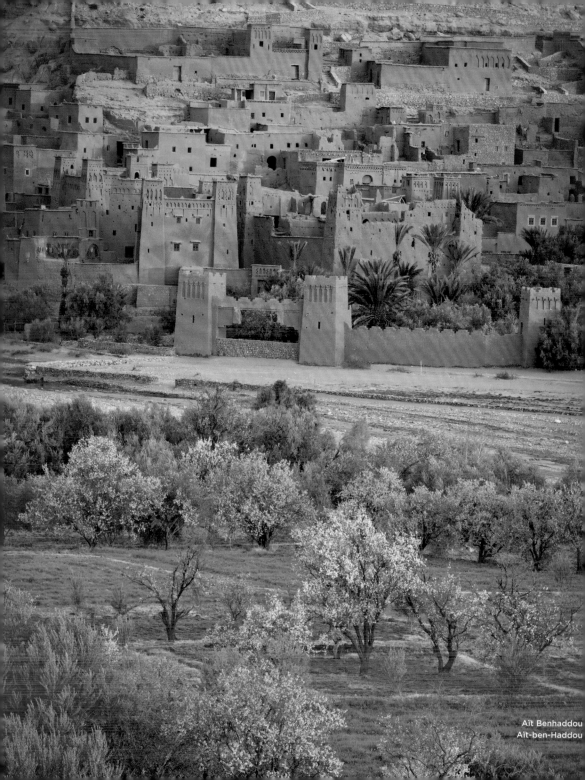

Aït Benhaddou
Aït-ben-Haddou

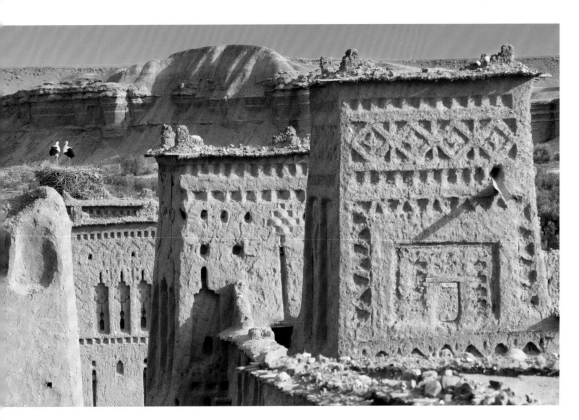

Aït Benhaddou
Aït-ben-Haddou

Aït Benhaddou, Ouarzazate & Skoura

Earth buildings and clay forts characterize these three places. Views of Aït Benhaddou and Ouarzazate are well known, as famous directors have used them as a backdrop for numerous films, amongst them the cinematic epics *Lawrence of Arabia* and *Gladiator*. Ouarzazate is the gateway to the Dadès Gorges, where in spring the almond trees bloom and soft spots of colour appear before the reddish shimmering mountains.

Aït Ben Haddou, Ouarzazate & Skoura

Los edificios de tierra y castillos de arcilla caracterizan la imagen de estos tres lugares: a Aït Benhaddou y Ouarzazate han venido directores de renombre a rodar numerosas películas, entre ellas el éxito mundial *Lawrence de Arabia* y *Gladiator*. Ouarzazate es la puerta de entrada al Dadestal, donde en primavera florecen los almendros y ante las rojizas y brillantes montañas destacan con sus frágiles puntitos blancos.

Aït-ben-Haddou, Ouarzazate & Skoura

Des bâtiments en terre et des châteaux d'argile caractérisent l'identité de ces trois lieux – une image bien connue : c'est à Aït-ben-Haddou et Ouarzazate que des réalisateurs de renom ont tourné de nombreux films, dont le succès mondiaux *Lawrence d'Arabie* et *Gladiator*. Ouarzazate est la porte d'entrée de la vallée du Dadès, où, au printemps, les amandiers fleurissent et prospèrent devant les montagnes rougeâtres et chatoyantes.

Ait-Ben-Haddou, Ouarzazate & Skoura

Edifici e castelli in argilla caratterizzano questi tre luoghi – un quadro di certo ben noto: ad Ait-Ben-Haddou e Ouarzazate registi di fama hanno girato numerosi film, tra cui il successo mondiale *Lawrence d'Arabia* e *Gladiator*. Ouarzazate è la porta d'accesso alla valle del Dade, dove in primavera fioriscono i mandorli, creando una delicata cornice alle montagne scintillanti di rosso.

Aït Benhaddou, Ouarzazate & Skoura

Lehmbauten und Lehmburgen prägen das Bild dieser drei Orte – ein bekanntes Bild: In Aït Benhaddou und Ouarzazate drehten namhafte Regisseure zahlreiche Filme, unter ihnen *Lawrence von Arabien* und *Gladiator*. Ouarzazate ist das Tor zum Dadestal, in dem im Frühjahr die Mandelbäume blühen und zarte Tupfer vor die rötlich schimmernden Bergen setzen.

Aït Ben-Haddou, Ouarzazate & Skoura

Gebouwen en burchten van leem bepalen het aanzien van deze drie plaatsen. Een bekend beeld: in Aït Benhaddou en Ouarzazate schoten gerenommeerde regisseurs tal van films, waaronder *Lawrence of Arabia* en *Gladiator*. Ouarzazate is de toegangspoort tot het Dades-dal, waar in het voorjaar de amandelbomen bloeien en zachte toeven rood vormen voor de roodachtig glanzende bergen.

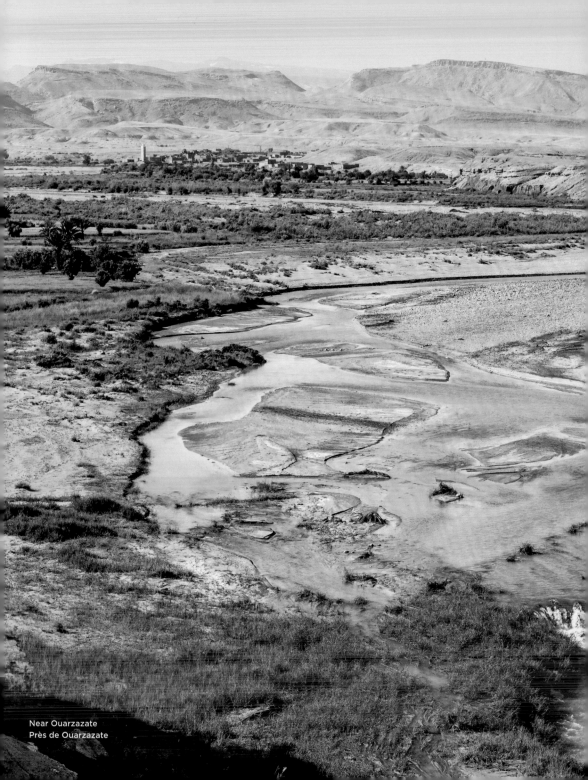

Near Ouarzazate
Près de Ouarzazate

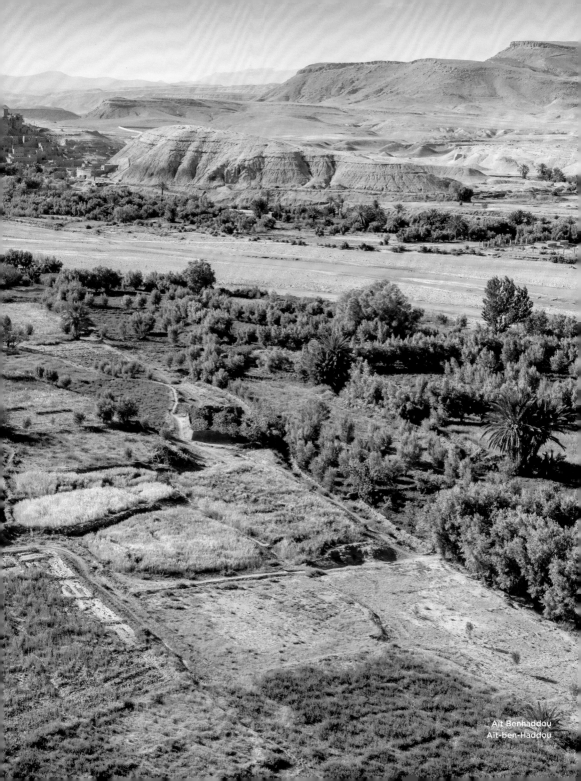

Aït Benhaddou
Aït-ben-Haddou

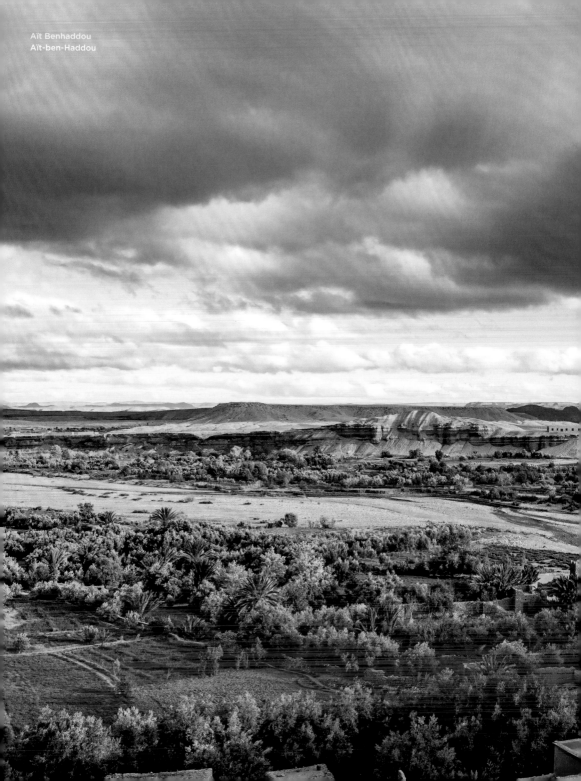

Aït Benhaddou
Aït-ben-Haddou

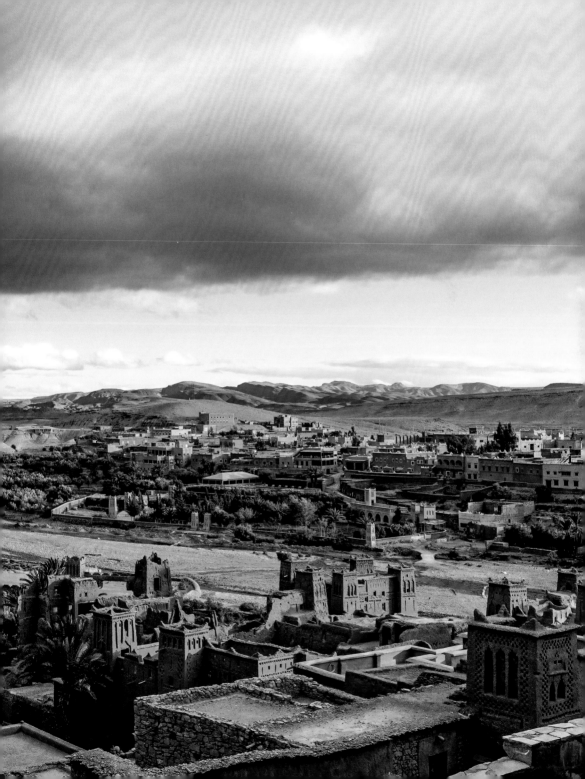

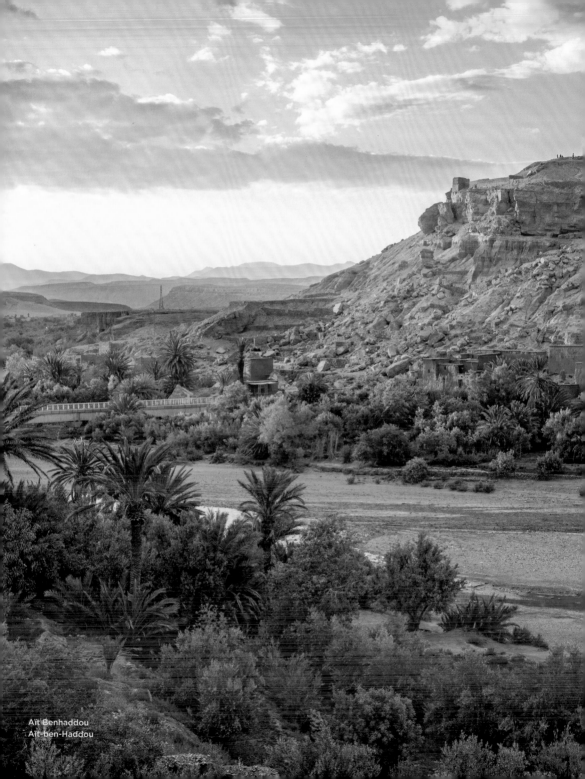

Aït Benhaddou
Aït-ben-Haddou

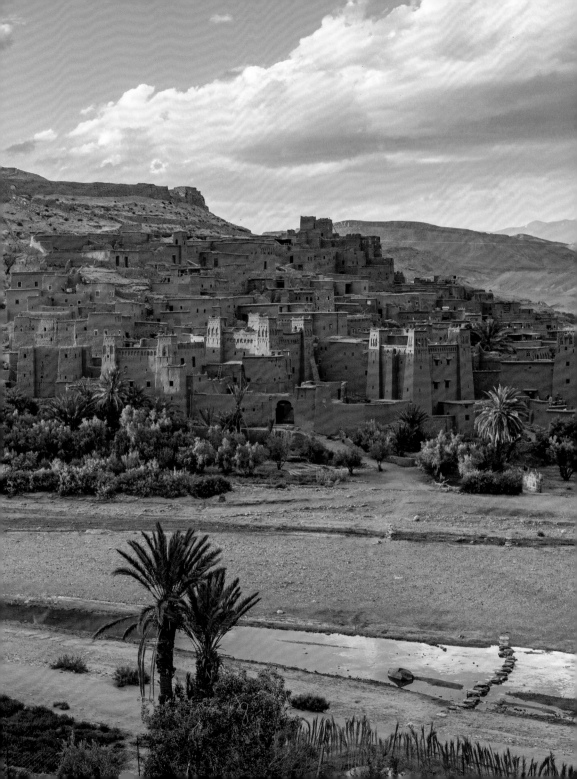

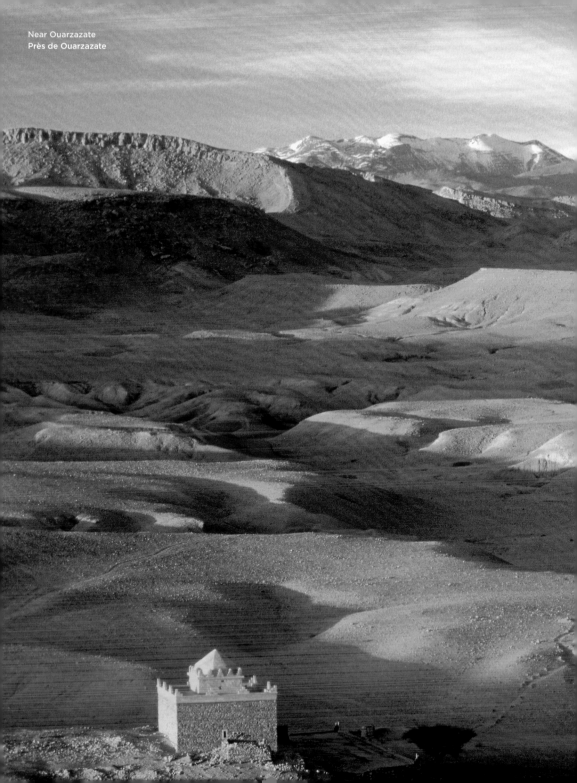

Near Ouarzazate
Près de Ouarzazate

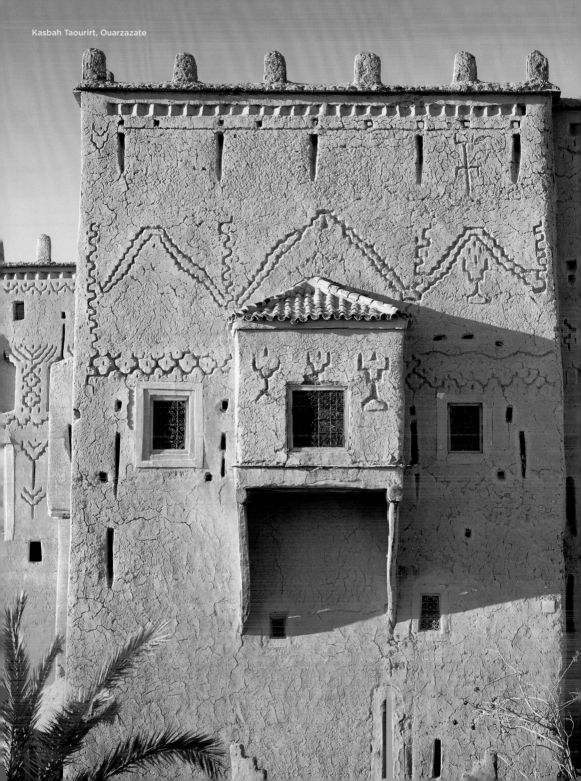

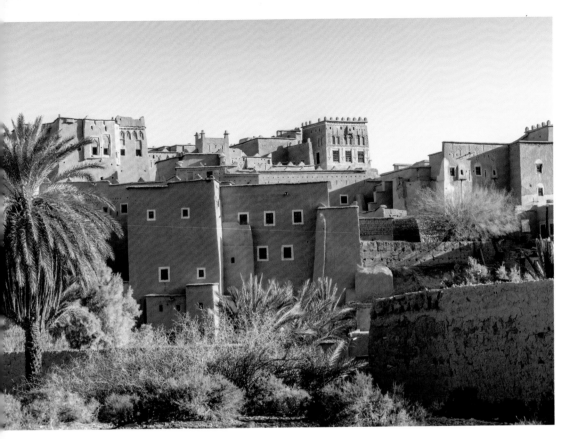

asbah Taourirt, Ouarzazate

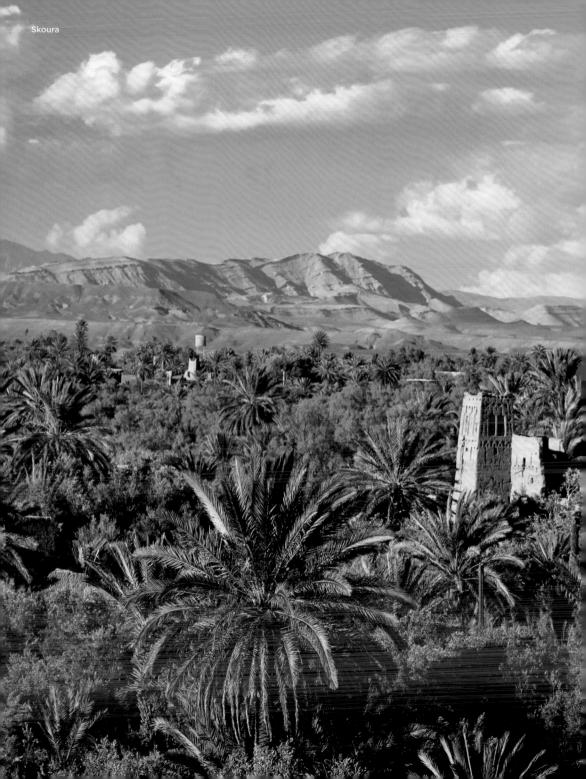

Skoura

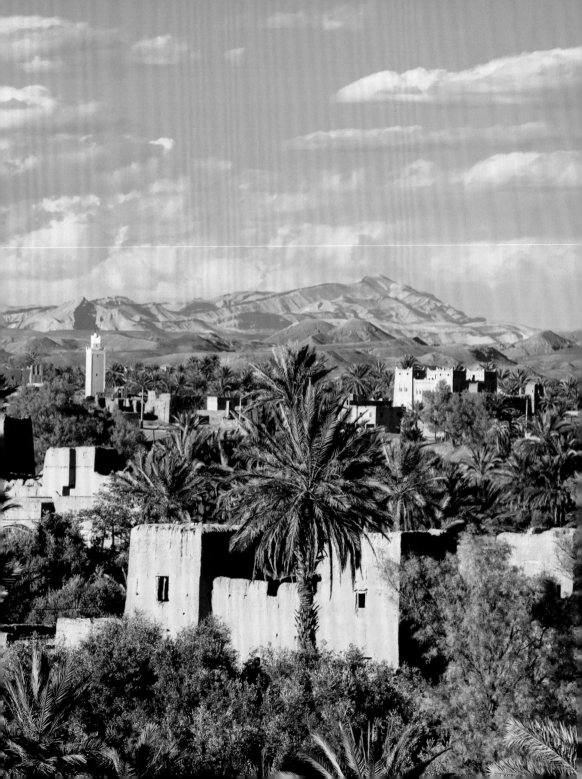

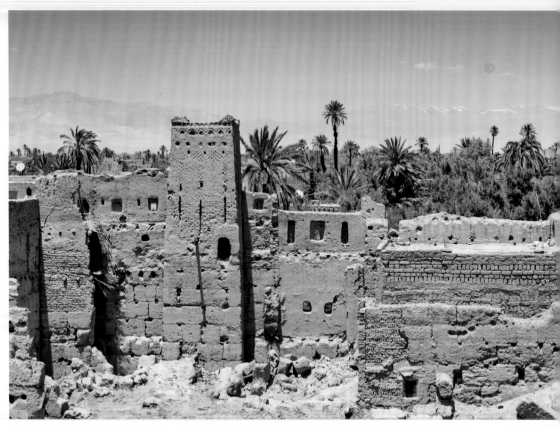

Kasbah Amahidil, Skoura

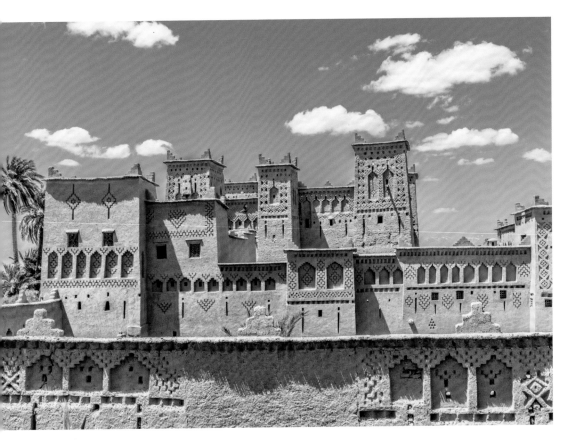

Kasbah Amahidil, Skoura

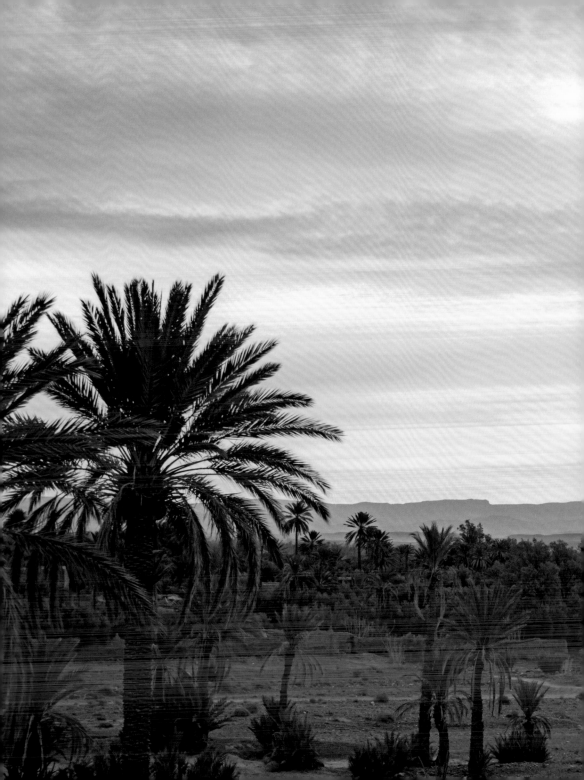

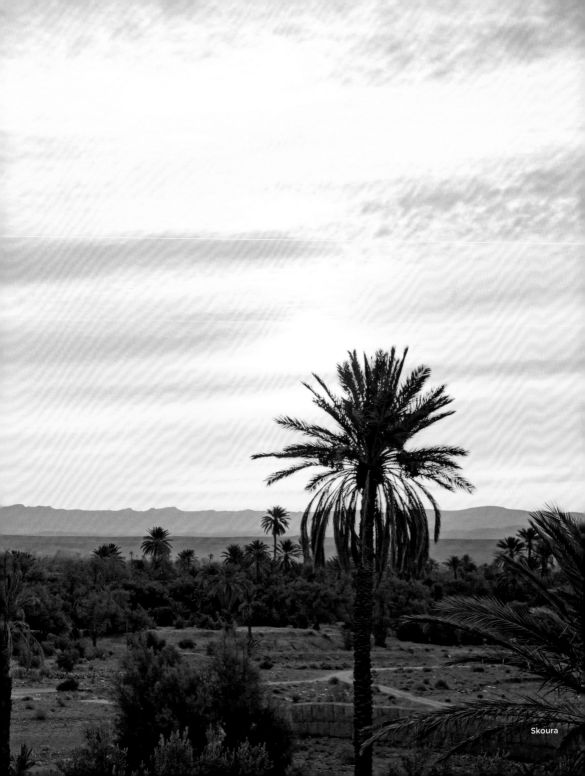

Skoura

Riads

From the outside, one has no idea what a grandiose inner life these houses conceal behind their unadorned facades. The inner courtyards are edged with columns, water splashes from richly decorated fountains and the walls are adorned with mosaics. The green is pleasing on the eye and the word *riad* is derived from the Arabic word for garden. Many *riads* are today used as hotels.

Riads

Vu de l'extérieur, vous n'avez aucune idée de la vie intérieure grandiose que ces maisons cachent derrière leurs façades sans fioritures : les cours sont bordées de colonnes splendides, les éclaboussures d'eau des fontaines richement décorées viennent faire briller les murs ornés de mosaïques. La verdure est un plaisir pour les yeux – « *riad* » est un dérivé du mot arabe pour « jardin ». De nombreux *riads* sont aujourd'hui encore utilisés comme hôtels.

Riads

Von außen ahnt man nicht, welch grandioses Innenleben diese Häuser hinter den schmucklosen Fassaden bergen: Die Innenhöfe säumen Säulen, Wasser plätschert aus reich verzierten Brunnen, die Wände sind mit Mosaiken geschmückt. Grün erfreut das Auge – *Riad* leitet sich vom arabischen Wort für Garten ab. Viele *Riads* werden heute als Hotels genutzt.

Riads

Desde el exterior, no tienes ni idea de la grandiosa vida interior que estas casas esconden tras las fachadas sin adornos: las columnas de los patios interiores, las salpicaduras de agua de fuentes muy decoradas, las paredes están adornadas con mosaicos. El verde deleita la vista (*Riad* proviene de la palabra árabe para jardín). Hoy en día muchos *riads* se utilizan como hoteles.

Riads

Dall'esterno non trapela la vita lussuriosa che queste case nascondono dietro le loro facciate disadorne: i cortili interni sono fiancheggiati da colonne, l'acqua spruzza da fontane riccamente decorate, le pareti sono adornate da mosaici. Il verde rallegra l'occhio – il nome *riad* deriva dalla parola araba per "giardino". Molti *riad* sono utilizzati oggi come hotel.

Riads

Van buitenaf is niet te zien wat voor grandioos leven zich achter de onopgesmukte muren afspeelt: de binnenhoven zijn omzoomd met zuilen, water spettert uit rijkversierde fonteinen, de muren zijn versierd met mozaïeken. Groen streelt het oog – *riad* is afgeleid van het Arabische woord voor tuin. Veel *riads* dienen tegenwoordig als hotel.

MARRAKESH

MARRAKESH

MARRAKESH

MARRAKESH

MEKNES

MARRAKESH

FES

FES

FES

MARRAKESH

MARRAKESH

FES

FES

ESSAOUIRA

FES

FES

MARRAKESH

MARRAKESH

265

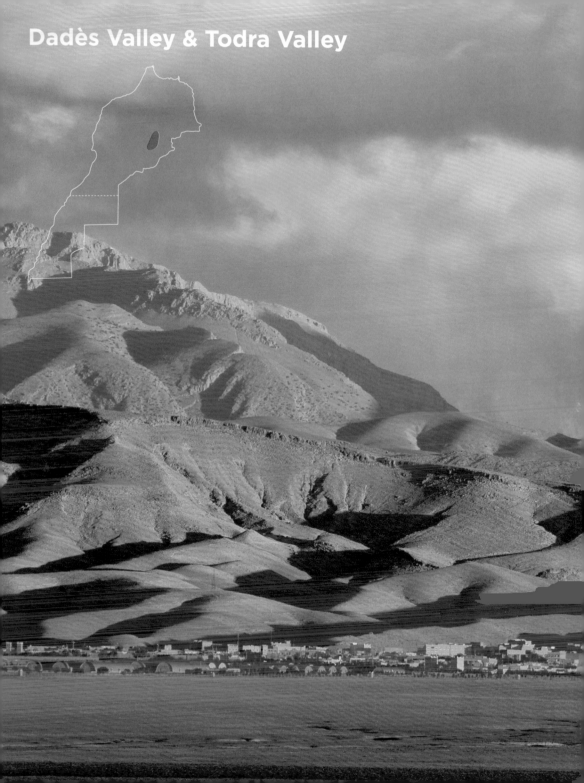

Dadès Valley & Todra Valley

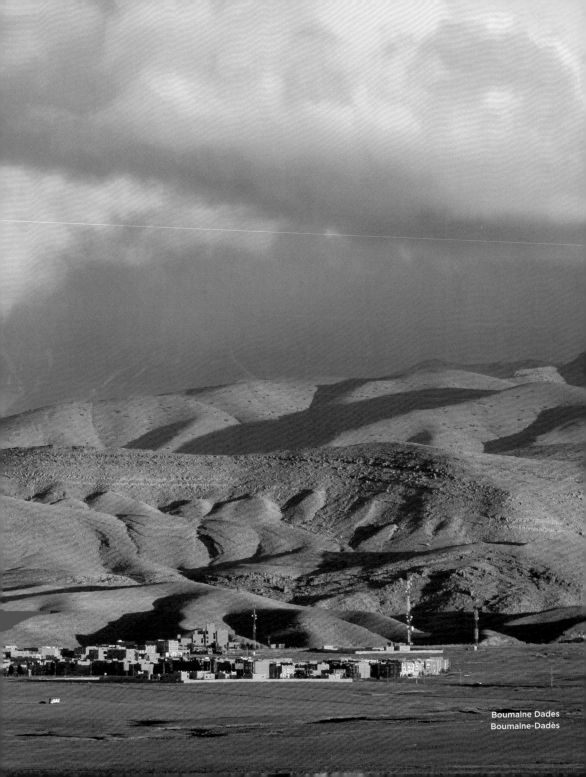

Boumalne Dades
Boumalne-Dadès

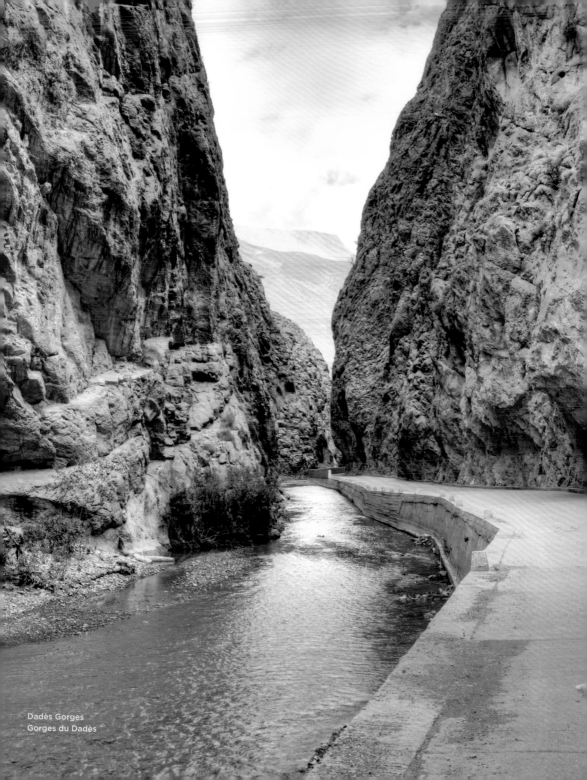

Dadès Gorges
Gorges du Dadès

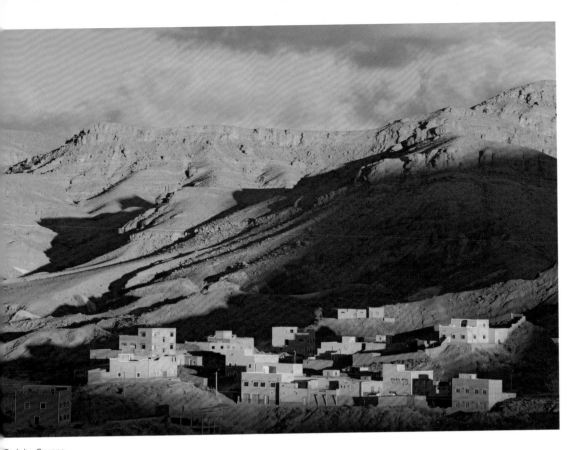

Todgha Gorges
Gorges du Todra

Dadès Valley & Todra Valley

The rivers Dadès and Todra have dug deep into the rocks of the High Atlas, forming mighty gorges. The inhabitants use the river water to irrigate the oases. The "Road of 1000 Casbahs", upon which centuries-old clay forts built by Berbers may be admired, runs through the Dadès valley.

Dadestal & Todratal

Los ríos Dades y Todra han excavado profundamente en las rocas del Alto Atlas y han formado poderosos desfiladeros. Los habitantes utilizan el agua del río para regar los oasis. Por el Dadestal discurre el "Camino de las 1000 Kasbahs", en el que se pueden admirar los castillos de arcilla centenarios construidos por los bereberes.

Dadès & Toudra

Les rivières Dadès et Toudra ont creusé profondément dans les roches du Haut Atlas et formé de puissantes gorges. Les habitants utilisent l'eau de la rivière pour irriguer les oasis. La « Route des 1000 kasbahs », où l'on peut admirer des châteaux d'argile séculaires construits par les Berbères, traverse la vallée du Dadès.

Le valli del Dades & del Todra

I fiumi Dades e Todra sono scavati nelle rocce dell'Alto Atlante e hanno formato imponenti gole. Gli abitanti usano l'acqua del fiume per irrigare le oasi. La "via delle 1000 kasbah", in cui si possono ammirare secolari castelli di argilla costruiti dai berberi, attraversa la valle del Dades.

Dadestal & Todratal

Die Flüsse Dades und Todra haben sich tief ins Gestein des Hohen Atlas gegraben und mächtige Schluchten gebildet. Die Bewohner nutzen das Flusswasser zum Bewässern der Oasen. Durchs Dadestal verläuft die „Straße der 1000 Kasbahs", in der jahrhundertealte, von Berbern errichtete Lehmburgen zu bewundern sind.

Dades-dal & Todra-dal

De rivieren de Dades en de Todra hebben de rotsen van de Hoge Atlas diep uitgesleten en indrukwekkende kloven gevormd. De inwoners gebruiken het rivierwater om de oases te irrigeren. Door het Dades-dal loopt de 'Weg van de 1000 kashba's', waar eeuwenoude lemen burchten te bewonderen zijn die door Berbers zijn gebouwd.

269

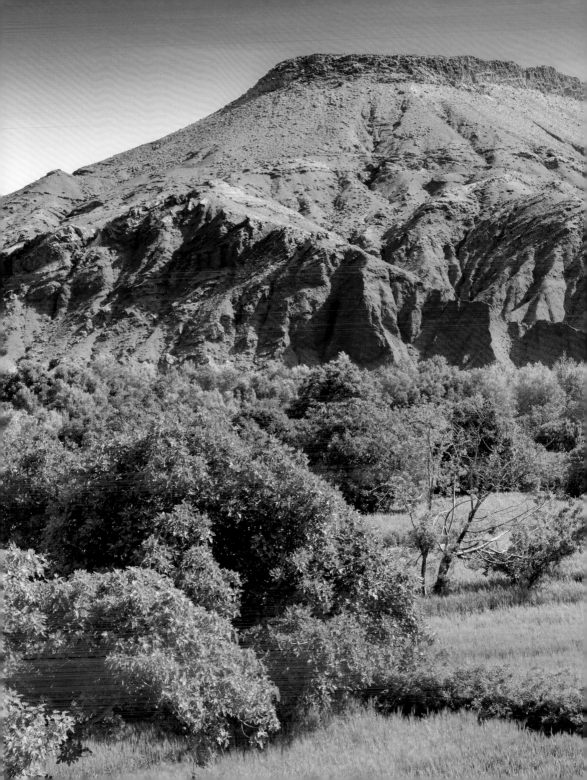

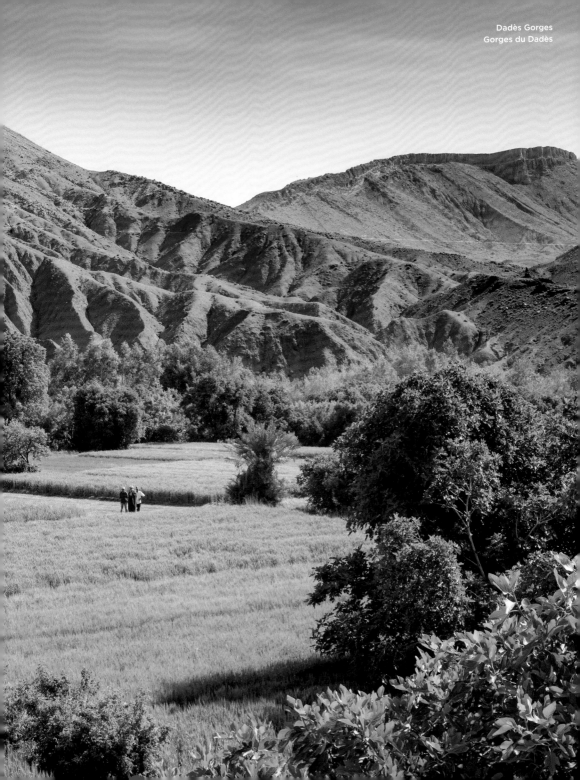
Dadès Gorges
Gorges du Dadès

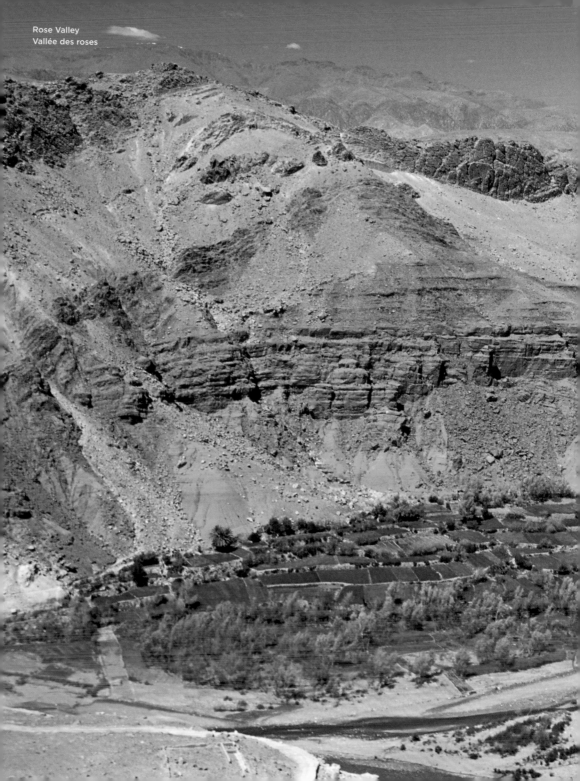
Rose Valley
Vallée des roses

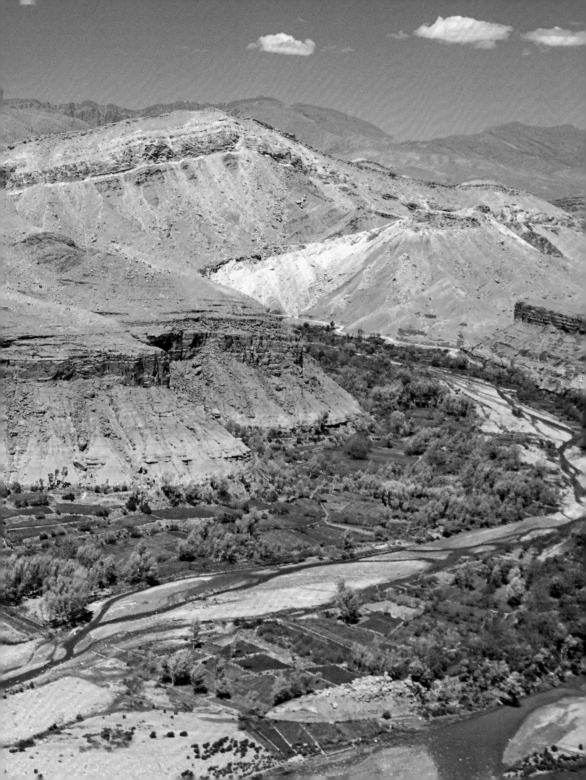

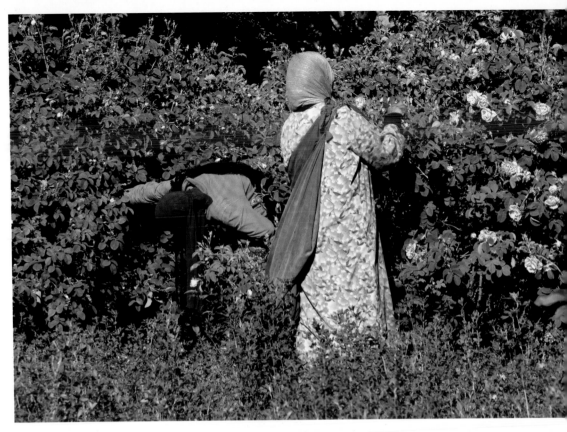

Rose Valley
Vallée des roses

Valley of Roses

"Hiking is the nose's pleasure" is the refrain for this valley, which follows the course of the river M'Goun to its source. Of course, this is only in spring, when the roses bloom and the almond blossoms perfume the air. By the beginning of May the aroma has gone, and the women are ready with the harvest. Between 500 and 1000 tons of rose petals are collected. Distilled, they are used in the production of cosmetics and fine sweets and pastries. The celebrations take place in mid-May, with the Festival of Roses being popular with locals and tourists alike.

Vallée des roses

« La randonnée est un plaisir pour le nez », voici ce que vous pourriez chanter dans cette vallée qui suit le cours de la rivière M'Goun jusqu'à ses sources. Bien sûr, cela vaut seulement au printemps, quand les roses fleurissent et les amandiers s'épanouissent. Début mai, il n'y a plus rien à sentir, les femmes ont fini la récolte. Entre 500 et 1 000 tonnes de pétales de roses sont ramassées. Distillés, ils sont utilisés en cosmétique et comme parfum pour les bonbons et les pâtisseries. Une grande fête a lieu à la mi-mai : le Festival des roses – qui est très populaire auprès de la population locale et des touristes.

Tal der Rosen

„Das Wandern ist der Nase Lust" möchte man singen in diesem Tal, das dem Lauf des Flusses M' Goun bis zu seinen Quellen folgt. Natürlich nur im Frühjahr, wenn die Rosen blühen und die Mandelblüten duften. Anfang Mai gibt es nichts mehr zu riechen, da sind die Frauen mit der Ernte fertig. Zwischen 500 und 1000 Tonnen Rosenblätter werden eingefahren. Destilliert finden sie Verwendung in Kosmetika und verfeinern Süßwaren und Gebäck. Mitte Mai wird dann gefeiert: Das Festival der Rosen ist bei Einheimischen wie bei Touristen beliebt.

Rose Valley
Vallée des roses

Valle de las Rosas

'El senderismo es un placer para el olfato''
es lo que entran ganas de cantar en este
valle que sigue el curso del río M' Goun
hasta sus manantiales. Por supuesto, solo
en primavera, cuando florecen las rosas
y las flores de almendro desprenden
su aroma. A principios de mayo no hay
nada más que oler; las mujeres están
listas para la cosecha. Se recogen entre
500 y 1000 toneladas de pétalos de rosa.
Destilados, se utilizan para la cosmética
y la refinación de dulces y bollería. La
celebración tendrá lugar a mediados de
mayo: La Fiesta de las Rosas es popular
entre los lugareños y turistas por igual.

Valle delle Rose

"Viaggiare è un piacere per chi ha naso"
verrebbe da cantare in questa valle che
segue il corso del fiume M'Goun fino
alle sue sorgenti. Naturalmente solo in
primavera, quando le rose fioriscono e i
fiori di mandorlo spargono tutt'intorno il
loro profumo. All'inizio di maggio tutti gli
odori però svaniscono: le donne portano
a termine in questo periodo la raccolta. I
petali di rosa così ottenuti raggiungono
500, addirittura 1000 tonnellate. Una volta
distillati sono utilizzati in cosmetica e in
pasticceria. A metà maggio si aprono poi
i festeggiamenti: il Festival delle rose è
popolare sia tra la gente del posto che tra
i turisti.

Dal van de rozen

'Wandelen is het genot van de neus' is wat
je in deze vallei wilt zingen, die de loop
van de rivier M' Goun volgt tot aan zijn
bron. Natuurlijk alleen in het voorjaar, als
de rozen bloeien en de amandelbloesems
geuren. Begin mei valt er niets meer te
ruiken, want dan zijn de vrouwen klaar
met de oogst. Tussen de 500 en 1000 ton
rozenblaadjes worden binnengebracht.
Gedistilleerd worden ze gebruikt in
cosmetica en verfijnen ze zoetigheden en
gebak. Half mei vinden de feestelijkheden
plaats: het Rozenfestival is bij zowel de
lokale bevolking als toeristen populair.

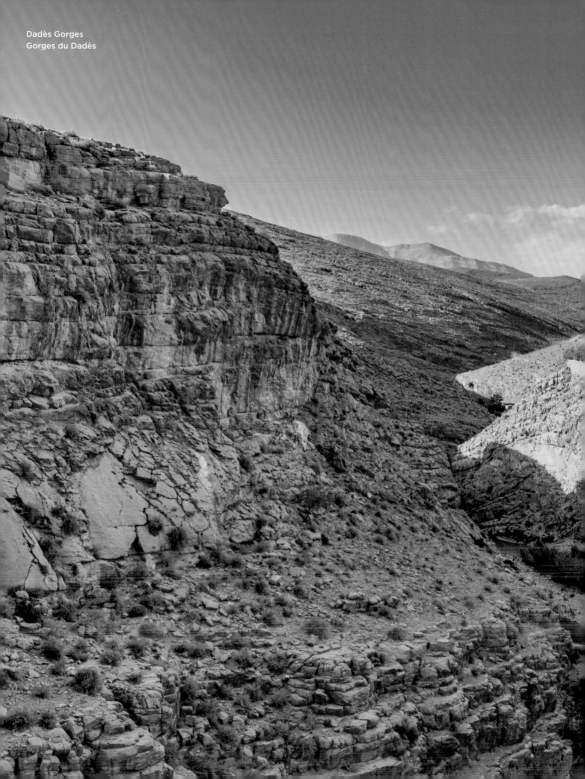

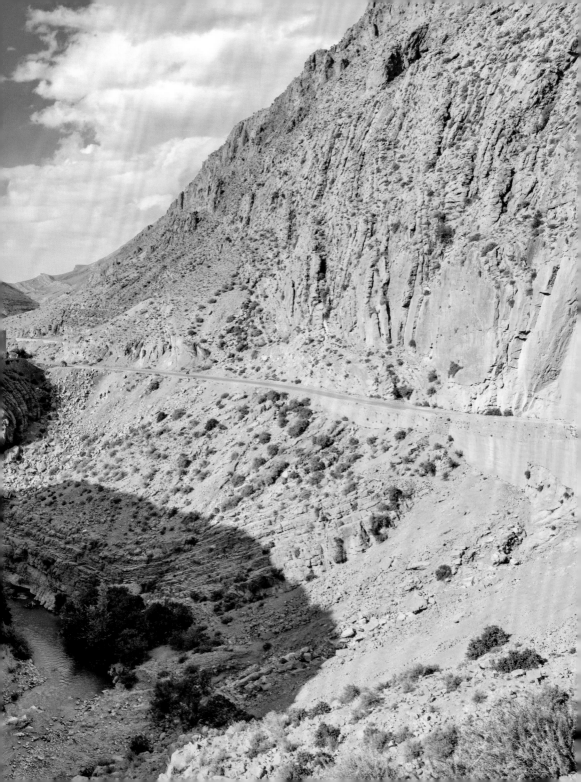

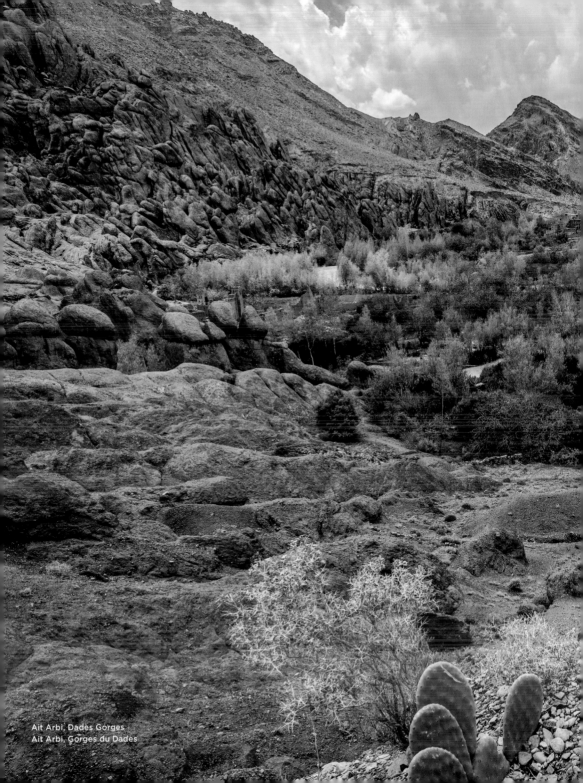

Aït Arbi, Dadès Gorges
Aït Arbi, Gorges du Dadès

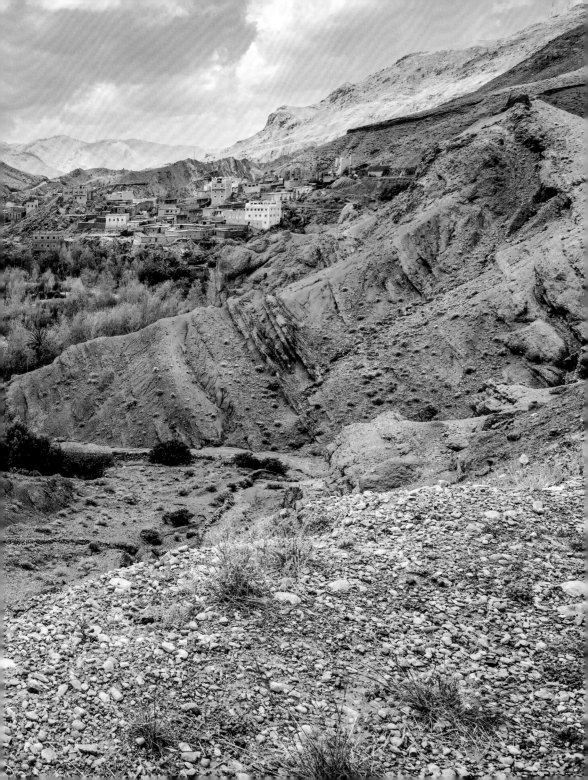

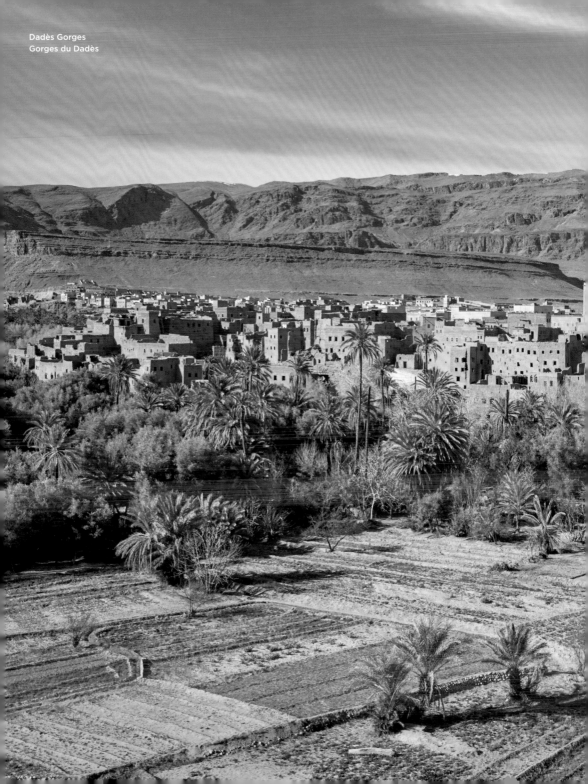

Dadès Gorges
Gorges du Dadès

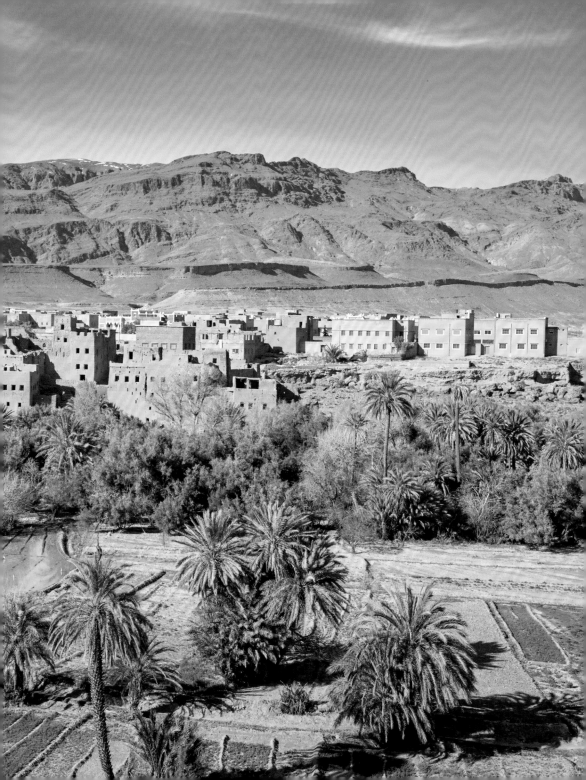

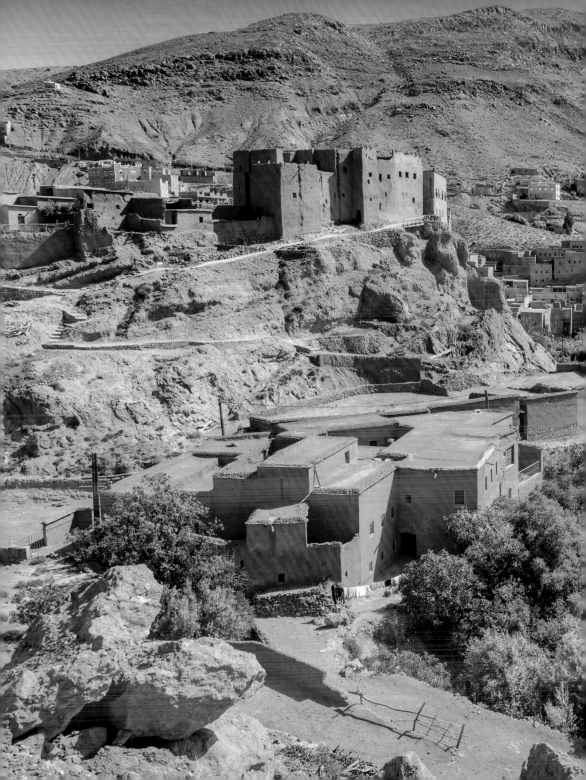

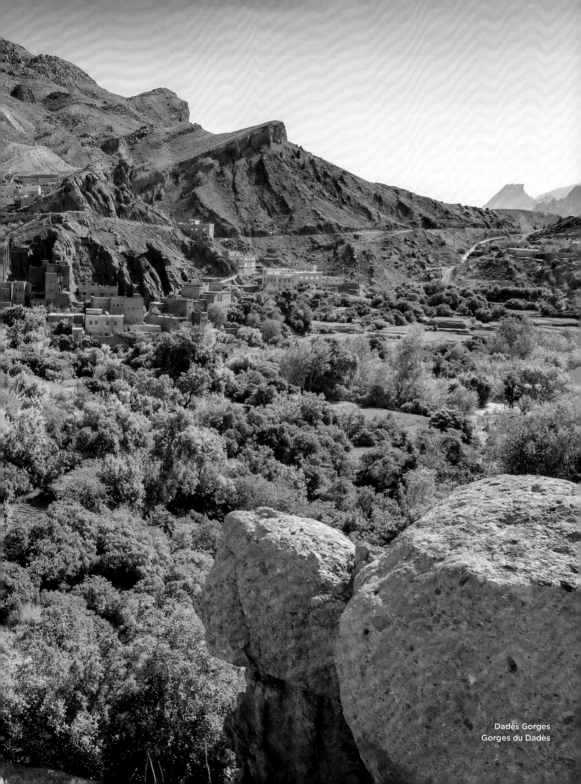

Dadès Gorges
Gorges du Dadès

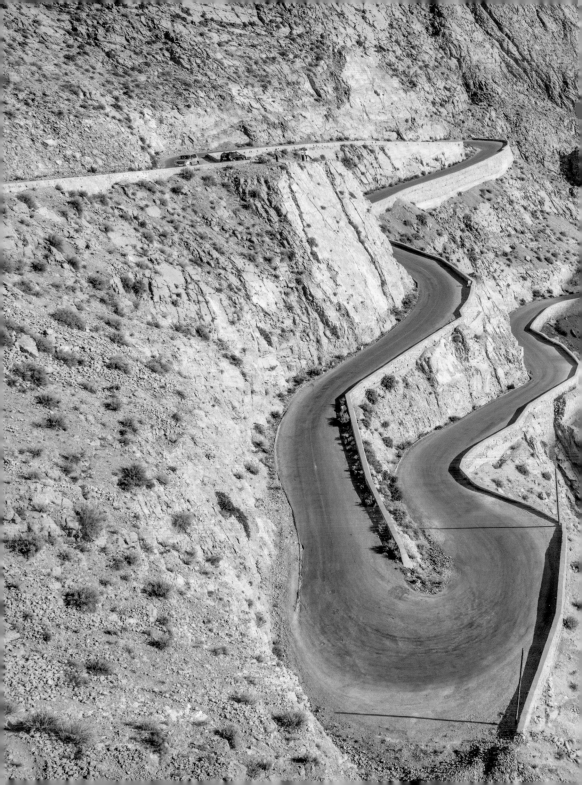

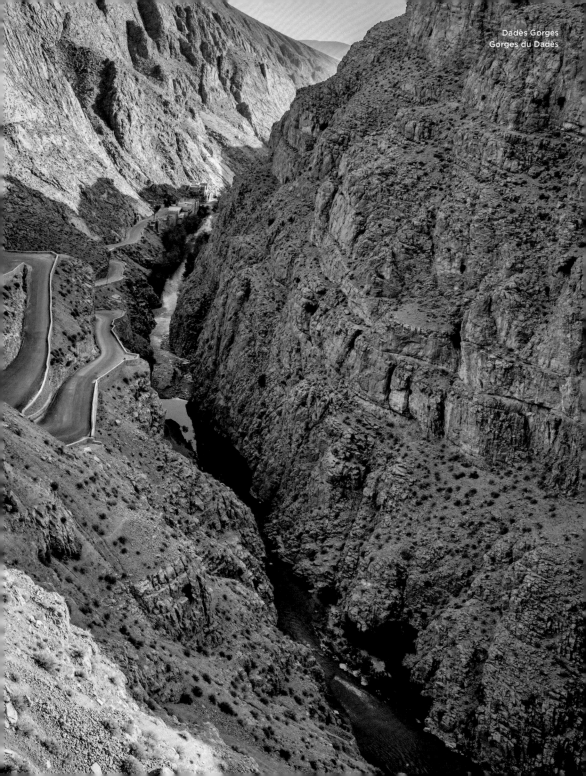

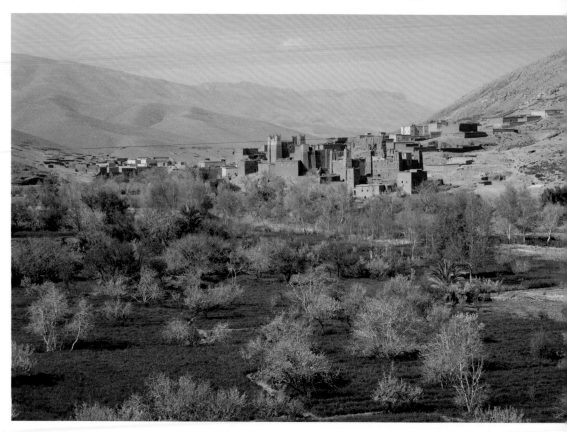

Ait Arbi, Dadès Gorges
Ait Arbi, Gorges du Dadès

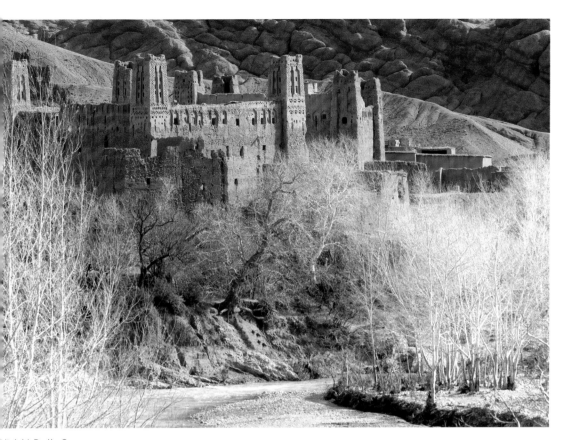

Ait Arbi, Dadès Gorges
Ait Arbi, Gorges du Dadès

Tinghir

Tinghir

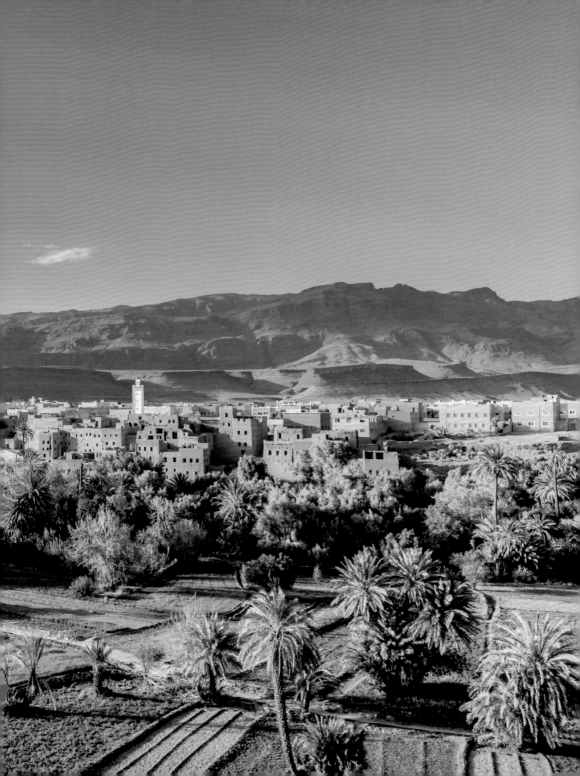

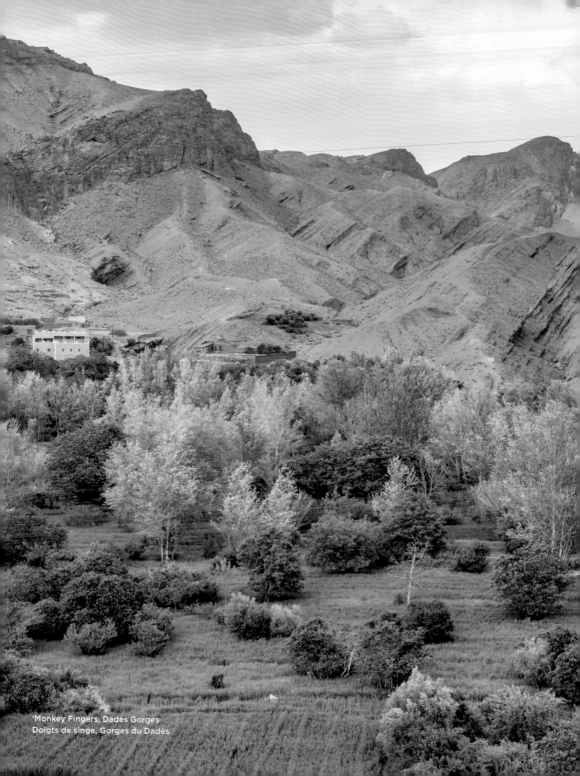

'Monkey Fingers, Dadès Gorges
Doigts de singe, Gorges du Dadès

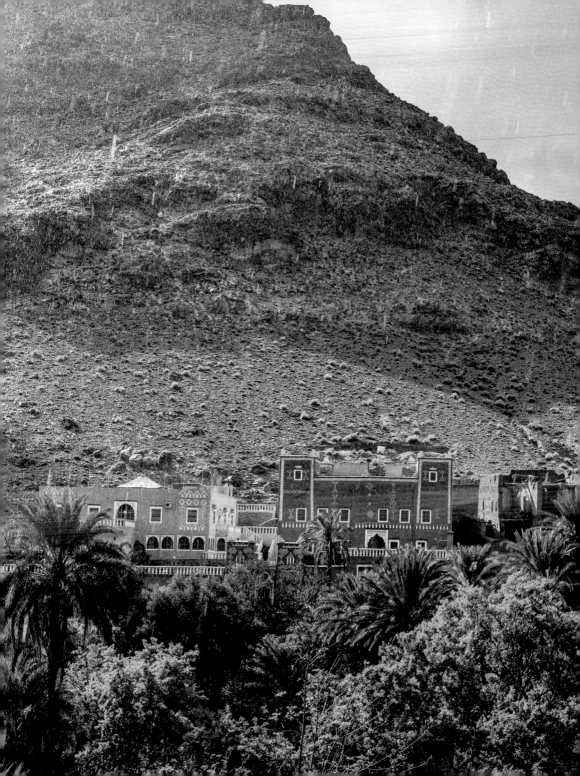

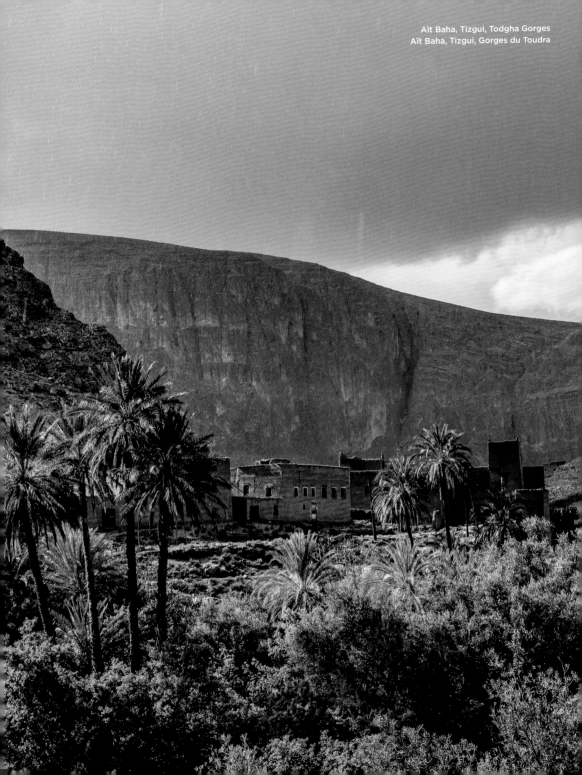

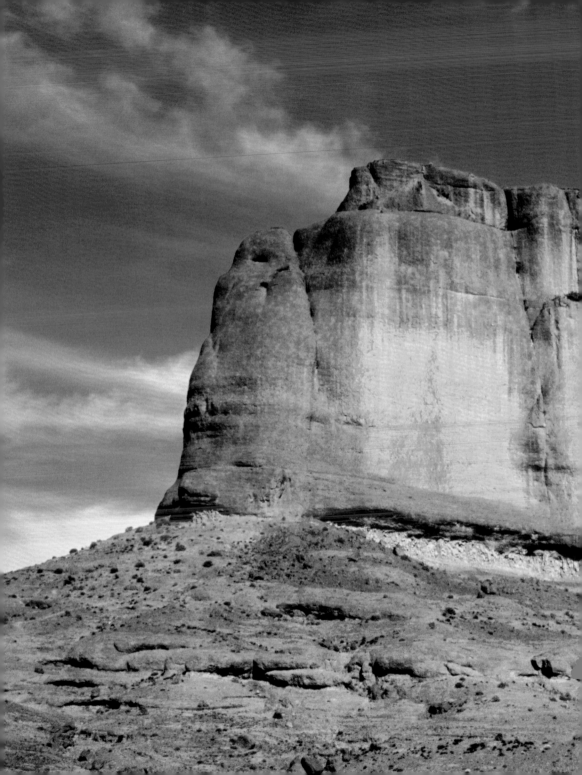

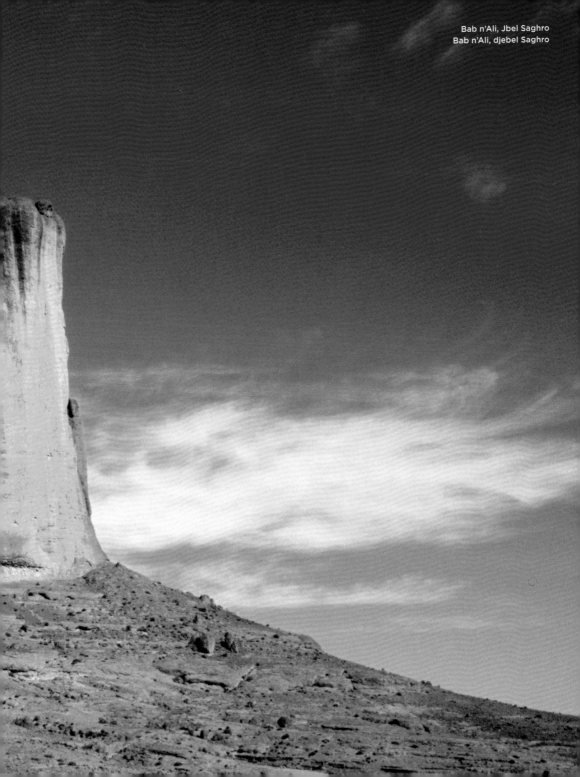

Bab n'Ali, Jbel Saghro
Bab n'Ali, djebel Saghro

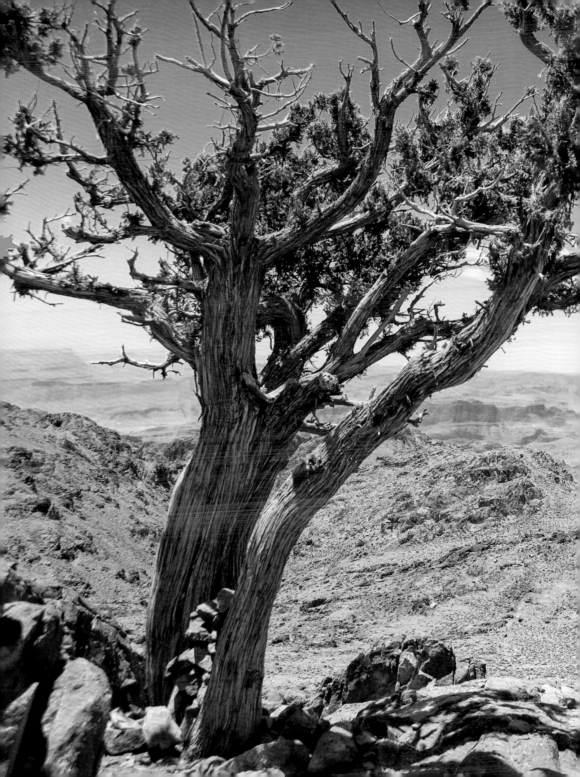

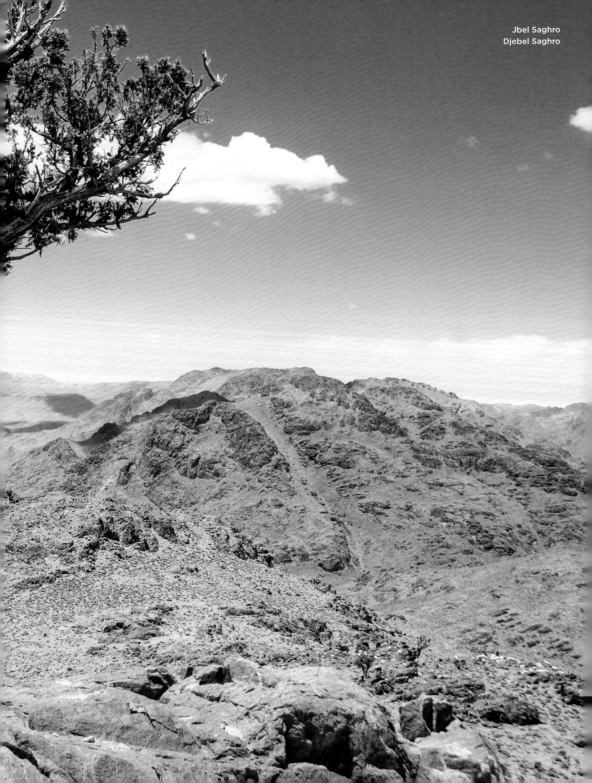

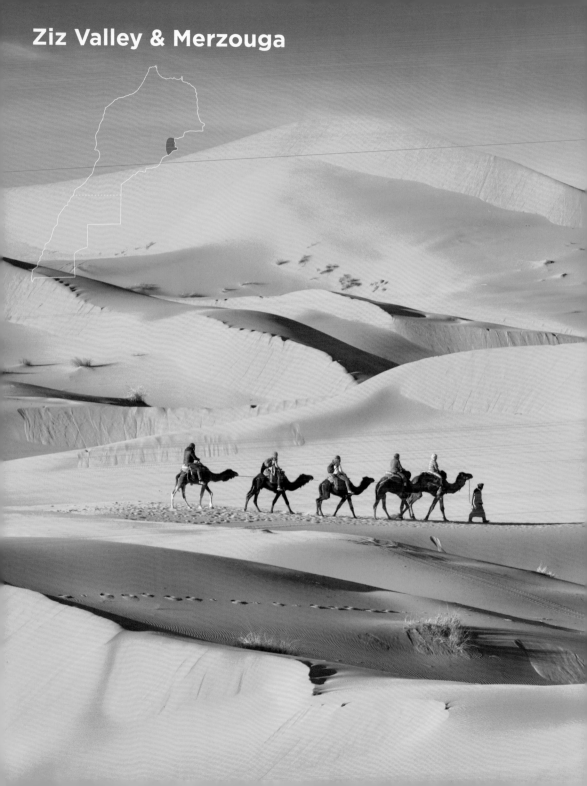

Ziz Valley & Merzouga

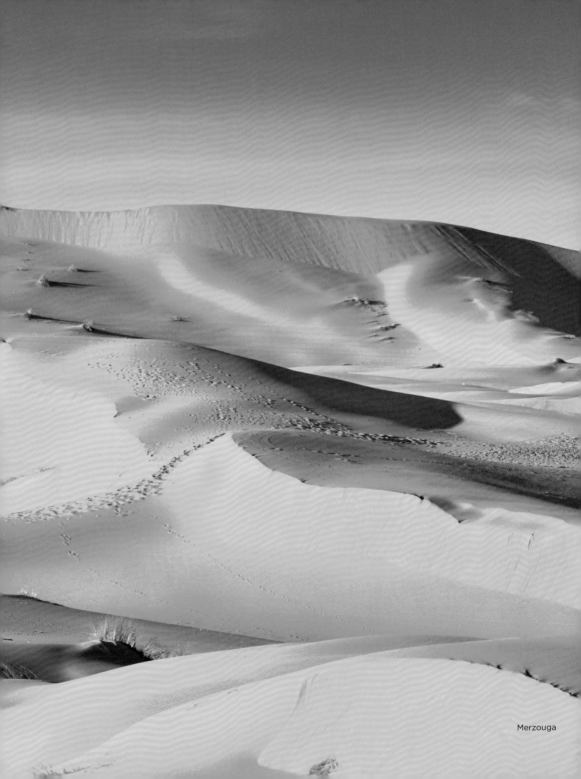

Merzouga

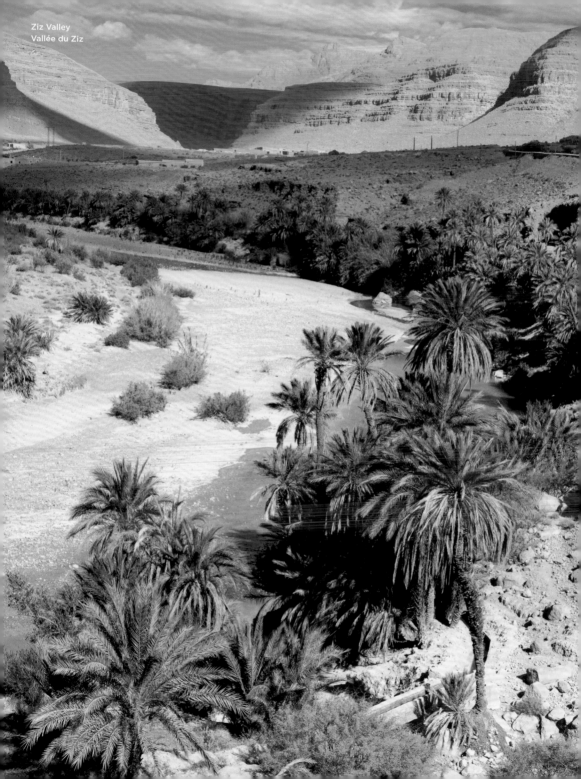

Ziz Valley
Vallée du Ziz

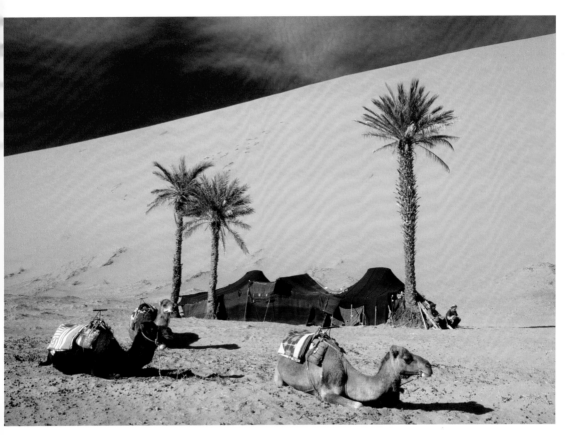

Merzouga

Ziz Valley & Merzouga
The river Ziz supplies water to Tafilalt, Morocco's largest oasis. It extends to Erg Chebbi, the second largest dune area in the country at 22 km from north to south, on the edge of which Merzouga lies.

Valle del Ziz & Merzouga
El río Ziz abastece de agua a Tafilalet, el oasis más grande de Marruecos. Se extiende hasta Erg Chebbi, la segunda zona de dunas más grande del país, con 22 km de longitud, y en cuyo borde se encuentra Merzouga. Desde allí se llega al pueblo de Gnaoua.

Vallée du Ziz & Merzouga
Le fleuve Ziz fournit de l'eau à Tafilalet, la plus grande oasis du Maroc. Elle s'étend jusqu'à l'erg Chebbi, la deuxième plus grande zone de dunes du pays, longue de 22 km, sur le bord de laquelle se trouve Merzouga.

Valle dello Ziz & Merzouga
Il fiume Ziz fornisce acqua a Tafilalet, la più grande oasi del Marocco. Si estende fino all'Erg Chebbi, che con i suoi 22 km di estensione è la seconda duna più grande del paese. Ai suoi confini si trova Merzouga, da dove si raggiunge il villaggio di Gnaoua.

Ziztal & Merzouga
Der Fluss Ziz versorgt das Tafilalet, das ausgedehnteste Oasengebiet Marokkos, mit Wasser. Es erstreckt sich bis zum Erg Chebbi, dem mit 22 km Länge zweitgrößten Dünengebiet des Landes, an dessen Rand Merzouga liegt.

Ziz-dal & Merzouga
De rivier de Ziz levert water aan Tafilalet, de grootste oase van Marokko. Hij strekt zich uit tot Erg Chebbi, het een na grootste duingebied van het land, 22 km lang, aan de rand waarvan Merzouga ligt. Van daaruit bereikt u het dorp Gnaoua.

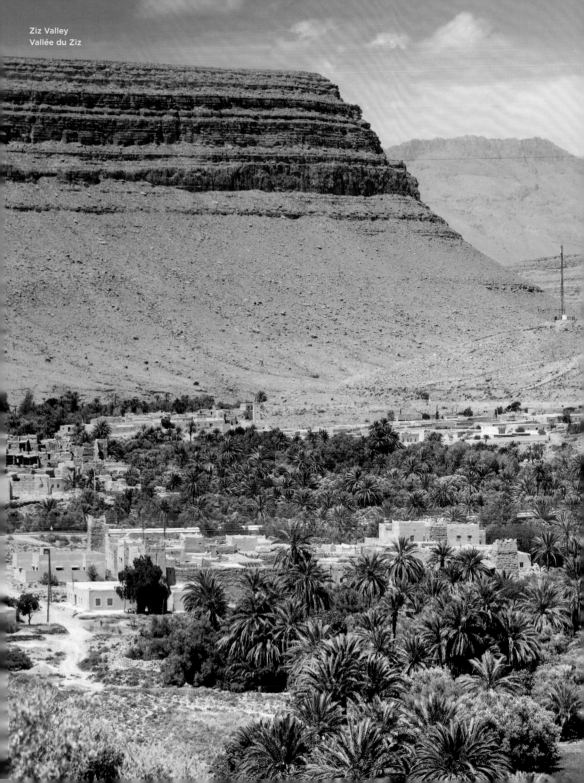

Ziz Valley
Vallée du Ziz

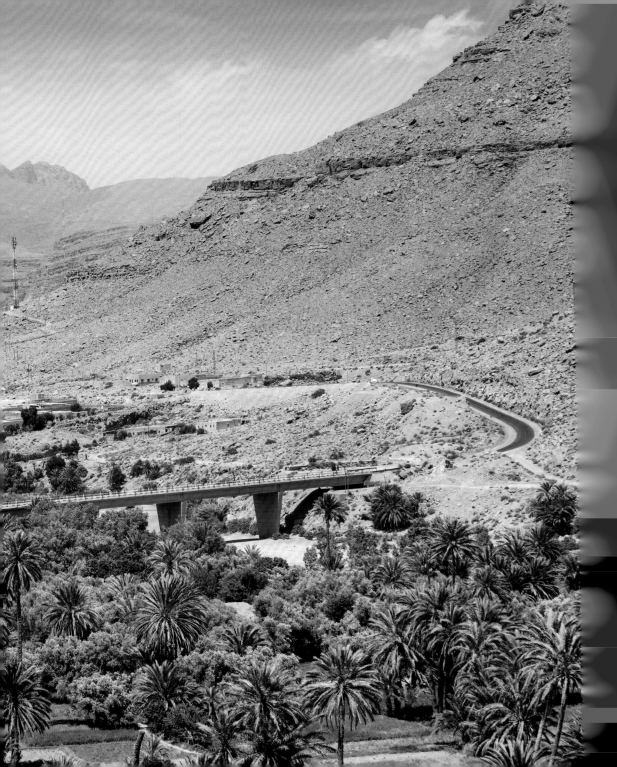

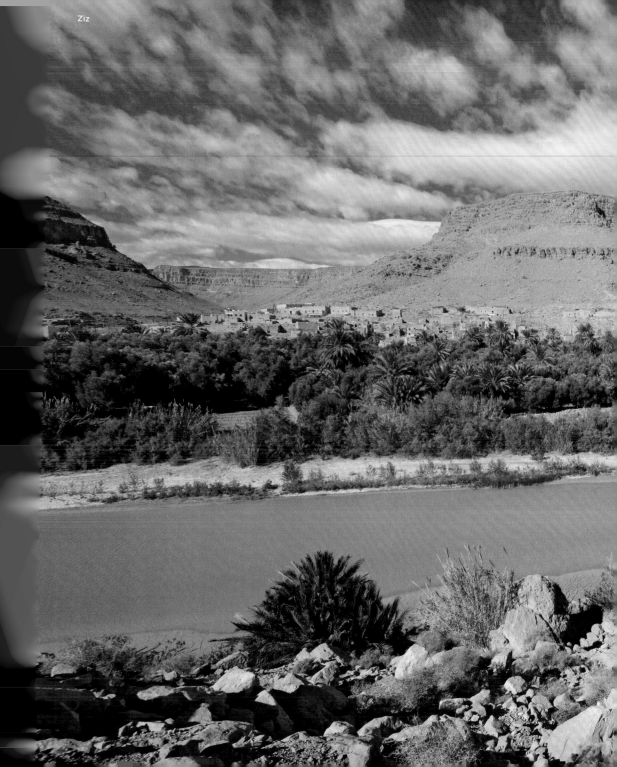

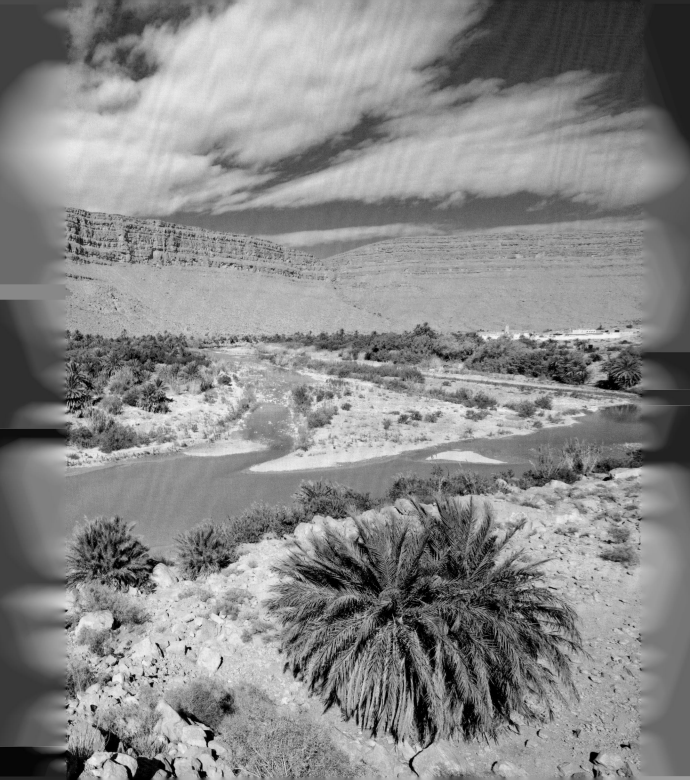

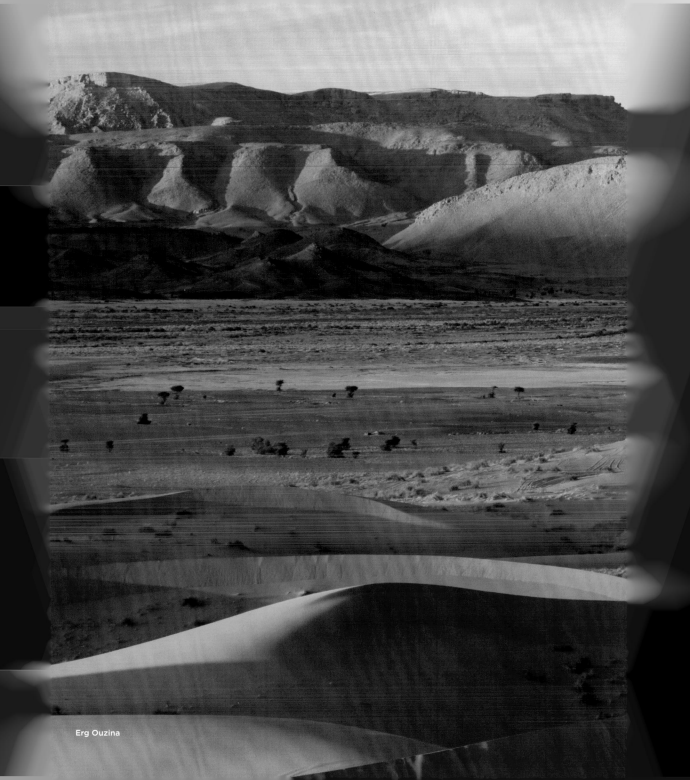

Erg Ouzina

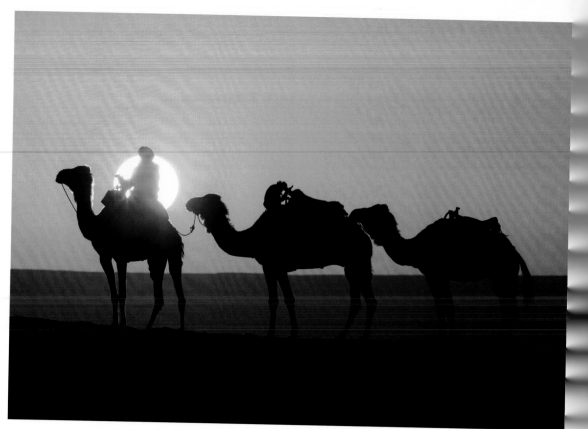

Merzouga

Excursion into the desert

The ride on a dromedary starts with a wobble. The animal leans on its front legs, stands up with its rear legs and then brings the front legs into position. Afterwards it will be comfortable, as one supports one's legs on the neck of the animal, enjoying the soft cradle and the wonderful desert landscape. This is much more pleasurable than a tour with an all-terrain vehicle, which the organisers also offer. If you want to spend the night in the desert, you'll have to dress warmly, because as soon as the sun has disappeared the temperature drops rapidly.

Excursion dans le désert

La promenade en dromadaire commence par un déséquilibre : l'animal s'appuie sur ses pattes avant, se tient debout derrière et met ensuite les pattes avant en position. Ensuite, il deviendra confortable : soutenez les jambes sur le cou de l'animal, profitez du bercement tranquille et du merveilleux paysage désertique. C'est beaucoup plus agréable qu'un tour en véhicule tout-terrain, que les organisateurs proposent également. Si vous voulez passer la nuit dans le désert, vous devrez vous habiller chaudement. Dès que le soleil a disparu, le désert devient glacial.

Ausflug in die Wüste

Der Ritt auf einem Dromedar beginnt mit einer Wackelpartie: Das Tier stützt sich auf die eingeschlagenen Vorderbeine, steht hinten auf und bringt dann die vorderen Läufe in Position. Danach wird's gemütlich: Beine am Hals des Tieres abstützen, das weiche Wiegen und die herrliche Wüstenlandschaft genießen. Das ist viel schöner als eine Tour mit dem Geländewagen, die Veranstalter auch anbieten. Wer in der Wüste übernachten will, muss sich warm anziehen: Sobald die Sonne verschwunden ist, wird es eiskalt.

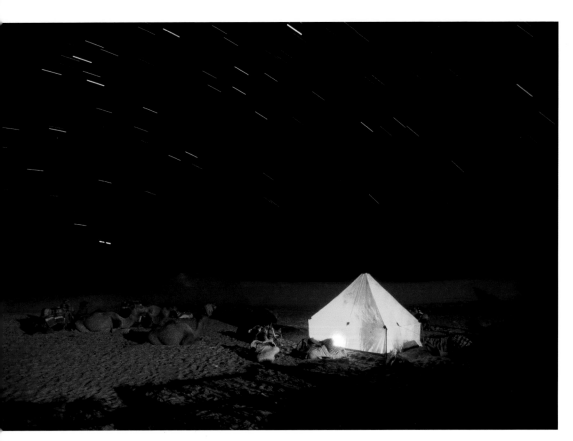

Merzouga

Excursión al desierto

El paseo en un dromedario comienza con un bamboleo: el animal se apoya en sus patas delanteras, pone en pie sus patas traseras y entonces las delanteras. Después de esto, la experiencia es cómoda: al apoyar las piernas en el cuello del animal, se disfruta el suave balanceo y el maravilloso paisaje desértico. Esto es mucho más agradable que un tour con un vehículo todoterreno, que también ofrecen los organizadores. Si se desea pasar la noche en el desierto, hay que ir bien abrigado, pues en cuanto se va el sol, hace mucho frío.

Escursione nel deserto

Il viaggio su un dromedario è all'inizio piuttosto oscillante: l'animale si appoggia sulle zampe anteriori piegate, distende quindi quelle posteriori e porta infine quelle anteriori in posizione eretta. Da qui in poi diventerà più comodo: con le gambe intorno al collo dell'animale, dolcemente cullati, si potrà godere del meraviglioso paesaggio del deserto. Un'escursione così è molto più bella dei tour con fuoristrada che vengono offerti. Chi vuole trascorrere la notte nel deserto deve portarsi abiti pesanti: non appena il sole cala farà freddo.

Excursie in de woestijn

De rit op een dromedaris begint met veel gewiebel: het dier leunt op zijn voorpoten, staat met zijn achterpoten op en brengt dan zijn voorpoten in positie. Daarna wordt het comfortabel: steun uw benen op de hals van het dier, geniet van het zachte wiegen en het prachtige woestijnlandschap. Dat is veel leuker dan een tocht met een terreinwagen, die de organisatoren ook aanbieden. Wie in de woestijn wil overnachten, moet zich warm kleden: zodra de zon is verdwenen, wordt het ijskoud.

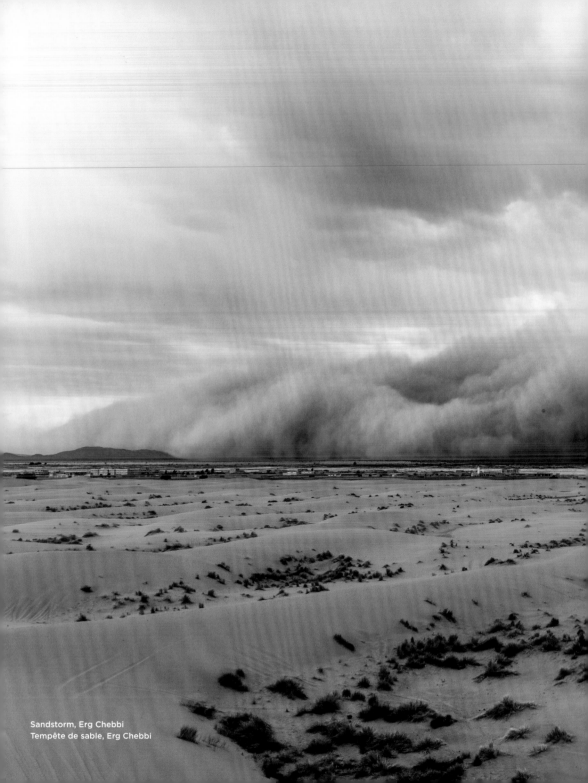

Sandstorm, Erg Chebbi
Tempête de sable, Erg Chebbi

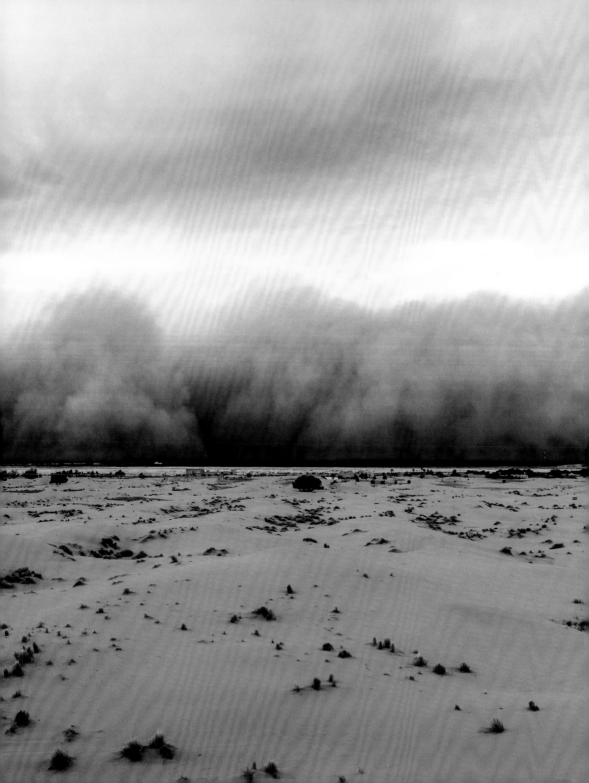

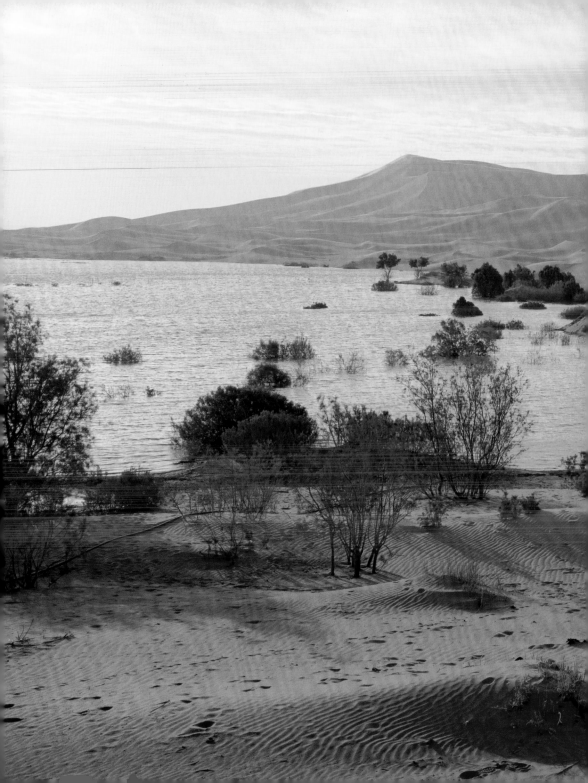

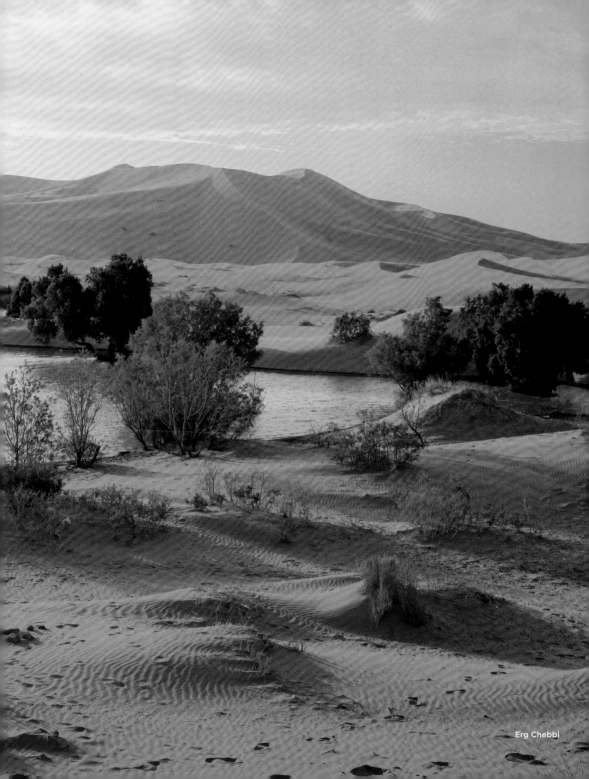

Erg Chebbi

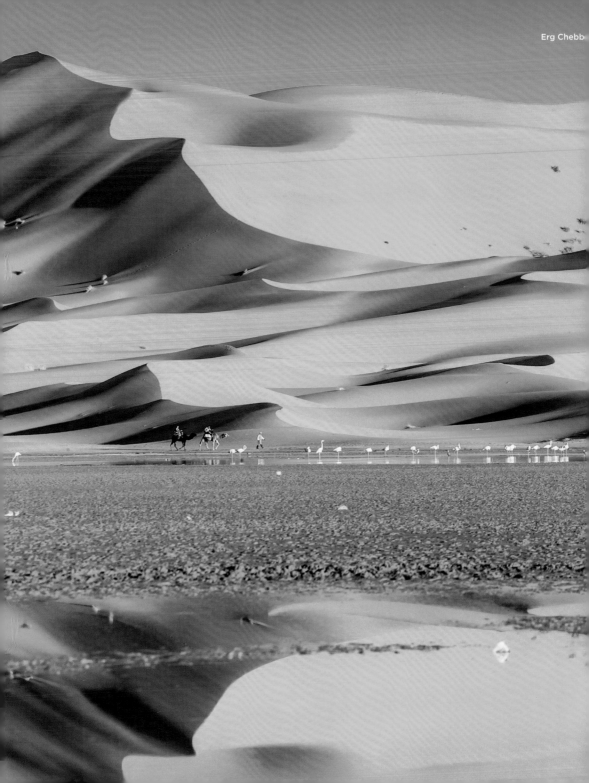

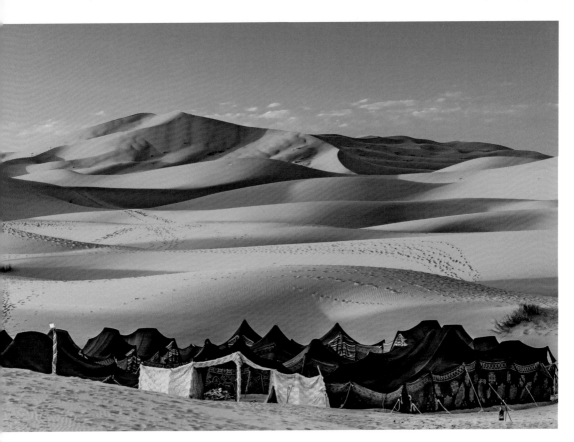

Erg Chebbi

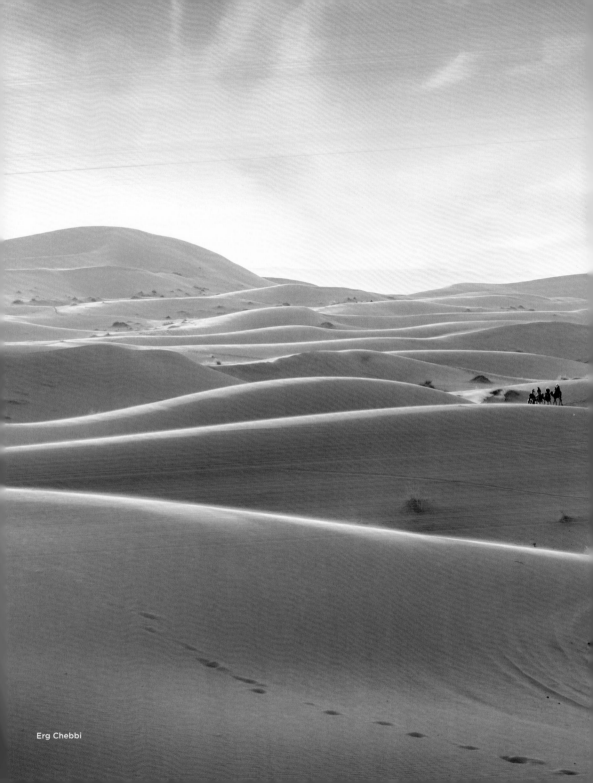

Erg Chebbi

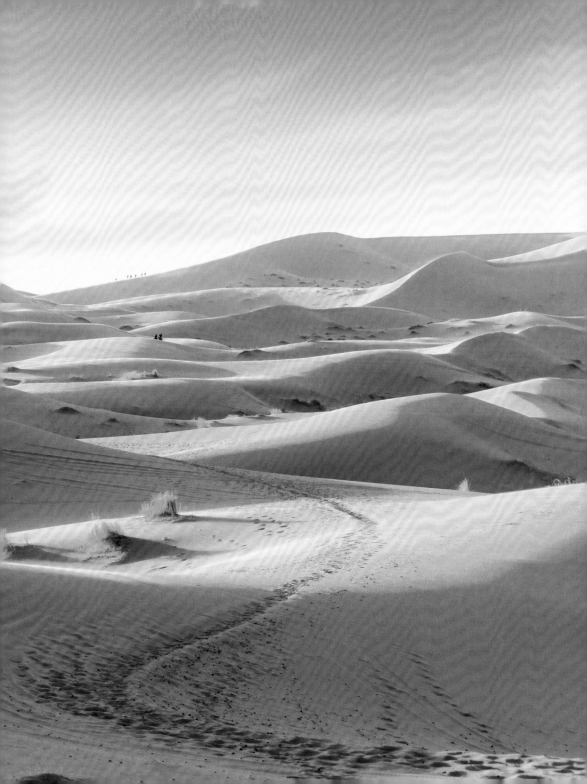

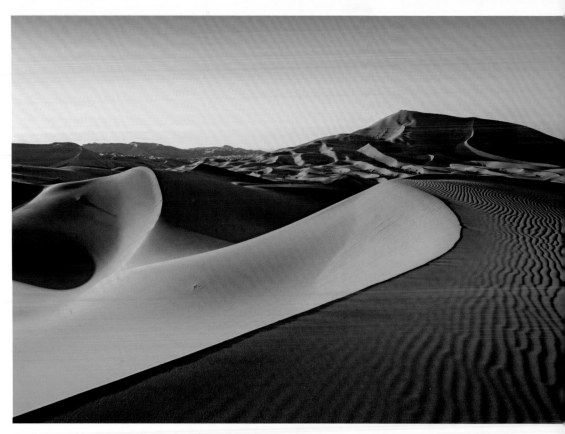

Erg Chebbi

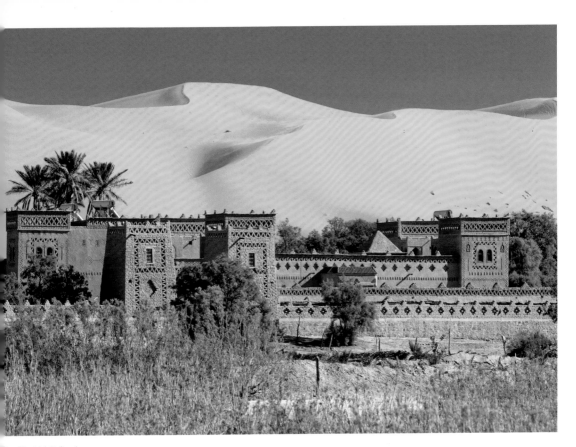

Erg Chebbi, Erfoud

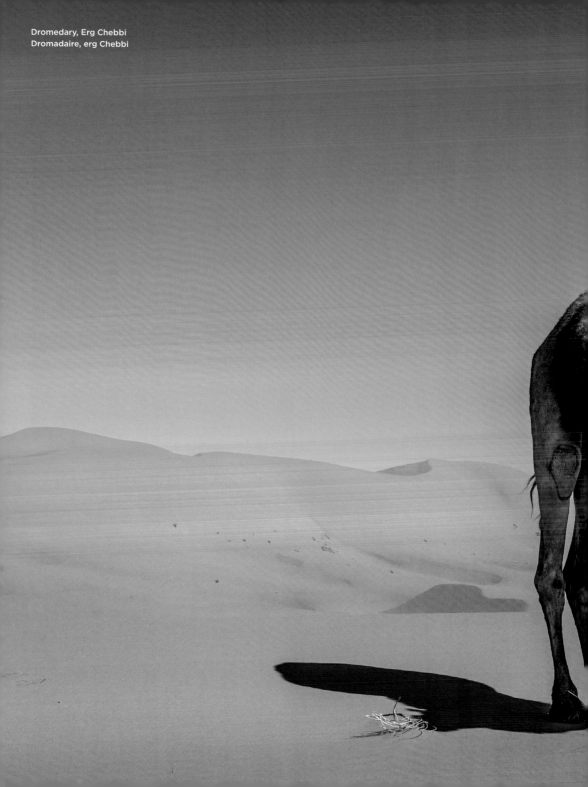

Dromedary, Erg Chebbi
Dromadaire, erg Chebbi

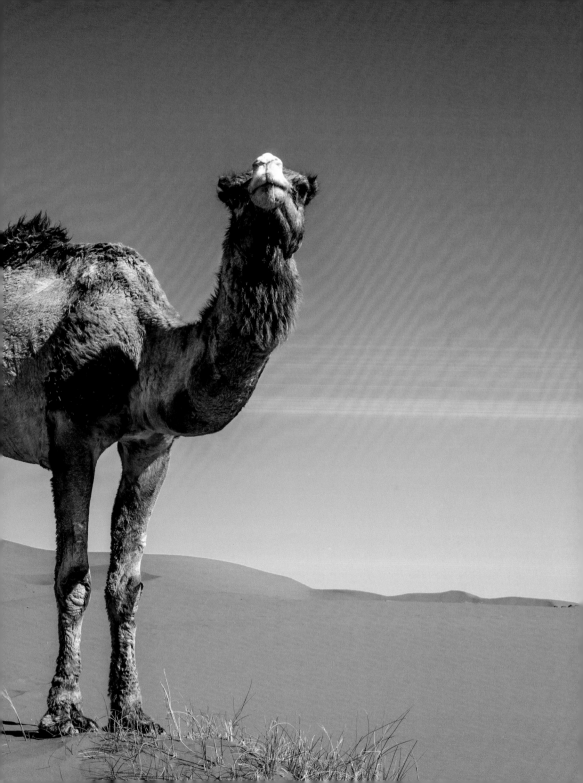

Erg Chebbi

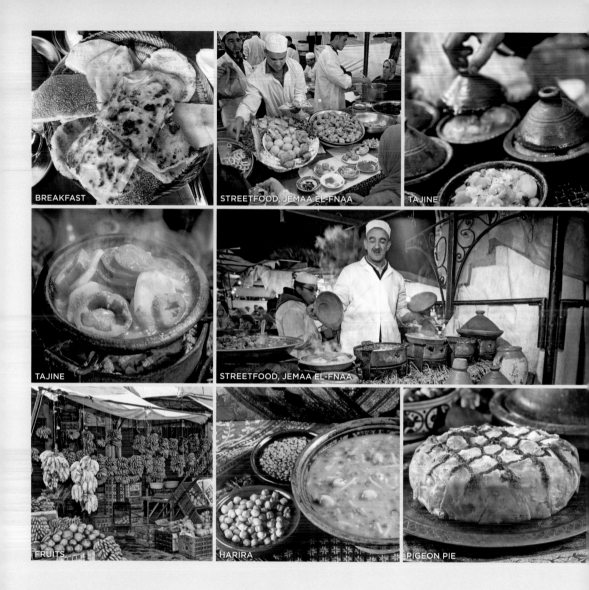

BREAKFAST

STREETFOOD, JEMAA EL-FNAA

TAJINE

TAJINE

STREETFOOD, JEMAA EL-FNAA

FRUITS

HARIRA

PIGEON PIE

Culinary

Couscous is only one of Morocco's specialities, whose cuisine is characterised by diversity. The country supplies high quality food products: fish, meat, fruit, vegetables and spices such as Ras-el-Hanout ('Top of the House'), a spice mixture usually consisting of a dozen, or even many more, ingredients. The Berbers are known for their *tajine* pot, with its conical lid, and the dishes prepared in it bear the same name.

Gastronomie

Le couscous n'est qu'une des nombreuses spécialités marocaines, dont la cuisine se caractérise avant tout par sa diversité. Le pays fournit les meilleurs produits, poissons, viandes, fruits, légumes et épices tels que le ras-el-hanout, qui se compose de 35 ingrédients différents. Les Berbères utilisaient déjà le plat à *tajine* avec son couvercle conique, les recettes préparées dans ce plat portaient le nom de celui-ci.

Kulinarisches

Couscous ist nur eine Spezialität Marokkos, dessen Küche sich durch Vielfalt auszeichnet. Das Land liefert beste Produkte, Fisch, Fleisch, Obst, Gemüse und Gewürze wie Ras-el-Hanout, das aus 35 Zutaten besteht. Bereits die Berber stellten den *Tajine*-Topf mit seinem kegelförmigen Hut her, die in ihm zubereiteten Gerichte tragen den Namen des Topfes.

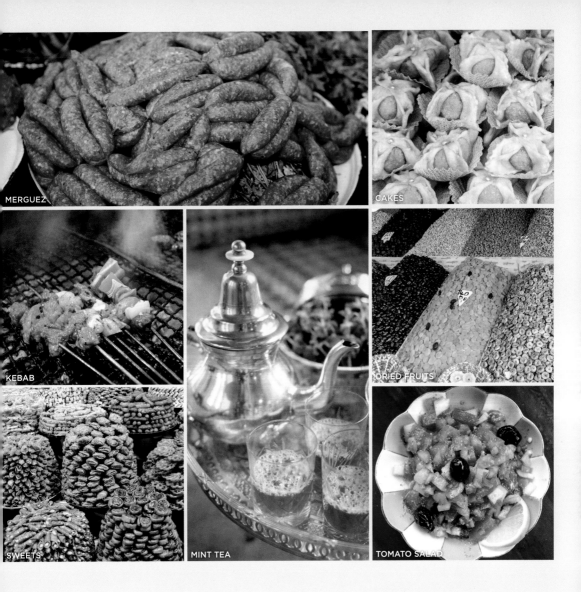

MERGUEZ

CAKES

KEBAB

DRIED FRUITS

SWEETS

MINT TEA

TOMATO SALAD

Gastronomía

El cuscús es solo una de las especialidades de Marruecos, cuya cocina se caracteriza por la diversidad. El país exporta los mejores productos: pescado, carne, frutas, verduras y especias, como el Ras-el-Hanout, que consta de 35 ingredientes. Los bereberes ya producían la olla *tajine* con su sombrero cónico, los platos preparados en ella llevan el nombre de la olla.

In cucina

Il cuscus è solo una delle specialità marocchine, la cui cucina è caratterizzata dalla diversità. Il paese fornisce materie prime di alta qualità - pesce, carne, frutta, verdura e spezie come il Ras el Hanout, che consiste di 35 ingredienti. I berberi già producevano le *tajine* con il caratteristico coperchio a cono; le pietanze così preparate prendono il nome da questo piatto tipico.

Culinair

Couscous is slechts één Marokkaanse specialiteit, want de keuken van Marokko wordt gekenmerkt door diversiteit. Het land levert uitstekende producten: vis, vlees, fruit, groenten en specerijen zoals ras-el-hanout, dat uit 35 ingrediënten bestaat. De Berbers maakten de *tajine* met zijn kegelvormige hoed al – de gerechten die erin bereid worden, dragen de naam van deze pot.

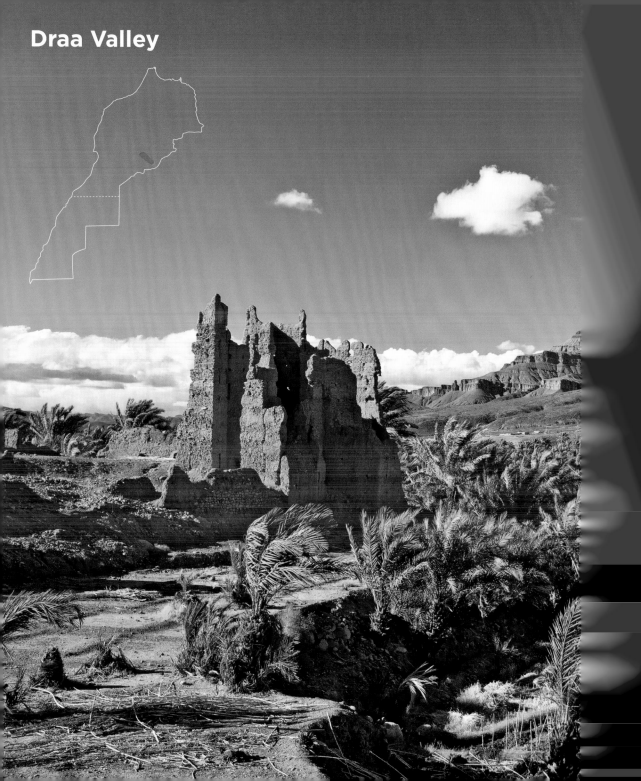

Draa Valley

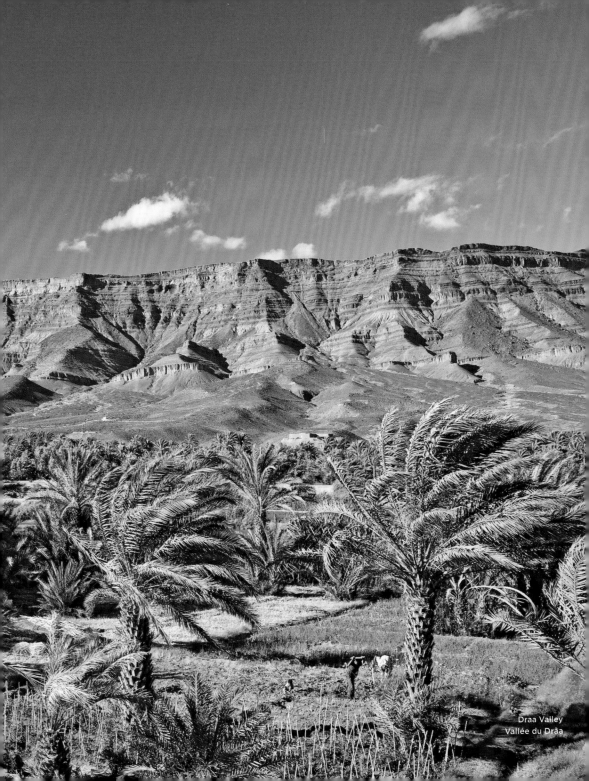

Draa Valley
Vallée du Drâa

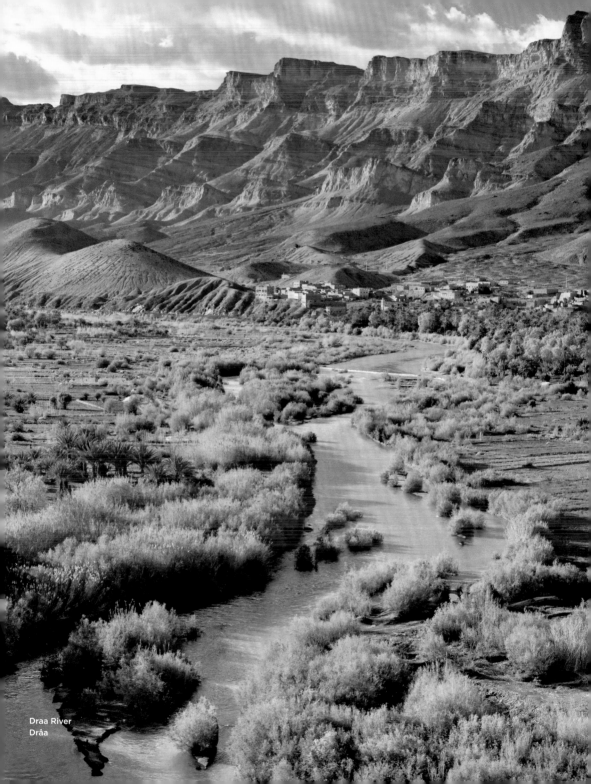

Draa River
Drâa

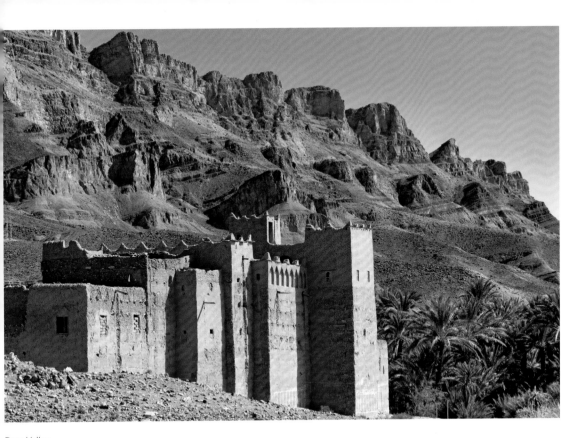

Draa Valley
Vallée du Drâa

Draa Valley

With a length of 1100 km, the Draa is Morocco's longest river. But this statement is misleading, in that behind Zagora the riverbed is dry most of the year, hence the name Wadi Draa. Zagora, an extensive oasis on the banks of the Draa, used to be an important caravan station and today serves as a starting point for excursions into the desert.

Valle del Draa

Con una longitud de 1100 km, el Draa es el río más largo de Marruecos. Pero esta afirmación es una teoría gris: detrás de Zagora el lecho del río está seco la mayor parte del año; de ahí el nombre de Wadi Draa. Zagora, un extenso oasis situado a orillas del Draa, solía ser una importante estación de caravanas y hoy sirve como punto de partida para excursiones al desierto.

Drâa

D'une longueur de 1100 km, le Drâa est le plus long fleuve du Maroc. Mais cette affirmation est trompeuse : derrière Zagora, le lit de la rivière est sec la majeure partie de l'année, d'où le nom d'Oued Drâa. Zagora, une vaste oasis sur les rives du Drâa, était autrefois une importante station de caravane et sert aujourd'hui de point de départ pour des excursions dans le désert.

La valle del Draa

Con un'estensione di 1100 km, il Draa è il fiume più lungo del Marocco. Ma questa è un'affermazione puramente teorica: una volta oltrepassata Zagora, il letto del fiume rimane asciutto per la maggior parte dell'anno, per cui viene chiamato *uadi*, termine che designa un fiume a carattere non perenne. Zagora, un'ampia oasi sulle rive del Draa, era un'importante stazione per le vie carovaniere e oggi serve come punto di partenza per le escursioni nel deserto.

Draatal

Mit einer Länge von 1100 km ist die Draa der längste Fluss Marokkos. Doch diese Angabe ist graue Theorie: Hinter Zagora ist das Flussbett die meiste Zeit des Jahres trocken, daher auch der Name Wadi Draa. Zagora, eine ausgedehnte Oase am Ufer der Draa, war früher eine bedeutende Karawanenstation und dient heute als Ausgangspunkt für Exkursionen in die Wüste.

Draa-dal

Met een lengte van 1100 km is de Draa de langste rivier van Marokko. Maar deze grootspraak is puur theoretisch: achter Zagora is de rivierbedding het grootste deel van het jaar droog. Vandaar de naam Wadi Draa. Zagora, een uitgestrekte oase aan de oevers van de Draa, was vroeger een belangrijke karavaanhalte en dient tegenwoordig als beginpunt voor excursies in de woestijn.

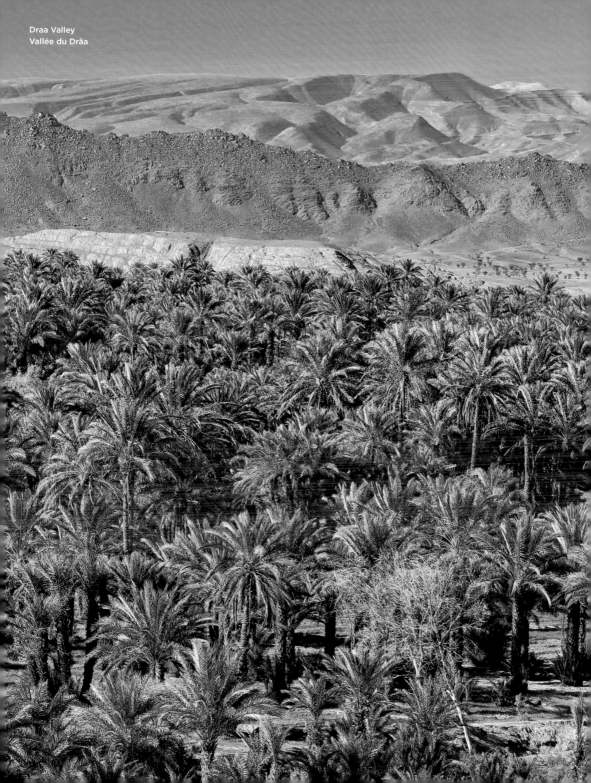

Draa Valley
Vallée du Drâa

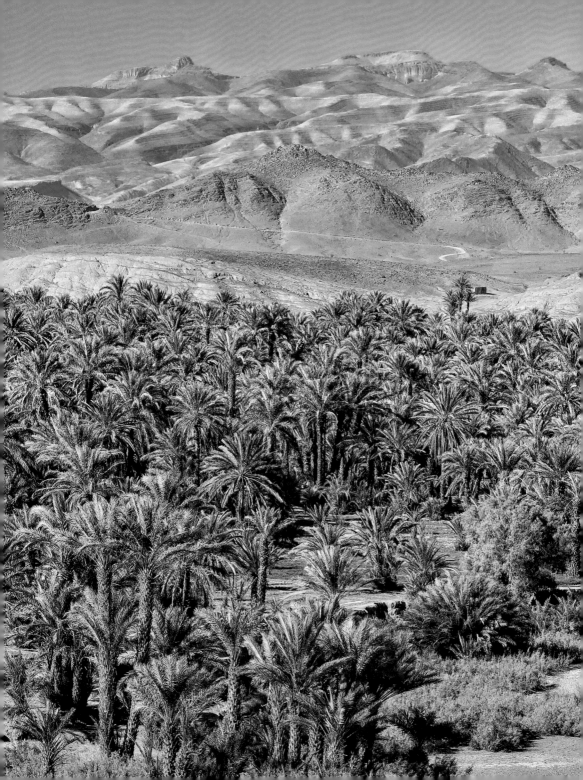

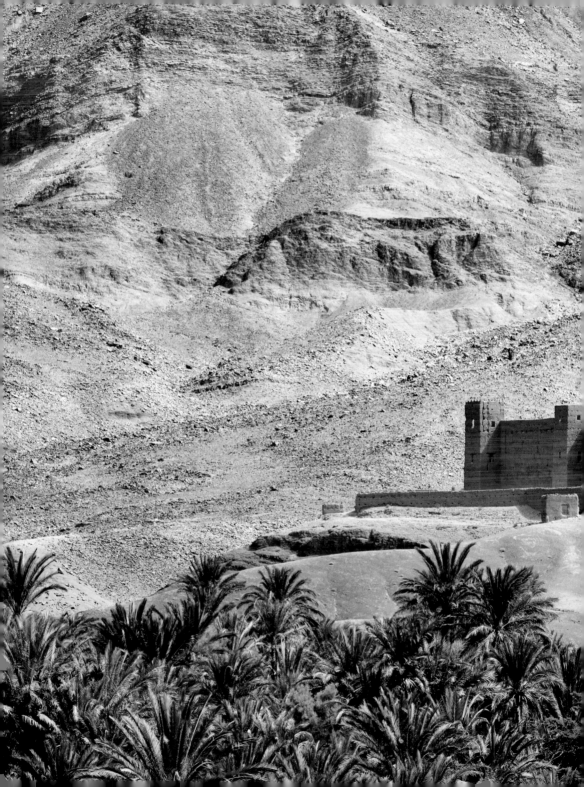

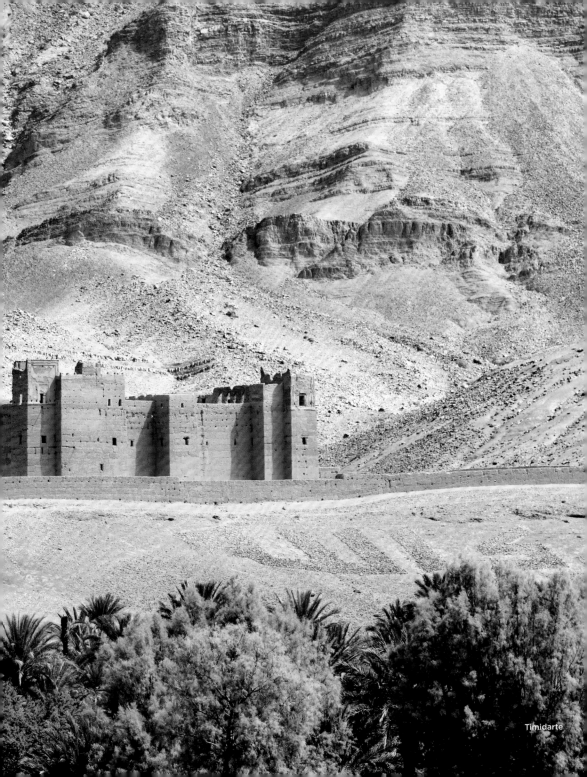

Timidarte

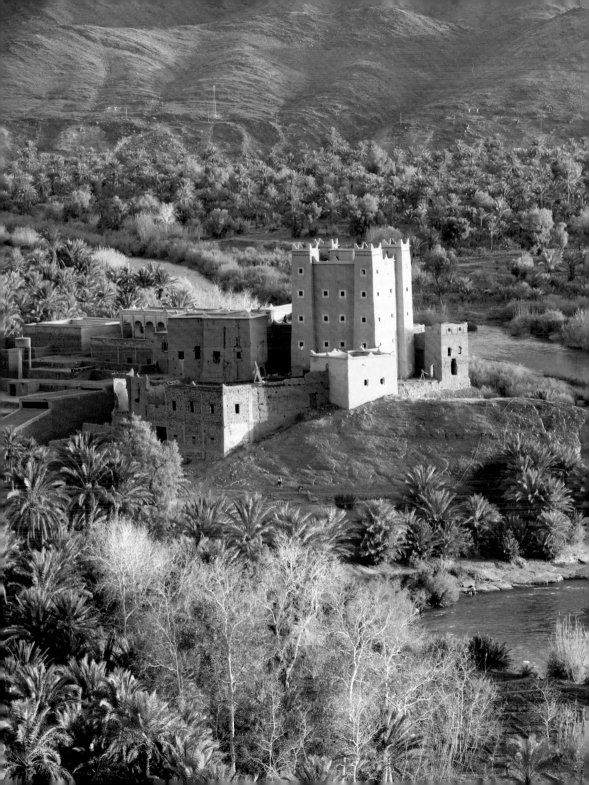

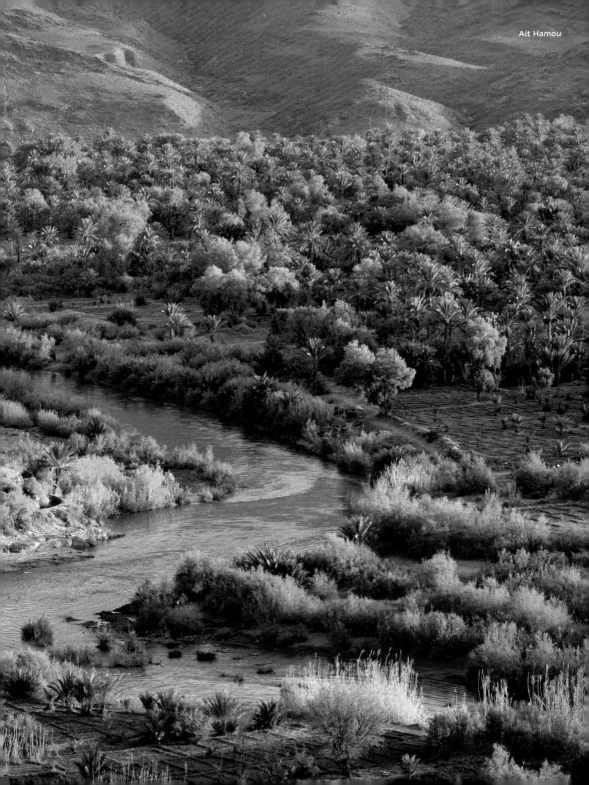

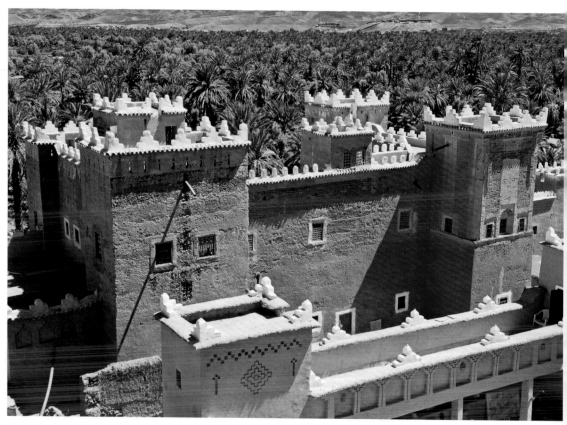

Kasbah Qiad Ali, Agdz

Casbah Qaid Ali

The older of these two kasbahs is
250 years old, and the newer one with
the fortified towers only 150 years. The
grandfather of the present owners was
an important man, a *Qaid*, or tribal leader
of a Berber clan. Should these buildings
deteriorate like so many other casbahs?
No, said the heirs and decided to generate
the necessary money for the upkeep
through income from tourism. The palm
grove became a campsite, with volunteers,
among them students from Germany,
helping to renovate it.

Caïd Ali de la Kasbah

Au Maroc, la tradition oblige. La plus
ancienne des deux kasbahs du pays a
250 ans, une autre – aux tours fortifiées
– a, elle, 150 ans. Le grand-père des
propriétaires actuels était un homme
important, un *Caïd*, chef de tribu du clan
berbère. À la question : doit-on laisser les
châteaux d'argile se décomposer comme
tant d'autres kasbahs ? Non, ont répondu
les héritiers, et ont ainsi décidé de trouver
l'argent nécessaire à leur rénovation grâce
aux revenus générés par le tourisme. La
palmeraie est devenue un camping et des
bénévoles, dont des étudiants allemands,
ont participé à sa rénovation.

Kasbahs Qaid Ali

Tradition verpflichtet. Die älteste der
beiden Kasbahs ist 250 Jahre alt, die
mit den Wehrtürmen 150 Jahre. Der
Großvater der heutigen Besitzer war ein
wichtiger Mann, ein *Qaid*, Stammesführer
des Berberclans. Sollten die Lehmburgen
verfallen wie so viele andere Kasbahs?
Nein, sagten die Erben und beschlossen,
das nötige Geld durch Einnahmen aus
dem Tourismus zu erwirtschaften. Der
Palmenhain wurde zum Campingplatz,
Freiwillige, unter ihnen auch Studenten aus
Deutschland, halfen mit beim Renovieren.

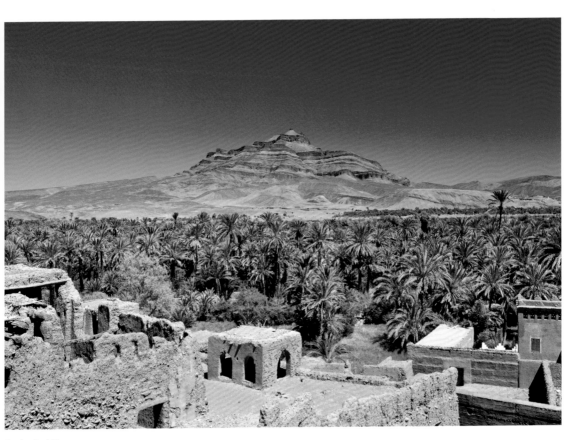

Agdz, Jbel Kissane
Agdz, djebel Kissane

Qaid Ali de Kasbah

La tradición obliga. La más antigua de
las dos kasbahs tiene 250 años, la de las
torres fortificadas 150 años. El abuelo de
los actuales propietarios era un hombre
importante, un *Qaid*, líder tribal del clan
bereber. ¿Deberían los castillos de arcilla
decaer como tantas otras kasbahs? "No",
dijeron los herederos y decidieron generar
el dinero necesario a través de los ingresos
del turismo. El Palmenhain se convirtió en
un camping y personas voluntarias (entre
ellas, estudiantes de Alemania) ayudaron a
renovarlo.

Kasbah di Qaid Ali

La tradizione va mantenuta d'obbligo. La
più antica delle due kasbah ha 250 anni,
quella con le torri fortificate 150. Il nonno
degli attuali proprietari era un uomo
importante, un *qaid*, ossia un leader di
tribù del clan berbero. Perché mai i castelli
d'argilla dovevano decadere come tante
altre kasbah? No, si dissero gli eredi e
decisero di usare le entrate ottenute con il
turismo per mantenerli. Il palmeto diventò
così un campeggio; alcuni volontari, tra cui
studenti provenienti dalla Germania, hanno
contribuito a ristrutturarlo.

Kashba's van qaid Ali

Traditie verplicht. De oudste van de twee
kashba's is 250 jaar oud, die met de
vestingtoren 150 jaar. De grootvader van
de huidige eigenaars was een belangrijk
man, een qaid of caïd, een stamleider
van de Berberclan. Moest het de lemen
burchten net zo vergaan als zoveel andere
kashba's? Nee, zei de erfgenamen en ze
besloten het nodige geld bij elkaar te
krijgen door inkomsten uit toerisme. De
palmenbosschage werd een camping en
vrijwilligers, onder wie Duitse studenten,
hielpen bij de renovaties.

Jbel Kissane
Djebel Kissane

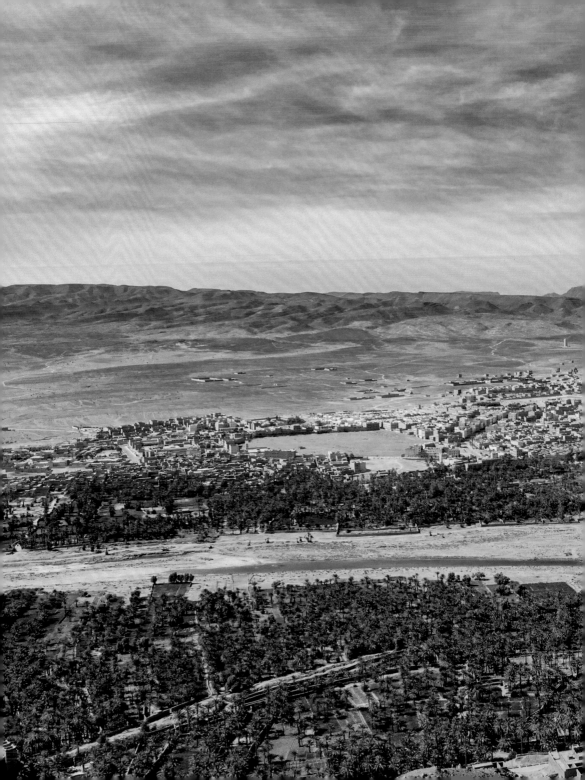

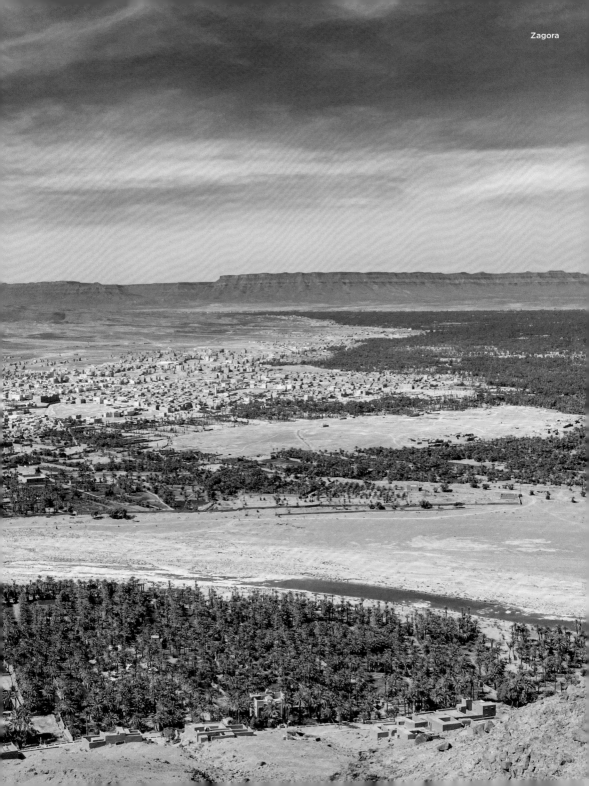

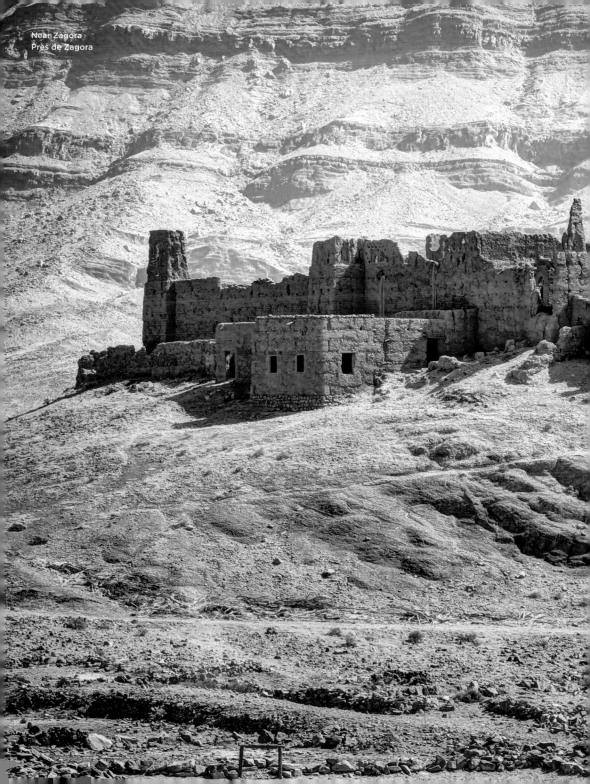

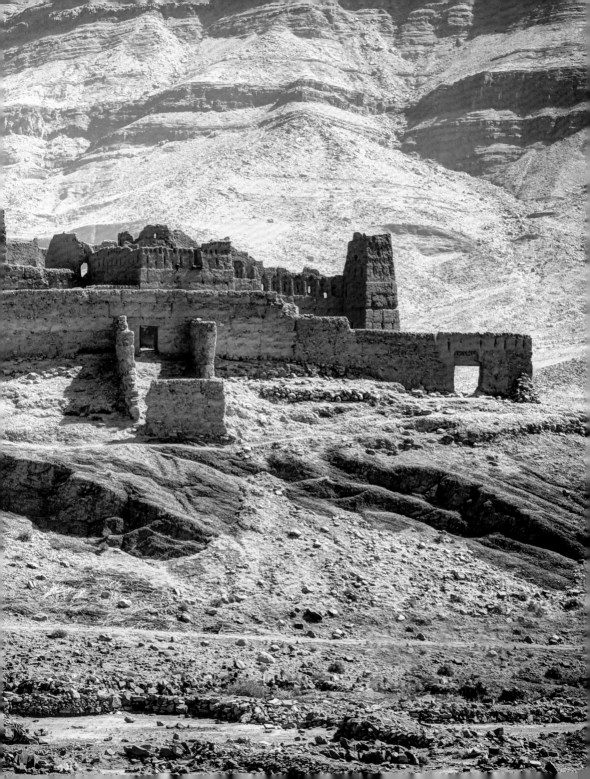

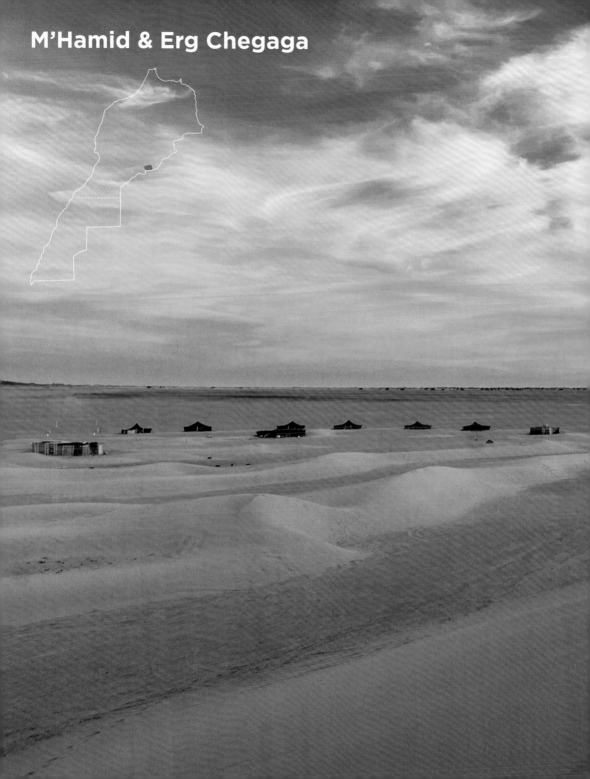

M'Hamid & Erg Chegaga

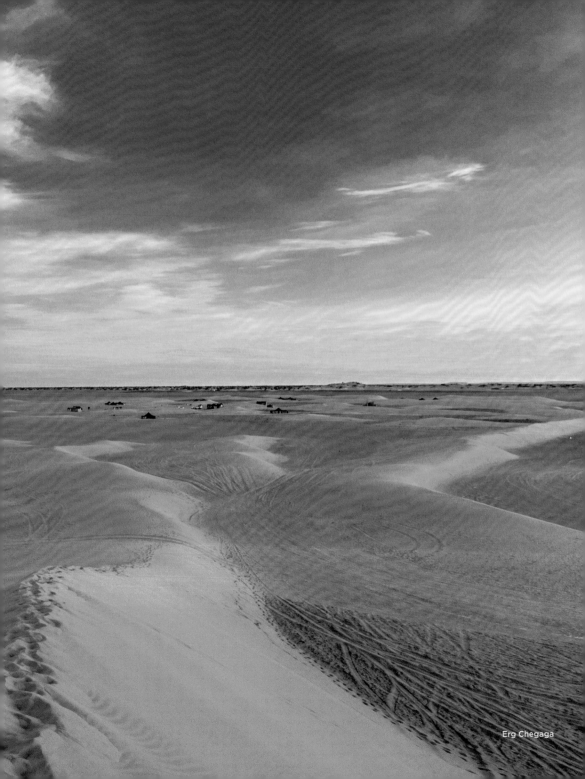

Erg Chegaga

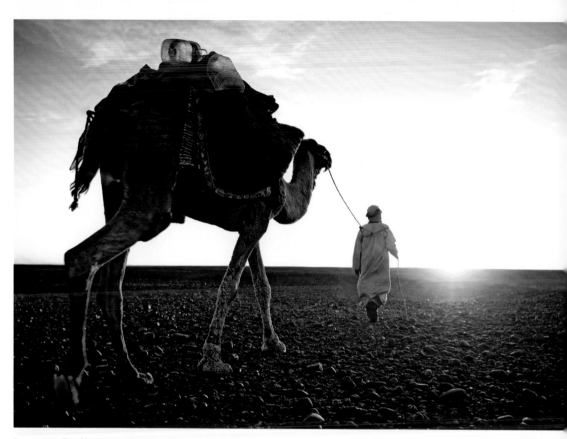

Dromedary, Erg Chegaga
Dromadaire, erg Chegaga

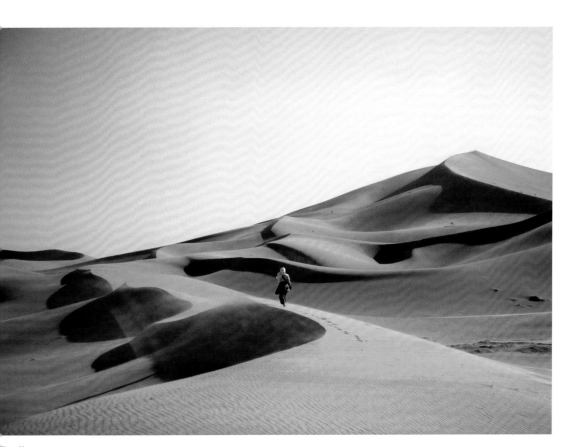

Erg Chegaga

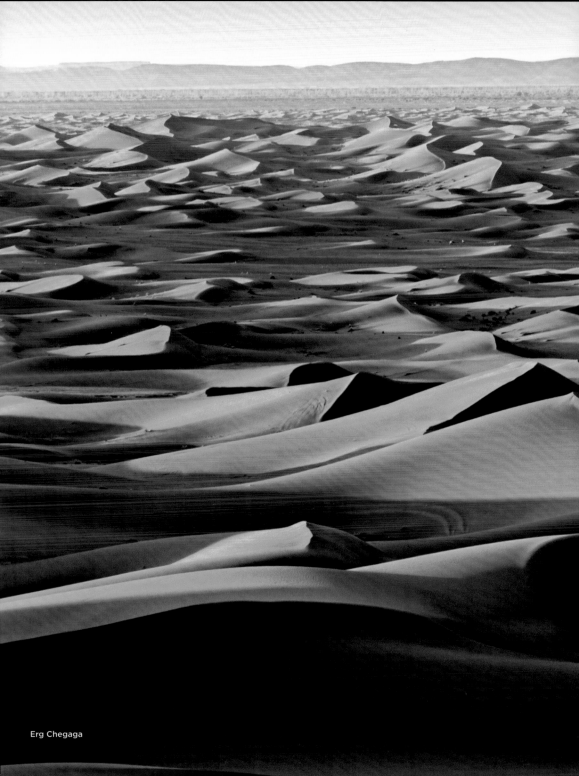

Erg Chegaga

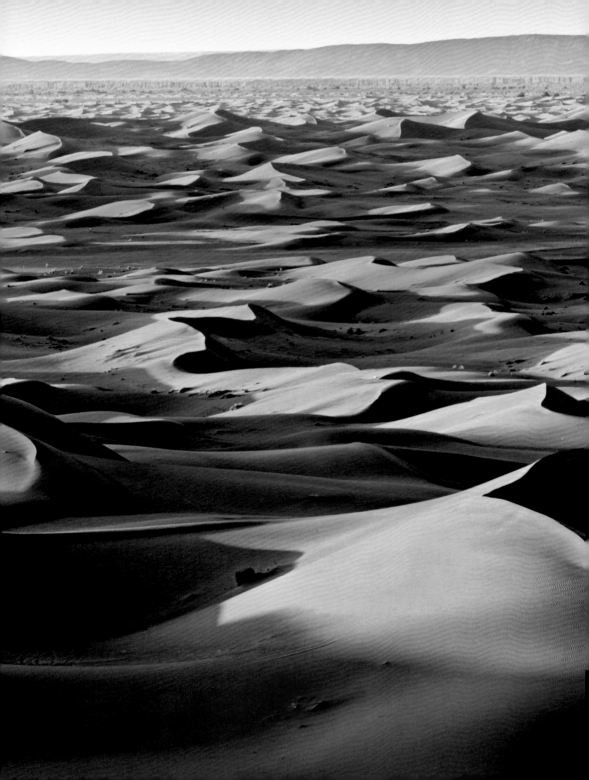

Erg Chegaga

M'Hamid

M'Hamid used to be a blossoming oasis through which the caravans passed. Today, the Draa has less and less water and, instead of caravans, the tourists move through here. The oasis is the gateway to the Erg Chegaga sand dune desert and everything here revolves around desert tourism. A very special experience is the overnight stay in one of the bivouacs between the sand dunes.

M'Hamid El Ghizlane

M'Hamid était une oasis florissante à travers laquelle passaient les caravanes. Aujourd'hui, le Drâa est de plus en plus sec et au lieu de caravanes, ce sont les touristes que l'on trouve désormais ici. L'oasis est la porte d'entrée du désert de sable de l'erg Chegaga et du tourisme dans le désert. Passer la nuit dans l'un des bivouacs entre les dunes de sable est une expérience très spéciale.

M'Hamid

M'Hamid war früher eine blühende Oase, durch die die Karawanen zogen. Heute führt die Draa immer seltener Wasser und statt der Karawanen ziehen nun die Touristen hierher. Die Oase ist das Tor zur Sanddünenwüste Erg Chegaga und alles dreht sich um den Wüstentourismus. Ein ganz besonderes Erlebnis ist die Übernachtung in einem der Biwaks zwischen den Sanddünen.

Erg Chegaga

M'Hamid

M'Hamid era un oasis en flor por el que pasaban las caravanas. Hoy en día el Draa tiene cada vez menos agua y en lugar de caravanas, vienen los turistas. El oasis es la puerta de entrada al desierto de dunas del Erg Chegaga y todo gira en torno al turismo desértico. Una experiencia muy especial es pasar la noche en uno de los bivouacs entre las dunas de arena.

M'Hamid

M'Hamid era un tempo un'oasi lussureggiante, attraversata dalle vie carovaniere. Oggi il fiume Draa porta sempre meno acqua e invece di carovane sono solo i turisti a giungere fin qui. L'oasi è la porta d'accesso al deserto di dune di sabbia dell'Erg Chegaga e tutto qui ruota intorno al turismo legato al deserto. Un'esperienza molto speciale è il pernottamento in uno dei bivacchi tra le dune di sabbia.

M'Hamid

M'Hamid was vroeger een bloeiende oase waar de karavanen doorheen trokken. Tegenwoordig vervoert de Draa steeds minder water en trekken toeristen in plaats van karavanen hierheen. De oase vormt de toegang tot de zandduinenwoestijn van Erg Chegaga en alles draait hier om het woestijntoerisme. Een overnachting in een van de bivakken tussen de zandduinen is een bijzondere belevenis.

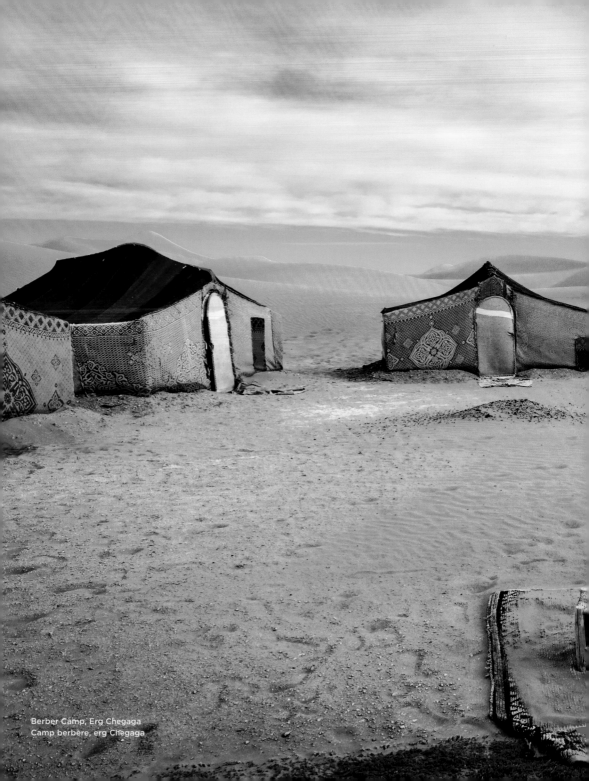

Berber Camp, Erg Chegaga
Camp berbère, erg Chegaga

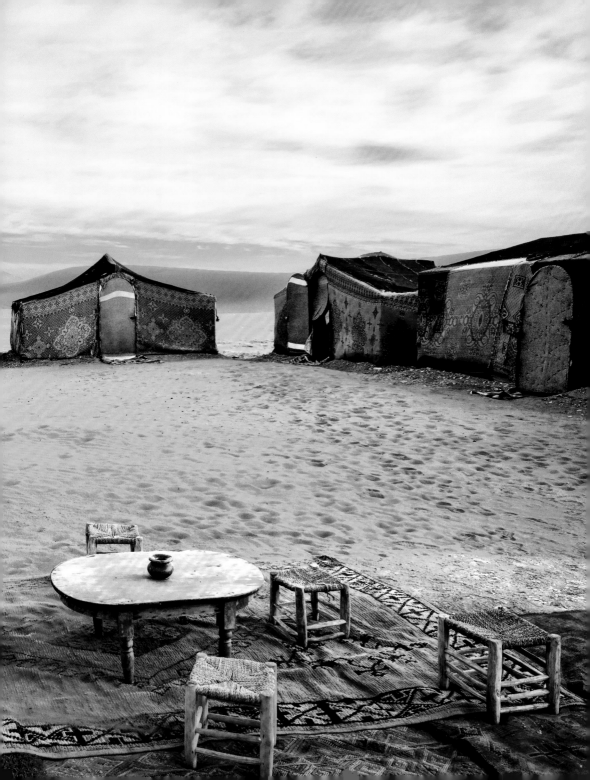

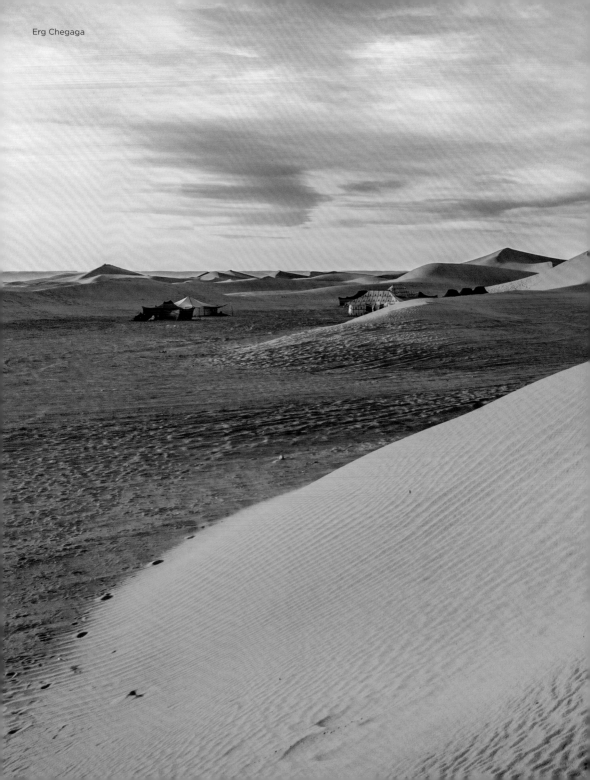

Erg Chegaga

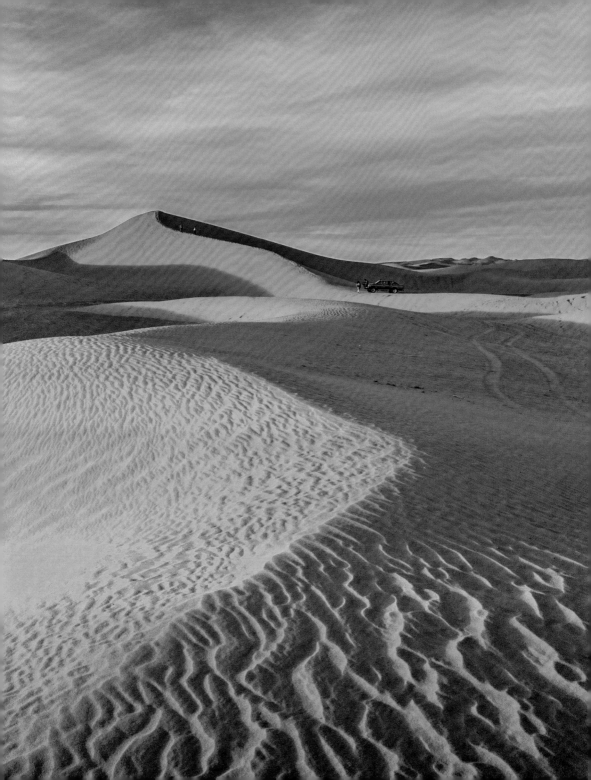

Dromedary
Dromadaire

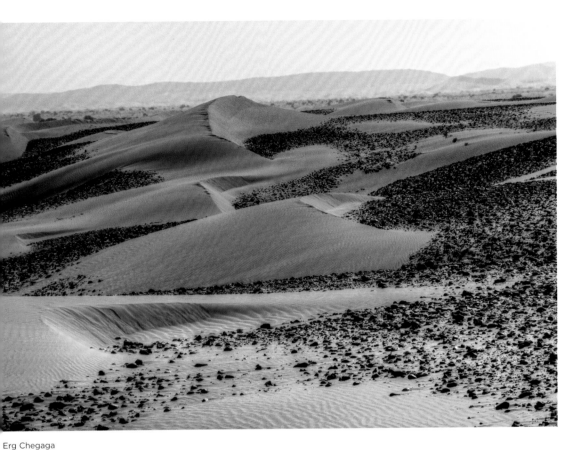

Erg Chegaga

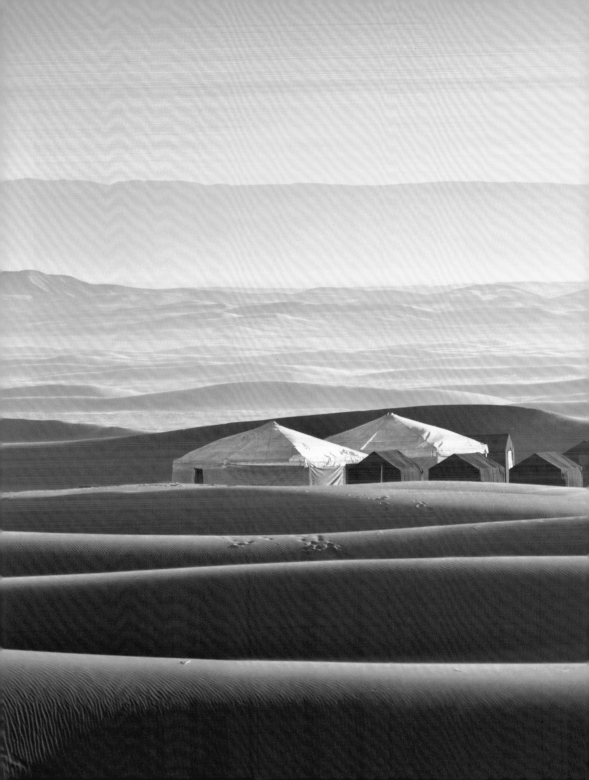

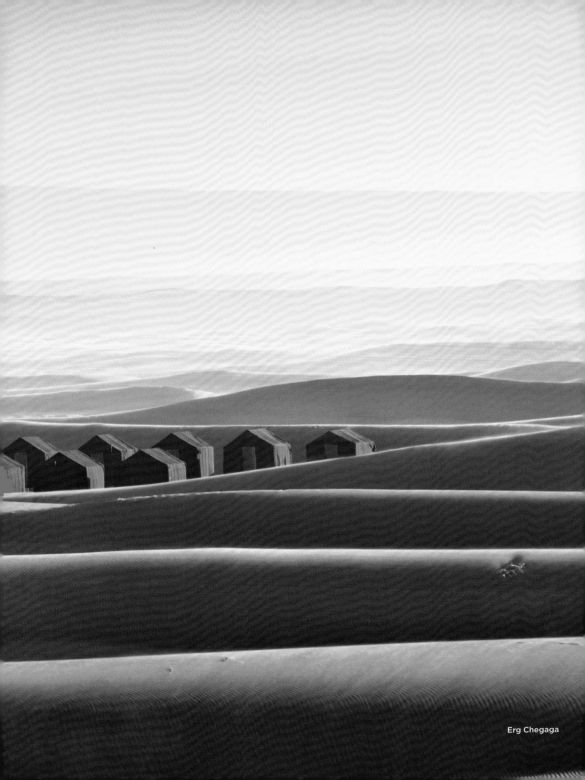

Erg Chegaga

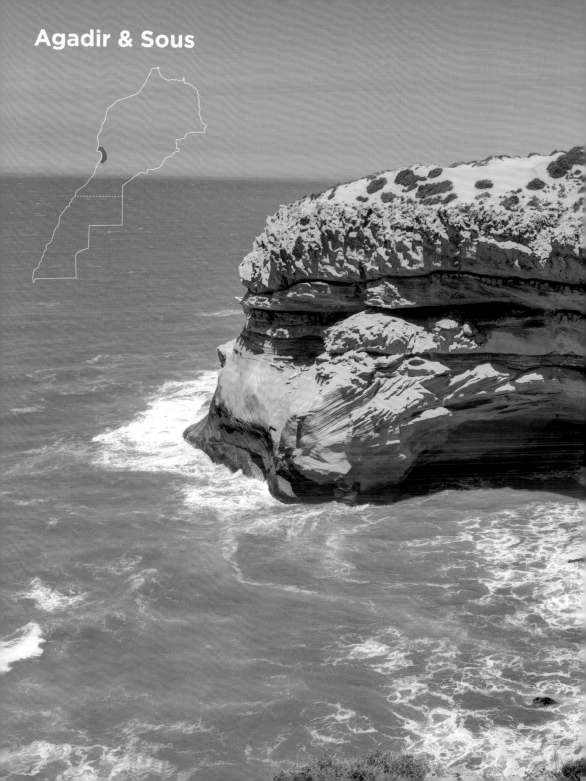

Agadir & Sous

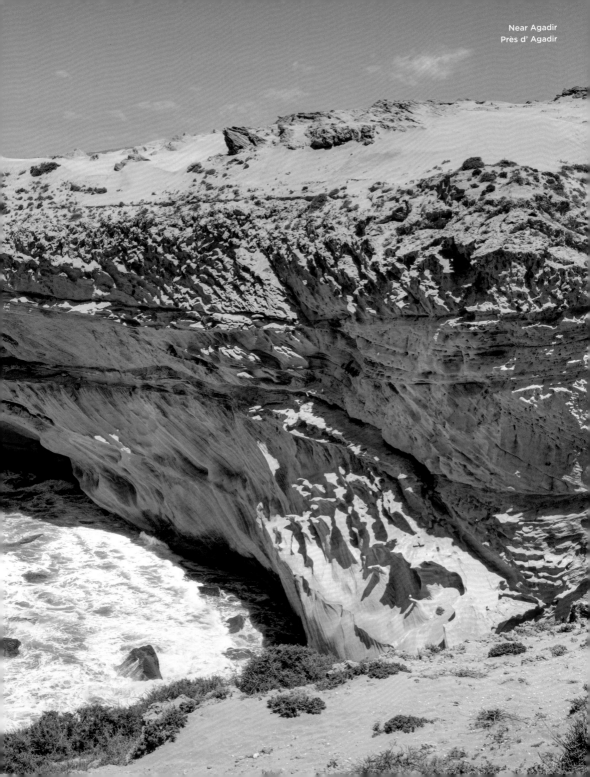

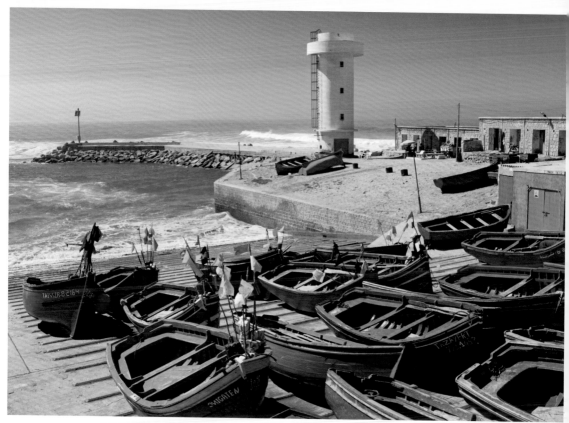

Imsouane

Agadir & Sous

Although the water temperatures do not rise above 20 °C, Agadir is the most popular seaside resort in the country, with its promenade lined with palm trees. In the hinterland of Agadir, the relatively water-rich Souss plain stretches between the High Atlas and the Anti-Atlas, allowing the argan trees to grow, from whose nuts the Berber women extract a high-quality oil.

Agadir & la plaine du Souss

Bien que la température de l'eau ne dépasse pas 20 °C, Agadir est la station balnéaire la plus populaire du pays avec sa promenade bordée de palmiers. Dans l'arrière-pays d'Agadir, la plaine du Souss, relativement riche en eau, s'étend entre le Haut Atlas et l'Anti-Atlas. C'est là aussi que poussent les arganiers, dont les femmes berbères tirent une huile de grande qualité.

Agadir & Souss-Ebene

Obwohl die Wassertemperaturen nicht über 20 °C steigen, ist Agadir mit seiner von Palmen gesäumten Strandpromenade der beliebteste Badeort des Landes. Im Hinterland von Agadir erstreckt sich zwischen dem Hohen Atlas und dem Anti-Atlas die relativ wasserreiche Souss-Ebene. Hier gedeihen auch die Arganbäume, aus deren Nüssen die Berberfrauen ein hochwertiges Öl gewinnen.

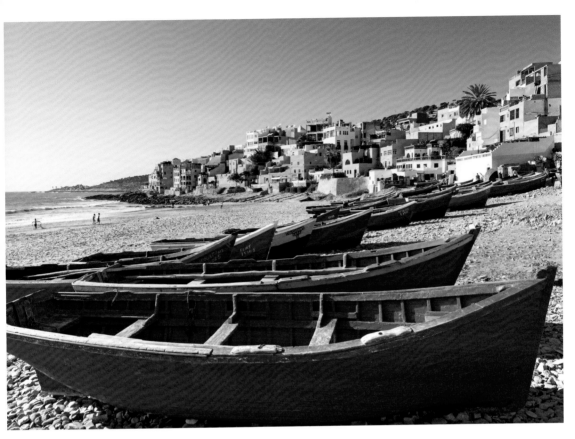

Taghazout

Agadir & Souss Llanura

A pesar de que la temperatura del agua no supera los 20 °C, Agadir es el balneario más popular del país, con su paseo marítimo bordeado de palmeras. En el interior de Agadir, la llanura de Souss, relativamente rica en agua, se extiende entre el Alto Atlas y el Anti-Atlas. Aquí también crecen los árboles de argán, de cuyos frutos las mujeres bereberes extraen un aceite de alta calidad.

Pianura di Agadir & Souss

Anche se la temperatura dell'acqua non supera i 20 °C, Agadir, con il suo lungomare fiancheggiato da palme, è la località balneare più popolare del paese. Nell'entroterra di Agadir, la pianura relativamente ricca di acqua del Souss si estende tra l'Alto Atlante e l'Anti Atlante. Anche qui crescono gli alberi di argan, dai cui frutti le donne berbere estraggono un olio di alta qualità.

Agadir & Souss-vallei

Hoewel de watertemperatuur niet boven de 20 °C komt, is Agadir met zijn met palmbomen omzoomde boulevard de populairste badplaats van het land. In het achterland van Agadir strekt de relatief waterrijke Souss-vallei zich uit tussen de Hoge Atlas en de Anti-Atlas. Ook hier groeien de arganbomen, die noten leveren waar Berbervrouwen een hoogwaardige olie uit winnen.

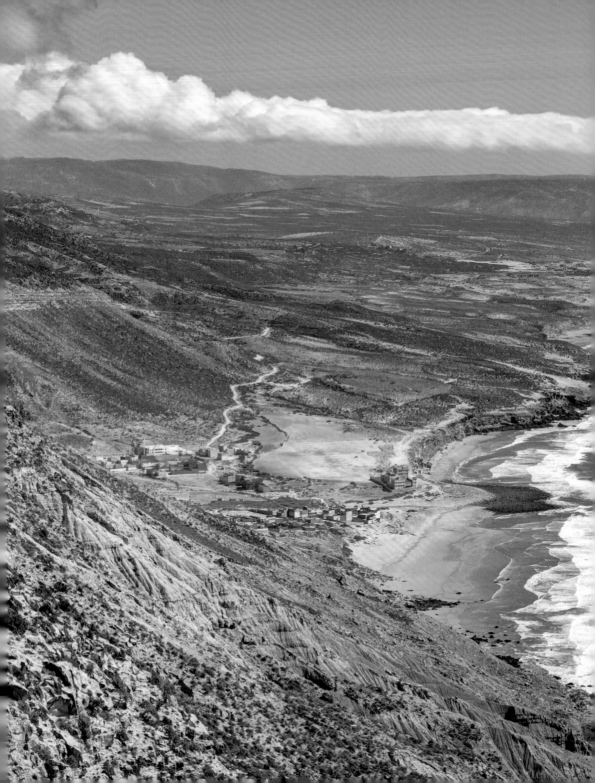

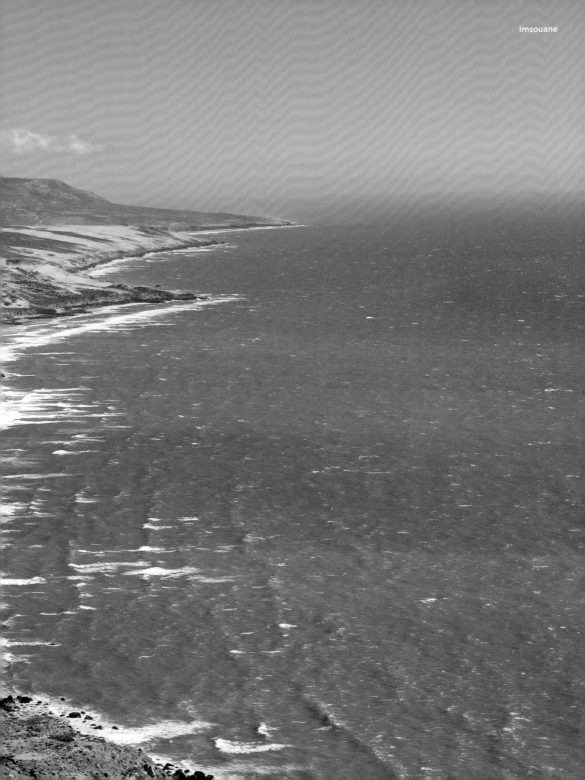
Imsouane

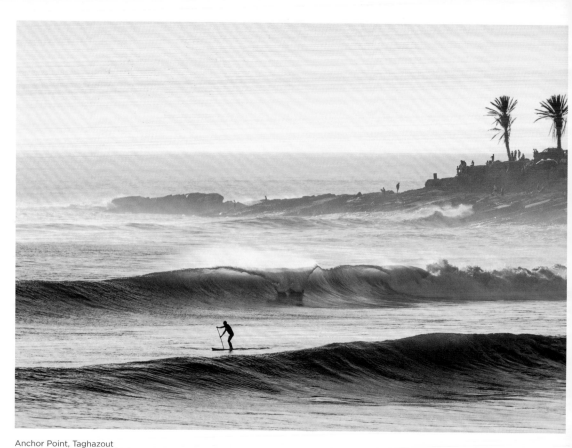

Anchor Point, Taghazout
La pointe des ancres, Taghazout

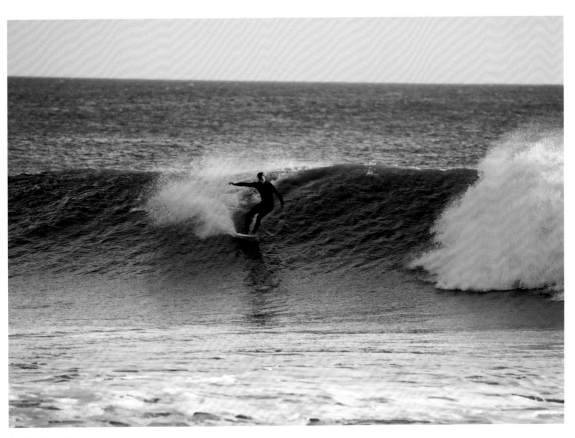

Anchor Point, Taghazout
La pointe des ancres, Taghazout

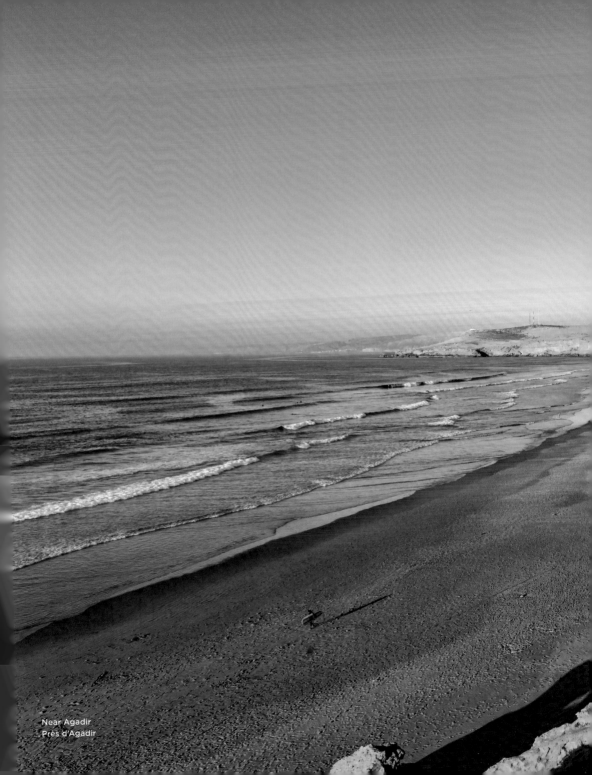

Near Agadir
Près d'Agadir

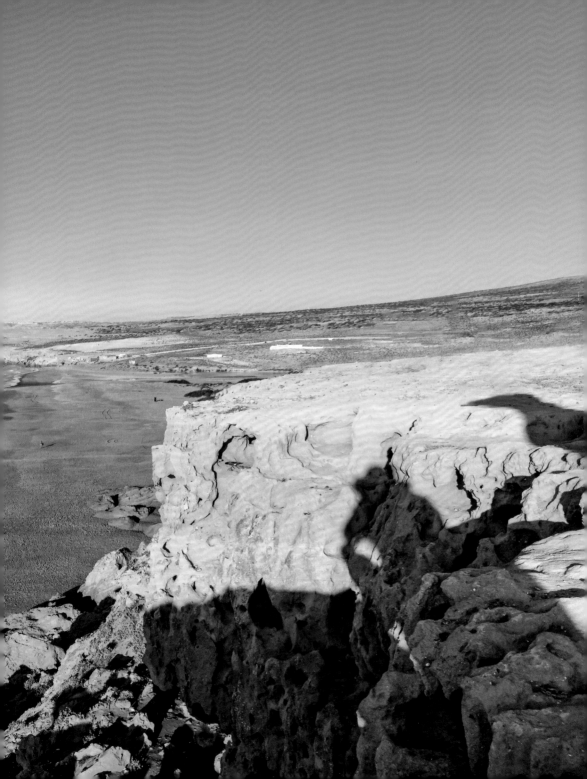

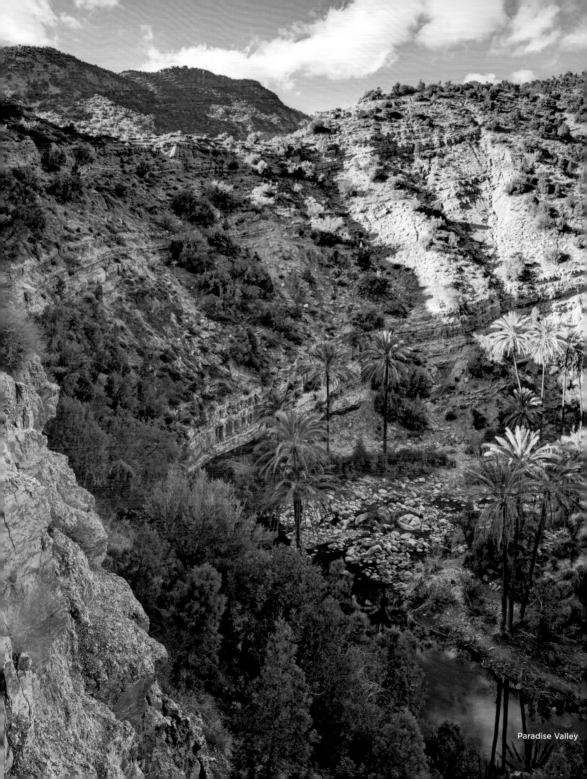
Paradise Valley

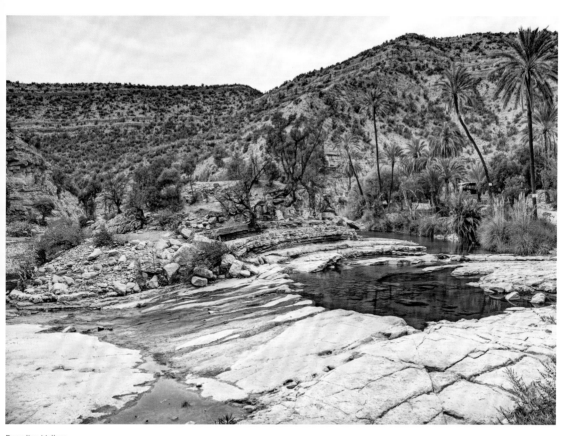

Paradise Valley

Paradise Valley
Rock guitarist Jimi Hendrix is said to have given this valley its name. In the 1970s, when the hippies came to Morocco, it became their meeting place. Today it is no longer an insider tip, but still a beautiful spot with rapids, water basins, rocks and palm trees.

Valle del Paraíso
Se dice que el guitarrista de rock Jimi Hendrix le dio el nombre a este valle. En la década de 1970, cuando los hippies llegaron a Marruecos, se convirtió en su lugar de encuentro. Hoy en día ya no es una punta privilegiada, sino un lugar hermoso con rápidos, cuencas, rocas, palmeras.

Paradise Valley
Le guitariste de rock Jimi Hendrix aurait lui-même baptisé cette vallée. Dans les années 1970, quand les hippies sont venus au Maroc, c'est devenu leur lieu de rencontre privilégié. Aujourd'hui, ce n'est plus un site réservé aux initiés, mais la Paradise Valley reste un endroit magnifique avec des rapides, des bassins d'eau, des rochers et des palmiers.

Valle del Paradiso
Si dice che sia stato il chitarrista rock Jimi Hendrix a dare a questa valle il suo nome. Negli anni '70 del Novecento, quando gli hippie arrivarono in Marocco, divenne il loro punto d'incontro. Oggi non è più un posto conosciuto ai pochi come allora, ma con le sue rapide, i bacini d'acqua, le rocce e le palme mostra ancora tutto il suo splendore.

Paradise Valley
Der Rockgitarrist Jimi Hendrix soll diesem Tal seinen Namen gegeben haben. In den 1970er-Jahren, als die Hippies nach Marokko strömten, wurde es zu deren Treff. Heute ist es kein Geheimtipp mehr, aber noch immer ein wunderschönes Fleckchen mit Stromschnellen, Wasserbecken, Felsen und Palmen.

Paradise Valley
Rockgitarrist Jimi Hendrix zou deze vallei zijn naam hebben gegeven. In de jaren zeventig, toen de hippies naar Marokko stroomden, werd het hun ontmoetingsplaats. Nu is dat geen tip voor ingewijden meer, maar het is nog altijd een prachtige plek met stroomversnellingen, waterbekkens, rotsen en palmbomen.

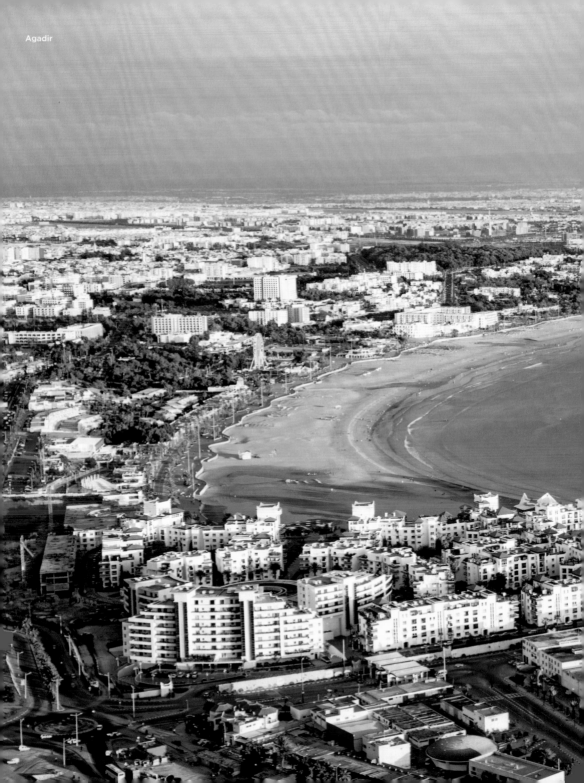

Agadir

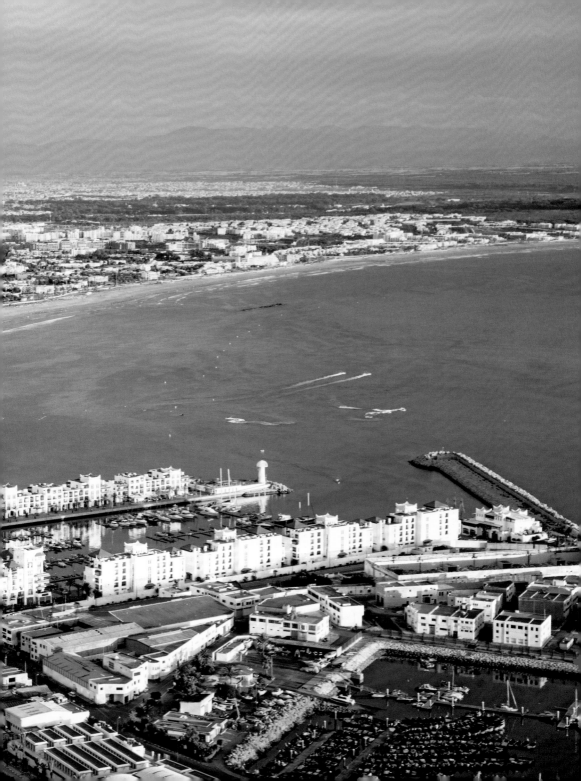

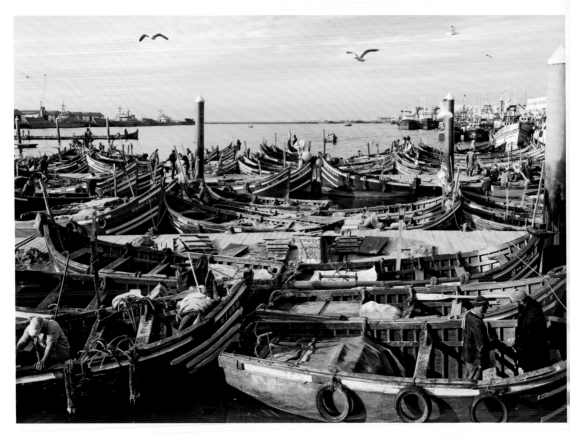

Agadir

Agadir

In the old fishing harbour, wooden boats are still being built and the fishermen sell their goods at auction as always. Next to it is the marina, where expensive yachts bob up and down. Agadir meets the needs of international tourists, with its seafront promenade and relaxed atmosphere—there is no strict dress code here and the restaurants serve alcohol.

Agadir

Dans l'ancien port de pêche, des bateaux en bois sont encore fabriqués et les pêcheurs vendent leurs marchandises aux enchères, comme ils l'ont toujours fait. Tout près se trouve la marina, où des yachts de luxe viennent s'amarrer. Agadir répond aux attentes des touristes internationaux avec sa promenade en bord de mer et son atmosphère détendue – il n'y a pas de code vestimentaire strict ici et les restaurants servent de l'alcool.

Agadir

Im alten Fischereihafen werden noch hölzerne Boote gebaut und die Fischer versteigern ihre Ware wie seit eh und je. Daneben die Marina, in der teure Yachten dümpeln. Mit seiner Strandpromenade und dem freizügigen Ambiente – hier herrscht keine strenge Kleiderordnung und die Lokale schenken Alkohol aus – erfüllt Agadir die Bedürfnisse internationaler Touristen.

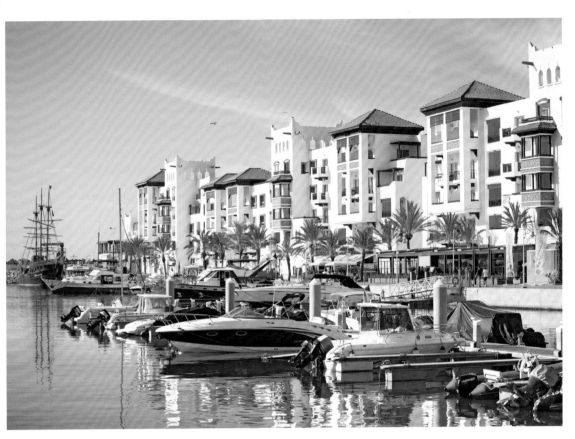

Agadir

Agadir

En el antiguo puerto pesquero se siguen
construyendo barcos de madera y los
pescadores venden sus productos en
subastas, como siempre. Al lado está el
puerto deportivo, donde se bambolean
los yates caros. Agadir satisface las
necesidades de los turistas internacionales
con su paseo maritimo y su ambiente
relajado: aquí no hay un código de
vestimenta estricto y en los restaurantes se
sirve alcohol.

Agadir

Nel vecchio porto di pescatori vengono
ancora costruite barche di legno e i
pescatori vendono come da sempre i
loro prodotti all'asta. Qui accanto si trova
il porto turistico, dove barche costose
fanno bella mostra di sé. Agadir piace ai
turisti internazionali per il suo lungomare
e l'atmosfera rilassata – qui non vige un
codice rigoroso per ciò che riguarda
l'abbigliamento e i locali servono alcolici.

Agadir

In de oude vissershaven worden nog
steeds houten boten gebouwd en de
vissers verkopen hun goederen nog
altijd bij opbod. Daarnaast ligt de
jachthaven, waar dure jachten wiegen.
Agadir voldoet met zijn boulevard en
ontspannen sfeer – hier gelden geen strikte
kledingvoorschriften en de restaurants
schenken alcohol – aan alle behoeften van
internationale toeristen.

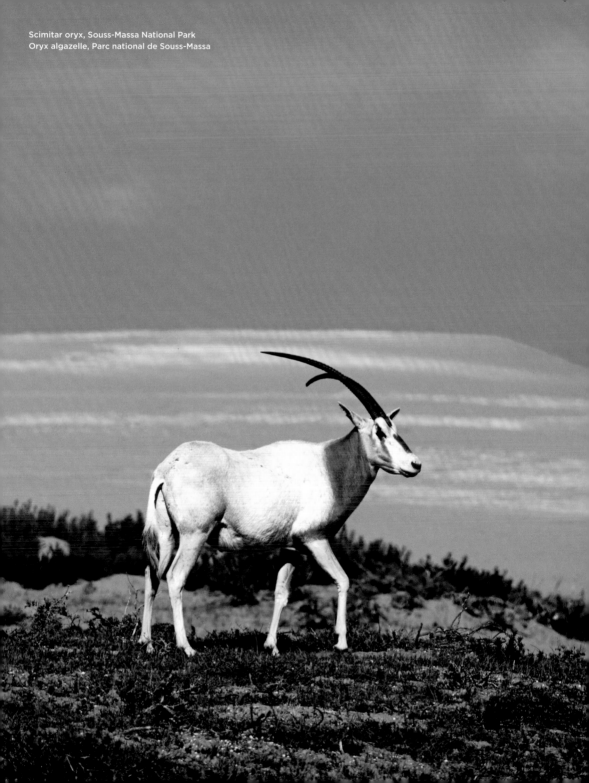

Scimitar oryx, Souss-Massa National Park
Oryx algazelle, Parc national de Souss-Massa

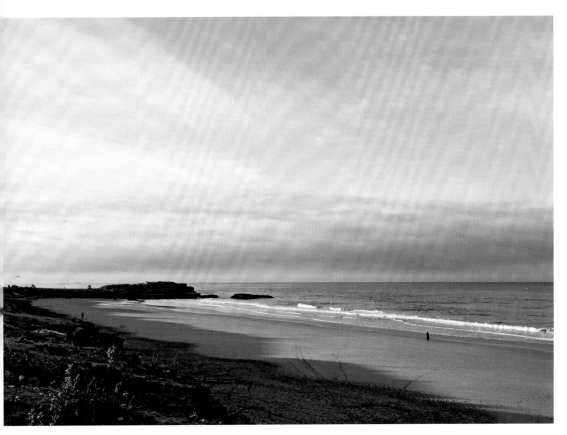

Tamraght

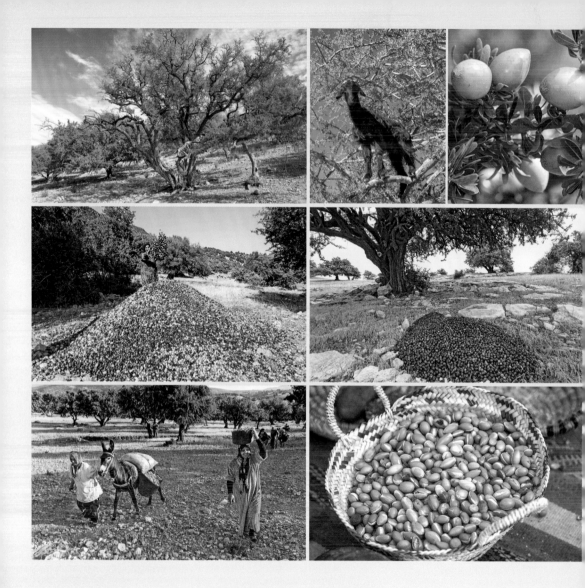

Argan oil

From the kernels of the nuts of the argan tree, the Berbers extract an oil that not only complements food, but is also used in cosmetics. The hard work is traditionally done by women, who have been fairly remunerated since they have been organised into cooperatives. The Arganeraie Biosphere Reserve is protected by UNESCO.

Huile d'Argan

À partir du noyau des noix de l'arganier, les Berbères extraient une huile qui non seulement raffine la nourriture, mais trouve également une utilisation dans les cosmétiques. Ce dur labeur est traditionnellement effectué par les femmes, qui sont rémunérées de façon équitable depuis qu'elles sont organisées en coopératives. En tant que réserve de biosphère, l'arganeraie est protégée par l'UNESCO.

Arganöl

Aus den Kernen der Nüsse des Arganbaums gewinnen die Berber ein Öl, das nicht nur Speisen verfeinert, sondern auch in der Kosmetik Verwendung findet. Die schwere Arbeit übernehmen traditionell die Frauen, die aber fair entlohnt werden, seit sie in Kooperativen organisiert sind. Die Arganeraie steht als Biosphärenreservat unter dem Schutz der UNESCO.

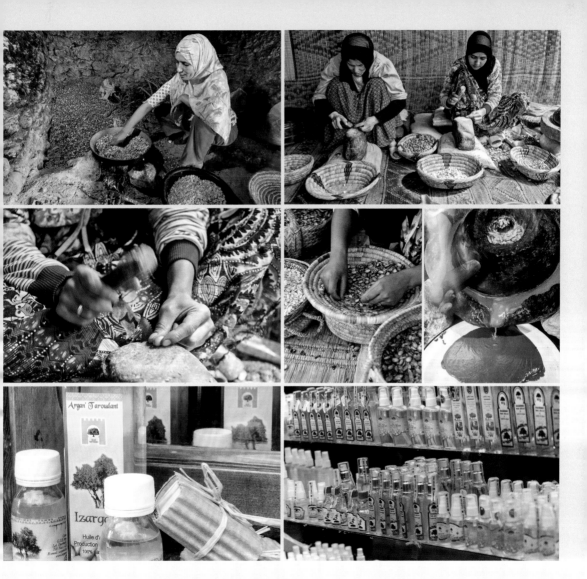

Aceite de Argán

De los granos de las nueces del árbol de argán los bereberes extraen un aceite que no solo refina los alimentos, sino que también se utiliza en cosmética. El trabajo duro lo realizan tradicionalmente las mujeres, que han sido bastante remuneradas desde que se organizaron en cooperativas. Como reserva de la biosfera, la Arganeraie está protegida por la UNESCO.

Olio di Argan

Dai semi dei frutti dell'argan i berberi estraggono un olio che non solo serve per condire, ma è usato anche in cosmetica. Il duro lavoro è tradizionalmente svolto dalle donne, la cui retribuzione è abbastanza equa da quando sono state organizzate cooperative. Come riserva di biosfera, l'arganeto è protetto dall'UNESCO.

Arganolie

Uit de pitten van de noten van de arganboom winnen de Berbers een olie die niet alleen voor voedselbereiding wordt gebruikt, maar ook in cosmetica. Van oudsher wordt het zware werk gedaan door vrouwen, die een redelijk inkomen hebben omdat ze in coöperaties zijn georganiseerd. De Arganeraie Reserve is door de Unesco aangewezen als biosfeerreservaat.

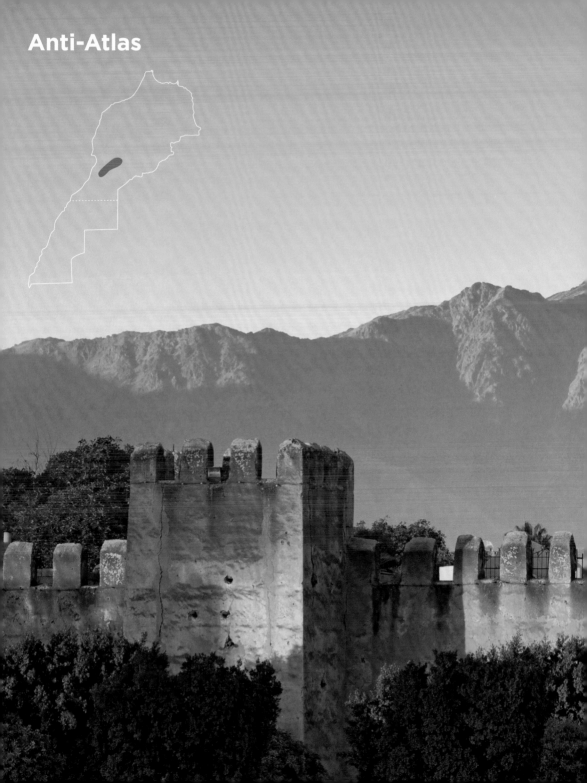

Anti-Atlas

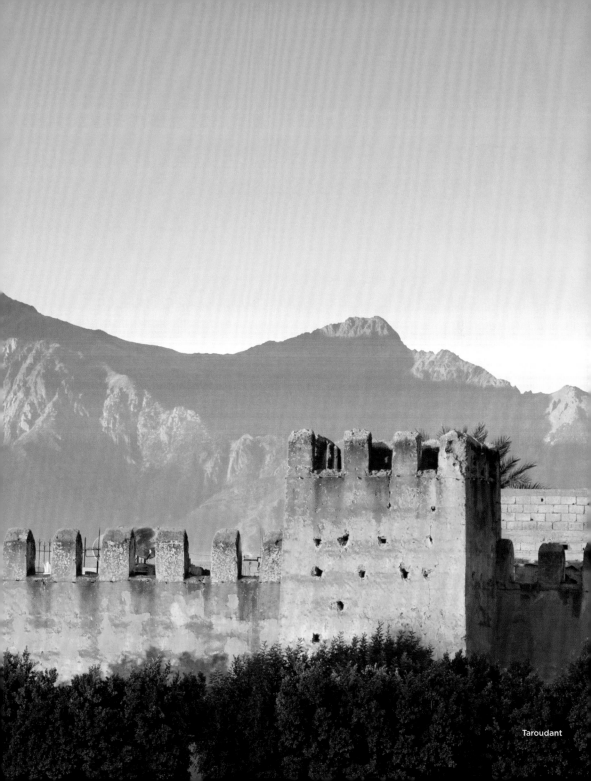
Taroudant

Donkey, Anti-Atlas
Âne, Anti-Atlas

Anti-Atlas

Whilst the High and Middle Atlas lie on the Eurasian continental plate, the Anti-Atlas belongs to the African continental plate and is thus older than the other mountain ranges. Apart from the coastal slopes, which are covered with rich vegetation, the region is arid and crossed by dry river valleys. Unlike in the north, the Berbers living here did not erect clay buildings, but built stone houses. Typical for the area are the Agadire, or stone community storehouses.

Anti-Atlas

Alors que le Haut et le Moyen Atlas reposent sur la plaque continentale eurasienne, l'Anti-Atlas appartient à la plaque continentale africaine et est donc plus ancien que les autres chaînes de montagnes. Outre les pentes côtières, qui sont couvertes d'une riche végétation, la région est aride et traversée par des vallées fluviales sèches. Contrairement au nord, les Berbères qui vivent ici n'érigent pas de bâtiments en terre cuite, mais des maisons en pierre. Les agadires, magasins communautaires, sont typiques de la région.

Anti-Atlas

Während der Hohe und der Mittlere Atlas auf der eurasischen Kontinentalplatte liegen, gehört der Anti-Atlas zur afrikanischen Kontinentalplatte und ist damit älter als die anderen Gebirgsketten. Abgesehen von den Küstenhängen, die mit reicher Vegetation bedeckt sind, ist die Region arid und wird von trockenen Flusstälern durchzogen. Anders als im Norden errichteten die hier ansässigen Berber keine Lehmbauten, sondern Steinhäuser. Typisch für die Gegend sind die Agadire, Gemeinschaftsspeicher.

Dromedary, Anti-Atlas
Dromadaire, Anti-Atlas

Anti-Atlas

Mientras que el Alto y Medio Atlas se encuentran en la placa continental euroasiática, el Anti-Atlas pertenece a la placa continental africana y, por lo tanto, es más antiguo que las otras cadenas montañosas. Aparte de las laderas costeras, que están cubiertas de una rica vegetación, la región es árida y está atravesada por valles fluviales secos. A diferencia del norte, los bereberes que vivían aquí no construyeron edificios de barro, sino casas de piedra. Típico de la zona es el Agadir, fortificación colectiva.

Anti Atlante

Mentre l'Alto e Medio Atlante si trovano sulla placca continentale euroasiatica, l'Anti Atlante appartiene a quella africana ed è quindi più antico delle altre due catene montuose. A prescindere dai pendii costieri, coperti da una ricca vegetazione, la regione è arida e attraversata da valli fluviali asciutte. A differenza del nord, i berberi non eressero in queste zone edifici in argilla ma in pietra. Tipici della zona sono gli *agadir*, i granai fortificati della comunità.

Anti-Atlas

Terwijl de Hoge en Midden-Atlas op het Euraziatische continentale plat liggen, behoort de Anti-Atlas tot het Afrikaanse continentale plat en is hij dus ouder dan de andere bergketens. Afgezien van de kusthellingen, die bedekt zijn met een weelderige vegetatie, is de regio droog en doorkruist door droge rivierdalen. Anders dan in het noorden bouwden de hier woonachtige Berbers geen lemen gebouwen, maar stenen huizen. Typerend voor de omgeving zijn de *agadire*, gemeenschappelijke pakhuizen.

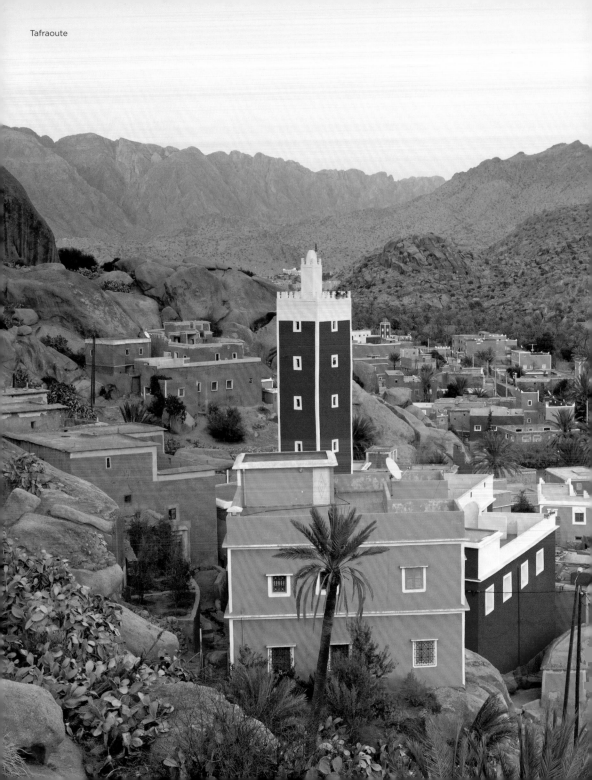

Tafraoute

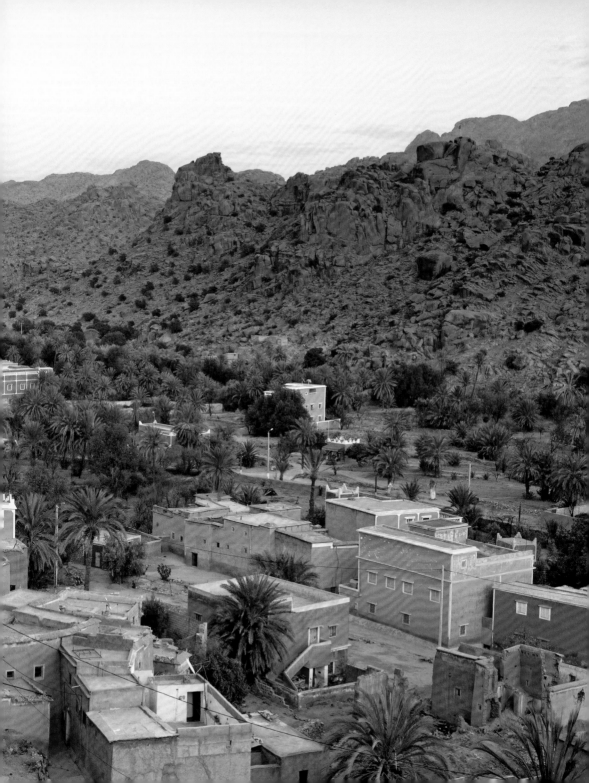

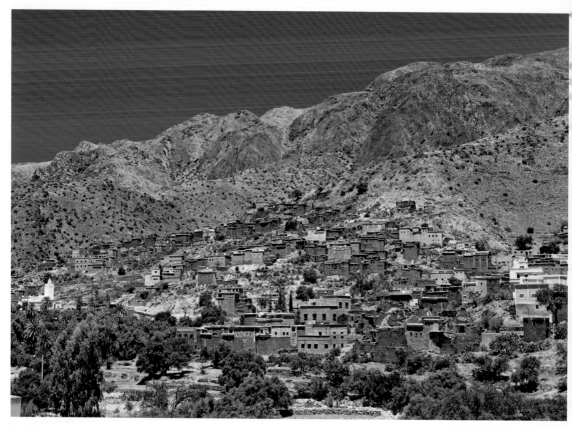
Anti-Atlas

Ait Mansour Valley

Green was the Prophet Muhammad's favourite colour, and green also represents paradise. The Ait Mansour Valley is a little paradise. Red rocks reach upwards in the gorge, and a river accompanies the road, where the palm trees grow so close to the road that you think you are driving through a jungle. As many people have migrated away, the houses and gardens lack a caring hand. This can be seen in two ways: as a blot on paradise, or as a wildly romantic accessory.

La vallée d'Aït Mansour

Le vert était la couleur préférée du prophète Mahomet, une couleur qui illustre aussi très bien le paradis. La vallée d'Aït Mansour est un véritable petit paradis vert. Dans les gorges, des rochers rougeâtres se forment, une rivière accompagne la piste et les palmiers sont si proches de la route que l'on pense traverser une jungle. Comme beaucoup de gens ont émigré, les maisons et les jardins n'ont pas l'air très accueillants. Cela peut être vu comme une petite erreur du paradis, ou bien comme un accessoire indispensable et follement romantique à ce paysage paradisiaque.

Aït-Mansour-Tal

Grün war die Lieblingsfarbe des Propheten Mohammed, grün stellt er sich auch das Paradies vor. Das Aït-Mansour-Tal ist ein kleines Paradies. In der Schlucht wachsen rötliche Felsen empor, ein Fluss begleitet die Piste, die Palmen rücken so eng an die Straße heran, dass man glaubt durch einen Dschungel zu fahren. Da viele Menschen abgewandert sind, fehlt den Häusern und Gärten die pflegende Hand. Das kann man so oder so sehen: als kleinen Fehler im Paradies oder als wildromantisches Beiwerk.

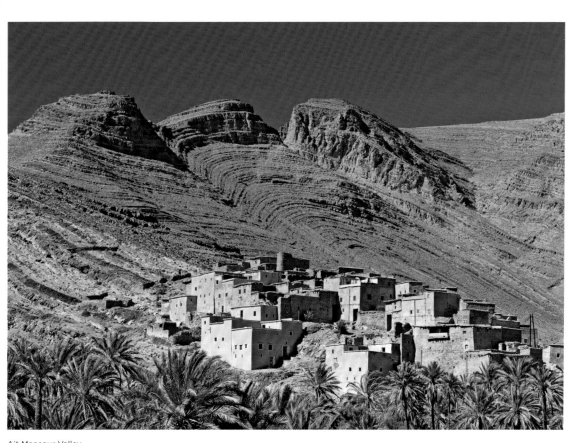

Ait Mansour Valley
Vallée d'Aït Mansour

Valle de Aït-Mansour

El verde era el color favorito del Profeta
Mahoma, verde se imaginaba también
el paraíso. El valle de Aït-Mansour es
un pequeño paraíso. En la garganta
crecen rocas rojas, un río acompaña
el camino, las palmeras se mueven tan
cerca de la carretera que uno piensa que
va conduciendo a través de una selva.
Como muchas personas han emigrado,
las casas y los jardines carecen de la
mano que los cuida. Esto puede verse de
dos formas distintas: como un pequeño
error en el paraíso o como un accesorio
salvajemente romántico.

Valle di Aït Mansour

Il verde era il colore preferito del profeta
Maometto e nella sua immaginazione il
paradiso era verde. La valle di Aït Mansour
è un piccolo paradiso. Nella gola si
ergono rocce rosse, il fiume costeggia la
strada, così costellata di palme che si ha
l'impressione di guidare attraverso una
giungla. Poiché molta gente è emigrata,
le case e i giardini non hanno un aspetto
curato - una piccola imperfezione in
paradiso oppure un tocco di romanticismo
dai toni selvaggi.

Vallee d'Aït Mansour

Groen was de favoriete kleur van de
profeet Mohammed en groen staat ook
voor het paradijs. De Vallee d'Aït Mansour
is een klein paradijs. In de bergkloof
steken rode rotsen omhoog, begeleidt een
rivier de weg en rukken de palmbomen
zo dicht bij de weg op dat je denkt dat je
door een jungle rijdt. Omdat veel mensen
zijn weggetrokken, worden de huizen
en tuinen verwaarloosd. Dit kan op twee
manieren worden bekeken: als een foutje
in het paradijs of als een wild romantische
bijkomstigheid.

Donkey, Anti-Atlas
Âne, Anti-Atlas

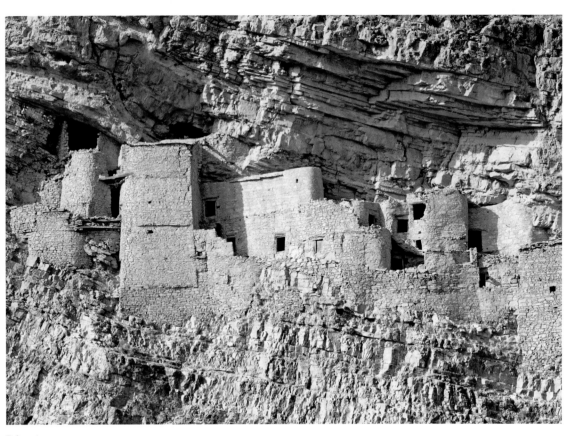

Tafraoute

Ameln Valley
Vallée d'Ammeln

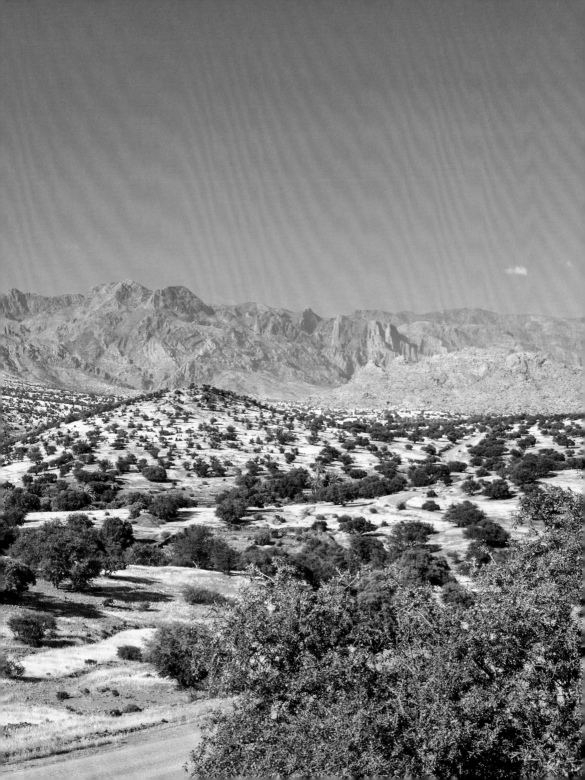

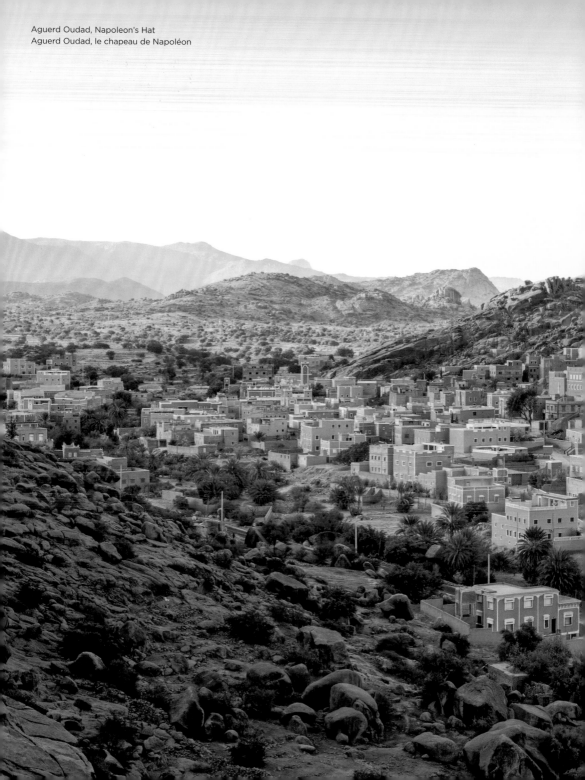

Aguerd Oudad, Napoleon's Hat
Aguerd Oudad, le chapeau de Napoléon

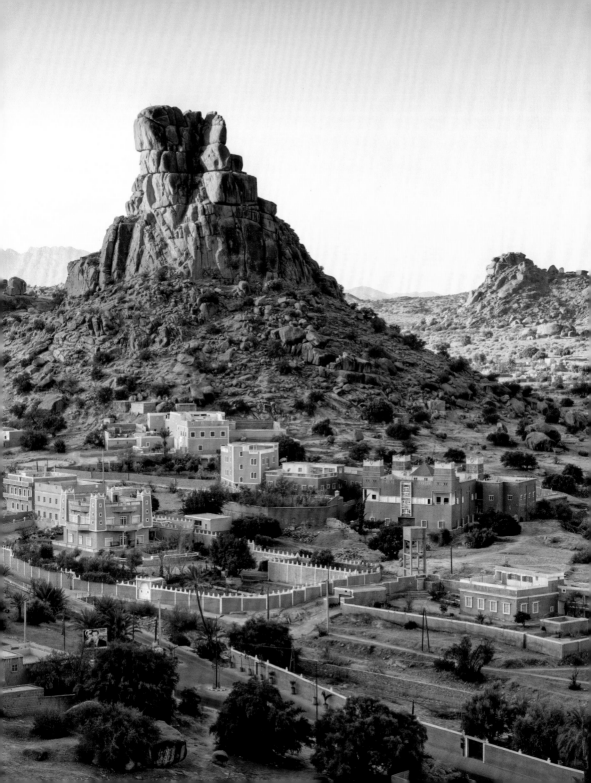

Anti-Atlas

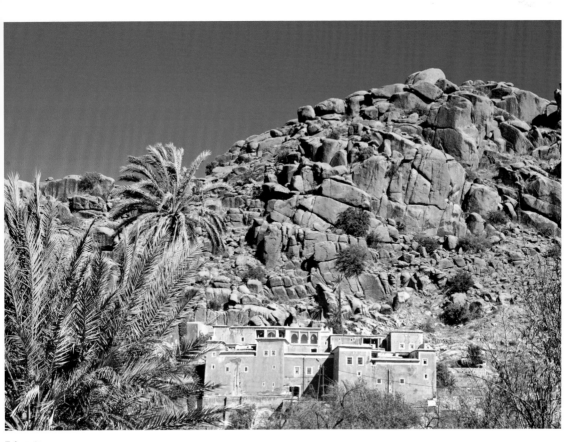

Tafraoute

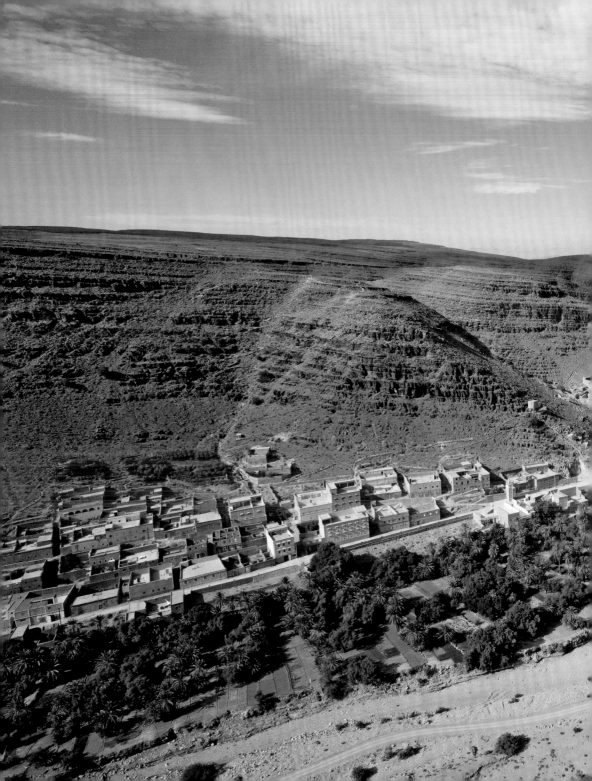

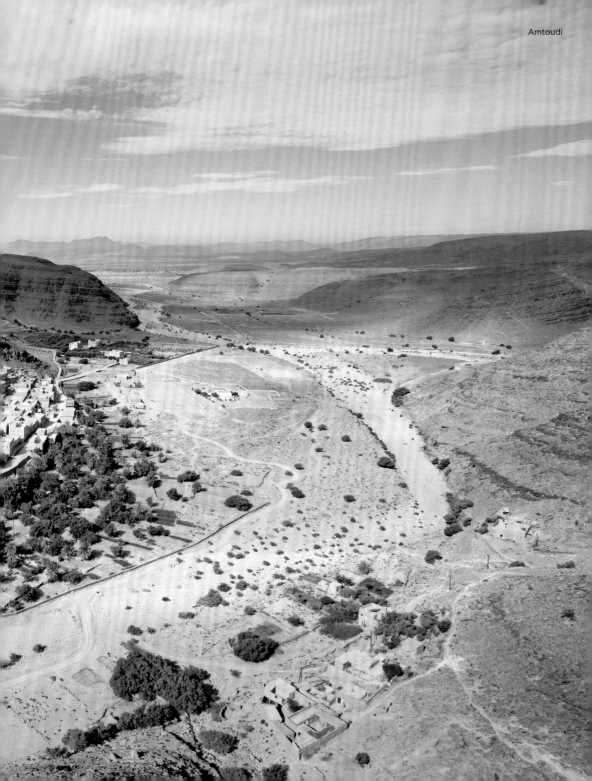
Amtoudi

Anti-Atlas

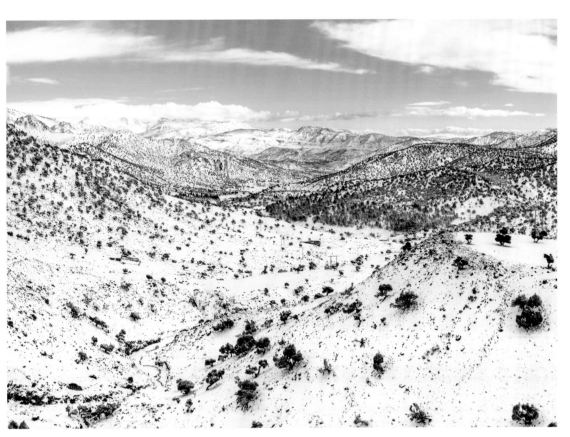

Aguelmous

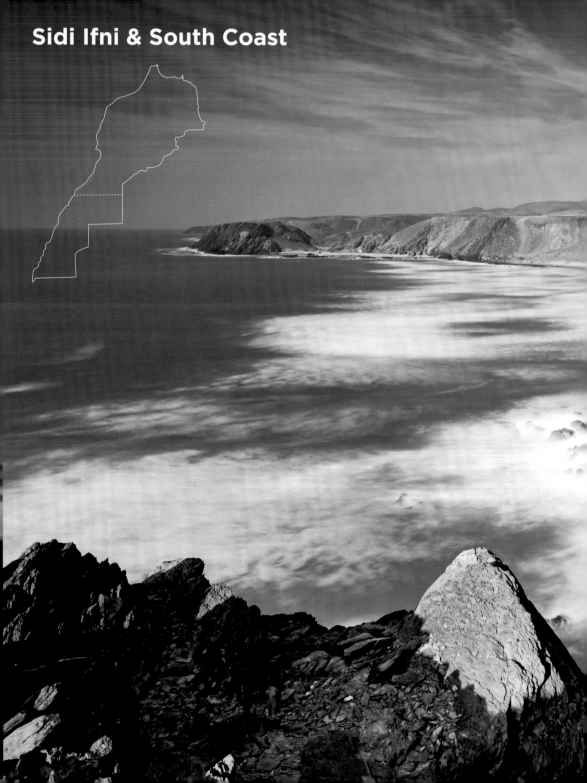

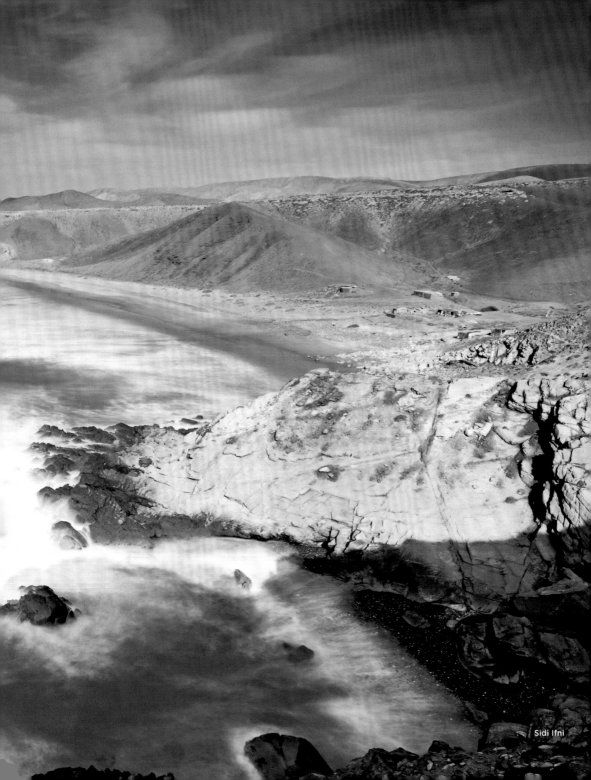

Sidi Ifni

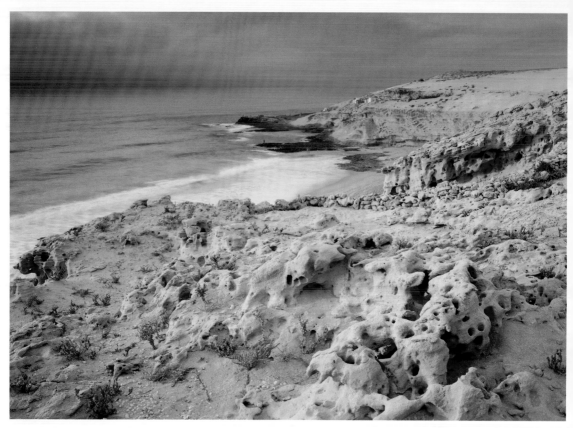

Aglou Beach
Plage d'Aglou

Sidni Ifni & South Coast

The southern Atlantic coast, with its
wide sandy beaches, has not yet been
developed for tourism. In the former
garrison town of Sidi Ifni, art deco
buildings erected by the Spanish colonial
masters in the 1930s come as a surprise.
They have been renovated in recent years
and shine in a new splendour. The water
is cold, but surfers find ideal conditions
here. A worthwhile excursion is to Legzira,
north of the city, where a rocky arch curves
picturesquely over the beach.

Sidi Ifni & la côte sud

La côte sud de l'Atlantique avec ses
larges plages de sable fin n'a pas encore
été aménagée pour le tourisme. Dans
l'ancienne ville de garnison de Sidi Ifni, les
bâtiments art déco érigés par les maîtres
coloniaux espagnols dans les années
1930 sont une véritable surprise. Ils ont été
rénovés ces dernières années et brillent
d'une nouvelle splendeur. L'eau est froide,
mais les surfeurs y trouvent des conditions
idéales. Une excursion intéressante peut se
faire à Lagzira au nord de la ville, où une
arche rocheuse et pittoresque surplombe
la plage.

Sidi Ifni & Südküste

Die südliche Atlantikküste mit ihren
weiten Sandstränden ist touristisch noch
wenig erschlossen. In der ehemaligen
Garnisonsstadt Sidi Ifni überraschen
Art-Déco-Bauten, die die spanischen
Kolonialherren in den 1930er-Jahren
errichteten. Sie wurden in den letzten
Jahren renoviert und erstrahlen in neuem
Glanz. Das Wasser ist kalt, aber Surfer
finden hier ideale Bedingungen. Lohnend
ist der Ausflug zum nördlich der Stadt
gelegenen Legzira, wo sich ein Felsbogen
malerisch über den Strand schwingt.

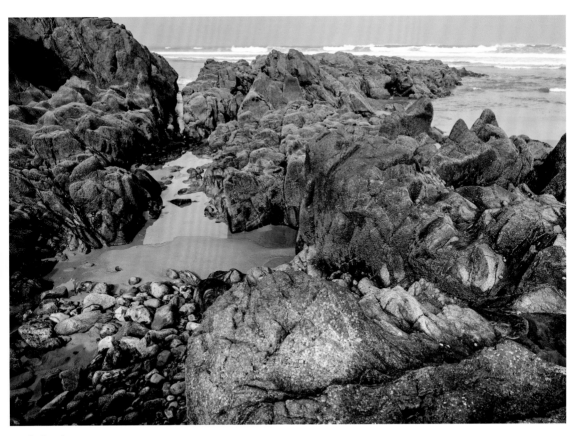

Legzira Beach
Plage de Legzira

Sidi Ifni & Costa Sur

La costa sur del Atlántico con sus amplias playas de arena aún no ha sido desarrollada para el turismo. En la antigua ciudad guarnición de Sidi Ifni, los edificios Art Deco erigidos por los amos coloniales españoles en la década de 1930 son una sorpresa. Han sido renovados en los últimos años y brillan con nuevo esplendor. El agua está fría, pero los surfistas encuentran aquí las condiciones ideales. Una excursión que merece la hacer pena es a Legzira, al norte de la ciudad, donde un arco rocoso se balancea pintorescamente sobre la playa.

Sidi Ifni & costa meridionale

La costa atlantica meridionale, con le sue ampie spiagge sabbiose, non è ancora stata raggiunta dal grande turismo. Nell'ex città di guarnigione di Sidi Ifni colpiscono gli edifici in stile art déco eretti dai colonizzatori spagnoli negli anni '30 del Novecento. Ristrutturati di recente, brillano oggi di nuovo splendore. L'acqua qui è fredda, ma i surfisti trovano condizioni ideali. Un'escursione interessante è quella a Legzira, a nord della città, dove una scogliera arcuata sovrasta pittorescamente la spiaggia.

Sidi Ifni & zuidkust

De Zuid-Atlantische kust met zijn brede zandstranden is nog niet erg ontwikkeld voor het toerisme. In het voormalige garnizoensstadje Sidi Ifni zijn de in de jaren dertig door de Spaanse kolonisten gebouwde art deco-gebouwen verrassend. Ze zijn in de afgelopen jaren gerenoveerd en schitteren met vernieuwde pracht en praal. Het water is koud, maar surfers vinden hier ideale omstandigheden. Een uitstapje naar Legzira, ten noorden van de stad, waar een boog in de rotsen zich schilderachtig over het strand kromt, is de moeite waard.

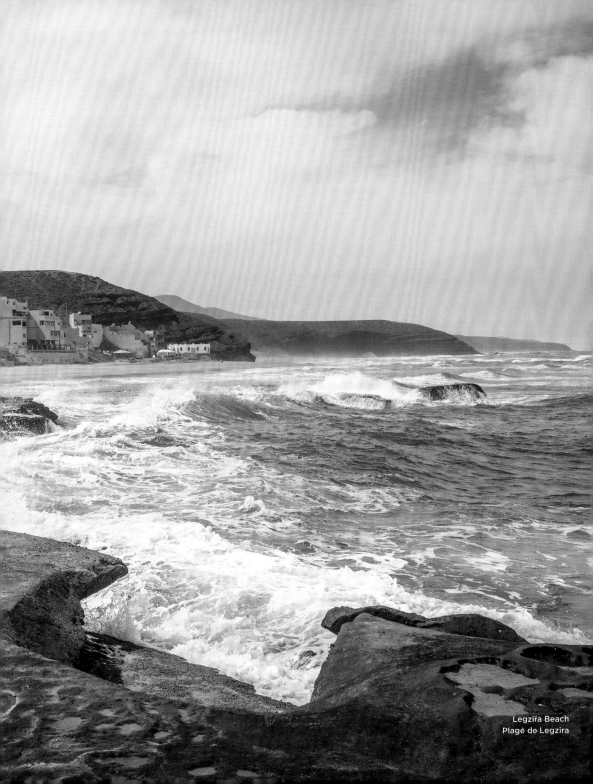

Legzira Beach
Plage de Legzira

Tiznit

Tiznit

A 5 km long wall of compacted clay reinforced with towers protects Tiznit. Silversmiths, who enjoy an excellent reputation throughout the country, live and work within these ramparts. The craftsmen make jewellery for the Berber women to wear, and weapons for the Berber men. The men do without body jewellery, except amulets, but love decorated daggers, swords, shields and pistols. The Berbers effect a kind of magic on their jewellery, and silver is considered a metal conferring health benefits.

Tiznit

Un mur de 5 km de long en terre battue, renforcé par des tours d'argile, protège Tiznit. Les orfèvres, qui jouissent d'une excellente réputation dans tout le pays, vivent et travaillent au sein même des remparts. Les artisans fabriquent des bijoux pour les femmes berbères, et des armes pour les hommes. Ils se dispensent des bijoux corporels, mis à part les amulettes, et préfèrent les poignards décorés, les épées, les boucliers et les pistolets. Les bijoux berbères auraient un effet magique, l'argent est considéré là-bas comme un métal particulièrement béni.

Tiznit

Eine 5 km lange, mit Türmen bewehrte Mauer aus Stampflehm legt sich schützend um Tiznit. Innerhalb des Walls leben und arbeiten Silberschmiede, die landesweit einen ausgezeichneten Ruf genießen. Die Handwerker fertigen Schmuck, wie ihn die Berberfrauen tragen, und Waffen für die Berbermänner. Die verzichten auf Körperschmuck, Amulette ausgenommen, lieben aber verzierte Dolche, Schwerter, Schilder, Pistolen. Die Berber weisen Schmuck eine magische Wirkung zu, Silber wird als besonders segensreiches Metall angesehen.

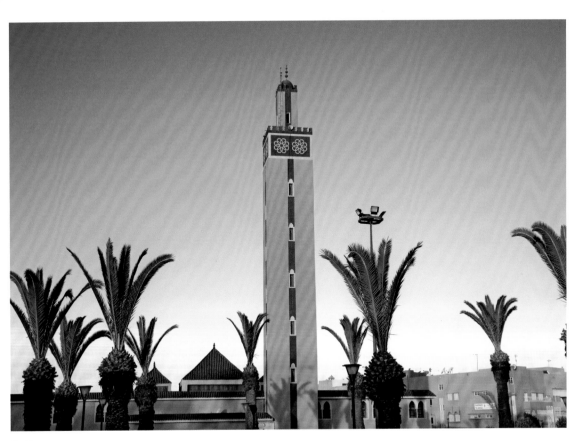

Tiznit

Tiznit

Un muro de arcilla apisonada de 5 km de largo reforzado con torres protege Tiznit. Los plateros, que gozan de una excelente reputación en todo el país, viven y trabajan dentro de la muralla. Los artesanos hacen joyas como las que usan las mujeres bereberes, y armas para los hombres bereberes. No usan joyas para el cuerpo, excepto amuletos; pero les encantan las dagas decoradas, las espadas, los escudos, las pistolas. La joyería bereber tiene un efecto mágico; la plata es considerada un metal particularmente bendecido.

Tiznit

Un muro di argilla di 5 km di lunghezza, puntellato da torri di difesa, racchiude Tiznit proteggendola. Orefici famosi in tutto il paese vivono e lavorano all'interno di queste mura. Gli artigiani realizzano gioielli come quelli indossati dalle donne berbere e armi per gli uomini berberi - che, ad eccezion fatta per gli amuleti, fanno a meno dei gioielli prediligendo pugnali decorati, spade, scudi e pistole. I gioielli hanno per i berberi un'aura magica: l'argento è considerato un metallo particolarmente portafortuna.

Tiznit

Een 5 km lange muur van aangestampte klei versterkt met torens ligt beschermend om Tiznit heen. Binnen de muren wonen en werken zilversmeden, die in het hele land een uitstekende reputatie genieten. De ambachtslieden maken sieraden zoals Berbervrouwen die dragen en wapens voor de Berbermannen. Mannen zien af van lichamelijke opsmuk, amuletten daargelaten, maar houden erg van versierde dolken, zwaarden, schilden en pistolen. Berbers dichten sieraden een magische werking toe: zilver wordt beschouwd als een bijzonder heilzaam metaal.

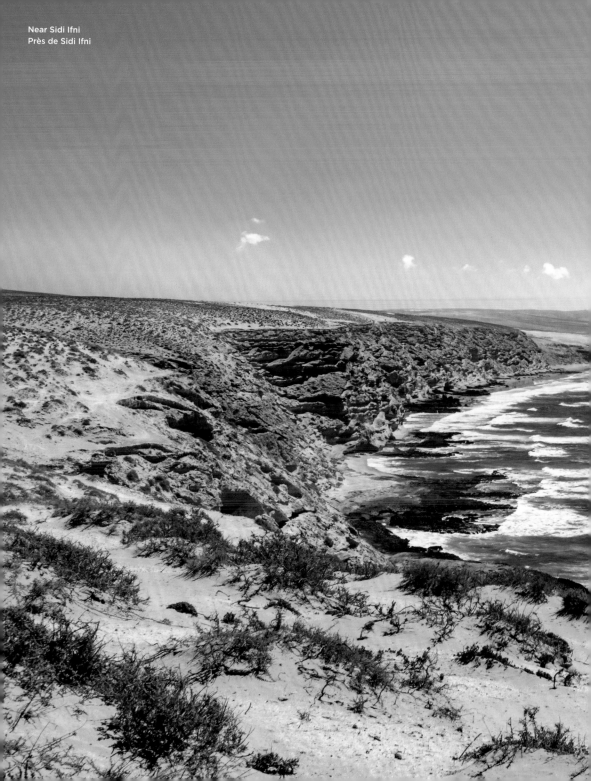

Near Sidi Ifni
Près de Sidi Ifni

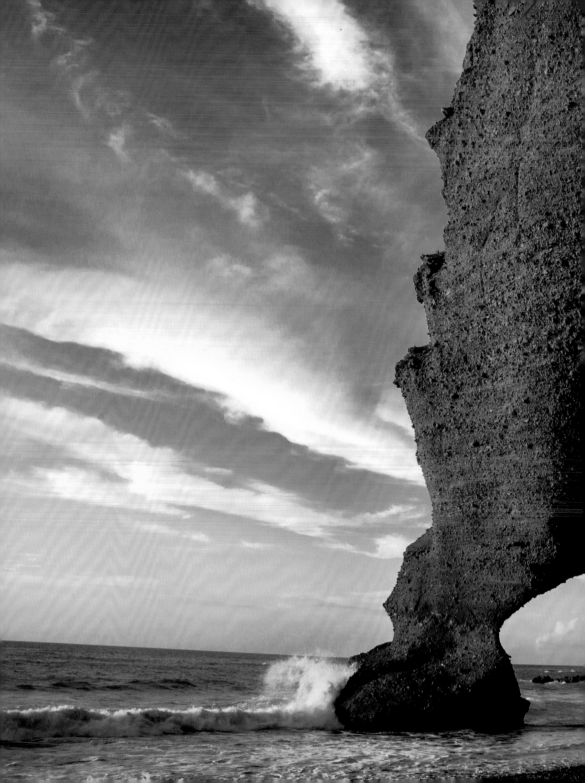

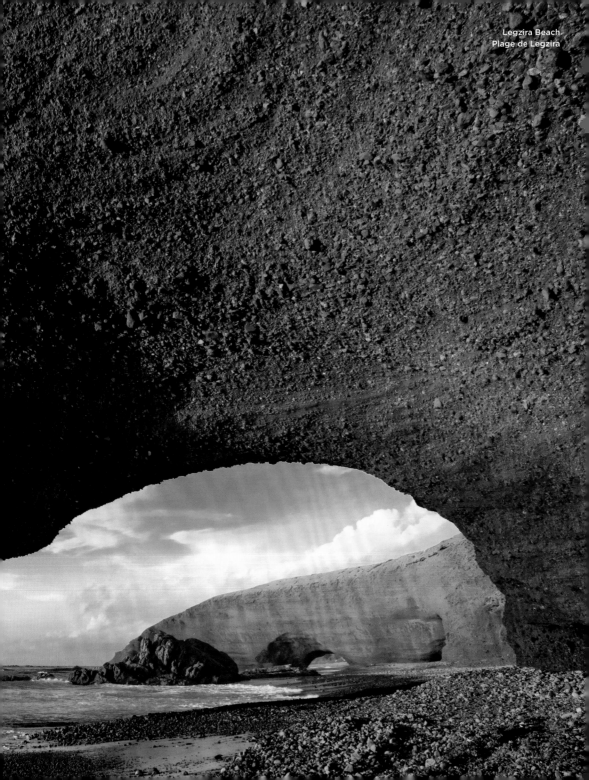

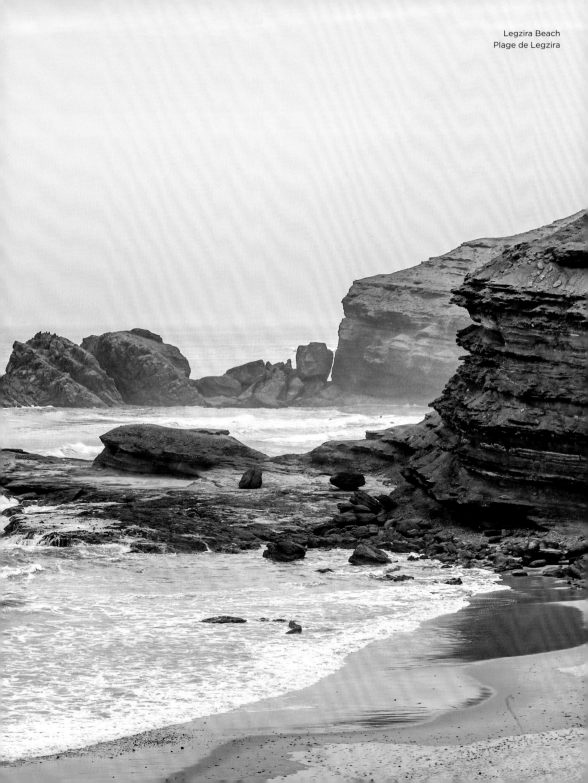

Legzira Beach
Plage de Legzira

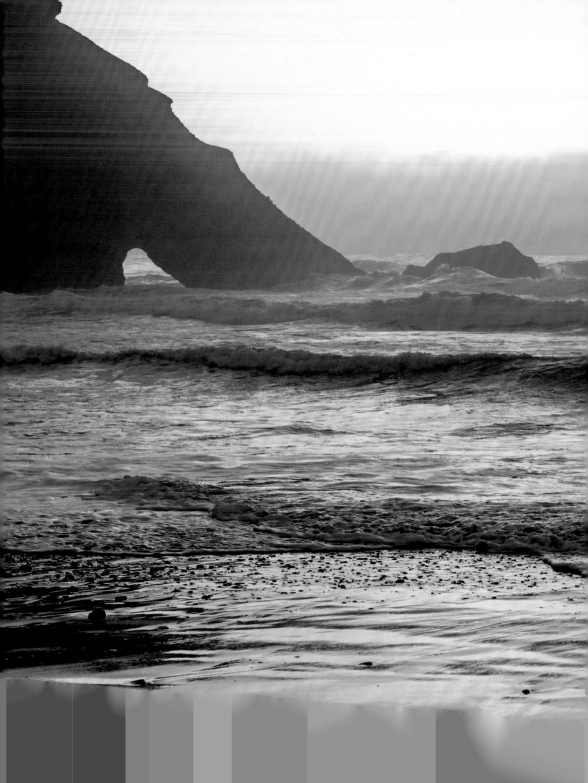

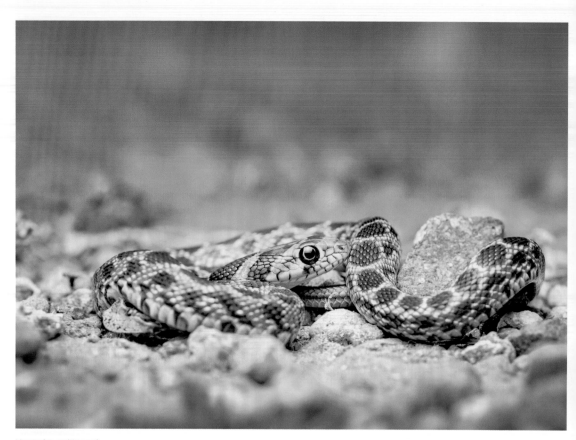

Horseshoe whip snake
Couleuvre fer-à-cheval

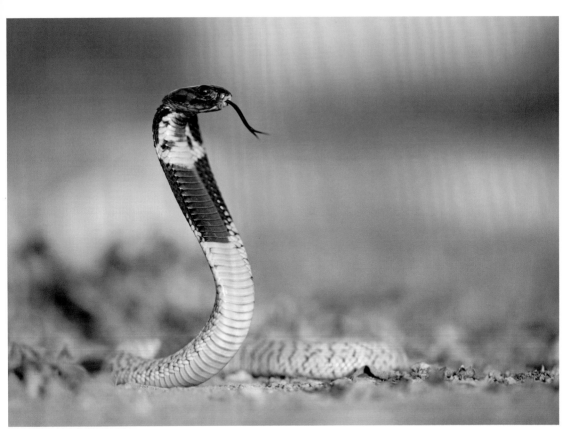

Egyptian cobra
Cobra égyptien

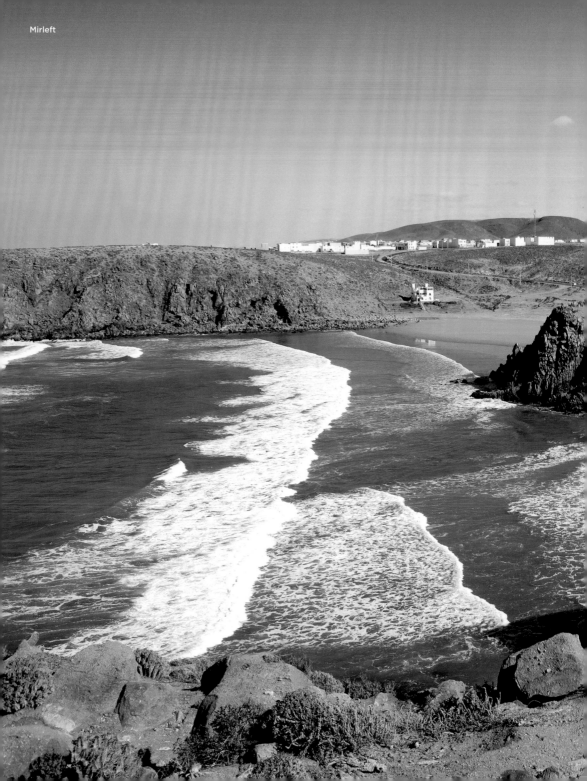

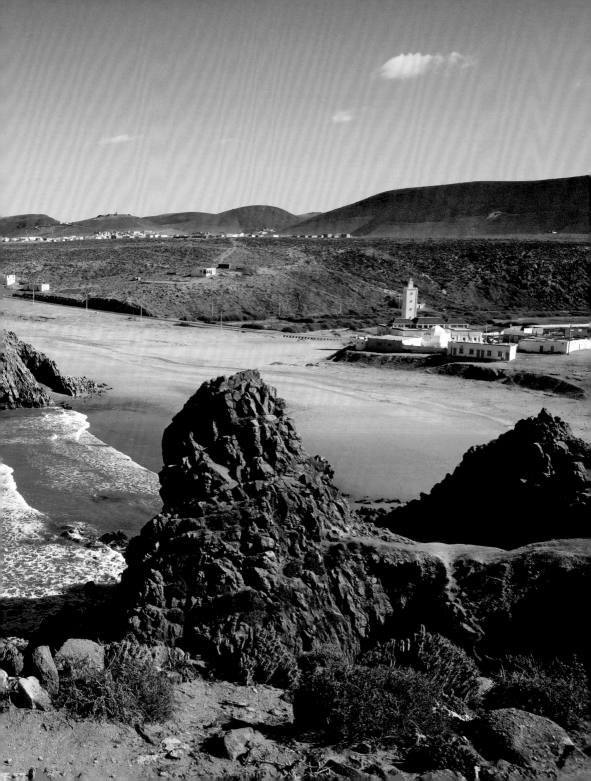

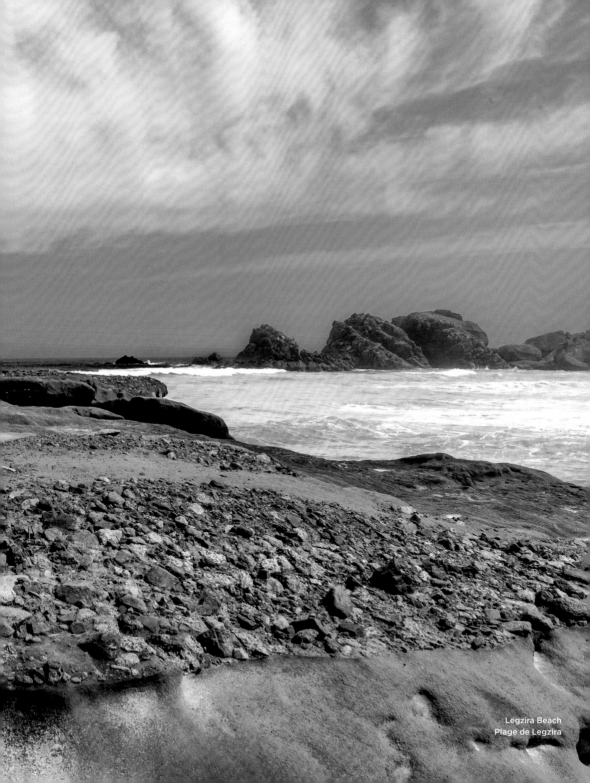

Legzira Beach
Plage de Legzira

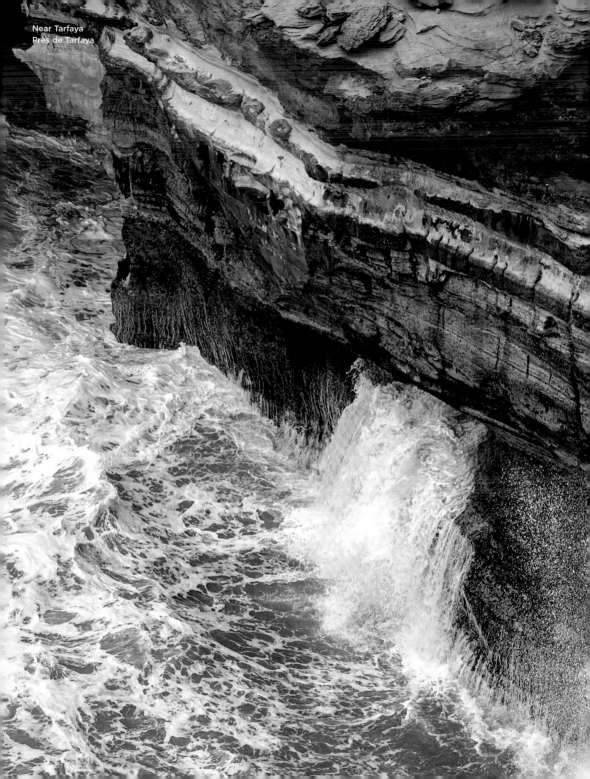
Near Tarfaya
Près de Tarfaya

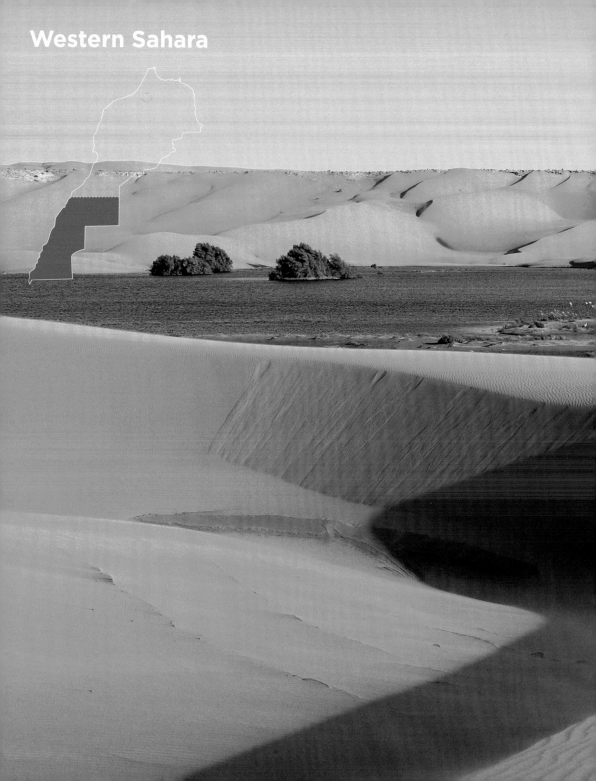

Western Sahara

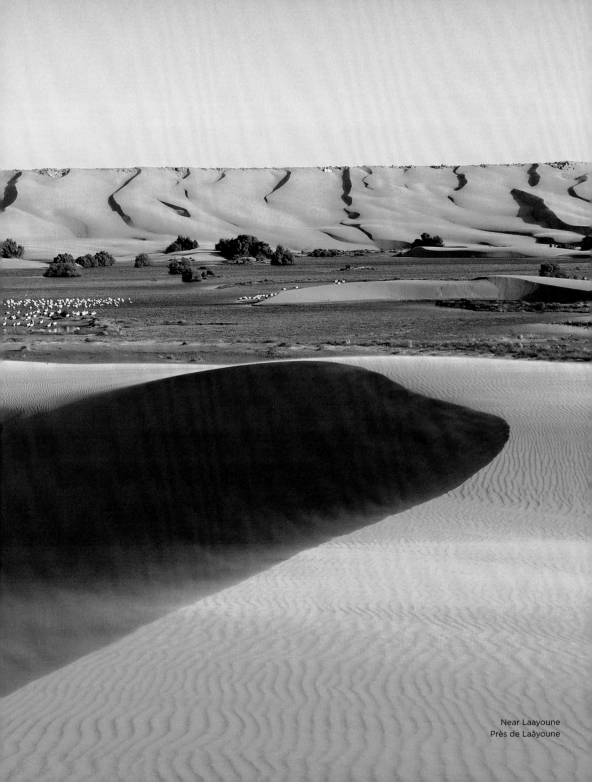

Near Laayoune
Près de Laâyoune

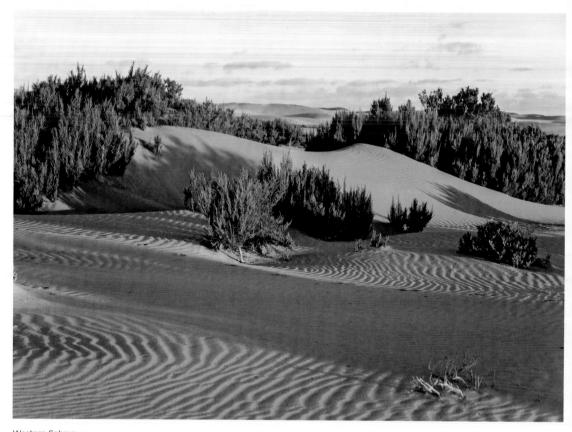

Western Sahara
Sahara occidental

Western Sahara

Until 1976, Western Sahara was occupied by Spain, who exploited the phosphate mines and the nomads living there. Following a bloody war over the independence of the territory, the King declared "autonomy under Moroccan sovereignty" in 2006. Morocco has been investing in the desert region since the turn of the millennium in order to strengthen its claims to the annexed territory. The tourist infrastructure, especially in the city of Dakhla, also benefits from this.

Sahara occidental

Jusqu'en 1976, le Sahara occidental était occupé par des Espagnols qui exploitaient les mines de phosphate et les nomades qui y vivaient. Après une guerre sanglante pour l'indépendance du territoire, le roi a déclaré l'« autonomie sous souveraineté marocaine » en 2006. Le Maroc investit dans la région désertique depuis le début du millénaire afin de manifester ses revendications sur le territoire annexé. L'infrastructure touristique, en particulier dans la ville de Dakhla, en profite également.

Westsahara

Die Westsahara war bis 1976 von Spaniern besetzt, die die Phosphatminen und die dort ansässigen Nomaden ausbeuteten. Nach einem blutigen Krieg, bei dem es um die Frage der Unabhängigkeit des Gebiets ging, erklärte der König 2006 die „Autonomie unter marokkanischer Oberhoheit". Um seine Ansprüche auf das annektierte Gebiet zu manifestieren, investiert Marokko seit der Jahrtausendwende in die Wüstenregion. Davon profitiert auch die touristische Infrastruktur vor allem in der Stadt Dakhla.

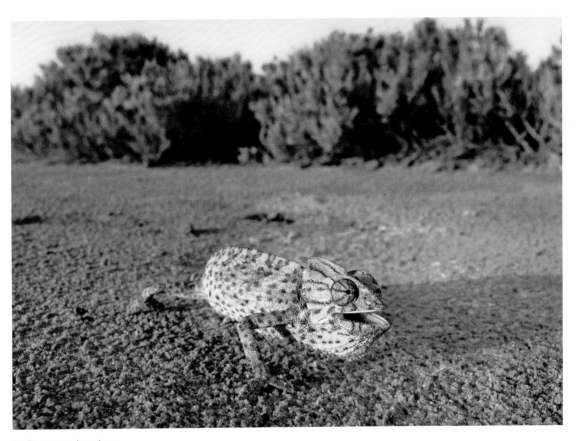

Mediterranean chameleon
Caméléon commun

Sáhara Occidental

Hasta 1976, el Sáhara Occidental estaba ocupado por españoles que explotaban las minas de fosfato y los nómadas que vivían allí. Después de una sangrienta guerra por la independencia del territorio, el rey declaró "autonomía bajo soberanía marroquí" en 2006. Marruecos ha estado invirtiendo en la región desértica desde el cambio de milenio para manifestar sus reivindicaciones sobre el territorio anexionado. La infraestructura turística, especialmente en la ciudad de Dakhla, también se beneficia de ello.

Sahara occidentale

Fino al 1976, il Sahara occidentale era il regno degli spagnoli, che li sfruttavano le miniere di fosfati, e dei nomadi che vi abitavano. Dopo una sanguinosa guerra per l'indipendenza, nel 2006 il re ha dichiarato "l'autonomia sotto la sovranità marocchina". A dimostrazione della propria autorità in queste zone, il Marocco investe nella regione desertica dall'inizio del nuovo millennio. Ne trae vantaggio anche l'infrastruttura turistica, soprattutto nella città di Dakhla.

Westelijke Sahara

Tot 1976 werd de Westelijke Sahara bezet door de Spanjaarden, die de fosfaatmijnen en de daar levende nomaden uitbuitten. Na een bloedige oorlog over de onafhankelijkheid van het gebied verklaarde de koning het in 2006 officieel 'autonoom onder Marokkaanse soevereiniteit'. Marokko investeert al sinds het begin van het millennium in het woestijngebied om zijn aanspraken op het geannexeerde gebied kenbaar te maken. Ook de toeristische infrastructuur, met name in de stad Dakhla, profiteert hiervan.

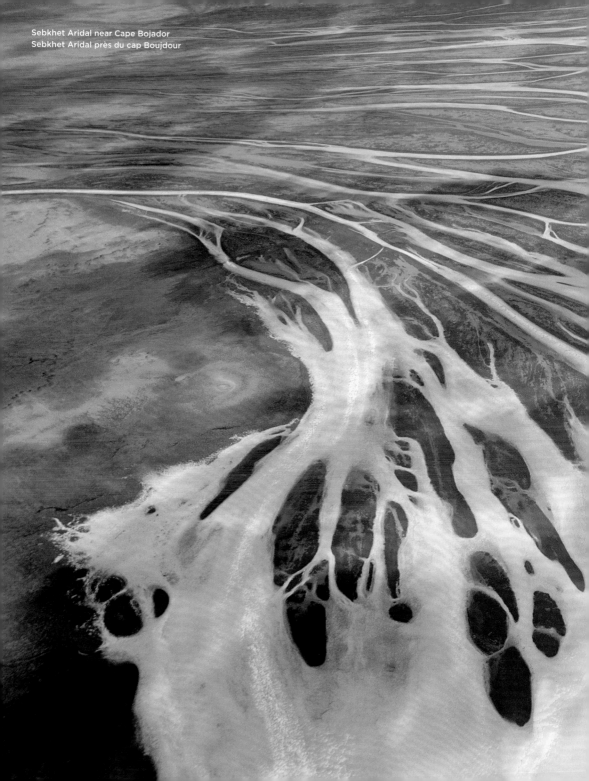

Sebkhet Aridal near Cape Bojador
Sebkhet Aridal près du cap Boujdour

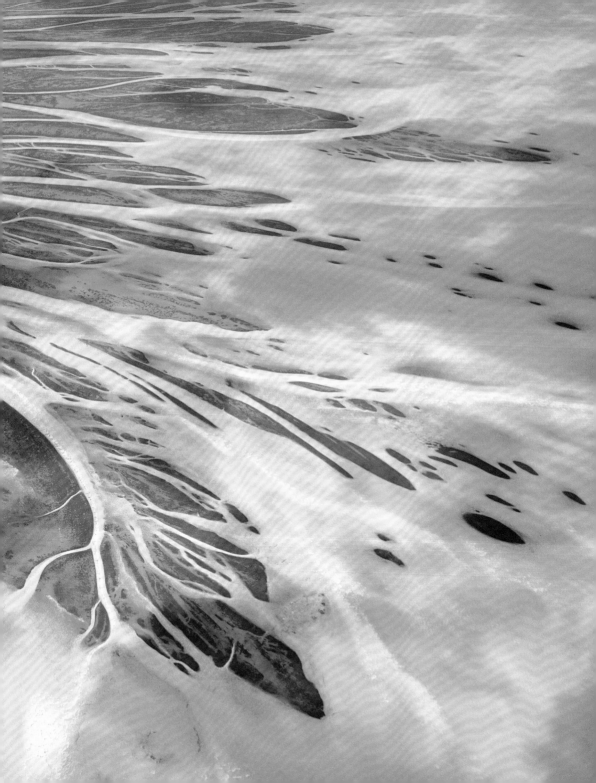

Dromedaries
Dromadaires

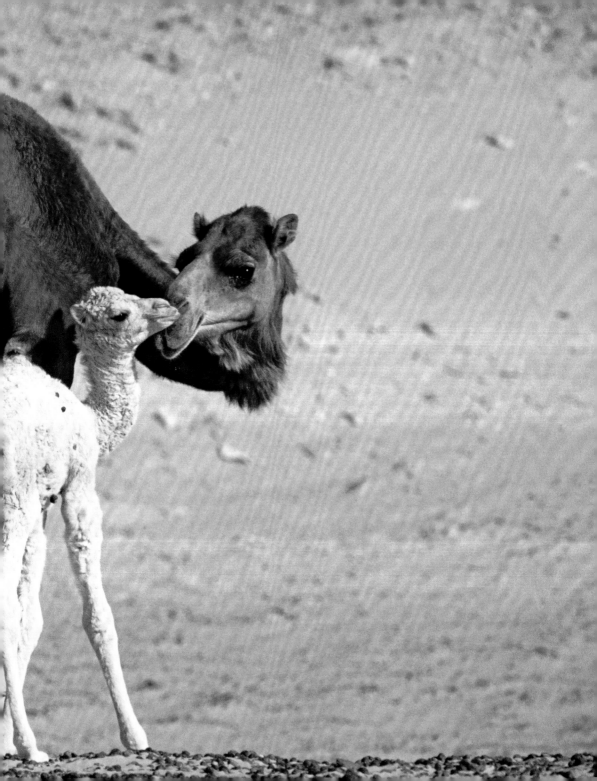

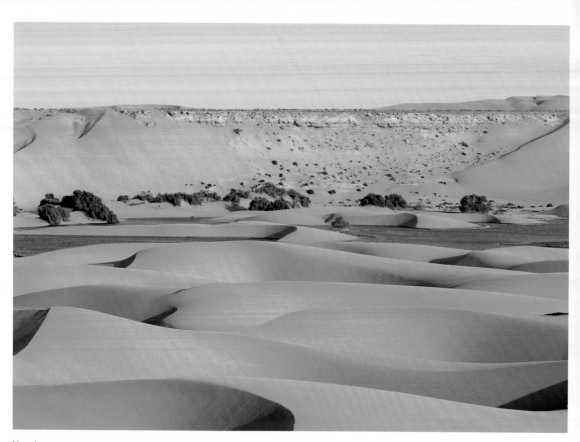

Near Laayoune
Près de Laâyoune

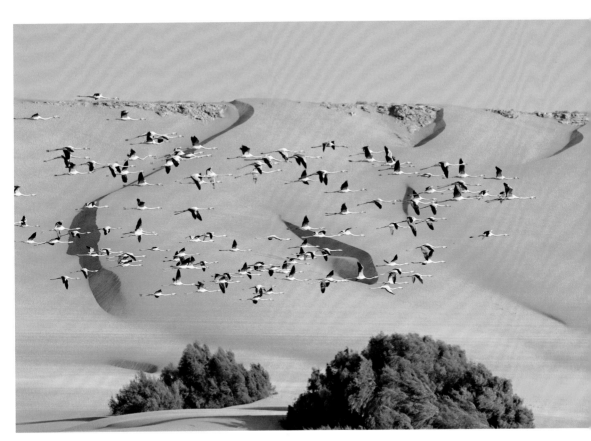

Near Laayoune
Près de Laâyoune

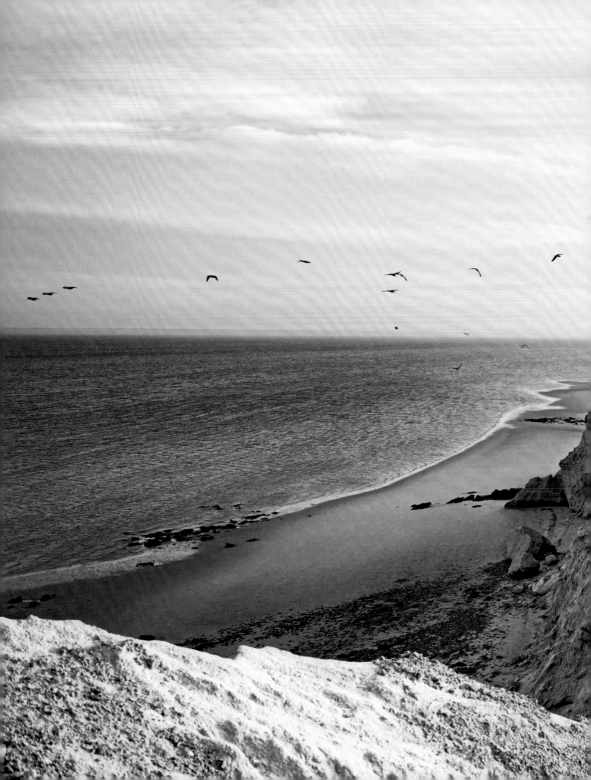

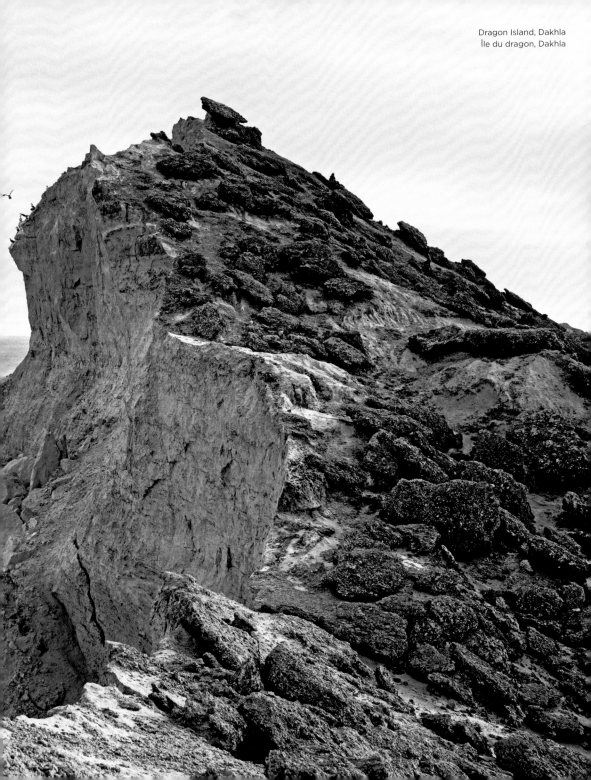

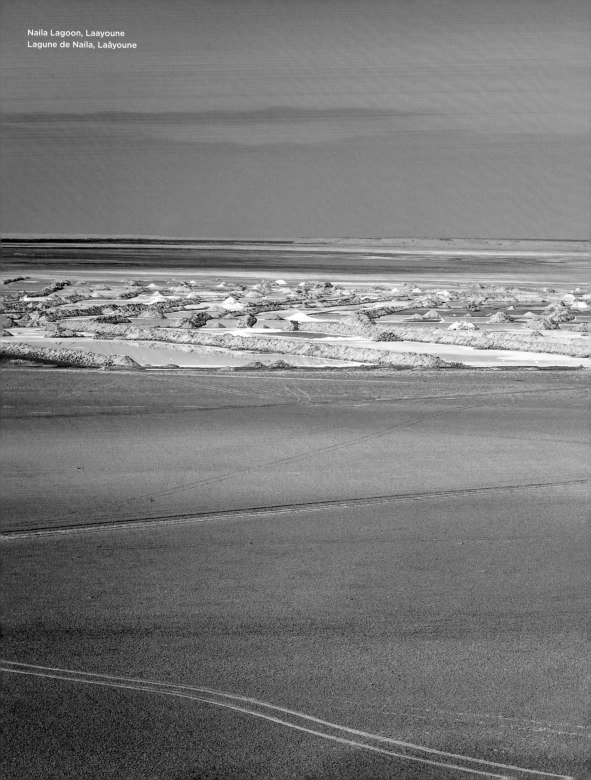

Naila Lagoon, Laayoune
Lagune de Naila, Laâyoune

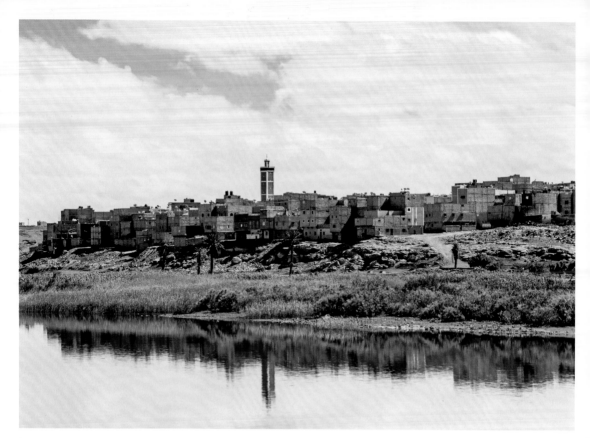

Laayoune
Laâyoune

El Aaiún/Laayoune

El Aaiún (Laayoune) is a modern, fast growing city. The Moroccan government is investing a lot of money to make the area attractive to Moroccans. Those who settle here have advantages: high wages, tax reductions and good educational opportunities. The reason for these offers lies in the conflict in Western Sahara, which has been smouldering for decades. Morocco claims the territory, the indigenous people oppose it and would like to see El Aaiún as the capital of the 'Sahrawi Arab Democratic Republic'.

El Aaiún

El Aaiún (Laâyoune en français) est une ville moderne et en pleine croissance. Le gouvernement marocain investit beaucoup d'argent pour la rendre plus attractive auprès de ses propres habitants. Ceux qui s'installent ici ont des avantages : des salaires élevés, des réductions d'impôts et de bonnes écoles. La raison de ces offres réside dans le conflit au Sahara occidental, qui fait rage depuis des décennies : le Maroc revendique le territoire, le peuple autochtone s'y oppose et aimerait voir El Aaiún devenir la capitale de la République arabe sahraouie démocratique.

El Aaiún

El Aaiún (franz. Laâyounee) ist eine moderne, schnell wachsende Stadt. Die marokkanische Regierung investiert viel Geld, um sie für Marokkaner attraktiv zu machen. Wer sich hier niederlässt, hat Vorteile: hohe Löhne, Steuerermäßigungen, gute Bildungsmöglichkeiten. Der Grund für diese Angebote liegt im seit Jahrzehnten schwelenden Westsahara-Konflikt: Marokko erhebt Anspruch auf das Gebiet, die Indigenen wehren sich dagegen und würden El Aaiún gern als Hauptstadt der Demokratischen Arabischen Republik Sahara sehen.

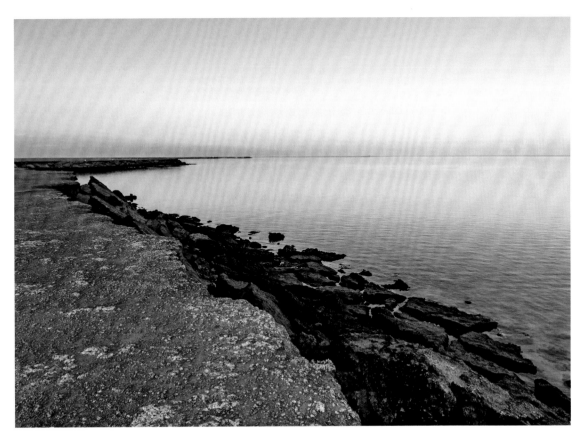

Dakhla

El Aaiún

El Aaiún (en francés: Laâyounee) es una ciudad moderna y de rápido crecimiento. El gobierno marroquí está invirtiendo mucho dinero para hacerla atractiva para los marroquíes. Los que se instalan aquí reciben ciertas ventajas: altos salarios, reducciones de impuestos, buenas oportunidades educativas. La razón de estas ofertas radica en el conflicto del Sáhara Occidental, que ha estado ardiendo durante décadas: Marruecos reivindica el territorio, los indígenas se oponen a él y quieren que El Aaiún sea la capital de la República Árabe Democrática del Sáhara.

El Aaiún

El Aaiún (Laâyounee in francese) è una città moderna e in rapida crescita. Il governo marocchino sta investendo molto per renderla attraente per i marocchini. Chi si stabilisce qui gode infatti di numerosi vantaggi: salari elevati, sgravi fiscali, buone opportunità di istruzione. La ragione di queste offerte risiede nel conflitto del Sahara occidentale, che si protrae da decenni: il governo del Marocco rivendica il territorio, nonostante gli abitanti nativi vi si oppongano e vorrebbero vedere El Aaiún come la capitale della Repubblica Democratica Araba dei Sahrawi.

Al-Ajoen

Al-Ajoen is een moderne, snelgroeiende stad. De Marokkaanse overheid investeert veel geld om hem aantrekkelijk te maken voor Marokkanen. Wie zich hier vestigt, heeft voordelen: hoge lonen, belastingverlaging, goede onderwijsinstellingen. De reden voor al deze voordelen ligt in het conflict in de Westelijke Sahara dat al tientallen jaren broeit: Marokko doet aanspraak op het grondgebied, terwijl de inheemse bevolking zich daartegen verzet en Al-Ajoen graag zou zien als de hoofdstad van de Democratische Arabische Republiek Sahara.

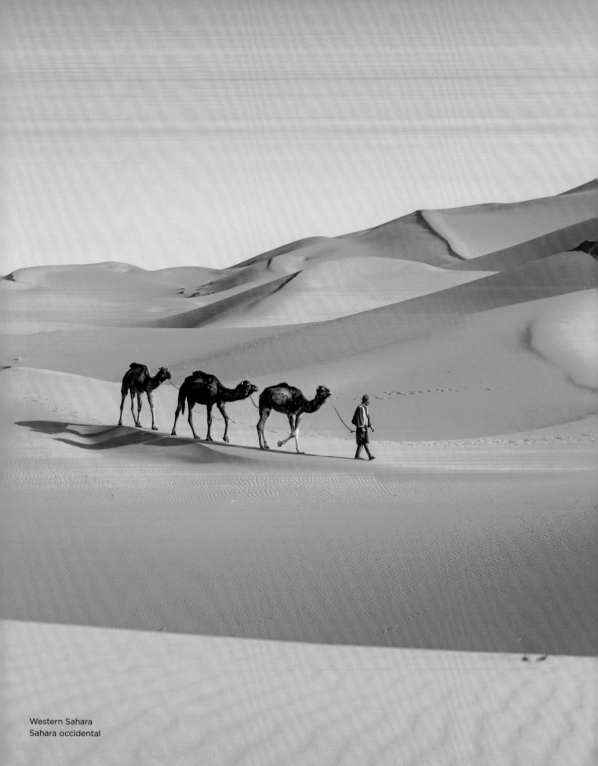

Western Sahara
Sahara occidental

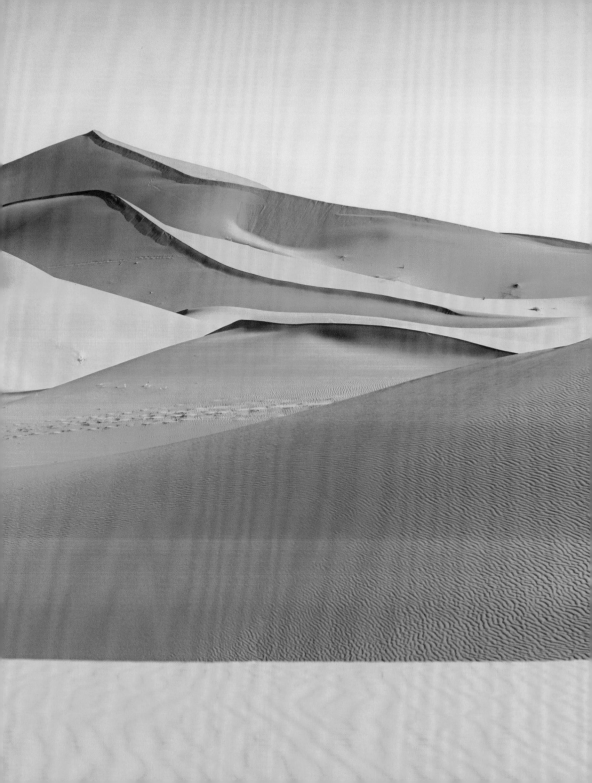

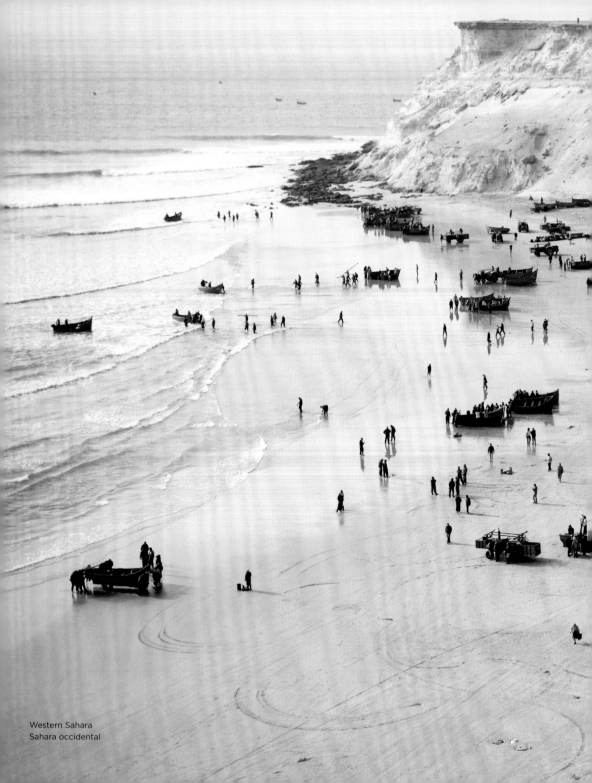

Western Sahara
Sahara occidental

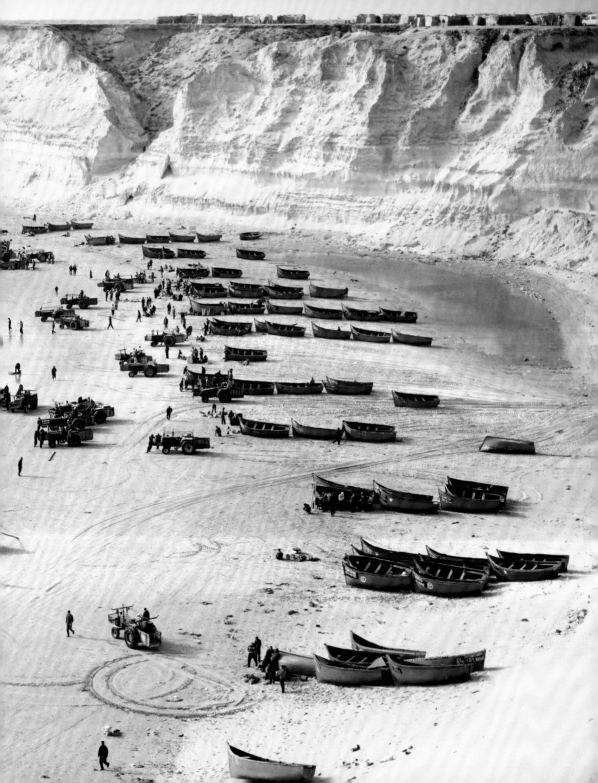

Near Dakhla
Près de Dakhla

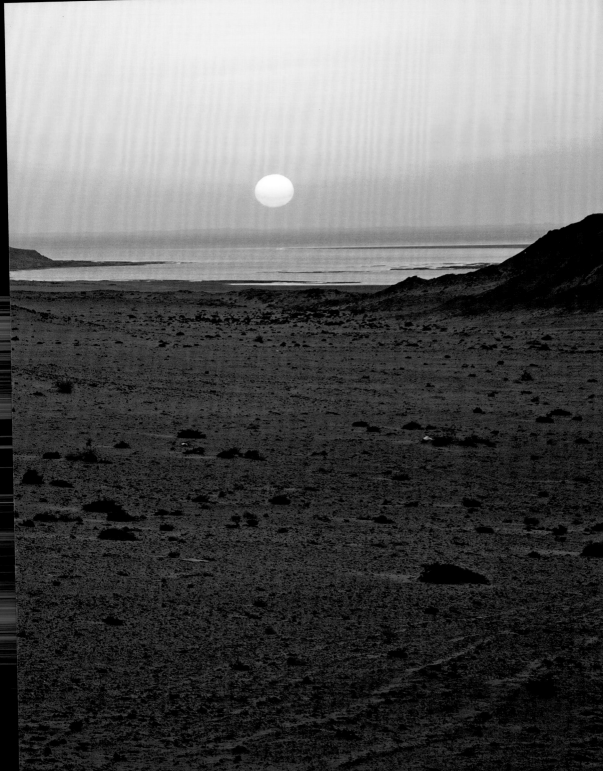

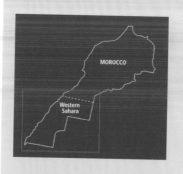

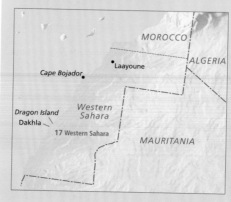

MOROCCO

Western Sahara

MOROCCO

ALGERIA

Laayoune

Cape Bojador

Dragon Island
Dakhla

Western
Sahara

17 Western Sahara

MAURITANIA

Atlantic Ocean

Canarian Islands

Tarfaya

Laayoune

Western Sahara
17 Western Sahara

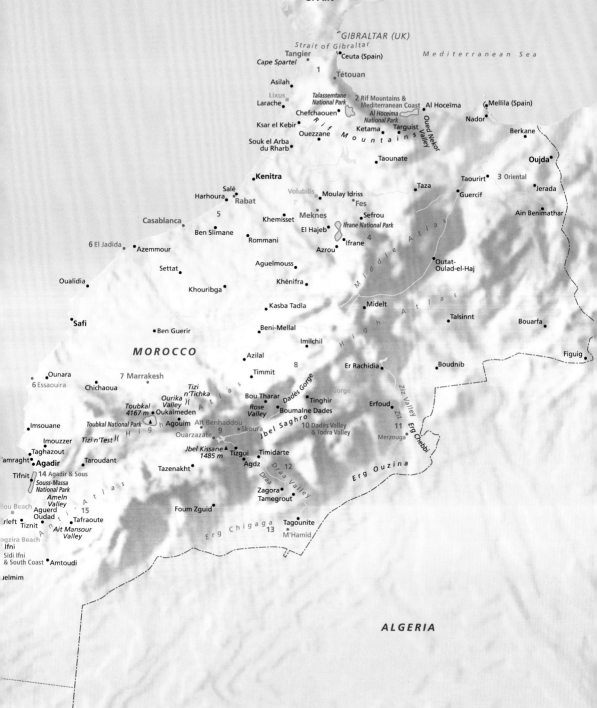

SPAIN

GIBRALTAR (UK)

Strait of Gibraltar

Mediterranean Sea

Tangier
Cape Spartel
1
Ceuta (Spain)
Tétouan
Asilah
Lixus
Larache
Talassemtane National Park
2 Rif Mountains & Mediterranean Coast
Al Hoceïma
Mellila (Spain)
Chefchaouen
Al Hoceïma National Park
Nador
Ksar el Kebir
Rif Mountains
Ketama
Targuist
Berkane
Ouezzane
Oued Nekor Valley
Souk el Arba du Rharb
Taounate
Taza
Oujda
Kenitra
Taourirt
3 Oriental
Jerada
Salé
Volubilis
Moulay Idriss
Guercif
Harhoura
Rabat
Fes
Ain Benimathar
Casablanca
Khemisset
Meknes
Sefrou
5
El Hajeb
Ifrane National Park
Azrou
Ben Slimane
Ifrane
4
Outat-Oulad-el-Haj
Rommani
Azrou
Middle Atlas
6 El Jadida
Azemmour
Aguelmouss
Settat
Khénifra
Oualidia
Khouribga
Kasba Tadla
Midelt
Talsinnt
Safi
Beni-Mellal
Bouarfa
Ben Guerir
High Atlas
MOROCCO
Azilal
Imilchil
Timmit
Er Rachidia
Figuig
7 Marrakesh
8
Boudnib
Chichaoua
Tizi n'Tichka
6 Essaouira
Ounara
Ourika Valley
Bou Tharar
Dadès Gorge
Atlas
Todra Gorge
Toubkal 4167 m
Oukaïmeden
Rose Valley
Tinghir
Ziz Valley
Imsouane
Toubkal National Park
Agouim
Boumalne Dades
Erfoud
11
Imouzzer
Agadir
Tizi n'Test
High
Agadir
Aït Benhaddou
9
Skoura
10 Dadès Valley & Todra Valley
Ziz
Erg Chebbi
Taghazout
Ouarzazate
Merzouga
amraght
Taroudant
Jbel Kissane 1485 m
Tizgui
Timidarte
Agadir
Tifnit
14 Agadir & Sous
Tazenakht
Agdz
Souss-Massa National Park
12
Erg Ouzina
ou Beach
Ameln Valley
Aguerd Oudad
15
Foum Zguid
Draa Valley
Zagora
Tamegrout
rleft
Tafraoute
Tiznit
egzira Beach
Sidi Ifni
Ifni
Aït Mansour Valley
Tagounite
13
M'Hamid
& South Coast
Amtoudi
Anti Atlas
Erg Chigaga
uelmim

ALGERIA

Photo credits

Getty images

2 Pavliha; 4/5 Pavliha; 6/7 Pavliha; 8/9 AlbertoLoyo; 10/11 Pavliha; 12/13 Pavliha; 14/15 RilindH; 16 Pavliha; 24/25 Rachid Dahnoun; 26 MONTICO Lionel/hemispicture.com; 28/29 Neil Farrin/robertharding; 30/31 Albert Engeln; 32 Neil Farrin; 33 Pierre-Yves Babelon; 34/35 Ignacio Palacios; 38/39 Ivan Vdovin; 40/41 luisapuccini; 42 holgs Holger Mette; 43 pierivb; 46/47 Albert Engeln; 48/49 Albert Engeln; 50/51 Mike Truelove; 52/53 Simon Montgomery/robertharding; 54 DEA/C. SAPPA; 55 Wigbert Röth; 56/57 Siempreverde22; 58 Izzet Keribar; 59 Pierre-Yves Babelon; 60/61 Izzet Keribar; 66 JulianSchaldach; 67 Andrew Walmsley/Alamy Stock Photo; 68/69 DEA/C. SAPPA; 70 MUSTAFA EL HASSOUNI; 71 Dave Stamboulis; 73 Santiago Urquijo; 74/75 MUSTAFA EL HASSOUNI; 76/77 Raquel Maria Carbonell Pagola; 82 Raquel Maria Carbonell Pagola; 83 Raquel Maria Carbonell Pagola; 86/87 Neil Farrin; 90/91 Thanachai Wachiraworakam; 92/93 Lee Frost; 96/97 Siqui Sanchez; 99 Ugurhan Betin; 100/101 Pavliha; 102/103 mdmworks; 104 Kelly Cheng; 105 Kelly Cheng; 108 NurPhoto; 109 NurPhoto; 110/111 Pavliha; 112/113 Tuul & Bruno Morandi; 120/121 Athanasios Gioumpasis; 130/131 Pavliha; 132/133 Westend61; 134 AGF; 136/137 DESCHAMPS Tristan/hemis.fr; 138 Zdenek Kajzr; 139 Michael Marquand; 140/141 Walter Bibikow; 142 Andrea Pistolesi; 144/145 Pavliha; 148 Richard Sharrocks; 149 Izzet Keribar; 150/151 Izzet Keribar; 152/153 Walter Bibikow; 154 Walter Bibikow; 158 Michel RENAUDEAU; 159 Walter Bibikow; 160/161 YOSHIHIRO TAKADA; 162/163 YOSHIHIRO TAKADA; 164/165 AlxeyPnferov; 166 Jason Langley/Aurora Photos; 168/169 Pavliha; 170/171 Paul Williams – Funkystock; 174/175 Visions Of Our Land; 176 Rachel Lewis; 177 Rachel Lewis; 178/179 Jose Fuste Raga/Sebun Photo; 180/181 Thanachai Wachiraworakam; 182 Paul Williams – Funkystock; 183 Aziz Ary Neto; 184/185 danm; 186/187 Jean-Pierre Lescourret; 188/189 ppart; 190/191 Andrea Pistolesi; 192 Neil Emmerson; 193 raspu; 194 Stefan Cristian Cioata; Starcevic; Christopher Griffiths; pulpitis; nimu1956; encrier; Starcevic; stockstudioX; kasto80; Nisangha; Madzia71; Mytho; 195 Stefan Cristian Cioata; Paul Biris; Stefan Cristian Cioata; Paul Biris; VanderWolf-Images; Alvaro Faraco; Nicolas Ayer/EyeEm; Danita Delimont; 196/197 guenterguni; 198/199 Matthew Williams-Ellis; 202/203 Maremagnum; 205 Wolfgang Kaehler; 206/207 Thomas Dressler; 210 Pavliha; 212/213 Pavliha;

214/215 A J Withey; 216/217 Mark A Paulda; 219 Jason Langley/Aurora Photos; 220/221 Pavliha; 222/223 Mark A Paulda; 224/225 mrsixinthemix; 227 MONTICO Lionel/hemispicture.com; 228/229 Pavliha; 230/231 MONTICO Lionel/Hemis.fr; 232 MONTICO Lionel/Hemis.fr; 234/235 Pavliha; 236/237 Danita Delimont; 238/239 Leonid Andronov; 240/241 Pavliha; 246/247 Pavliha; 248/249 Pavliha; 250/251 Pavliha; 252/253 Starcevic; 258/259 Ian Cumming; 260 Starcevic; 261 Starcevic; 262/263 Stefan Cristian Cioata; 268 Klaus Lang; 272/273 Lou GRIVE/GAMMA-RAPHO; 274 GIUGLIO Gil; 275 Ian Cumming; 276/277 Starcevic; 278/279 Pavliha; 284/285 Starcevic; 287 Visions Of Our Land; 288/289 Pavliha; 290/291 Pavliha; 292/293 Starcevic; 294/295 Pavliha; 312/313 Pavliha; 318/319 Manuel Breva Colmeiro; 320 Daniel Schoenen; 322/323 Pavliha; 324/325 Pavliha; 332/333 Jean-Pierre Lescourret; 334/335 Mauricio Abreu; 342/343 Maremagnum; 344/345 Davide Seddio; 346/347 Maremagnum; 350/351 Frans Lemmens; 352 Eric TEISSEDRE; 353 Eric TEISSEDRE; 354/355 Pavliha; 356/357 Maremagnum; 358 Frans Lemmens; 359 Eric TEISSEDRE; 362/363 Jacques84250; 364 Walter Bibikow; 366/367 Jacques84250; 368 Mariss Balodis; 370/371 Astalor; 372 Jacques84250; 373 Jacques84250; 374/375 Tim E White; 376 Krzysztof Dydynski; 377 Tim E White; 378/379 Ladislav Pavliha; 380/381 Jacques84250; 382 Martin Harvey; 383 Daniel Reiter/STOCK4B; 386/387 Neil Farrin; 388 nicolamargaret; 389 nicolamargaret; 390/391 Doug Pearson; 392 Wigbert Röth; 393 Wigbert Röth; 394/395 MOIRENC Camille/hemis.fr; 396 Aldo Pavan; 397 Amar Grover/John Warburton-Lee Photography Ltd; 400/401 Doug Pearson; 404/405 MOIRENC Camille/hemis.fr; 408/409 Julian Schaldach/EyeEm; 411 Pavliha; 412/413 Ababsolutum; 416/417 JulianSchaldach; 418/419 Tony Yong; 420/421 Pavliha; 422/423 Pavliha; 424 kristianbell; 425 kristianbell; 426/427 GARDEL Bertrand/hemis.fr; 428/429 Pavliha; 430/431 Pavliha; 436/437 Yann Arthus-Bertrand; 442/443 David Degner; 444/445 Pavliha; 448/449 hadynyah; 450/451 David Head

Huber Images

27 Anna Serrano; 62/63 Jan Wlodarczyk; 72 TC; 88 Jan Wlodarczyk; 89 Jan Wlodarczyk; 94/95 Paolo Giocoso/SIME; 98 Jan Wlodarczyk; 106/107 Tim Mannakee; 114 Anna Serrano; 126/127 Tim Mannakee; 156/157 Hans Peter Huber;

167 Jürgen Ritterbach; 211 Jerome Lorieau; 226 TC; 244 Douglas Pearson; 245 Massimo Ripani; 254/255 Massimo Ripani; 266/267 Ugo Mellone; 280/281 Jan Wlodarczyk; 286 Fridmar Damm; 300/301 Jan Wlodarczyk; 303 Tim Mannakee; 308/309 Ugo Mellone; 310 Massimo Ripani; 311 Alessandro Saffo; 314/315 Massimo Ripani; 316 Alessandro Saffo; 317 Alessandro Saffo; 321 Tim Mannakee; 326 Jan Wlodarczyk; 326 Jan Wlodarczyk; 326 Massimo Ripani; 330 Massimo Ripani; 331 Massimo Ripani; 336/337 Tuul & Bruno Morandi; 340/341 Massimo Ripani; 348 Guillem Lopez; 410 Riccardo Spila; 432/433 Tuul & Bruno Morandi; 435 Ugo Mellone

laif

204 Guy Thouvenin/robertharding; 208/209 Yorck Maecke/GAFF; 349 Maecke/GAFF; 406 Jason Langley/Aurora; 414 Bruno Morandi; 440 Bruno Morandi; 441 Bruno Morandi

mauritius images

18 imageBROKER/Jason Langley; 21 Jan Wlodarczyk/Alamy; 22/23 Alamy/Jason Langley; 36/37 Masterfile RM; 44/45 Marek Zuk/Alamy; 64 Marco Cristofori; 64 Beckhäuser, Marion; age fotostock/Jan Wlodarczyk; Novarc/Nicolas Marino; Novarc/Nicolas Marino; Axiom RF/Alexander Macfarlane; Axiom RF/Derelie Cherry; Axiom RF/Derelie Cherry; ClickAlps/Alistair Laming; age fotostock; 65 Danita Delimont; age fotostock/Jordi Caml; imageBROKER/Günter Flegar; imageBROKER/Günter Flegar; AGF/Hermes Images; age fotostock/Bernd Rohrschneider; 78 Emanuele Ciccomartino/Alamy; 79 age fotostock/Emanuele Ciccomartino; 80/81 Emanuele Ciccomartino; 84 Emanuele Ciccomartino/Alamy; 85 Emanuele Ciccomartino/Alamy; 115 philipus/Alamy; 116/117 Eduardo Blanco/Alamy; 118 Eduardo Blanco/Alamy; 119 Eduardo Blanco/Alamy; 122/123 imageBROKER/Daniel Schoenen; 124 Peter Carey/Alamy; Juergen Ritterbach/Alamy; Chris Dunham/Alamy; United Archives; fStop/Johannes Marburg; Danita Delimont; Prisma/VC-DLH; Masterfile RM/Marco Cristofori; imageBROKER/Wigbert Röth; 125 Stella Pappas/Alamy; Llewellyn/Alamy; 125 imageBROKER/XYZ PICTURES; imageBROKER/Wigbert Röth; Llewellyn/Alamy; Cosmo Condina/Alamy; Charles O. Cecil/Alamy; robertharding/Bruno Morandi; 128 Paul Thompson Images/Alamy; 129 imageBROKER/Jörg Dauerer; 135 imageBROKER/Jörg Dauerer; 143 Photononstop/Nicolas Thibaut; 146/147 nature picture library/Gavin Hellier; 155 OVIA IMAGES/Alamy; 172 imageBROKER/

Jason Langley; imageBROKER/Fabian von Poser; 172 imageBROKER/Günter Flegar; imageBROKER/Stefan Kiefer; 173 imageBROKER/Moritz Wolf; imageBROKER/Daniel Schoenen; imageBROKER/Egon Bömsch; Daniel Korzeniewski/Alamy; Jan Wlodarczyk/Alamy; Nikreates/Alamy; imageBROKER/Günter Flegar; 200 imageBROKER/Jose Antonio Moreno castellano; 201 imageBROKER/Moritz Wolf; 218 Kevin Foy/Alamy; 233 george robertson/Alamy; 242/243 imageBROKER/Paul Williams – Funkystock; 256 imageBROKER/Paul Williams – FunkyStock; 257 imageBROKER/Peter Schickert; 264 age fotostock/Christian Goupi; age fotostock/Gonzalo Azumendi; John Warburton-Lee/Paul Harris; imageBROKER/Stefan Auth; imageBROKER/Jason Langley; imageBROKER/XYZ PICTURES; Selbach, Arthur F.; 265 Westend61 /hsimages; age fotostock/Christian Goupi; CuboImages/Michele Stanzione; Travel Collection/Selbach, Arthur F.; Westend61 /Klaus Mellenthin; age fotostock/Christian Goupi; John Warburton-Lee/Mauricio Abreu; Photononstop/Sébastien Rabany; Travel Collection/Selbach, Arthur F.; 269 age fotostock José Antonio Moreno; 270/271 Jerônimo Alba/Alamy; 282/283 Jerônimo Alba/Alamy; 296/297 Andy Sutton/Alamy; 298/299 Simon Grosset/Alamy; 302 age fotostock/José Antonio Moreno; 304/305 Jerônimo Alba/Alamy; 306/307 age fotostock/José Antonio Moreno; 326 CuboImages/Eddy Buttarelli; Simon Reddy/Alamy; imageBROKER/Günter Flegar; Simon Reddy/Alamy; 327 Robert Fried/Alamy; MARKA/Alam; Kevin Foy/Alamy; imageBROKER/Wigbert Röth; Bill Bachmann/Alamy; robertharding/Lee Frost; Chris Griffiths/Alamy; 328/319 imageBROKER/Wigbert Röth; 338 imageBROKER/Wigbert Röth; 339 imageBROKER/Wigbert Röth; 360/361 Alamy; 365 Alamy; 369 Rutger Klevenfeldt/Alamy; 384 Flowerphotos; nature picture library; imageBROKER/Michael Peuckert; Jan Fritz/Alamy; James O'Sullivan/Alamy; Photononstop/SÉbastien Rabany; imageBROKER/Michael Peuckert; 385 imageBROKER/Michael Peuckert; Shanti Hesse/Alamy; AA World Travel Library/Alamy; imageBROKER/Michael Peuckert; imageBROKER/Wigbert Röth; 398/399 imageBROKER/Wigbert Röth; 402 imageBROKER/Wigbert Röth; 403 imageBROKER/Wigbert Röth; 407 imageBROKER/Jason Langley; 415 Alamy; 434 Rachel Carbonell/Alamy; 438/439 Minden Pictures/Gerry Ellis; 446 Rachel Carbonell/Alamy; 447 Rachel Carbonell/Alamy; 452/453 imageBROKER/Peter Giovannini

KÖNEMANN

© 2020 koenemann.com GmbH
www.koenemann.com

© Éditions Place des Victoires
6, rue du Mail – 75002 Paris
www.victoires.com
Dépôt légal : 1er trimestre 2020
ISBN: 978-2-8099-1776-5

Series Concept: koenemann.com GmbH

Responsible Editor: Jennifer Wintgens
Picture Editing: Jennifer Wintgens
Layout: Marta Wajer/Christoph Eiden
Colour Separation: Prepress, Cologne
Text: Christine Metzger
Translations: koenemann.com GmbH
Maps: Angelika Solibieda
Front cover: Huber Images/Jan Wlodarczyk

Printed in China by Shyft Publishing/Hunan Tianwen Xinhua Printing Co., Ltd

978-3-7419-2509-2